Protestant and Catholic Women in Nazi Germany

Michael Phayer

Protestant and Catholic Women in Nazi Germany

 Wayne State University Press
Detroit 1990

Library of Congress Cataloging-in-Publication Data

Phayer, Michael, 1935-
 Protestant and Catholic women in Nazi Germany / Michael Phayer.
 p. cm.
 Includes bibliographical references.
 ISBN 0–8143–2211–5
 1. Women, Christian—Germany—History—20th century. 2. Germany—
Social conditions—1933–1945. 3. National socialism—Religious
aspects. 4. Church and state—Germany—History—1933–1945.
I. Title.
HQ1623.P47 1990
305.48'862'0943—dc20 89–16574
 CIP

For My Mother
Aveline Heshion Phayer

Contents

7

Illustrations

Figures and Tables

Figures

Tables

11

Abbreviations

ADC	Archiv Deutscher Caritas (House Archives)	BAB	Bistumsarchiv Berlin (Diocesan Archives)
ADW	Archiv des Diakonischen Werkes (House Archives)	BAF	Bistumsarchiv Freiburg (Diocesan Archives)
AEKB	Archiv des Evangelischen Konsistoriums Berlin-Brandenburg (Provincial Archives)	BDC	Berlin Document Center
		BDM	Bund Deutscher Mädel (League of German Girls)
AEKU	Archiv der Evangelischen Kirche der Union (Central Archives)	DNVP	Deutschnationale Volkspartei (German Nationalist Party)
AVKZ	Archiv der Veröffentlichungen des Kommissions für Zeitgeschichte (House Archives)	EKW	Evangelische Kirche von Westfalen (Provincial Archives)
		HAK	Historisches Archiv Köln (Diocesan Archives)

KDF Katholischer NSV National-
 Deutscher sozialistische
 Frauenbund (Central Volkswohlfahrt
 Archives) (National Socialist
OAT Ordinariatsarchiv Welfare
 Trier (Diocesan Association)
 Archives) SA Sturmabteilung
NSDAP National- (Brown Shirts)
 sozialistische SS Schutzstafel
 Deutsche (Himmler's Black-
 Arbeiterpartei Uniformed Elite
 (National Socialist Corps)
 German Workers' WHW Winterhilfswerk
 Party) (Winter Welfare
NSF National- Drive)
 sozialistische
 Frauenschaft
 (National Socialist
 Women's
 Association)

Introduction

Writing a book on Protestant and Catholic women during the National Socialist era would appear to be an uncomplicated and straightforward proposition. The subject seems to deal with well-defined subgroups that for ideological reasons were distinct from national socialism. But if we ask ourselves who is excluded from our study, ambiguity sets in. Virtually everyone in Germany was either Protestant or Catholic. Even many National Socialists maintained ties to traditional religious institutions. Although a minority of Germans no longer practiced their religion, most still counted themselves as nominal Christians. Besides, backsliders and apostates tended to be men rather than women. Who, then, is the object of this study?

The question, it turns out, cannot be answered quite as neatly as I would like. In France, where dechristianization has been a common historical and sociological theme, a threefold division of Christians is used: those who regularly practice, occasional conformists, and the nonpracticing. If we were to adopt these categories, then this book would mostly concern the first group—zealous Christians. But dechristianization terminology ill suits Germany. Most German women would fall into the first group of "the practicing" during the earlier decades of the century. Consequently, were we to borrow French terms, we would end up where we began with a massive, undifferentiated population. We know, furthermore, that considerable support for national socialism came from within this population. Where else, after all? Thus, even the distinction

between Christians and National Socialists breaks down for many women at least until about the middle of the decade of the 1930s. Indeed, I shall argue that zealous Protestant women were among Hitler's earliest and most enthusiastic supporters.

The problem lies in the difficulty we experience in discovering differentiations within the massive Catholic and Protestant population. Unfortunately, there is very little historical literature to guide us or offer us a foothold. Historians have produced a great body of literature on German women which covers every subgroup—liberal, feminist, socialist, and Jewish—save one, Christian women, the largest subgroup by far of all. By default or neglect, Protestant and Catholic women have been lumped together as conservatives or even protofascists. Common sense should warn us that a population as enormous as that of Christian women could not possibly be socially, politically, or temperamentally monolithic.[1] In short, it simply will not do to speak in terms of a Catholic or a Protestant posture vis-à-vis national socialism.

By way of answering the question I have raised here, I attempt to introduce some plurality within Christian women in the first chapter. It is relatively easy to distinguish attitudinal differences amongst Protestants and Catholics, but I attempt to go further and discover differentiations within each subgroup. It is then on the basis of these more specific identifications, which are not in every case as well defined as I would like, that I address the broader question of the disposition—or rather, dispositions—within each subgroup of Christian women toward national socialism.

But I should not try to dodge the question that I have posed by simply postponing the answer. In the first instance, the women who will concern us in this study are those who consistently sought to govern their attitudes toward national socialism and its ideology by Christian standards as they perceived them. In other words, I propose that there were some Protestant women and some Catholic women whose alltägliche views were primarily grounded in religious principles rather than social or political or economic considerations. Or, to put it another way, what they thought about women in society, about their country's political situation, and about eco-

nomic systems was colored by their religious views and experiences. We will be able to learn more about the content of these Christian views by studying the literature and purposes of five organizations of women: the Evangelical Women's League, the Protestant Ladies' Auxiliary, the Catholic German Women's League, the Catholic Women and Mothers' Sodality, and the Elizabeth Society. Collectively, these five associations counted a membership of about two and a half million by 1930, and their in-house publications and newspapers had a greater circulation by far than any other women's group or groups. Because they constituted a very significant minority of churchgoing women, we can rely on the associations of these women to provide us with insights into the mentality of zealous Protestant and Catholic women on the eve of the National Socialist seizure of power and, to a considerable extent, during the Nazi years as well.

In the second instance this book is about all practicing Protestant and Catholic women, not just the most ardent. To what extent can we take the more select group of the "committed" as representative of all churchgoing Christian women? There was, by all means, a considerable agreement in mentality among all churchgoing women. Beneath a superficial plurality, reflected by the various associations of Christian women, there was a bedrock of credal homogeneity. Until the confrontation with national socialism occurs in the latter years of the thirties, it is impossible to draw a line distinguishing "committed" churchgoers from the rest of the faithful. Even if this were possible theoretically, the sources would not allow us to develop such a distinction in practice.

Differentiation only becomes possible in connection with the ideological confrontation between national socialism and the Christian churches. The response of the faithful under National Socialist duress was not uniform. Generally speaking, women who were members of the associations mentioned above were prepared to take a stand on the great moral questions of the day. The majority, by contrast, preferred not to allow them to become issues of conscience. We know this because of the factions that emerged from the Protestant Church Struggle and through Catholic membership drives for its national charity project, Caritas. Some Protestant women

and some Catholic women emerge as more committed to their church or credal principles than others, which created a healthy tension in the churches and a situation in the country that National Socialists viewed as dangerously volatile. The opportunity existed for the committed minority to influence the majority of churchgoers in the ideological confrontation. National Socialists became painfully aware of this potential whenever they launched an ill-advised attack on a church or church figure resulting in a ground swell of support for religion that, momentarily, provided all of the faithful with the zeal of the committed.

In the long run, however, the committed minority remained a minority. This study, therefore, deals with smaller circles of women as it progresses. Thus, it begins by inquiring about the attitude of all Christian women toward national socialism, then deals with those who risked dissent, and finally it takes up the few who were involved in resistance. I argue that the central issue that causes this narrowing of the circle is racism. At first there is ambiguity about it, but by the middle years of the 1930s its implications for religion become clear and a sorting out process takes place that separates the faithful from the zealous. Finally, during the war years an even more limited number of religiously committed women attempt to rescue Jews. As this study progresses, I shall be at pains to delineate the tripartite circles of the faithful, the dissenters, and the resisters. But I admit that the edges of these concentric circles are soft, and I ask the reader for some license in this respect. Although I make use of quantitative data when possible, strict categories based on this sort of evidence are not always possible or desirable.

In a small but significant way this book is also about Jews. It became increasingly common in modern times for Jews to convert to Christianity. The public has recently become more aware of this movement because of the minor controversy surrounding the Catholic church's beatification of Edith Stein in 1987. Some questioned the judgment of this step since she died because she was Jewish not because she was Christian. At the time of the Holocaust itself, such a question would not have occurred to many Jews regardless of their religious preferences. I do not know if Christian Jews thought of themselves

as Jews, Christians, or Germans, or in what order they did so, but it is clear that the ordeal that we call the Holocaust awakened deep feelings of ethnic solidarity between Jews of various religious persuasions. As a result, we find a hugely disproportionate number of Jews in the small circle of Christian resisters.

Several considerations led me to deal with Protestant and Catholic women separately in this study. Unfortunately, ecumenism had not yet graced the Christian scene when hostilities between national socialism and the churches arose. As a result, Protestant and Catholic women usually did not think of themselves as "sister" followers of Christ opposed to Nazi neopaganism. Jealousy and spitefulness characterized their feelings for one another to such an extent that the leader of National Socialist women, Gertrud Scholtz-Klink, figured that the easiest way to promote her organization of women at the expense of the Christian associations of women was to play Catholics off Protestants, and vice versa.

The second reason is deeply anchored in Germany's history—the Reformation of Martin Luther. In the intervening centuries both confessions developed their own traditions which struck root regionally throughout the land. The ability of these traditions to stamp the mentalities of people in times of duress is remarkable. By 1935 nazism had created such a time. As we will see again and again in our study, Protestant women's response to national socialism's challenge tended to center around the Bible, whereas the Catholic response often centered around Mary.

Religious tradition made a difference in yet another way. In the post–Reformation era the Tridentine church developed a strong hierarchical tradition, which the nineteenth century only reinforced. The eagerness of the Vatican secretary of state, Eugenio Pacelli, to arrive at an understanding with national socialism led to the signing of the Concordat in the very first year of Hitler's rule. Advantages and disadvantages resulted, as we will see, but the point is that the Concordat gave Catholics a unity that is plain to see when compared to the hopeless divisions in the Protestant sector. Thus, when discord arose between national socialism and the churches, Protestants and Catholics experienced it differently.

These institutional and religious factors colored the experience of Protestant and Catholic women too deeply to be disregarded. Had I attempted to write this study strictly from the point of view of a social historian—from the vantage of women's history, let us say—then it would not have been suitable to make confessional divisions. But faith, not feminism, was the basic issue in the confrontation of Protestant and Catholic women with Nazi neopaganism. Institutional and religious elements overwhelmed social factors.

This orientation has led me to interpret the experience of Protestant and Catholic women differently than Claudia Koonz does in her survey of women in National Socialist Germany and to develop aspects of their response to Hitler's regime that her study either does not take up or treats only in passing.[2] A significant difference in interpretation, for example, has to do with the Protestant Church Struggle, which I see as the critical factor behind the relationship of women of this confession with nazism in general and with National Socialist women in particular. Koonz finds generational differences among the leaders of Protestant women, or personal ambition among them to become the *Führerin* of Protestant or of German women, a more compelling factor than the Protestant Church Struggle. These differing approaches result in distinctly contrasting judgments on the leading actor in this drama, Agnes von Grone, whom the Nazis accused of leading Protestant women astray.

A major variance in emphases between Koonz's *Mothers in the Fatherland* and my study concerns the activities of Protestant and Catholic women during the several years just before the war down to the time during the war when it appeared that Germany might emerge victorious. Because church leaders became aware that a postwar nazified Europe would lead to a final showdown between Christian and National Socialist ideology, they turned to churchgoing women to hold the ground on behalf of religion. As a result of this encouragement from churchmen, and because of their own initiative, Protestant women became intensely involved during these years with a Bible program, and Catholics, with catechetical work among the youth. My emphasis on this endeavor led to another difference of interpretation with Koonz.

Whereas Koonz believes that women's experiences in National Socialist Germany caused increased segregation into a women's world, I argue that it promoted greater integration for them in the churches, and, through them, in community affairs. For Protestant women it led, in fact, directly to eldership and full ministerial ordination.

No one, of course, can write about the Nazi era without dealing with racial issues. In this regard I hope to contribute new information and greater accuracy to the historical record. There is general agreement all around that Protestants displayed more tolerance toward the Nazi's racist ideology than Catholics. I bring this issue to bear on women at considerable depth by attempting to distinguish different levels of alienation among Protestants and Catholics regarding National Socialist racism. Naturally, I have benefited by recent studies, such as those by Sarah Gordon, Ian Kershaw, and Detlev Peukert in my attempt to trace the all too gradual change of mind among women of the churches regarding racism.[3] More than others, I have set this experience in the context of religious teachings and of institutional religion. In this connection, I introduce a key personality, Margarete Sommer, whose activity sheds light, at one and the same time, on Catholic concern for Jews and on the pusillanimity of Catholic church leaders.[4] Recent publications in the documentary series published by the *Kommission für Zeitgeschichte* show that, contrary to what has been written, the impetus for church intervention on behalf of Jews during the Holocaust came from the Berlin circle.[5] Margarete Sommer was most prominent within this group.

There is one other gap in the history of the Third Reich that I hope this study will narrow—the role of women in the Protestant Church Struggle. Although major, comprehensive histories in both German and English have dealt with the church struggle in considerable detail, women play no part in these accounts.[6] It is difficult to grasp how their part could have been neglected for so long. Women constituted more than half of the faithful, and although the power struggles for church positions took place among men, men could not hope to retain authority if women did not back them. The omission of women in the history of the church seems extraordinarily

strange in light of the fact that church*men* during the Nazi
era consistently said that their female counterparts were vi-
tal in the fight against National Socialist ideology and neo-
paganism.

Finally, a word about source material is in order. I have
attempted to write a national, rather than regional, account.
Several factors made this possible. The largest single women's
group in Germany at the beginning of the National Socialist
era was the Protestant Ladies' Auxiliary. The auxiliary had affil-
iates all over the country, although it seems to have been
strongest in Prussia and weakest in Bavaria, as one might ex-
pect. Correspondence from these affiliates was regularly
printed in the auxiliary's newspaper, *Der Bote der deutschen
Frauenwelt* (henceforth referred to simply as *Der Bote*). With
the single exception of 1930, I was able to locate the issues
for every year in one or the other library or archive in the Fed-
eral Republic or Democratic Republic. In addition to this valu-
able source, the papers and records of the auxiliary, which are
extensive, survived national socialism and the war. They are
housed in the Archiv des diakonischen Werkes in Berlin.

In addition to these sources, excellent records on Agnes
von Grone, the principal woman involved in the Protestant
Church Struggle, are available in a number of archives, above
all, the Berlin Document Center and the regional church ar-
chives of Westphalia in Bielefeld.

Unfortunately, the situation on the Catholic side is much
less advantageous. Each of the three organizations of Catholic
women aspired to be national in scope, but none of them
achieved this goal. Taken together, however, they show ex-
cellent distribution throughout "Catholic" parts of Germany.
No Catholic association of women published a newspaper
corresponding to *Der Bote,* which reflected ideas from all
over the country. Once the National Socialists came to power,
the content of the in-house publications of Catholic women's
associations was censored to a much greater extent than was
the case with *Der Bote.* As a result, we do not get to hear the
voices of Catholic women discussing issues that national so-
cialism introduced to German society. To aggravate this situ-
ation, there are no central archival records extant for either the

sodality, the largest organization of Catholic women, or the league, the second largest. Those of the former were destroyed by the gestapo, while those of the latter, I was told, simply never existed.

As a result of these circumstances, my account of the experience of Catholic women depends largely on regional or diocesan archives. The collections in Trier, Freiburg, Cologne, and Berlin were all useful (Munich's was evidently destroyed). Two national collections helped fill in some of the gaps left by the diocesan records. Even though there is relatively little material by women or derived from one of their associations in the multivolume *Veröffentlichungen der Kommission für Zeitgeschichte* (Reihe A), there is an abundance of material about women. These documents, which often reflect the dependence of the church on women in the ideological struggle with national socialism, are quite valuable. The archives of the Kommission are also useful, because they have microfilm copies all of the records of the dean of the Catholic episcopacy during the National Socialist era, Cardinal Bertram, the one-time archbishop of Breslau (now in Poland). Finally, the archives of the Catholic church's national charity, Caritas, in Freiburg (Archiv Deutscher Caritas) were indispensable. Since women, not men, were engaged in charity, Caritas records provide an overall view of the activity of women during the Third Reich.

This study would not have been possible without a great deal of help. I am indebted to a number of anonymous librarians and archivists and would especially like to recognize the friendly assistance of Herr Deppe and the staff of the archives and library of the Diakonischen Werkes in Berlin; of Dr. Hans Steinberg, archivist of the Evangelische Kirche von Westfalen; of Dr. Ulrich von Hehl, who is in charge of the office of the Kommission für Zeitgeschichte in Bonn; and, finally, of Herr Strecker of Archiv Deutscher Caritas in Freiburg. Research trips to these archives were supported by grants from Marquette University, the American Philosophical Society (for microfilming), and the National Endowment for the Humanities. Pastor Fritz Mybes generously sent me pictures of Protestant women. The Marquette University library staff was unfailingly

helpful and efficient. Jude Hartwick was tireless as a research assistant. I would also like to thank my wife, Pat, who put up with life in a Volkswagen camper while we traveled up and down Germany visiting archives, and who helped me collect data in many of them.

1
Protestant and Catholic Women before National Socialism

Of the many organizations of German women of this century, the largest, still-functioning ones are those of Catholic and Protestant women. As happens so often in German history, national socialism has become the prism through which the historical significance of these women and their organizations can be most acutely considered. It is especially important to establish the record of Christian women during the National Socialist era, because, in contrast to Jewish, liberal, and socialist women's groups, their organizations were not suppressed at the beginning of Hitler's rule. This suggests that the National Socialists felt their movement was somehow more akin to the churches and their organized followers than to other groups of women. Although in the end this would prove not to be the case, a primary task for us at the outset of this study is to discover the reason for the initial goodwill between national socialism and organizations of Protestant and Catholic women.

There was in fact both variation and confusion among

these women with regard to nazism as they encountered it in the latter years of the twenties and, especially, the early 1930s. Ambiguity and confusion typified the National Socialist side, as well, where, on the one hand, both women in general and the vitality of Christian women's convictions were belittled, and, on the other, their organizations were seen as potential allies in the National Socialist revolution. Since the organizations of both Protestant and Catholic women antedate nazism, my aim in this chapter will be to grasp how these women saw themselves and their place in history and German society before I take up their actual encounter with national socialism in subsequent chapters.

What is noteworthy about Protestant and Catholic women's groups during the first quarter of the twentieth century is their great popularity. The Protestant Ladies' Auxiliary was the fastest growing women's organization in Germany from the time of its inception in 1899 to the end of the Weimar Republic.[1] By 1910 it counted two hundred thousand members, a half million by 1925, and a million by 1933.[2] During the Wilhelmine era, the auxiliary grew faster in four Prussian provinces than all other women's groups *combined,* and it matched the growth of *all* other women's groups in seven other provinces.[3] In addition, a much smaller number of women joined another Protestant organization, Paula Müller's Evangelical Women's League.

Organizations of Catholic women grew as remarkably as those of Protestants, although somewhat more slowly. By the middle years of the Weimar Republic the Catholic German Women's League and the Catholic Women and Mother's Sodality both had a membership of about 250,000. By the time of the National Socialist era, however, the sodality's membership had reached 900,000. A third, much smaller organization of Catholic women, the St. Elizabeth Society, counted 50,000 members by 1930. Altogether, then, the three organizations of Catholic women equalled in size the two groups of Protestant women (Figure 1).[4]

How strikingly different the situation of National Socialist women. When Hitler came to power, the Nazi organization of women could not compare either in size or distribution with those of Protestant and Catholic women. One can understand

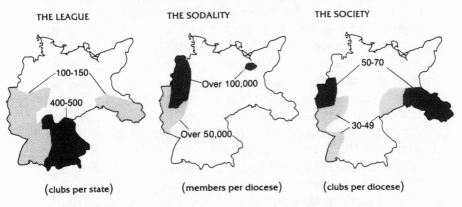

Figure 1.
Area Concentrations of Catholic Women's Associations

THE LEAGUE THE SODALITY THE SOCIETY

(clubs per state) (members per diocese) (clubs per diocese)

Sources:
For the league—Becker, 17; for the sodality—*Frau und Mutter* 25,
no. 1(January 1934): 16; for the society—Elvira Mayer-Montfort,
"Aus der Geschichte der deutschen Elizabethverein," *Elizabethbriefe*
(1931). 13ff.

then why the Nazis wished to befriend and assimilate these
Christian groups into the National Socialist Organization of
Women (NSF) or, subsequently, into the German Women's
Enterprise. As it turned out, the success of this venture de-
pended on the ideology or ideological rigidity of the Protes-
tant and Catholic women, a question that is considerably
more complex than that concerning membership statistics.
Why were National Socialists intolerant of socialist, feminist,
and liberal women, but tolerant, initially, of Christian women? I
will address this question in this chapter by considering the
flexibility or inflexibility of Protestant and Catholic women with
regard to other values and movements within pluralistic, pre–
National Socialist Germany.

The organizations I have mentioned were not Catholic or
Protestant in name alone. All of the them, with the single ex-
ception of the Evangelical league, were closely affiliated with
their churches. The two largest organizations, the Protestant
auxiliary and Catholic sodality, were fully integrated into the
organizational structure of their respective churches. At the
grass roots level, the pastor of the church served as president
of the auxiliary, and other churchmen were active in the direc-

tion of the organization at a provincial and national level.[5] The
situation of the sodality was similar, but clergymen controlled
the organization at the diocesan and national level to a greater
extent than was the case with the auxiliary.[6] The Catholic and
Protestant leagues were alike in that both kept direction in the
hands of their women members, but the former sought for
years to gain full organizational membership in the structure
of the German Catholic church, and finally achieved it in
1921.[7] We may say then that Protestant and Catholic club
women were directly associated through their organizations
with their churches. Although the trend among both groups
of women was toward greater autonomy and self-direction,
the close, working relationship between them and their
churches still obtained in the 1930s. This factor is of funda-
mental importance in understanding why Protestant and
Catholic women eventually ran afoul of national socialism.

The emergence of organizations of church women at the
turn of the century was no accident. It occurred at a time when
women were becoming more active in society and, in their
churches, more active than men. In terms of both church
membership and fidelity to sacramental life, Catholic and Prot-
estant women were remaining more faithful than men. By
1900 Protestant women outnumbered men at communion
by 10 to 15 percent nationally, and by more than 50 percent
in large cities.[8] This trend would continue throughout the cen-
tury. Although the discrepancies are not as great within the
Catholic church, women have clearly been more faithful, a fact
which did not escape the attention of the National Socialists.[9]
Not surprisingly, men's church affiliated organizations, such as
the Blessed Sacrament Sodality, the St. Vincent de Paul Soci-
ety (both Catholic), and the Protestant Men's Apostolate, be-
came increasingly moribund after 1900.[10] Given this situation
it is hardly surprising that women would become more visible
in the institutional churches. In fact, the leaders of the Protes-
tant and Catholic leagues, Paula Müller and Gerta Krabbel, re-
spectively, had already began publicly to discuss the question
of women's ordination during the early years of the Weimar
Republic.[11] In 1927 Protestant women won the right to func-
tion as assistant pastors (Vikarin) in some synods, and women
of both confessions were taking theological degrees in

sharply increased numbers.[12] Even the conservative Protestant Ladies' Auxiliary supported this development by placing women theologians within their organization.[13] In 1926 Maria Weigle, whose expertise in the Scriptures and interest in developing Bible study programs were to take on enormous importance during the Third Reich, was hired by the auxiliary. The painfully obvious malaise among Christian men, already well afoot before the National Socialist era, forced the men who led the churches to rely increasingly on women and their organizations to bring Christian ideology to bear on public life.[14] This development is of great importance for our study, because the close tie between Protestant and Catholic women and their churches would eventually cause friction with national socialism.

No one, however, could ever have foreseen that the expression that Christian ideology took on among women—charity in the form of personal contact—would become a source of conflict with any government Germany might have. Under the inspiration of such great churchmen as the Protestant Johann Heinrich Wichern and the Catholic Emmanuel von Ketteler, the energies of German Christians had begun to turn toward the kinds of social work which industrialization necessitates. In their early years the purpose of both the Protestant auxiliary and Catholic sodality was clearly charity—local health care. At a time when many smaller German towns could not manage a *Gemeindehaus,* church-related organizations of women provided sick care and help for the elderly and the disabled, and relief for the poor.[15] In larger cities they established soup kitchens and provided light health care services for the industrial proletariat. By the turn of the century, associations of Protestant and Catholic women were helping needy young mothers, an interest that grew considerably in the first five decades of the century.[16] Even the Catholic German Women's League and Evangelical Women's League, whose founders had thought in terms of the economic, political, and social education of women, found that their members would not ignore local charity.[17] Thus, when Protestant and Catholic women became active outside the home, it was in this realm. We may say, then, that the ideology of Protestant and Catholic women, as professed by their organizations, was

Christian in a traditional sense; these women followed the evangelical admonition to feed the poor and care for the sick.

Later on, this approach to the problem of poverty—self-help within the community rather than elaborate, centralized state systems of social security—fit nicely with the National Socialist *Winterhilfswerk,* the campaign to assist those who had fallen on bad times during the depression. Actually the *Winterhilfswerk* relief program antedated the Nazi Regime, and Protestant and Catholic women, working as volunteers up and down the land, had supported it generously. After the Nazis took over *Winterhilfswerk,* most churchgoing club women assumed, incorrectly, as it turned out, that a new era of close cooperation between church and state in the realm of public relief was at hand. National socialism exploited this goodwill.

The cooperation between party and church welfare agencies is important for a second reason; it set the stage for conflict on questions concerning race. At issue here was not the fate of Jews, but the implications of National Socialist ideology for traditional Christian teaching and the practice of charity. Euthanasia eventually became a central question in this regard, but there were other earlier ones: sterilization, propagation as breeding a superior race rather than children of God, and a range of practical matters that would be carried out in one manner or in another depending on whether welfare was viewed as charity or as an extension of eugenics. The Christian community dealt with these questions in earnest while paying relatively little heed to the impact of National Socialist racial ideology as it concerned the Jewish community.

Although welfare is of primary importance, the attraction between many Protestant and Catholic women and national socialism went well beyond the boundary of poor relief. An entire range of issues, all related to the question of women's "place," provided additional grounds of mutual admiration for many churchgoing women and National Socialist politicians. Before the Great War Protestant and Catholic women had not shown much interest in feminism, or they reacted negatively to it by joining a church affiliated women's group in place of the liberal Federation of German Women's Associations at a time when the latter was in its heyday. Issues of the women's

movement such as suffrage and a double standard of morality were ignored by most Christian women, except for those in the Protestant and Catholic leagues. During the Weimar Republic, however, such matters could no longer be dismissed out of hand, partly because women had become employed in both light and heavy industry during the war, where they remained afterward for demographic, familial, or personal reasons.[18] Those churchgoing women who did not hold with roles for their gender outside the home were threatened, or felt their Christian ideology was threatened, by this development. Here again we deal with a question that arose independently of national socialism but that provided in due time the grounds of mutual attraction between it and many women of the churches.

The difficulty we have in addressing this question in the German context derives from the fact that the socioeconomic situation of women generally was in state of precipitous change during the Weimar Republic. As a result there was positive development in Protestant and Catholic women's attitudes toward "women's place" but, also, a negative reaction to the fast pace that the transition found itself in during the decade of the twenties. We might visualize Protestant and Catholic women of the Weimar era as sojourners who had reached a point somewhere between the turn of the century mentality, which flatly refused to address questions like prostitution and insisted on a strictly domestic role for women, and the post–World War II mentality, which does not blush from excoriating the government for its failure to attack the problem of the trade in "sex tourism" and holds that women may seek fulfillment at home or in the business world as they see fit.[19] Clearly, there has been a progression within the German mainstream on the "woman question," but its evolution might be described as fitful during the Weimar Republic, partly because, within such an immense population, opinions could be diversified on this large and many-sided issue. It will be useful to review some of the questions that confronted women after the Great War in order to be able to compare the attitudes of churchwomen with those of the National Socialists.

A highly vexing issue for many Protestants and Catholics concerned the schools and the education of women. The

burning issue here was whether the schools would be secular or confessional; it turned out to be a question that was never settled.[20] Secondly, many churchwomen fought against a reform of the curriculum that would treat boys and girls alike, thereby effectively erasing sex roles. While being very vocal on these issues, Christian women tended to ignore what the women's movement considered the burning issue in education, namely, equal employment of women as teachers.[21] The Protestant auxiliary even argued that degree requirements for female teachers ought to be reduced! In the eyes of most Protestant and Catholic women, the schools were to support the Christian family by producing "good women and mothers."[22] The volatile school debate was yet another issue that arose well before national socialism's political prominence but that would nevertheless be skillfully exploited by them to attract the vote of Protestant and Catholic women, especially the former.

The school debate tells us that many churchgoing women were apprehensive about the question of women's "rightful place" and role—home and motherhood in their minds. This concern resulted partly from the postwar demographic situation when the rate of employment of German women did in fact surpass that of other European women.[23] Many women were alarmed by a lower quota of marriages with the consequent lower birthrate, along with the appearance within the younger generation of a "liberated woman" wearing her short skirt and *Bubikopf* haircut as a badge of independence.[24] Other factors that contributed to the falling birthrate—abortion, birth control, and more frequent divorce—disturbed them equally. When all of these factors coalesced in large metropolitan centers with international reputations for their scintillating night life, which Berlin of the twenties epitomized, it smacked of Sodom and Gomorrah. Christian society seemed to be morally deteriorating, and women were held responsible!

> Independence [for women] in economic and social affairs has brought with it a lack of [female] inner security and self-reliance in the face of this altogether new life-style. The consequence is illustrated by the progressive disruption of family life, the

blame for which falls on women and mothers for the most part.[25]

This harsh judgment was prompted, no doubt, by the sudden increase in employment among women between 1925 and 1929, which suggested that they were making a conscious choice between two values, motherhood and family life, on the one hand, and a salary and independence on the other.[26]

By no means did all Protestants and Catholics hold with this critical view of women. Many saw clearly enough that most women worked not for personal pleasure or profit but out of necessity.[27] Because of male mortality during the Great War, they had to support themselves and, sometimes, their families as well.[28] The Catholic league paid increasing attention to workingwomen, organizing seminars for them and providing valuable moral support.[29] It pressed for employment opportunities for both men and women, and defended the latter's right to work when the economic depression cast them out of the public's favor.[30] The league also urged that women become active in politics both as voters and as candidates for office. Even the Catholic sodality, which did not see itself as an organization for women's rights and did not press for roles for women outside the home, protested the economic exploitation of women in a variety of trades.[31] Although the Protestant league was less an advocate of women than the Catholic league, it gave women an alternative to the auxiliary. Also, some liberal Protestant women, who were not rigid about the confessional versus the nonconfessional school, chose to bypass both the auxiliary and the league and join the secular Federation of German Women's Associations.[32] It would be a serious mistake, then, to view either Protestant or Catholic women as an homogeneous group during the Weimar Republic. There was, rather, a tug-of-war going on within confessional circles of women over a large range of questions regarding their gender.

Although this contest developed quite independently of national socialism, its outcome was certainly influenced by the rise of political conservatism. This point may be illustrated by the largest organizations of Catholic women, the league and the sodality. The former, which may be described as a social

feminist group, grew at a faster rate during the two years fol-
lowing women's suffrage, 1919 and 1920, than at any other
time in its history. The years of the sodality's most rapid rate
of growth, on the other hand, were between 1928 and 1931,
precisely the time when "mothercare" interest, with its em-
phasis on domesticity for women, was sweeping the country.
Since both organizations were affiliated with the church, Cath-
olic women could make a choice between an organization
that advocated women's affairs and one that did not.[33] In-
deed, the choice caused rivalry between them, and, when so-
dality membership finally far surpassed that of the league, bit-
terness developed. The working attitude of the church in
Germany favored the sodality view of womanhood, and this
view was mightily reinforced by the papal encyclicals, *Casti
Connubii* and *Quadragesimo Anno,* which counseled women
to keep to their traditional role in the family and discouraged
mothers from seeking employment outside the home.[34] Na-
tional socialism of course provided an enormous boost to this
view from the secular side.

Among Catholics, the tug-of-war regarding women's
roles was intramural, but, among Protestant women, national
socialism played a more direct role. During the latter years of
the Weimar Republic, the largest organization of Protestant
women, the auxiliary, became absorbed in mothercare ser-
vices (prenatal and postnatal education and care and rest
homes for mothers). Like the Catholic sodality, the auxiliary
realized spectacular growth as a result of mothercare involve-
ment, doubling its membership in certain areas even though
the organization was by then twenty-five years old.[35] Al-
though the mothercare field came to enjoy widespread pop-
ularity in Germany independent of Hitler's movement, Na-
tional Socialists and Nazi women became intensely interested
in it themselves, because of mothercare's great public appeal
and because of their own pronatalist policies and racist beliefs.
The overlapping of interest in mothercare work on the part of
Protestant women and national socialism is of fundamental
importance to this study because it was at once the basis of
their mutual attraction and eventual opposition.

The interest in mothercare work among Protestant and
Catholic women was an important phase of the attitudinal

evolution regarding women's roles that they have gone through since 1900. But it was only one phase, and not all churchgoing women assigned it the same value by any means. What is important to point out in these introductory remarks is that when the National Socialist movement criss-crossed with the Protestant and Catholic mainstream, it gave support to those women who favored the mothercare move-ment and who were reacting against the fast pace of change in women's lives that the Great War and the economic turbu-lence of the Weimar era had occasioned.

If for some Protestants and Catholics the question of nondomestic roles for women was a peripheral one and for others it was antithetical to their view of the nature of Christian society, nationalism was a more dominant value that was al-most never in conflict with religious loyalties. What this means in terms of the eventual relationship between Protestant and Catholic women and national socialism is simply that as long as the latter presented itself in a Christian guise, there could be no problem with it in principle. Here, again, however, it would be simplistic to treat churchgoing women as an undif-ferentiated mass. Women's affairs and feminism cut across the great Protestant and Catholic mainstream without respect to denomination, but the issue of nationalism divided them into separate, confessional camps. As with shades of gray, it is dif-ficult to distinguish degrees of nationalism among and within German women, but it will be useful for our understanding of the experience of Christian women during the National So-cialist period to attempt to nuance their portrait.

Within the two principal confessions, Protestant women were clearly more nationalistic than Catholic, a circumstance that made them more receptive to national socialism. The tie between Protestantism and nationalism had its roots deep in the nineteenth century. It had been Johann Heinrich Wichern's dream to make the Protestant church a national church.[36] The unification of Germany under Protestant Prussia reinforced the feeling that the reformed religion was the soul of the nation. Wichern founded the Inner Mission, the Protestant church's central charity agency, and, when the Protestant auxiliary came into existence, it was linked organizationally to it. The idea was that Protestant women would become active in pub-

lic relief—especially in large, industrial centers—in order to demonstrate to potential Socialist voters that their welfare was assured through organized religion, or, alternately, that they need not turn to the Socialist party, newly envigorated by the lifting of the ban against it.[37] Thus, theoretically, national unity would be achieved through Protestantism.

The link between the nation and religion was forged by the Empress Augusta Victoria herself who founded the Protestant Ladies' Auxiliary, a fact that gave Protestant women enormous satisfaction and pride. The auxiliary salted its newspaper with copy on the royal family and even gave coverage to the nation's growing naval fleet.[38] When the Great War came, the zeal of Protestant women knew no bounds. They threw themselves into the effort, making winter clothes for soldiers, caring for German refugees, running courses of instruction on the proper care of battle victims, setting up and operating hospitals, opening businesses to teach people how to knit (so that they could provide gloves and other accessories for the military), and operating schools to train women how to do factory work.[39] The energy with which Protestant women lost themselves in patriotic work astounded the leaders of the auxiliary, who professed to be mildly upset when the rank and file dropped traditional work to rush to the national cause.[40] But, on the other hand, it was grand to see Protestantism and nationalism so vitally and indigenously interlaced in the *Volksleben,* a process that swelled the auxiliary's membership, bringing in thousands of new, younger faces.[41]

The nationalism stirred up by the Great War breathed new life and identity into the Protestant auxiliary, and it cannot be underestimated in terms of the attraction of women to national socialism. During the Weimar years churchgoing women fed bitterly on the emotion of nationalism because of the despised Versailles peace settlement. But this alone does not account for Protestant women's support of Hitler, since other parties of the political right were nearly as nationalistic as the National Socialists. For this reason, it will be necessary for us to try to discover how nationalism interacted with other factors—specifically, the natalist movement—in order to account for the National Socialist vote of Protestant women.

For Catholic women the links to nationalism were weaker. The unification of the country on a *kleindeutsch* basis had left Catholics a minority. The *Kulturkampf* beset them immediately thereafter, creating a ghetto mentality and a reputation as second-class citizens.[42] Although Kaiser Wilhelm II made attempts to strengthen the bond of loyalty between Catholics and the throne, none of the organizations of Catholic women could claim the empress as its founder. During the years before the Great War, the literature of organizations of Catholic women carried no nationalistic copy, nor affectionate feature stories on the royal family nor on militaristic themes. Once the war was underway, Catholics showed more patriotism and got involved with projects in support of the military effort but not nearly to the extent of Protestant women.[43] Although the Catholic German Women's League made an effort to "give special and useful service to our threatened Fatherland" during the Great War, their efforts lacked the nationalistic and völkish enthusiasm of Protestants.[44] In all likelihood, Catholic women, like men, experienced the war as an opportunity for social integration rather than as a life or death struggle for the soul of the nation.[45]

The separate historical traditions of Protestantism and Catholicism lingered on after the Great War causing Protestant and Catholic believers to view the experiences of the nation—the lost war, the birth of the new republic, and the tumultuous events of the decade of the twenties—in quite different lights. As a consequence, German women of the principal confessions would later be disposed to view national socialism differently. Although in the long run the great majority of churchgoing women had the same experience with national socialism because of a common Christian ideology, in the short run Protestants expected more from it than Catholics because of their nationalistic disappointments.

The divergence of attitudes between the two groups found early expression in the constitutional crisis of 1917 and the concomitant question of women's suffrage. Although the Federation of German Women's Associations demanded that women be included in any liberal reform, both the Protestant league and the Protestant auxiliary opposed suffrage.[46] On the Catholic side the sodality was not yet nationally organized

and did not address the issue, but the league, while taking a position of "strong neutrality," did not oppose the franchise for women and, in all likelihood, favored it.[47] When the Weimar constitution provided women with the vote, the league was eager to involve itself and its members in the democratic process.[48] It joined with the Federation of German Women's Associations and with the League of Jewish Women to promote programs instructing German women on how to use the franchise responsibly.[49] This attitude contrasts sharply with that of the Protestant auxiliary, which warned its newly enfranchised members not to become "alienated from their holiest, best, and truest responsibility"—motherhood.[50]

The difference in outlook regarding suffrage gives at least some indication of overall attitudes among Catholic and Protestant women during the Weimar Republic. The latter greeted the new parliamentary system of government with suspicion and distrust, since it reminded them of the country's collapse and the flight of the empress and kaiser, for whose return they would have gladly surrendered the vote. When the early political success of the Social Democratic and liberal parties made it appear likely that their values, rather than specifically Christian ones, would be established in the young republic, Protestant women grew ever more negative. Bitterly disappointed by the mooted outcome of the school bill, which would have guaranteed confessional schools and a sexist education, and unable to find any other major cause to support for the greater part of the Republic's existence, Protestant women cast their votes for the parties of protest and obstruction, commiserated over the chains of Versailles, and wove elaborate variations on the stab-in-the-back explanation of the lost war.[51]

Catholic women, who had less invested emotionally in the nation's recent past, looked upon the Weimar Republic as an opportunity for a fresh start both for themselves and for the country. Rather than wallow in self-pity over the Versailles *Diktat,* the league's newspaper guardedly praised the Dawes Plan, noted approvingly that the country was once again honored within the family of nations, and supported pacifism.[52] On the domestic front, the league ran political meetings for women called *Frauenwahlsammlungen,* defended women's right to employment, and gave important support to the

working woman.[53] Of course, most Catholic women did not identify with the league's social feminism, but they sensed that the republic offered them greater social and political parity than they had had under the empire. Enfranchisement did not come at the expense of losing a national symbol, as it did in the minds of most Protestant women, nor did it threaten their image of "women's place," probably because of their natural tie to the strong Catholic Center party.

We should also remember that the Weimar years were a time of strong growth and maturation for both the league and the sodality. The latter began to make the significant step from status as a sodality, or primarily spiritual association, to that of a Catholic society whose activity would be characterized by interaction with a secular culture in the interests of religion.[54] Thus, while there was differentiation amongst Catholic women of the twenties, a number of factors made them more optimistic as a group than Protestant women who nurtured the idea of a poisonous Weimar "*System.*"

These prefatory remarks have attempted to outline similarities and differences in the mind-sets of Protestant and Catholic women in the first three decades of the twentieth century. If I have stated the case with some accuracy thus far, the argument of the next two chapters, which finds Protestant women giving national socialism greater support than Catholic, will not catch us by surprise. Before going on, we ought to pause to put Protestant women in a final perspective. While it is true that they stood closer to national socialism than Catholics, their religious commitment cannot be left out of the equation. To do so would be to overlook the very tension that would color the somewhat stormy relationship that developed between Protestant women and the National Socialist regime. Although we have pictured the auxiliary as the most conservative of the several organizations of churchgoing women, it did not stand on the extreme right in Weimar Germany's political spectrum. That place belonged to the Empress Luise League (*Bund Königin Luise*), which grew rapidly in the half decade before Hitler's seizure of power, reaching a membership of 200,000.[55] This group was at once more militaristic, more nationalistic, and more anti-Semitic than the auxiliary. Thus, the many Protestant women who decided to

join the auxiliary between 1927 and 1933 chose it in preference to a specifically secular organization (the Federation of German Women's Associations) and in preference to a specifically anti-Semitic one (the Empress Luise League). The choice of the auxiliary allowed these women to blend Christianity with national devotion.

This does not imply, by any means, that Protestant women were free of the anti-Semitism that plagued their country and church. It does imply, however, that, when questions regarding race came into conflict with the principles of the Gospel or teachings of the Protestant church, many women were unwilling to sacrifice the latter. We see, then, that both in this regard and in connection with welfare, Jews are not dealt with as Jews. Religious orthodoxy, not the well-being of an ethnic group, was at stake.

2
Protestant Women for Hitler

dentifying which Germans voted for Hitler and explaining why they did so has long been a fascinating historical exercise. Theodor Geiger, one of the first to tackle it, thought national socialism's vote could be explained in terms of class.[1] Richard Hamilton, one of the most recent analysts, thinks it cannot.[2] In this chapter we will be concerned with just one group of Germans and why they voted for Hitler—Protestant women.

Limiting the focus to "just one group" seems to imply confidence that a more widely accepted explanation can be found. This would be to promise too much. Our chosen population, numbering many millions, contained internal diversifications, which, while not nearly so extensive as those within the entire society, nevertheless caution against simplification. The sophistication of the National Socialist political machine allowed their politicians to fine-tune their appeal to much smaller subgroups than Protestant women. Or, to put it another way, there were many subgroups within the huge pop-

ulation of Protestant women to whom the National Socialist politician could pose very specific concerns in his effort to win votes. We must be ready, then, to admit at the outset that many different aspirations or grievances appealed to this or that Protestant woman and that, within this large population, the priority of reasons for voting for Hitler would have varied.

Alongside the debate over class as the critical factor in the National Socialist vote is the question of gender. Some of the more prominent issues in the campaigns between 1930 and 1933 appealed to Germans without respect to sex. Protestant women were certainly highly responsive to many of these: nationalism, along with the despised Versailles *Diktat*, loathing of the Weimar *Systemzeit*, and a rejection of atheistic Marxism, on the one hand, and of capitalist conglomerates on the other.[3] But other questions, those having to do with school, the family, religion, social policy, and so on, were more gender-specific. All political parties of the center and right sought women's votes by appealing to them on issues such as these.[4] Even Socialist and Communist women concentrated more on these questions.[5] We stand a better chance of understanding why Protestant women voted for Hitler if we concentrate on matters that were gender-specific, trusting that these issues weighed more heavily with them than class-related grievances.

We may pose the question this way: Did Protestant women vote National Socialist because of concerns they had as women? The argument will be that they did. To state it precisely: völkisch religion and motherhood formed basic links between Protestant women and national socialism prior to Hitler's taking of office.

The assertion is based on a study of the Protestant Ladies' Auxiliary. Although this was the largest organization of German women in the country when the National Socialist era began, it would be ridiculous to claim that it spoke for all Protestant women. For whom, then, did it speak? Posing this question returns us to the fundamental debate regarding class and the National Socialist vote. Data presented in this chapter will show that the auxiliary was primarily a middle-class association of women. Those historians who base their interpretations primarily on economic analysis would conclude from this

that Protestant women voted for Hitler for the same reasons as their husbands—fear of proletarianization. Even though the evidence for such an interpretation is fairly strong, I have chosen not to follow it for several reasons, one of which is the fact that once Germany's economic recovery was accomplished, most of the women identified with the auxiliary did not hesitate to loosen ties to national socialism over a noneconomic question.[6]

Before taking up the question of why Protestant women backed national socialism, we should attempt to demonstrate that they actually did. Protestant women comprised an enormous population that could be subdivided endlessly: those who went to church as opposed to those who did not; the old versus the young; lower-, middle-, and upper-class status, and so on. There is a tendency to think that only the youth were Nazi activists while only retired busybodies were church activists (such as auxiliary members), and, secondly, a tendency to think that only Protestant backsliders voted for the National Socialists.[7] Are we perhaps discussing two different people whose paths seldom crossed, an elderly churchgoer and a younger voter whose last appearance for a Sunday service was when she was confirmed as a young girl?

Definitely not. When the Protestant Ladies' Auxiliary split into two groups in 1935–36, the schismatic Protestant Ladies' *Service* estimated that 80 to 90 percent of its members were also members of the National Socialist party.[8] This means that the number of active Protestants who were also active National Socialists would have been in the neighborhood of seventy-five thousand in this group alone. In addition, many of the women who remained in the auxiliary were members of the party and had been members for some time before Hitler's achievement of dictatorial power. Many of these members, like Klara Lönnies and Agnes von Grone, were in fact its leaders. It is quite possible then that as many as a quarter of a million women were both party members and members of the Protestant auxiliary.

Most people, of course, shied away from becoming members of either the party or the auxiliary, but they went to church and they went to the polls. For many years historians have told us that it was the Protestant vote that brought Hitler

to national prominence, and recent studies have not revised this view.[9] It is quite obvious that the party would have drawn some of its support from among Protestants who had lost their faith, but these credal dropouts did not provide all of the original support by any means. It is more likely, in fact, that, in the 1932 presidential runoff election between Hitler and Hindenburg, nominal Protestants cast their vote for the latter while the churchgoers backed Hitler.[10] Recent scholarship has demonstrated that areas of strong Protestant religiosity were also areas of a strong National Socialist vote.[11] The idea that it was the youth who swept Hitler to political prominence finds less support now than a decade ago.[12] Even if it were true, the notion that church activists were for the most part elderly women can be demonstrated to be false. Around 1930 most women members of church-affiliated clubs were between thirty and fifty years of age.[13] We should not pretend, then, that older, zealous Protestants worked for the church while younger backsliders worked for the National Socialists.

We may take the analysis one step further and ask which churchgoing Protestant women voted National Socialist. The answer, in a word, is the middle class, but they had company. Although it has recently been asserted that, in explaining National Socialist support as a middle-class phenomenon, historians have been discussing a nonfact, no one denies the importance of the middle-class vote for Hitler.[14] The National Socialist vote-by-class within the Protestant Ladies' Auxiliary warrants our interest because it may be a fair reflection of the pattern of the country. This would imply an overwhelming middle-class vote, from all ranges within this class, but also support for Hitler issuing both from the lower and upper classes. Let us consider the social composition of the auxiliary more closely.

From the very beginning the rural populace and the middle class dominated the membership of the auxiliary. The lower class, on the other hand, was conspicuously underrepresented. This would be, above all, true in highly industrialized areas where socialism had won wide support. In the Ruhr valley, for example, the lower class contributed only about 15 percent of the auxiliary's members around 1910, even though

Table 1.

Old Middle-Class Membership in the Protestant Ladies' Auxiliary and in the NSDAP in Westphalia, 1930 (as a percentage of all members)

	PLA	NSDAP
Professions	7	5
Handicrafts	10	}34
Shopkeepers	20	
Total	37	39

Sources:
For the auxiliary, EKW Hilferinnen Records; for the NSDAP, Wilfried Böhnke, *Die NSDAP in Ruhrgebiet, 1920–33* (Bonn, 1974), 199. The data on shopkeepers is especially interesting because, while they declined rapidly in the 1920s as a percent of the total population (down 7 percent), they rose rapidly in auxiliary membership (up 8 percent).

it constituted about 70 percent of the population in that area.[15] After the Great War the trend toward middle-class dominance continued.[16] Urban groups of women from such lower middle-class subgroups as shopkeepers and civil servants became much more active in the auxiliary (a growth of nearly 10 percent for each group) during the Weimar Republic. The handicrafts, already overrepresented before the Great War, more than maintained their representation during the interwar period.[17] There was also a significant increase among women from professional families, coming from the homes of doctors, ministers, engineers, architects, rentiers, and entrepreneurs.[18] Upper-class and aristocratic membership in the auxiliary is difficult to measure, but it seems to have been disproportionately large.[19] One thing is certain: members with some level of aristocratic rank were very conspicuous among the leaders of the auxiliary, accounting for a third of all the women on the executive committee in 1931.[20] Throughout the entire Weimar and National Socialist eras, women from titled families held the presidency of the organization.

The picture of the auxiliary's social composition indicates strong upper-class leadership, an overwhelming middle-class membership, and a lingering lower-class interest. With regard to the middle class, it is interesting to note how nearly parallel certain pockets within it supported the auxiliary and national socialism (Table 1). This comparison indicates that many Prot-

estant women would certainly have seen a close link between their secular interests and aspirations and Hitler's political fortunes.

The grievances and problems which led the middle class to support Hitler are well known and well documented.[21] Fear of social and economic displacement, anti-Bolshevism, anti-modernism, and anti-Semitism constituted deeply felt negative attitudes, and a longing for national renewal along with militarism and völkisch pride were widespread aspirations. When completely itemized, it is an extensive list, pieces of which can be matched up with specific segments of what social historians call the Old and the New Middle Class. We may assume that, to some extent, upper- and lower-class women shared these feelings, especially when it came to national renewal, militarism, and Francophobia.[22] Since Protestant women did not lead isolated lives but were strongly influenced by their families and neighbors, and vice versa, we suspect that their motives for supporting Hitler had something in common with those of their fathers, brothers, husbands, and sons. We find these attitudes reflected, in fact, in the auxiliary's newspaper, *Der Bote*.[23] Protestant women provided the middle class with much of its characteristic feeling that what was pure, good, and wholesome still existed as a remnant in the soul of the Volk and that, as the embodiment of this remnant, they held the promise of the country's future.[24]

The overlapping of social bases of the Protestant auxiliary and the National Socialist party (NSDAP) provide us with solid clues as to what attracted Protestant women to Hitler. In fact, however, Protestant women were not inclined to view their relationship to national socialism in terms of a response dictated by class interest. They did not think of themselves as a middle-class, self-interest group, but as German Protestants, and, if they were members of the auxiliary, as church activists. To any accusation of being merely a one-class, self-interest group, the auxiliary could point with some justification to its lower- and upper-class membership, to its extensive and very visible community service, and to the impoverishment of the middle class itself.[25] Protestant women choose, rather, to view their attraction to national socialism in religious terms. This strikes us as hypocritical; we are tempted to ask whether reli-

gious motives were really no more than a cover for middle-class anxieties. But the fact that the female National Socialist vote came later than the male, and that Protestant men failed to see the connection between their religion and national socialism that women claimed to sense, indicates that additional—gender-specific—factors did play a role.[26] Granting that it is always more difficult to explain peoples' motives than to trace their deeds, let us give our subjects the benefit of the doubt and ask what attracted them, as women, to national socialism.

Since the historical Hitler has come to be synonymous with evil, it strikes us as bizarre to think that women might have voted for him for religious reasons. Nevertheless, when Hitler came to power many Protestant women thought of this in terms of a national renewal that had a religious (Protestantism) and a secular (national socialism) manifestation. The predisposition to think in these terms has been noted regarding the presidential election of 1925 when Protestants viewed Hindenburg as some kind of reincarnated Martin Luther.[27] Not all Protestant women thought in this way, but it is significant that it typified the sentiment of the largest organization of women in Germany, the one million–member Protestant Ladies' Auxiliary. In simple and concrete terms, we might imagine a two-step process. First, the potential Protestant vote was consolidated under the roof of the church; then, when the conviction became widespread that Hitler was providentially marked, he became the overwhelming beneficiary of that vote. But let us explore the relationship more deeply.

After the Great War and the abdication of the kaiser, a new völkisch theology became popular in Old Prussia from whence it spread to the rest of the country. Faced with a democratic republic, young intellectuals began substituting "God and Volk" for "Throne and Altar" in Protestant theology. Although variations on the völkisch theme ran on endlessly, it was popularly interpreted to mean that God would work through his Volk to renew the country spiritually, so that it could return to its true ideals, implanted in the German soul by Martin Luther but then debauched by the Enlightenment, industrialization, and Jewish materialism.[28] It is possible that women, who were enrolling in theology in German universi-

ties in increasing numbers, took part in this intellectual discussion.[29] Directly or indirectly, they would have become familiar with the new völkisch theology because it was widespread in one form or another throughout the German Protestant church by 1924.[30] Protestant women of the auxiliary became awash in völkisch religious thought, identifying themselves as the Volk and as the soul of the völkisch movement (of spiritual and national renewal).[31]

The negative side of the new school of thought was anti-Semitism. Jews were not members of the Volk, and, to some extent or another, they were responsible for its demoralization. During the 1920s, church-affiliated racist groups popped up everywhere in Germany; in some areas, like Franconia and Saxony, the church was shameless in its exploitation of this issue.[32] Historians generally concur that the Protestant church became almost "officially" anti-Semitic during the Weimar era.[33] The National Socialists, fully aware of the anti-Semitism within Protestantism, exploited it skillfully, enlisting Protestant pastors as rally speakers in "Thalburg" and elsewhere and promising to support the church against Jewish interests.[34] Protestant women were themselves deeply imbued with anti-Semitism, although its extent would not become clear until the National Socialist implementation of an official anti-Semitic policy made this subject *Salonfähig*.[35]

Between 1930 and Hitler's achievement of power in 1933, the link between religion, in the form of the new theology, and Protestant women became even more explicit. During this time one particular subgroup of the Protestant church, the German Christians, pushed völkisch theology to the outer edge of orthodoxy and beyond. Putting nature above grace, some German Christians asserted that salvation was transmitted through Aryanism. Not coincidentally, they became the most anti-Semitic element in the Protestant church. It would, of course, be a great mistake to imagine that all or even the majority of the women in the Protestant auxiliary were German Christians. But they were strongly attracted toward forms of the new völkisch theology and had nothing against the German Christian movement, at least not before the *Sportpalast* scandal.[36] Precisely because of the general approval of the völkisch movement, the leaders of the auxiliary, the great ma-

jority of whom were women, chose a Pastor Hans Hermenau
to be the executive director of their organization in February
of 1932.[37] Hermenau, a fanatic National Socialist and radical
German Christian, tied the knot binding the largest organiza-
tion of women in Germany to national socialism through reli-
gion. The evidence of this bond may be found in the auxiliary's
newspapers, Der Bote, which Hermenau edited from early
1932 until his forced resignation in October of 1933. During
these critical election months, Hermenau politicized the Bote
in an explicit manner that was entirely new to the paper.[38] He
reinforced the anti-Semitism of Protestant women by identi-
fying Jews with leftist parties and with materialism. While con-
demning liberals, Communists, and, for the first time, Social
Democrats, the paper repeatedly urged Protestant women to
vote, and, by telling them not to squander their votes on splin-
ter parties on the right, the message to vote National Socialist
was clear.[39] In some small measure Hermenau deserves credit
for Hitler's success in 1932, for it was the Protestant districts
that gave him his impressive victories and, in those districts,
women "outnumbered men in the National Socialist constitu-
ency."[40]

We may sum up in the following manner. Völkisch reli-
gious thought suggested to Protestant women that the loss
of the Great War and the disgrace of the republic were signs
of spiritual sickness and God's displeasure with His people.
The economic chaos following the stock market crash in the
United States, which promised to overturn the despised Wei-
mar system, was seen by many Protestant women as the hand
of God testing and purifying His Volk so as to rid it of its ma-
terialism and secularism.[41] The timely emergence of National
Socialism was a sign that the time of fulfillment was at hand.
By polishing his religious image, Hitler encouraged the view
of many Protestant Christians that his movement was in some
way charismatic.[42] Most Protestant women probably agreed
with the German Christian view that God had sent Hitler to
lead Germany and that he was God's instrument.[43] Sin, pun-
ishment, purification, renewal: this is the stuff of a religious ex-
perience.

The connection between Protestantism and national so-
cialism was felt by women much more so than by men. Most

of the sixteen thousand Protestant ministers of Germany—an estimated two-thirds, in fact—were either neutral or opposed to the völkisch element of the National Socialist movement.[44] The great majority of churchgoing Protestant men had little, if any, inclination to see a religious connection to national socialism.[45] They voted for Hitler, but not for religious reasons. In sum, many Protestant women really did associate their religion with national socialism. In all likelihood, this attitude typified the churchgoing mainstream. Whether or not this religious connection to national socialism was sincere or mere middle-class window dressing, is a question that will be easier for us to address in subsequent chapters.

We may now turn to the second gender-specific issue that attracted women to Hitler and his movement: mothercare work. It was clear to the leaders of the auxiliary that national socialism would support pronatalism. But stating it in these terms puts the cart before the horse in one sense. Since National Socialist women had no viable natalist program of their own, they lusted after the well-established national program of the Protestant auxiliary. The attraction, therefore, was very much a mutual one. Let us look first at what Protestant women had been able to accomplish on their own.

The Protestant Ladies' Auxiliary was one of the most important organizations in Germany to pioneer mothercare services.[46] Arising about five years before national socialism's postdepression successes, mothercare work became the overriding preoccupation of the auxiliary until it was forced out of it in the mid-1930s. Widespread interest in maternity work was first generated by recuperation homes for mothers (*Muttererholungsheime*). These homes provided a place for mental, physical, and spiritual regeneration for mothers who could spend several days to a week relaxing in an atmosphere of peace and quiet. The auxiliary already had about a dozen of these homes in 1928. In spite of the depression, the number of homes grew rapidly: 21 in 1930, 30 in 1932, and 42 in the spring of 1933. The Berlin auxiliary affiliate had one home in 1928 that could accommodate twenty mothers; two years later they had established seven more with a 150-bed capacity.[47] The number of women using the auxiliary's facilities grew correspondingly from six thousand in 1929 to about fifteen

thousand in 1931.[48] Not surprisingly, mothercare work began
to dominate the activities of the auxiliary. Members were in-
volved in a wide variety of social work extending from hospi-
tals to orphanages and kindergartens, but by 1930 mother-
care accounted for 50 percent or more of total volunteer
hours.[49] This is understandable because when a mother left
her own home for one of the auxiliary recuperation homes,
members of the local affiliate looked out for her family, taking
care of all the cooking, washing, shopping, and baby-sitting
chores. Success with the homes led to expanded services
such as prenatal and postnatal care. By 1932 the auxiliary had
organized four separate fields of work on a national basis: re-
cuperation homes, maternal education, workshops for moth-
ers, and projects for young mothers (home economics), and
virtually all of the some fifty-six hundred affiliates of the auxil-
iary were involved in one or more of these programs.

This work was costly. There was an initial outlay of a sub-
stantial sum of money to build or buy a suitable residence that
could be converted into a rest home for several dozen
women. As the above data indicates, much of the expansion
of the work went on right during the most difficult years of the
depression. The Brunswick auxiliary affiliate, for example, built
its home in 1931.[50] In addition to initial expenses and oper-
ating expenses, the auxiliary also paid for guests who wanted
to visit the homes but could not afford it. Westphalia's home
in Bad Driburg charged 2.50RM to 3.50RM a day for room
and board.[51] Since about a thousand mothers used the facili-
ties in this province annually, the total per diem charges would
be around 12,000RM, if we figure the average guest stayed
four days. In Harzburg, just under half of the guests stayed
without paying their own per diem.[52] If the same ratio held for
Westphalia, then the province needed to come up with
5000RM or 6000RM each year just for recuperating mothers'
per diem. Part of this money came right out of the pocket-
books of the local members. Most of the remainder was cov-
ered from funds from the central office of the auxiliary, but
much of its annual budget came in the form of members' an-
nual dues.[53] Thus, either nationally or locally, individual Prot-
estant women were footing the bill for much of the mother-
care work.

The enormous popularity of this work, together with the burden of its cost, led the auxiliary to seek outside sources of support. The Protestant church had long been impressed with the success of the auxiliary and with its work and was therefore willing to subsidize the recuperation homes through its national charity office, Inner Mission. As the appeal of the program became obvious, many local churches designated their Sunday collections on Mother's Day for the auxiliary's mothercare work. This gave Protestant women direct access to the pocketbooks of churchgoers who were not auxiliary members; these churchgoers' contributions amounted to a hefty 500,000RM in 1930.[54] Access to the general public also became possible when the state of Prussia allowed auxiliary members to carry out a street and house collection once a year.[55] While these contributions were helpful, the auxiliary would have preferred a nationwide government subsidy. This is interesting because, throughout the Weimar period, Protestant women had promoted voluntarism over state funded social services. The political parties of the left and the Center party supported legislation that would have provided funds for programs to improve the health of expectant women and their babies, but the right, which got the votes of most Protestant women, opposed these programs as being too costly for the hard-pressed middle class.[56] The fact that many of the rest homes' guests were middle-class mothers, some of whom could not even afford their per diem, makes the auxiliary's appeal for federal funds seem inconsistent and self-serving.[57] When the auxiliary petitioned the Reichstag for funds in 1926, it was turned down, evidently on the grounds that the guests of the recuperation homes were not really physically ill. The National Socialist party was the only national party to respond to Protestant women's pleas for financial aid. They alone promised subsidies for the auxiliary's homes for mothers.[58]

This was not entirely a case of voter manipulation. When it came to the question of women's "place" and role in society, many Protestant women and National Socialists were in lockstep with one another.[59] The National Socialist politician, while speaking out of both sides of his mouth on the question of workingwomen, made it clear that the party's goal would be

to restore to every German woman the right to familial happiness.[60] When the General Association of German Women Teachers (*Allgemeiner Deutscher Lehrerinnenverein*) appealed to political parties regarding women's positions in schools, which were being threatened by the depression, it received an unequivocal negative answer from the National Socialists: women do not belong in public positions; they should be wives and mothers and should be able to live from their husband's earnings, and so on.[61]

School policy also illustrates how near to each other Protestant women and National Socialists were on the question of women's place. During the Weimar Republic Protestant women had detested educational reforms that attempted to remove sexism from the curriculum. As recently as 1927, 600,000 Protestant women had signed a petition to members of the cabinet asking them to oppose educational reforms that would cause girls and boys to learn the same subjects.[62] Furthermore, the auxiliary had relentlessly agitated throughout the decade for a law that would establish the confessional school over the nonconfessional, or "simultaneous," school.[63] When the von Keudell bill, which would have given Protestants the school system they preferred, failed in 1928, churchgoing women reacted with shock and anger.[64] The National Socialists, while remaining vague on the specific issue of the nature of the school system, promised to put public education on a Christian and völkisch basis.[65] Because of this pledge, the National Socialists offered Protestant women a favorable alternative when older parties, particularly the German Nationalist party (DNVP), failed to get favorable legislation passed. Thus, an early indication that the regime would favor a familial role for women came in the field of education.

The Protestant auxiliary was in complete agreement. In 1931 Klara Lönnies, executive director of the auxiliary's mothercare programs, used nationally broadcast radio programs, a widely viewed film, and a new photomagazine called *Mutter und Volk,* to urge the government to get women out of the factories and back into the home.[66] The National Socialists, for their part, recognized the mothercare services of Protestant women, calling it "immeasurably fruitful."[67] Because of their promise of support, the leaders of the auxiliary counted on

public funds for their mothercare work when and if the National Socialists came to power. Referring to national socialism, Lönnies wrote in June of 1932 that in the social and political movements of the future, mothercare would have high priority.[68] In sum, motherhood and mothercare services provided a second area of common interest that allowed many Protestants to support the National Socialist revolution with exuberance and anticipation.

We have argued that völkisch religion and natalist programs linked Protestant women to national socialism and induced them to vote for Hitler. Of course, they did not all vote for him and not all who voted National Socialist did so for these reasons. Furthermore, behind these big factors there were certainly other compelling reasons to vote for Hitler. Economic concerns and a fear of proletarianization ran a close second, no doubt, as motivators for many of the subject group we have dealt with. But for active, churchgoing Protestant women the religious factor was primary, and for members of the auxiliary, mothercare interests also led them toward national socialism. The striking growth of the auxiliary between 1927 and 1930, at which time it had already been in existence three decades, demonstrates the popularity of natalist interests in Germany. It also suggests that many thousands of other German women, who were not actual members of the auxiliary, would have been attracted to national socialism because of the natalist movement.

Emphasizing völkisch religion and mothercare over other factors is, admittedly, a matter of historical interpretation. There has been a trend in recent years to view intangible factors, such as the psychological and emotional, as more important in explaining national socialism's mass appeal than more conventional political factors, for instance, economic or ideological ones.[69] For Protestant women the religious link to national socialism provided an emotional charge, which for some (German Christians) verged on the fanatical. In highly Protestant areas, the people praised the SA (Sturm Abteilung or Brown Shirts) for its piety when its members went to church, and there was an identification of the cross with the swastika and of Hitler with Christ.[70] The natalist movement also provided a psychological attraction: the chance for

women to give themselves to a cause. They had a role to play in the country's renewal that demanded they make sacrifices. The dedication of Protestant women to mothercare work in the midst of the depression illustrates how the natalist program of national socialism could attract them through the urge toward "giving of oneself." We will see in chapter four that the factors discussed here, mothercare and völkisch religion, became intertwined in the minds of Protestant women in 1933 and 1934, allowing them to cast themselves in the role of heroine during the early years of national socialism.

3
Catholic Women against Hitler

In 1929 the Catholic German Women's League celebrated its twenty-fifth anniversary. In its first quarter of a century it had managed to tie the women's movement to Catholic Action, thereby realizing its twin goals of working for women and for the church. Pleased with this, the president of the league, Gerta Krabbel, noted in her anniversary address that "by and large the period of struggle is over."[1] It was, of course, just about to begin.

As the National Socialists came into political prominence after 1930, Catholic women held back, remaining aloof from the enthusiasm that the movement was generating among Protestant women. When Hitler took power, Catholic women looked on with some detachment and, not infrequently, with apprehension. Their attitude contrasts sharply with the anticipation and rejoicing that was typical of other Christian women. How are we to account for these contrasting mentalities among two populations of women, both of which sprang from the mainstream of German society? Were Catholic

women reticent because they were restrained by the church from climbing on the National Socialist bandwagon? Were the internal incentives that propelled Protestant women toward national socialism inefficacious for Catholic women? Or were they, as has recently been suggested, closet admirers of Hitler who obediently awaited a signal from the church before showering him with adulation?[2] This chapter searches for some answers to these questions.

The reaction of various subgroups of Germans to national socialism depended largely on the self-perception of each. Even within such a large subgroup as Protestant Germans the appeal of the National Socialist party varied greatly.[3] In this chapter I suggest that many of the same factors that attracted Protestant women to nazism appealed considerably less to their Catholic counterparts. A comparison of the two churches only amplifies this impression. Whereas several factions within the Protestant church, one being the German Christians, supported national socialism with total commitment, the Catholic church was suspicious of the movement and even condemned it in certain areas.[4] The political situation was an additional negative for Catholics. Whereas their party, along with that of the Socialists, had reached the height of political power during the Weimar era, there was no single Protestant party.

Nor did the situation of women, as a Catholic subgroup, dispose them favorably toward national socialism. One association, the league, relished the social, economic, and political possibilities that democracy had brought them. In strong contrast to the largest Protestant association, the auxiliary, the league grew rapidly during the early years of the Weimar Republic. Under the influence of democracy, the sodality, the largest organization of Catholic women, began to transform itself from a purely religious association to an action-oriented society on behalf of the moral values of Catholicism.[5] In 1926 the sodality formally petitioned the Fulda Bishops' Conference to alter its status from that of a pious, reflective association for mutual spiritual support to a women's Catholic action organization.[6] While this metamorphosis was going on in the second half of the decade of the twenties, the sodality experienced phenomenal growth (from about 300,000 in 1925 to about 900,000 in 1932).[7] As a subgroup, then, Catholic

women were orienting themselves successfully as Catholics to life in a democratic society.

In sum, Catholics in general and Catholic women in particular had less reason to be predisposed favorably to Hitler's movement than many Protestants. Furthermore, it is not difficult to demonstrate that Catholic women gave national socialism relatively little support at the polls. Still, the doubt lingers that perhaps they *wished* they could support Hitler, that they were closet admirers. While admitting that the historical sources make it difficult to be completely convincing, I shall argue against this interpretation. The problem is twofold. One organization of Catholic women, the league, was highly verbal in its opposition to Hitler, but the signing of the Concordat muzzled these women completely. The largest group of Catholic women, the sodality, was not verbal at all in its opposition to national socialism, because it was just getting to that point in its metamorphosis when it would have begun to formulate and express its opinions instead of letting churchmen do all the talking for it. To make matters worse, the sodality's internal papers were seized by the gestapo and destroyed. For these reasons, we can follow the reaction of only one group, the league, before the National Socialists took power. Even more unfortunate is the lack of any open forum, such as the newspaper of Protestant women, *Der Bote,* during the years between 1933 and 1939, which would allow us to gauge the nuances of opinion about Hitler among Catholic women.[8]

If we cannot distinguish shades of opinion among Catholics, we can at least compare them to Protestant women. What makes this possible is the fact that both groups of women were interested in the natalist movement, and the National Socialists appealed to both on this issue. In connection with natalism, a number of historically related issues arose: racist and völkisch preoccupations, religion (in relation with the former), and the place of women in society. These comparisons will give us some perspective on Catholic women in the early thirties. Thereafter, they are no longer valid because of developments in the Protestant church and changes of perception among Protestant women.

Although Catholic women did not develop mothercare work as early or nearly as extensively as Protestant women,

activity did pick up after 1925. The sodality's rest home for mothers in Rhondorf, founded in 1921, could accommodate six hundred women a year by 1933.[9] Members of the league were distinctly less interested in natalism than other Catholic women, but in 1931 they joined with the sodality in setting up a fund to help impoverished families.[10] The following year both of these organizations joined with Caritas, the national Catholic charity organization, to coordinate a program that would offer 2,000 educational courses to women on all aspects of motherhood, mother-child relationships, and the family.[11] Thus, just as the National Socialists came to power, Catholic women were intensifying their mothercare work.[12]

What was totally lacking in the approach of Catholic women to natalism was the sense of mission and calling that characterized Protestant women. Catholics did not equate emphasis on motherhood with the renewal of the German Volk, nor did they thank Hitler for giving them an important role to play as mothers after the national socialist seizure of power. Whereas Protestant women were fascinated with the völkisch movement, Catholics were not. The newspapers of Catholic women's organizations ran virtually no copy on völkisch themes.[13] The *Volksdeutsch* issue illustrates the point. The newspaper of the Protestant Ladies' Auxiliary, *Der Bote,* frequently reported on the plight of Germans living in other countries over whom Hitler would later work himself and Germany into a fever pitch. This concern is not reflected in Catholic women's papers, which tended to be downright laconic about the importance or singularity of the German Volk.[14]

The disenchantment of Catholic women may be partly explained by the German bishops who had put them on their guard against National Socialist racist and völkisch indoctrination.[15] Many Protestant church leaders were also suspicious, but a highly vocal faction, the German Christians, involved themselves and Protestant women deeply in völkisch movements.[16] Catholic women showed no inner compulsion to embrace them, even after 1930, when they vibrated constantly through the country. In 1933 the league decided to deal with the question of "The Catholic Woman and the German Race," stressing both the positive and negative, at its annual convention. Between the time the theme was announced

and the date of the convention, the National Socialist revolution occurred, whereupon the league cancelled its convention. Gertrud Ehrle, one of the league's leaders, explained that, under the new circumstances, they did not dare discuss this question in an open forum.[17] Thus, Catholic women dealt with the prevalent völkisch theme rationally while Protestant women were experiencing it as a compelling affective bond to the National Socialist movement.

Another reason for Catholic rejection of völkisch notions concerns National Socialist views on women. There are several avenues of thought here, not all of which were found offensive by all Catholic women. Let us begin by discussing Catholic and National Socialist ideals of womanhood, an issue which annoyed the mainstream of Catholic women.

Since the Catholic church had nurtured a strong Marian tradition throughout its history, Catholic women turned to apostolic times to find their ideal and, secondly, to the Middle Ages, a period during which they believed this ideal had been closely approximated. Central to this model was the state of virginity. Mary embodied this ideal because of the virgin birth, a traditional belief among Catholics. In the hierarchically structured Catholic church, celibacy was assigned a higher rank than the married state, and in the nineteenth and twentieth centuries the virginal ideal had been mightily reinforced by the renaissance of the Marian cult.[18] Even though most Catholic women obviously chose the married state, they continued to affirm virginity as heroic virtue in a manner that was foreign to Protestants. National socialism, contrastingly, looked to the heroic times of the Germanic tribes in search of the ideal völkisch woman, which it hoped to perfect as an Aryan type during the Third Reich.[19] Virginity only impeded the propagation of the Aryan race by lowering the birthrate. The National Socialist feminine ideal moved away from "flapper," "*Bubikopf*," and "the girl" images of the 1920s, since these sexually liberated "bachelors" were as useless to the movement as the Christian virgin, and developed in their stead the ideal of the healthy, natural, outdoors type of young woman whose full hips set her apart from the girlish figured flapper and equipped her for bounteous motherhood.[20] The true heroines of fascist Germany would be those who propagated the Aryan race, not

those who preserved the ideal of virginity behind convent walls. This attitude annoyed Catholic women, who took explicit exception to it, and assigned themselves the task of counteracting it throughout the decade of the thirties.[21]

It may seem unlikely that disagreement over nebulous ideals of womanhood would carry great importance in the midst of the depression when it came to a decision for or against national socialism. But, if it is true that internal factors drew Germans at large to Hitler's movement as much as external ones like unemployment, we should not overlook the negative impact of this element in explaining why Catholic women failed to vote for Hitler. When National Socialists spoke about pagan ideals of womanhood, it registered with Catholic women because it ran against the grain of their internal convictions. They responded by loading their in-house publications with copy on the Marian ideal of womanhood. Thus the link between Volk and religion broke down for Catholic women. Protestant women tended to overlook the difference between the National Socialist and Christian ideal of womanhood. The Reformation had, of course, weakened the Marian tradition among Protestants. Partly for this reason, Protestant women chose to believe National Socialists when they claimed the title of defender of Christianity against bolshevism rather than when they carried the shield of Teutonic pagan antiquity.

Catholic women also rejected the purely biological role that national socialism promoted for their gender. In their minds, National Socialists placed importance on women simply because they protected the race. Like Protestant women, Catholics saw that race was the cornerstone and dynamo of National Socialist ideology, but their interpretation of this perception was altogether different.[22] Protestants envisaged a spiritual role for themselves in fulfilling the biological function of motherhood, but Catholics did not. For them, emphasis on what was solely biological degraded women by violating their rights both as single and married people. A woman was, in effect, fair game for any male whom the state deigned racially acceptable.[23] The circumstances foreseen here are obviously extreme, but Catholic women felt that even in ordinary, day-to-day life the women of National Socialist Germany

would lack dignity. They did not wish to be reduced to a biological equation in the National Socialist scheme to purify the race.

While it is clear that Catholic women opposed national socialism's ideal of womanhood, we must not oversimplify. National Socialist election propaganda, promising a man for every woman and upholding the sanctity of the home in contrast to the marketplace, attracted many Catholic women. There was, furthermore, an area of agreement between National Socialist ideas on women's "place" and those put forward by the pope in the 1930 and 1931 encyclicals *Casti Connubii* and *Quadragesimo Anno*. The male-dominated Center party and church had no problem in agreeing that women belonged in the home. No doubt, many Catholic women also agreed with these ideas. A study of Austrian women has shown conclusively that employed women would have preferred overwhelmingly to be at home.[24] The evidence strongly suggests that, in Germany, Catholic women participated in the National Socialist–sponsored programs of the thirties, such as low-interest loans for newlyweds, that aimed to check female employment and turn around the slumping birthrate of the Weimar era.[25] Concern about a low birthrate and what that might portend bothered many Catholic women. In 1932 the sodality published statistics that claimed to show that a marriage between Catholics was more fertile than any other match (such as two Jews or two Protestants marrying each other, or any kind of "mixed" marriage). Certain aspects of National Socialist ideas about women, then, appealed to Catholic women. But we must not make the mistake of equating what women seemed to prefer as a way of life with National Socialist ideology concerning women. Catholic women, whether married or not, upheld the ideal of virginity and did not marry and bear offspring for the good of the Aryan race. Although there were areas of agreement between official church and National Socialist ideas on women, doctrinal issues separated the two, and Catholic women were very aware of what these were. *Quadragesimo Anno,* for example, lacks the emphasis on bearing many children that the National Socialists, for racists reasons, encouraged.[26] It is incorrect to assert that the National Socialist attitude toward women "most nearly ap-

proximated that of the Center [party] and Roman Catholic church." [27]

The most striking discrepancy between Protestant and Catholic women's views on national socialism lay in its relationships to religion. Protestant women perceived Hitler and his movement as a bulwark to religion; Catholic women did not. As the decisive national elections of July, 1932, drew near, Helene Weber and Gerta Krabbel, widely known within circles of Catholic women, voiced their alarm that national socialism posed a threat to Christianity. [28] The league's newspaper, *Frauenland,* warned Catholic women that, just as materialism was the religion of Marxism, so racism was the religion of national socialism. [29] Protestants also saw the danger of racism, but they believed that distinctions based on "God's Creative Order" justified it to some extent. [30] Catholic teaching did not incorporate this notion, for which reason National Socialist racism was rejected outright. In this way, what people believed colored their perceptions of national socialism and their attitudes toward the movement. When Protestant women saw the unrest in Germany caused by the depression, they interpreted it optimistically as God's hand quickening the spirit of his Volk. Catholic women saw the same discontent and attributed it more realistically to the outrageous campaign schemes and promises of the National Socialists, and they predicted that no good would come of it. [31]

Whether a person perceived national socialism as a spiritual or religious movement was fundamental. Since Catholic women did not see it in this light, they tended to be of one homogeneous mind regarding the other issues we have discussed—racism, virginity, and the ideal of womanhood. The gaps in the historical record make it more difficult for us to trace nuances of opinion within the Catholic female populace than with Protestants. But it is clear that the homogeneity among Catholic women broke down when it came to two issues—those dealing with women's roles outside the home and world peace.

The Catholic German Women's League, to its credit, broke new ground on both of these questions. [32] The league made no secret of its dislike of National Socialist ideas on women's place in the home. At its annual meeting in 1932,

the organization went on record as opposing both the Communists, who belittled women's role in the family, and the National Socialists, who were going too far with their cry of *zurück ins Haus!*[33] As a result partly of the league's activities during the 1920s, Catholic women felt they had begun to find a place for themselves outside of the home in both the economic and political sphere. The depression caused ill feeling toward working women and toward "double-dipping" families (those with two bread winners). National Socialist campaigners capitalized on this attitude, saying that women's nature ill suited them for extrafamilial roles.[34] The fact was that Germany's post–World War I demographic situation had forced many women into the economy. Many German women, like their Austrian counterparts, might have preferred a home life, but, once caught up in the job market, they needed the support that the league provided them. The depression worsened the predicament of the working woman, since unemployment affected heavy industry and construction—male-dominated categories of labor—much more than positions filled by women. This made it appear superficially that women were working at men's expense. Many people doubtlessly believed it when National Socialist politicians said that women were depriving men of jobs. But the league did not back off. In 1932 league affiliates in the large cities of the industrial middle Rhine held meetings to discuss women's employment and place in the business world.[35] Thus, in the eyes of league members, the National Socialists posed a threat to the gains they had made in German society since the end of World War I.[36]

The willingness of the league to stand up for employed women found little echo among other Catholic women's groups. Most Catholic women simply were not interested in the cause of women's rights. When the sodality, which largely ignored such questions, clearly established itself as the dominant Catholic women's organization in the late twenties, some bitterness between the league and the sodality resulted. Thus, National Socialist opposition to workingwomen did not bother all Catholics. But those who were upset, league members, counted among their number some of the most vocal

and insightful women in the country. Once the National Socialist regime was in place, however, being articulate proved disadvantageous.

Another issue that had only limited appeal among Catholic women was pacifism. During the Weimar era, the league became involved fairly extensively in peace efforts. Naturally, this work put it on a collision course with national socialism. The troubled times of the postdepression years reawakened in the minds of many Germans the old grievances that plagued the hectic early years of the republic. Just such an issue—Germany's war reparations payments—brought Hitler to national attention in 1929, and, the following year, Chancellor Brüning of the Center party sought a cessation of payments due to the depression. Reparations were just one of many grievances that the Versailles peace treaty had imposed on Germany. The league's peace work induced it to confront these issues in a different frame of mind than other women. The newspaper of the Protestant Ladies' Auxiliary, for example, went over the Versailles-related grievances again and again, agonizing over the "stab-in-the-back" myth and the dishonorable, inequitable peace with its "war guilt" clause.[37] This unhealthy disposition did not characterize the league's publications, which sympathized with the fatherland without wallowing in a sea of self-pity.[38] Thus, instead of allowing an ugly mood to fester, the league worked positively for peace.

By 1931 few Germans had pacifism on their minds. Alarming numbers were turning on to the militant, action-oriented pitch of national socialism, whose patriotic parades and rallies implicitly promised a redemption of Germany's lost honor. Much of Hitler's political success has been attributed to the party's militancy, which, in a number of psychologically persuasive ways, such as the *Fronterlebniss* phenomenon, led women as well as men to believe in a return to glory.[39] In the midst of this belligerency, the league continued with a constructive, bury-the-hatchet approach. It joined with the American feminist, Carrie Chapman-Catt, to work toward arms control. By 1931, 215,000 Catholic women had signed a petition urging the international disarmament conference in Geneva to press on with arms control.[40] At the same time the league's

publications promoted moderation in international affairs and demobilization.[41] This persistent commitment to pacifism in the midst of National Socialist militancy is impressive.

Yet this attitude did not typify all Catholic women. The league, as we have seen, represented only a minority of them, and this makes it difficult to judge to what extent other women found the National Socialist appeal for a return to glory irresistible. The sodality, whose membership had ballooned to nearly a million by the early 1930s, helped fund the construction of the "Women's Peace Church," or *Frauenfriedenskirche*, in Frankfurt, and it regularly published papal pleas for justice and international peace.[42] But it did not take the lead in these matters, and the organization itself was not yet truly activist like the league. This makes it difficult to judge how the majority of Catholic women were reacting to National Socialist militancy. A specialist on Catholic women's voting patterns maintains that they were not attracted by the party's militant demeanor, but this judgment rests on the record of just one city, Cologne.[43] Thus, we do not yet really know whether Catholic women generally were out of step with the militant National Socialist drumbeat.

What is clear is that certain elements of national socialism were offensive to all Catholic women and that other factors displeased a good-sized minority. National Socialist attitudes toward religion, race, and the Marian ideal of womanhood fall into the first category, and the party's militancy and attitude toward working women into the second. Did Catholic women therefore vote en masse against national socialism? Let us investigate their record before proceeding to the more difficult problem of what motivated them to vote as they did.

The stock answer that historians have given to the question of the Catholic vote has been that Catholics remained loyal to their party, the Center, after the depression, and that it was the Protestants whose votes carried Hitler to high office.[44] Recent historical scholarship, particularly the studies of Thomas Childers and Richard F. Hamilton, who have analyzed National Socialist political support more closely than before, has not substantially revised this picture.[45] In 1930 twenty-five of thirty-five election districts in Germany still had a confessional majority of more than 70 percent. Protestants were the

dominant group in nineteen of them, Catholics in six. The National Socialist vote in the former was over 20 percent—sometimes much higher—whereas in districts with a Catholic plurality it remained under 15 percent.[46] Local studies of confessionally mixed areas have provided similar evidence. In the county of Ebermannstadt, Franconia, there were thirty-nine towns and villages that were overwhelmingly Catholic and twenty-two where Protestants accounted for more than 80 percent of the populace. In the last free election in Germany, that of March, 1933, Protestants deluged the National Socialist ticket with their ballots, giving it pluralities ranging in the nineteenth percentile. Meanwhile, neighboring Catholic villages, with only several exceptions, contained the Nazi vote to the thirtieth percentile.[47]

These statistics confirm contemporary observations. *Frau und Mutter,* the publication of the sodality, asked its readers if they had used their influence at the ballot box to the best interest of the country during the critical elections of 1932. But the paper was confident that not many Catholics had strayed from the fold: "The recent election statistics show that unfortunately many women also turned to right-wing radicalism. But they also show that Roman Catholic women are the most true protectors of the Christian tradition."[48] On the Protestant side, General Superintendent Zoellner, a nationally known churchman, expressed the same opinion when he wrote the leader of National Socialist women that Protestant women had put themselves at the disposal of the party when it seized power while liberal and Catholic women had held back.[49] There is, then, widespread agreement that Catholic women did not support Hitler in appreciable numbers before the National Socialist revolution.

Explaining why Catholic women refused to vote National Socialist is a more difficult proposition. Does it have to do with internal factors, such as those we have already discussed, which would allow us to conclude that Catholic women did not *want* to vote for Hitler? Or does it have to do with party discipline (loyalty to the Center party and Chancellor Brüning) and obedience to the institutional church, in which case one could speculate that many Catholic women wanted to vote National Socialist but refrained from doing so?

The importance of the latter factors—obedience to party and to church—should not be underestimated, but neither should they be automatically viewed as external restraints keeping Catholic women from voting as internal impulses urged. The attitudes of the Protestant and Catholic churches toward national socialism certainly must have played key roles in determining the voting behavior of churchgoers. Catholic bishops spoke out individually and collectively against national socialism, some going so far as to forbid Catholics to become party members on pain of banishment from the sacraments. In the spring of 1931 the bishops of the upper, middle, and lower Rhine spoke out against nazism.[50] Catholic priests were often outspokenly anti-Hitler, whereas Protestant ministers often favored him. Catholics forbade National Socialist celebrations in church; Protestants often did not.[51] And so on. These church pronouncements and policies were undoubtedly major influences shaping attitudes of Catholics and Protestants at large toward national socialism. The fact that these influences were institutional did not mean that they would have to remain external. We saw in the previous chapter that Protestant women internalized the religious factor, allowing it to color their interpretations of national socialism and awarding it eschatological significance. It seems likely that Catholic women internalized religious factors in such a way as to turn them emotionally away from national socialism.

This was certainly the case with league women, who internalized both religious and secular factors to such an extent that they became effective campaigners for democracy and against fascism. Catholic women had good reason to be optimistic about democracy. It had brought them the vote, a more active role in the economy than they had had before the Great War, an opportunity to formulate public policy through active participation in the democratic process (league members were representatives in both state and federal parliaments), and, above all, an escape from the cultural ghetto for the first time since the unification of Germany.[52] Consequently, instead of losing faith in republican institutions after the depression, league leaders urged Catholic women to support the state and to take an active part in the elections of 1930. "The moment has come," wrote Helene Weber, "when all parties

must show that they are ready to help one another" regardless of their constituencies.[53] Thus, after the onset of the depression but before the rise to national prominence on the part of the National Socialists, the attitude of league members was constructive: dig in and make the system work.

What Helene Weber did not see in early 1930 was that the threat to German society and political stability would come from the right rather than from the left. Appalled by the success of National Socialists in the September, 1930, elections and suspecting that Catholic women may have voted for them, Weber began to sound the alarm warning women that all of their gains in the political, economic, social, and religious spheres were at stake.[54] As the threat of fascism became ever more real, Weber predicted that a National Socialist revolution would be as cataclysmic for Germany as the events of 1914 and 1918.

Convinced that the times were fateful, the leaders of the league intensified its political program after the depression. By the summer of 1931, league affiliates in southwest Germany had already sponsored some seventy caucuses in an effort to engage members in the political system, and, ultimately, to cultivate the female, Catholic vote.[55] Similar workshops were held in other parts of the country, and, before the calamitous elections of 1932, the league sponsored weekend, political seminars in large cities to turn out the vote for the Center party and against the National Socialists.[56] Intimating that the government of Chancellor Brüning of the Center party had been precipitously and injudiciously turned out of office, Helene Weber begged women to cast their votes against the radical right and radical left. Thus, many Catholic women preferred the Weimar system to a gamble on national socialism, which they saw as a danger to themselves as women and as Catholics.

It seems very unlikely that Catholic women of the league would have had the initiative to campaign against national socialism in the key elections of the first years of the 1930s had they merely been paying lip service to orders from the pulpit. Likewise, their active participation in the democratic system makes it seem unlikely that they walked like drones from the church to the polling places to cast their votes dutifully for the

Center party. In one respect, league women were a step ahead of many churchmen, who either were unaware of or did not care about the penalty that women would pay economically in the job market if national socialism came to power.[57] It is important to note that Catholic women spoke out against the antifeminism of the National Socialists, credit for which has been assigned, mistakenly, to liberal women's groups of the secular sector.[58] Consciousness of this issue provided Catholic women of the league with an incentive of their own to oppose National Socialist politicians.

It is more difficult, of course, to make a strong case for the main body of Catholic women who were less active in general and in politics in particular than league women. The sodality was more representative of the average churchgoer, but we have no really reliable clues as to what these anonymous women thought about national socialism and its leader before Hitler came to power. It is clear, however, that what national socialism stood for alarmed Catholic women much less than Communist ideology. Even after the big success of the National Socialists in 1930, the sodality warned its members throughout 1931 about the Communist danger—anticlericalism, atheism, and abortion—while ignoring problems such as racism, which Hitler posed.[59] Later, however, the sodality used its newspaper, which had a circulation of about 650,000 in 1933, to explore the ideological conflicts that national socialism posed for Catholic women and to discourage them from voting for Hitler.

The signing of the Concordat within months after Hitler was named chancellor allows us to test the mentality of Catholic women under new circumstances. About as quickly as the bat of an eye, the church's disapproval of nazism was dropped, and Catholics, like marionettes, were encouraged to integrate themselves in the new state and to work positively with it.[60] How did Catholic women respond? Although, in contrast to Protestant publications, there is little evidence of support for the regime, articles opposing national socialism disappeared from Catholic publications. While Catholic women still did not subscribe to the Protestant idea that the rise of national socialism corresponded to a spiritual awakening of the German people, they were aware that the regime

stood for a new departure, and, in the difficult economic cir-
cumstances that faced the country, they wished it well.[61] Even
while Concordat negotiations were going on, the sodality in-
vited Catholic women to bury the hatchet and make their
peace with national socialism, which, it was noted approv-
ingly, was cracking down on abortion, nudity, pornography,
and homosexuality.

A change in attitude toward the new government meant
that Catholic women would have to reinterpret recent history.
Instead of recalling episcopal strictures of recent years against
national socialism, the sodality's newspaper, *Frau und Mutter,*
remembered the bishops' warnings against the "godless ele-
ments" that, since 1925, spread their corruption in sports,
theater, film, fashions, and dance. Recalling the ideals of chas-
tity and Christian marriage of the recent encyclicals, *Casti Can-
nubii* and *Quadragesimo Anno,* the editorial pointed out "with
joyful pride . . . that the leaders of the state have not over-
looked these principles of healthy peoples and societies."[62]
Clearly, Catholics were straining themselves to put a new face
on fascism.

Even Gerta Krabbel of the league responded positively, if
tentatively, to the new government: "We stand now before a
new beginning. We have the feeling that everything bad since
1914 is over and we are going to move ahead. We hold our
breath and our hearts pound as we think what the coming
months and years will bring for Germany, Europe and the
world."[63] In September the league ran an article in its news-
paper entitled "Women as the Pillar of the Race," which was
obviously intended to reconcile their members with the di-
minished role that would be women's lot in the new Germany.
It is, of course, unimaginable to think that league members
were happy about this turn of events, and its leaders contin-
ued to say, privately, that they would go on trying to promote
women's roles in the economy and in public life.[64] The state-
ments of the league during the summer of 1933, which sound
especially conciliatory, must be read in the context of the Con-
cordat negotiations because of which the organization stood
in acute danger of becoming extinct.[65]

Unfortunately, we lack data on membership among
Catholic women in the National Socialist party, and are there-

fore unable to compare them satisfactorily with Protestant women on this decisive point. Before the signing of the Concordat, Catholics were discouraged or prohibited from joining the party. Afterward, they were free to do so, and both the party and the church allowed double membership (in a party-affiliated and church-affiliated organization), but almost immediately a competition between the National Socialist Welfare Association (NSV) or National Socialist Women's Association (NSF) and the various clubs of Catholic women developed.[66] Sometimes Catholic women would affiliate with a party organization but continue to run their club along confessional lines or according to the principles of the league or of the sodality. Party officials detested the building of these "black cells" within their organization.[67] Circumstances varied, however, from area to area, making it impossible to be precise about Catholic women's membership in party organizations. The impression that it was considerably less than that of Protestant women seems correct. Jill Stephenson has found that membership was much lower among German Catholic women than among Austrian women or among ethnic German women of Czechoslovakia.[68]

Fortunately, we are in a better position when it comes to comparing the relationship of confessional organizations of women with the NSF. At the time of Hitler's appointment, the latter organization was still small by comparison to church clubs, and its affiliates were not well distributed throughout the country. Furthermore, it was reeling from internal strife.[69] The leader of the NSF in southwest Germany at this time was Gertrud Scholtz-Klink, an extremely ambitious person who was even then building a power base that would soon allow her to take control nationally. In the spring of 1933 this redoubtable woman called a meeting at her headquarters in Karlsruhe of all Catholic and Protestant organizations of women in the state of Baden to invite them to fuse themselves into just one women's organization on the basis of a common German *Weltanschauung*.[70] Using a carrot-and-stick approach, Scholtz-Klink said flatteringly that the National Socialists wanted to preserve the best of the old Germany but added that she had the power to force them to join in her organization. Scholtz-Klink succeeded in intimidating the

churchwomen, but a representative of the Catholic delega-
tion, Elizabeth Denis, finally told her that the church organiza-
tions would join only on the basis of separate and autono-
mous confessional clubs.[71]

Within a year, Scholtz-Klink emerged as the national
leader of the NSF (*Reichsfrauenführerin*) in which capacity she
needed to prove herself by building a large membership and
taking control of aspects of social welfare that were of special
interest to women. Ravenously, she sought to pluck two ripe
plums: the mothercare services of Protestant and Catholic
women. With this in mind she invited her adversary at the
Karlsruhe meeting, Denis, to Berlin to discuss how Catholic
women's clubs fit into the national social welfare picture. In
preparation for this meeting, Denis sent Scholtz-Klink a
strongly conciliatory letter in which she attempted to explain
why Catholic women were not as forthcoming in cooperating
with the National Socialist state as Protestant women. Catho-
lics in leading circles were not reluctant and "certainly not
negative," Denis assured the *Reichsfrauenführerin,* regarding
the new regime. Reminding Scholtz-Klink of a remark she had
made at Karlsruhe to the effect that she put no value on "in-
stant converts" to national socialism, Denis explained that the
reservations of Catholics were religious in nature. Remaining
true to "faith, conscience, and church encompassed different
factors [for Catholics] than for Protestants."[72]

The meeting was nevertheless strained and awkward.
Denis came away with the feeling that Scholtz-Klink planned
to play Protestants off against Catholics so as to weaken the
latter.[73] Specifically, Denis expected trouble to arise over
mothercare work, and her expectations were confirmed a
week later when Scholtz-Klink issued a statement on "The
Guidelines for German Women's Enterprise in the Third
Reich."[74] This document pronounced the NSF to be the um-
brella organization for all women's associations, which would
be allowed to cooperate with the NSF in working for the good
of the Volk and the community "*if they showed goodwill.*"[75]
These guidelines applied specifically to mothercare work,
which the NSF would carry out under the NSV in cooperation
with Protestant and Catholic women's associations but in a
nonconfessional manner.

Denis's feeling that Catholic women were not as forth-
coming as Protestant women and that the reaction of the two
groups to Scholtz-Klink's guidelines on mothercare work
proved correct. The main issue regarding the latter turned out
to be racial teaching about which Protestants had fewer res-
ervations than Catholics, a fact which allowed them to reach a
tentative agreement with Scholtz-Klink on joint mothercare
work.[76] Denis's perception that Protestant women would find
an easier ambiance and relationship with the National Socialist
party than Catholics also proved correct for the early years of
Hitler's rule.

We cannot say, however, that all Catholic women shared
Denis's insights nor that they troubled themselves much over
possible conflicts of conscience that national socialism might
introduce into their lives. As a minority group whose more
elderly leaders had received seminary training in the era just
after Bismarck's *Kulturkampf,* Catholics were naturally relieved
when the Concordat was signed, removing what appeared to
be another situation wherein they would have to choose be-
tween loyalty to state or to church. The reaction of Catholics
to the new unity between church and state found concrete
expression in the election of November, 1933. Although this
election was highly staged and organized and can hardly be
termed free, the turn around in the Catholic vote was abrupt.
After having withheld their votes from the National Socialists
in the previous election in March, they reversed themselves in
November, voting overwhelmingly for Hitler's party, some-
times actually outdoing the Protestants.[77] The significance of
this about-face is greatly reduced, of course, by the circum-
stance of the Center party's withdrawal from the political
scene.

We have suggested that racism was a key element that
operated positively among Protestant women, inducing them
to favor national socialism, and negatively among Catholic
women with the opposite effect. One reason for this differ-
ence is that the Catholic church and its leaders were less anti-
Semitic than the Protestant establishment. Although some
priests lashed out at Jews, leading churchmen such as Cardinal
Faulhaber of Munich and Cardinal Schulte of Cologne op-
posed anti-Semitism from the pulpit and took care to estab-

lish cordial relations with the Jewish communities in their dioceses.[78] Yet there is at the same time a similarity between Catholic and Protestant women on this issue. Both groups seemed to restrict their awareness of racism to themselves and to their beliefs. In other words, they did not allow it to spill over into civic or secular affairs. As a result, no articles are to be found in either Protestant or Catholic women's publications during the years from 1930 to 1933, when they were still free to speak their minds, which attacked national socialism on account of its anti-Semitism. Whether or how racism impinged on religious doctrine was always the context in which churchgoing women framed the question, if they adverted to it at all. None of their many in-house publications condemned the anti-Semitic violence of the National Socialists, such as the attack in 1931 on Jewish shops along the Kurfürstendamm in Berlin. At no time did either Catholic nor Protestant women speak out in their publications on behalf of Jewish citizens.

We have argued that in the elections down to November of 1933, Protestant women voted for Hitler and Catholic women against him. This, of course, is an oversimplification. Some Catholics as well as Protestants voted National Socialist. But they compare in this respect inversely. That is, it seems certain that those Protestants who were most active in the church and most devoted to their religion voted for Hitler. Contrariwise, it seems certain that those Catholics who were least ultramontane and least consistent in the sacramental life of their church voted for him. Religion provided Protestant women with a compelling internal incentive to back national socialism, but this factor was inoperative among Catholic women.

While it is true that the Concordat temporarily papered over the misgivings of Catholic women toward national socialism, its influence should not be allowed to camouflage the pointed differences between their reception of the movement and that of Protestant women. Tradition, stretching back to Bismarck's time and extending down to the Weimar Republic, made Catholic women much less likely to risk an Armageddon in the form of nazism. In addition to historical factors, there were substantive issues that set Catholic women apart from the National Socialist movement. They were more

aware of ideological conflicts between their faith and national socialism. Their publications warned Catholic women of these problems, and the league actually campaigned against Hitler. If the Concordat lifted a weight from the shoulders of Catholics, it did not suddenly transform them into the optimists and enthusiasts who were legion among Protestant women.

In sum, although Catholic women had not viewed the rise of national socialism with anticipation as had Protestant women, they were thankful that they could join in the work of rebuilding and renewing their country. As long as the Concordat and the consciences of Catholic women were respected, both the sodality and the league were prepared to work with the party's national organizations in this work of renewal. The German bishops approved of this readiness to cooperate with other women's groups whose inspiration, it was clear, would be National Socialist.[79] In practical terms, this would mean that Catholic women would get involved in social welfare work in order to create a new society based on the National Socialist idea of a *Volksgemeinschaft*. It is to the experience of Catholic women and their organizations in this enterprise that we will turn our attention in chapter five, after considering how Protestant women fared in their first years of Hitler's rule.

4

A Dream Fulfilled: Protestant Women during the First Years of Nazi Rule

When Adolf Hitler consolidated his power in April, 1933, the president of the country's largest organization of women told the members of the Protestant auxiliary that the nation "stood at an historic turning point," that the "consciousness of the Germanic Volk had been awakened," and that the Protestant auxiliary "rejoices in this movement and asks God to bless it." [1] These words appear to be an accurate reflection of the mood of the majority of Protestant women who, propelled by their loathing of the Weimar Republic, rushed headlong into the Third Reich. Perceiving no conflicts between their goals and aspirations and those of the National Socialists, Protestant women greeted Hitler with pent-up anticipation and almost millennial expectations. What actually ensued was a stormy, decade-long relationship, beginning with a sixteen month honeymoon and followed by years of ever increasing disillusionment and bitterness. In this chapter, we will be concerned with the earlier experience.

Even though this is a relatively short period, lasting only

until the end of 1934 or mid-1935, we cannot afford to dismiss it because it bonded Protestant women to national socialism, or, at least, to Hitler. We have seen that what attracted Protestant women to national socialism was the sense that a spiritual renewal was underway, along with a mutual interest in mothercare work on behalf of the Volk. Since this work continued to blossom in the first years of the National Socialist era, Protestant women embraced the new regime warmly. Their enthusiastic commitment of these years made it difficult and painful for Protestant women to withdraw from it later on, or to withdraw from it decisively, when it became clear that the principles of nazism could not be reconciled with evangelical counsel. In other words, after the relationship with national socialism began to go sour, Protestant women could think back on the early, good years and hope for a return to those circumstances.

It is true that 1933 and 1934 were also the years when the Protestant Church Struggle became acute, but the political ramifications of this conflict were somewhat delayed at least as far as women were concerned. The German Christians, whose fanaticism allowed them to blend religion and dedication to national socialism without regard for ecclesial autonomy, stirred up enormous controversy in the church. Protestant women were very involved in this controversy, but its political implications had either not yet dawned on them or had not yet become critical until after 1934. Thus, when the women of the auxiliary in Westphalia acted against the German Christian faction in 1934, they took it for granted that this would not alter their relationship with local National Socialist groups.[2] Even as late as 1936, there were some auxiliary affiliates around the country that were politically acceptable to the leader of National Socialist women, Gertrud Scholtz-Klink.[3] Because of their original intention not to become involved in the church struggle, members of the auxiliary looked upon it as an unfortunate development, but not one that would in any way change their devotion to the National Socialist regime.

If the political ramifications of the Protestant Church Struggle did not yet touch women critically during the first two years of the new era, social and doctrinal aspects of it did. The place of Jews in the church was one of the key questions

in the dispute between German Christians and other Protestants. Women of the auxiliary had to deal with this question. Indeed, because the long-anticipated renewal of Germany was to be a völkisch renewal, Protestant women sensed the importance of this topic. We may look upon 1933 and 1934, then, as a period when the racist notions of rank-and-file Protestants found articulation in an environment that favored anti-Semitism. As Protestant women explored their own feelings regarding Jews, they became aware of differences amongst themselves and areas of difference and agreement between themselves and the National Socialist regime.

The words of the president of the auxiliary, quoted at the beginning of the chapter, reflect the mood among Protestant women at the outset of the National Socialist regime: calm waters and a favorable wind ahead. The words and actions of Hitler himself during the months of February, March, and April, 1933, did much to set this mood or mentality in the minds of Protestant women. The inaugural ceremonies in the hallowed Garnissonkirche in Potsdam had an unbelievable impact, suggesting to Protestants that a new era had dawned in which the church and the nation would once again be associates and partners.[4] That spring Protestants heard Hitler repeatedly woo Christians to his movement and government by broadcasting his favorable disposition toward the churches. Their relation to the state would be a favorable one; they would be protected from their enemies, the Communists; and they would become the basis for the country's new morality. During these same months Hitler constantly invoked the name of God, and his deeds seemed as good as his words. Government and party leaders returned to church, as did the SA, in uniform, trumpeting the new era of the Christian state. Hitler's own nationally broadcast speeches were imbued with prayerfulness, as when on 10 February he called upon all Germans to help build a new Reich "of Greatness and of Honor and of Power and of Glory and of Justice. Amen."[5]

This disposition convinced Protestant women that the new "Christian" state would put an end, finally, to secularism in the schools. After taking control of the government, the National Socialists continued to talk about school reform in phrases that were to the liking of Protestant women. When

spokesmen for the new regime said pejoratively that teaching girls the same subjects as boys was "liberal, democratic, and Marxist," they went even further than Protestant women had dared to go in years past, when they accused Weimar governments of pursuing educational reforms that avoided sexist curricula.[6] An end to the secular or "simultaneous" schools and an emphasis on home economics courses for girls constituted exactly what Protestant women had wanted and what the despised Weimar governments had withheld. The reaction of some Protestant women to these promises was so euphoric that they troubled themselves over possible ill effects that the return of girls and boys from secular to confessional schools might have on their children![7]

The National Socialist affirmation of "positive Christianity" made a profound impression on Protestant women who wasted no time in convincing themselves, and allowing others to convince them, that the new regime was rooted ideologically in Christian principles. In April of 1933 the president of the Protestant Ladies' Auxiliary, as we have seen, asked God to bless the National Socialist movement. In the weeks and months that followed, the leaders of the auxiliary showered the new regime with statements of approval in its official newspaper, *Der Bote*. Readers learned that the National Socialists saw the "churches as the most important factor for the preservation of völkisch elements;"[8] that God had sent Adolf Hitler, who was described as a God-fearing and deeply religious man, to save Germany;[9] and that Hitler could be counted on to end the long process of secularization of German society that had plagued the country.[10] One bubbly German Christian, Pastor Hans Hermenau, who was editing *Der Bote* at this time, allowed that "in difficult times God sent Hindenburg to save the nation; now He has sent us Hitler."[11]

Testimonials of this sort from a German Christian are anything but surprising. It is instructive to note, however, that after Hermenau was dismissed from the auxiliary, the strong pro-Hitler tone and endorsements of his regime continued unabated—and they came from women from the provinces as well as from the leadership. In February, 1934, Anna Katterfeld quoted a passage from a speech that Hitler was supposed to have given to an organization of farmers to the ef-

fect that Germans "have sinned in as much as we have cut
ourselves adrift from eternal principles and rules of life."[12] An-
other woman from the central office of the auxiliary urged
Hanoverian women "to build the Christian foundation of the
new state because the *Führer* has made this the cornerstone
of his work."[13]

We sense in these words of Protestant women a self-
fulfilling prophecy: wanting to believe Hitler was a religious
man, they believed it. In the very next week after the National
Socialist murders on the "Night of Long Knives," subscribers
to *Der Bote* read that God had entrusted "Adolf Hitler with our
leadership" and that he was God's instrument.[14] At a meeting
in Magdeburg of the auxiliary in the province of Saxony, a
Protestant prelate told forty-five hundred members that the
National Socialist movement was a spiritual revolution that
had its origins in God's creative order.[15] The women of Pom-
erania announced "joyfully" their support of the new order,[16]
and the women of Westphalia said that they had found a
friend in Hitler who had promised to support religion: "We
have taken up the battle against the destruction of our reli-
gion; we have again given Faith a presumption of right be-
cause we are convinced that the Volk needs and benefits from
its faith."[17] Thus, the largest women's newspaper in Germany
cast Hitler in the most favorable light possible and laced its
copy with sentiments of support for him. As far as most
churchgoing women were concerned, belief in Protestantism
and support of the National Socialist revolution went hand in
hand. The impression Hitler made in 1933 on the Protestant
populace was, in Klaus Scholder's words, unbelievably deep
and lasting.[18] This judgment seems squarely on the mark as far
as Protestant women were concerned, who in the years to
come exhibited an insatiable appetite for believing only the
best about Adolf Hitler.

Even as Protestant women warmly embraced their coun-
try's new leader, they were being swept into the vortex of the
National Socialist obsession with race. The leaders of the aux-
iliary had for some time sensed that the racial aspect of the
völkisch movement was potentially explosive, but their com-
mitment to what they thought was a völkisch-spiritual renewal
kept them from a careful scrutiny of the implications of racism.

As national socialism became more and more popular between 1930 and 1933, it appears to have had an echo effect within the auxiliary. Those who identified with the völkisch spiritual and national renewal moved into leadership roles (Agnes von Grone, Martha Messtorff, Lisa Somer, Klara Lönnies, and Helene von Oppen).[19] The election of Pastor Hans Hermenau, a German Christian, as executive director of the auxiliary in February, 1932, is a clear indication of the pro-völkisch sentiment among these leaders. Although at this early date in the unfolding drama of the Protestant Church Struggle no one knew how significant the German Christian faction was going to become, a number of auxiliary leaders (and rank-and-file members as well) sympathized with the German Christians or joined them.[20] While the choice of Hermenau did not mean that the Protestant Ladies' Auxiliary was going to throw in with the German Christians, we can certainly say that the women who led the auxiliary looked upon them as kindred spirits and as one of the more orthodox of the racist religious factions within the German Protestant church.[21] Protestant women wanted to be the leading edge of völkisch renewal, and Pastor Hermenau seemed a good bet for this venture.[22]

Unknown to the leadership of the auxiliary, he was also a sure bet to commit their organization to the worst features of National Socialist racism. This became clear in the spring of 1933. During his first months as editor of *Der Bote*, Hermenau soft-pedaled the German Christian movement, but, as their potential became more obvious, he let his own highly racist views be known. God had made races distinct as part of the "order of creation," Hermenau claimed, and, going way beyond the limits of orthodoxy, he maintained that because the *blood* of German women had been redeemed, all Germans shared in this redemption through women's reproductive function (so much for baptism!).[23] Hermenau's abstract theories had awesome concrete applications. In the German Christian view, Hitler would have complete control over the church (*summus episcopus*) and could therefore extend anti-Semitic racist legislation (known as the April Laws) to the church. This would mean that Jewish converts in the ministry would be deprived of positions of authority and pulpit privileges. Protes-

tant women were vulnerable on the question of church-state relations because they wanted so much to be part of the völkisch renewal. Hermenau shrewdly chose the period following Hitler's inaugural ceremonies in the Garnissonkirche to affirm explicitly that the German Christians were the "true" element of Protestantism that corresponded with the new political element of Germany, national socialism.[24] Thus, well before the *Sportpalast* scandal burst upon the Protestant church, the auxiliary found itself committed to the radical German Christian faction.

Although this cost Hermenau his job, considerable damage had already been done.[25] Hermenau's actions were not unfolding in a vacuum. As he led Protestant women toward a more and more radical racist position, Germans witnessed the first evidences of National Socialist anti-Semitism right in their own neighborhoods. The boycott of Jewish businesses was followed by the April Laws, which made anti-Semitism an official policy of the country. The effect this had on Protestant women was to open the sore of anti-Semitism. Racial slurs, which had usually only been hinted at in the past decades, could now be voiced openly. Indeed, one could invoke religion in defense of one's anti-Semitism. The action of the government and National Socialist regime, together with the inability of the Protestant church to take a united stand on the question of race, left the door open to the women of the auxiliary to deal with this issue as they pleased. Above all, Hermenau's bold assertions in the spring of 1933 made the entire issue of anti-Semitism *Salonfähig* in the pages of the auxiliary's newspaper, *Der Bote*. Given the situation within the country and the church and given the fact that Hermenau had already opened Pandora's box, there was not much that the leaders of the auxiliary could do other than let the plurality of opinion amongst Protestant women regarding Jews express itself in the pages of *Der Bote*.

Protestant women were predisposed toward anti-Semitism and racist tenets because their spiritual leaders had done nothing to curb dangerous racial views afoot in Germany. Furthermore, Inner Mission, the coordinator of all Protestant charities to which the auxiliary was administratively tied, had discussed eugenic questions widely during the 1920s,

reaching a position in favor of sterilization legislation for the genetically handicapped by 1931. These discussions could not avoid racial questions and, consequently, a theological justification for sterilization. Because of ideas developed by a particular theological school of thought, which held that God created separate and distinct races, it was believed that a mysterious "common principle of life" gave preference to the rights of the race over those of the individual in eugenic matters.[26] We find these ideas clearly expressed in *Der Bote* in 1933. There was a divine "order of creation" that made some races inferior to others.[27] This is not particularly surprising since Hermenau was still editing the paper. But there is no doubt that many Protestant women held this view as well. The notion that the races were created distinctly and were meant to stay distinct was incorporated into the auxiliary's film, *The Vast River.*[28]

There were, nevertheless, clear limits to the racism of Protestant women. Even Pastor Hermenau, although he thwarted copy on the Old Testament, never denied in the pages of *Der Bote* that God revealed His Word to the Jewish people. Furthermore, once the auxiliary was free of Pastor Hermenau, the validity of the Word of God as proclaimed in the Old Testament was consistently upheld.[29] Also, the German Faith Movement's apotheosis of race was rejected in *Der Bote* in no uncertain terms (after Hermenau's release as editor). Most Protestant women stayed within the limits of orthodoxy: the Christian community was not founded on race but on faith in God. Still, it was difficult to reconcile two givens: the fact of a creational "order" and the efficacy of faith. What was the situation of converted Jews? What was the effect of baptism on them? Should they be allowed to attend church services with other Protestants? These questions surfaced at a regional meeting of the auxiliary in Saxony in 1934 in the context of a discussion on Christianity, the Old Testament, and the Volk. The women ended up affirming the legitimacy of the Old Testament and took the position that Christianity knows no racial boundaries.[30] This appears to have been a majority opinion among Protestant women, but it was by no means universal.

Beyond the church doors and the speculation of theolo-

gians, the question of the place of Jews in society under the National Socialists confronted all Germans. The events of April assured this, but the National Socialist position on interracial marriage personalized the issue and brought it home. Such marriages, which had in fact been ever more common in Germany since the nineteenth century, deteriorated Aryan stock, according to National Socialist doctrine. Indeed, the situation was now critical because one half of the German populace was "exceptional" and the other half "inferior." If action was not taken to stop these marriages, the balance would shift in one hundred years' time favoring the "inferior" stock by a ratio of exactly 89.9 to 11.1 "exceptional."[31] Lest any doubt linger, the regime drew up charts for public consumption which "proved" the point.

This racist pitch found a receptive audience among Protestant women. No one ever defended Jew-Gentile marriages in *Der Bote,* but views coinciding with the National Socialist position found their way into print. Anna Katterfeld wrote in early 1934 that mixing races was against the divine will, adding the usual social Darwinist nonsense about diluted races dying out. "If our race is to be saved from downfall," she concluded, "it is the sacred obligation of our leaders to build a dam and put an end to any additional, ominous dilution of Aryan blood, *even when in the process harsh measures cannot be avoided.*"[32] A subsequent article, entitled "Marriage . . . But With Whom," shows the concurrence of National Socialist and auxiliary views: "The genetically healthy, racially valuable family will decide Germany's future." Whereas during the Weimar era marriage had been treated as a personal matter, now it was seen as a community matter. The youth should be made conscious of the genetic and racial aspects of marriage because "there is no undoing what is done."[33] As if to punctuate these racist principles, Klara Lönnies, head of the auxiliary's mothercare service, divorced her Jewish husband in 1933.[34]

The National Socialists took additional drastic action in 1933 on behalf of the Volk in the form of a sterilization law, or, more accurately, the Law for the Prevention of Hereditarily Diseased Offspring. Had this law been applied without regard to racial heritage, it could not be considered anti-Semitic. But, of course, it was not blind in its application. Given the current

beliefs about an "order of creation," it seems inevitable that Jews would be singled out as victims in undue proportions. Protestant women supported the sterilization law, as did the Protestant church and its national welfare agency, Inner Mission.[35] We get some idea of how interested Protestant women were in völkisch considerations by the fact that the auxiliary devoted an entire issue of *Der Bote* to a discussion of the sterilization law. Readers were informed regarding those whom the law would effect (the mentally ill and retarded, epileptics, the physically deformed, and the deaf and blind), and the reasons for the auxiliary's favorable disposition toward the new law were explained: the implementation of the program would be carried out carefully with all necessary paper work; sterilization would be by vasectomy, not castration; and, finally, it would be in the best interest of the Volk.[36] This cold and mindless statement was published in the newspaper of what was still Germany's largest organization of women, the Protestant Ladies' Auxiliary.

We may say, in sum, that Protestant women's understanding of theology and of society favored National Socialist racist policies so long as they did not negate the Word of God in the Old Testament (a point about which there was divided opinion). The issue of race was a complex one, however, which caused women to give it considerable thought. Unlike the religious bond that linked Protestant women instantaneously and lastingly to Hitler, the racial tie provoked more discussion, and, in the long run, tended to unravel. But in the short run, 1933–34, the auxiliary affirmed National Socialist racism. At no time did *Der Bote* object to anti-Semitic actions of the regime. This came about either because of virulent anti-Semitism on the part of some Protestant women, or because of the yearning of the great majority to be a part of the National Socialist restoration of the health of the Volk. Through motherhood and mothercare work, Protestant women wanted to be the spiritual and physical medium of this renewal. In 1933 and 1934 neither the rank and file nor the leaders of Protestant women saw how important racial considerations would become in the welfare program, including mothercare, of the National Socialist regime. This oversight

makes it important for us to understand the preoccupation of Protestant women with völkisch mothercare work.

The relationship between völkisch ideology and mother-care programs was obvious and explicit in the minds of auxiliary women. A 1934 article in Der Bote stated that "when a race no longer attributes to itself the privilege of having many, healthy children . . . it is on its deathbed."[37] Along the same line, the Wiesbaden auxiliary held that to preserve the destiny of the Volk women must support mothercare programs to make up for Weimar's neglect in this area.[38] Although ideas such as these found more frequent expression after the National Socialists took power, the fascination of Protestant women with völkisch renewal antedates national socialism and may have been, at least to some extent, independent of it. Protestant women liked to view themselves as the precursors of the völkisch renewal under the National Socialists. They were not just imagining this. One of the more prominent mothercare spokeswomen in Germany was Klara Lönnies of the auxiliary, who had been telling people for some time that the future of the nation depended on the well-being of its mothers.[39] When the Brunswick auxiliary opened its new mothercare rest home in 1931, it proudly reported that "mothers are the most worthwhile part of the Volk for which reason they must be allowed the spiritual and physical regeneration that they require."[40] Given this attitude and their pioneering work in mothercare services, it was natural and automatic for Protestant women to look forward enthusiastically to cooperating with the new National Socialist regime in this work.

Their expectations were largely fulfilled during the regime's first years but some problems did develop. The leadership of the auxiliary did not foresee that in a totalitarian system there would be difficulties of a practical if not ideological nature in carrying out their traditional communal work or more recent mothercare services. Since a number of leaders of the auxiliary were themselves members of the National Socialist party, they had no cause to anticipate trouble.[41] Some auxiliary members, including Klara Lönnies, had already had firsthand experience working on this or that program or pub-

lication of the party. Since many rank-and-file members of the auxiliary were also members of the National Socialist party, it seemed likely that the auxiliary and NSF could easily cooperate with one another in natalist projects as well as other types of communal welfare dictated by the depression.[42]

Nevertheless, when it came to practical questions, Protestant women were somewhat perplexed. Their confusion was reflected in a regional auxiliary meeting that took place in Brandenburg soon after Hitler came to power. Explaining that most of the women of the auxiliary were politically National Socialist, the president of the regional group wrote to Klara Lönnies, known nationally because of her pioneering mothercare work, asking for her views and advice on the subject. Lönnies's response catches the upbeat but naive attitude of Protestant women, which resulted from their optimism as well as from Hitler's avowals and honeyed words. Recounting her own work on behalf of the movement, Lönnies asserted proudly that the National Socialists were going to create one Volk and fashion a state out of them that was worthy of Germans. The *Weltanschauung,* from which this work would spring, was "positive Christianity." Since the auxiliary promoted the Volk through their Christian work on behalf of the community and had been at this task for thirty years, Hitler would be naturally opposed, Lönnies reasoned, to any opposition to the auxiliary. "If in a village where the Auxiliary has been active a newly established NSF undertook some project which destroyed the unity of the Auxiliary in the town, it would violate the principles of National Socialist thought." Thus, if some members were to join the NSF and withdraw their contributions to the auxiliary for its community work, this would violate the "rule of positive Christianity and the will of the Führer."[43] Although she admitted that competition between the auxiliary and NSF in community work might unavoidably arise, Lönnies was "completely convinced that a close cooperation with the leaders of the new state would push difficulties in practical work on behalf of the community out of the way."[44]

It is clear, then, that both the head and members of the auxiliary hoped in the inaugural days of the new regime that in towns and smaller cities, at least, where the work of the auxil-

iary was already well established, the NSF would simply let them carry on without bothering to set up their own organization to duplicate their efforts. Reciprocally, the auxiliary would respect the territory of the NSF. In larger cities, where both organizations of women were active, it was expected that they would be able to coordinate their efforts. In the long run, this was wishful thinking, but there were places where things worked out this way, and, in the short run, the NSF was not able to establish in a few months what it had taken the auxiliary thirty years to accomplish. Mostly for this reason, co-operation did develop between the National Socialist welfare office, NSV, together with its subsidiary, the NSF, and the auxiliary in 1933 and 1934. This tended to confirm the optimism of Protestant women regarding the new fascist regime.

The Rhenish province of Westphalia, where a fund drive took place in 1933 for *Mutter und Kind,* the Nazi mothercare program, offers interesting insights into the early relationship of the auxiliary with the NSV. To help collect funds for the *Mutter und Kind* drive, the NSV Westphalian office solicited help from a number of organizations: Inner Mission (through the volunteer work of the women of the auxiliary), Caritas (the Catholic charity, which drew on volunteer work of three women's organizations), the SA, Hitler Youth, and the League of German Girls (BDM). The members of these organizations worked the cities' sidewalks and houses collecting donations. About 60 percent of the members of the auxiliary took part in the work. A larger number would have been involved, but their services were either not required or the NSV, because of organizational mix-ups, failed to follow through, after having initially asked for their help. During the drive, auxiliary women worked at times with NSF and Caritas volunteers and, at times, especially in small villages, by themselves. A few problems arose. In some places auxiliary women were asked to wear an NSV badge rather than the auxiliary's broach as identification. Elsewhere the auxiliary received less than their share of recognition for their part in the campaign. More seriously, the auxiliary felt it had been shorted when it came time to distribute the funds to the agencies that had participated in the effort. Since the money was collected for the *Mutter und Kind* program, the auxiliary intended to use its share for its cher-

ished mothercare work, but the 8,868RM it received represented only a fraction of what its members had actually collected.[45] In the main, however, the auxiliary felt its team effort with the NSV and other organizations (the NSF) had been successful and altogether free of conflict.[46]

The optimism of Westphalian Protestant women and the good experience they had with the NSV in the *Mutter und Kind* campaign found expression elsewhere throughout the land in other ventures. In Schwein members of the auxiliary helped the local NSF club distribute clothes to the poor.[47] In some smaller cities and villages, the auxiliary had carried on Winter Relief Work (WHW) single-handedly since the depression and had given extensive support to it in larger cities. In the important WHW project of 1933, which collected food and clothing for thousands of destitute Germans, the NSV and auxiliary worked together in many areas or cities throughout the country—Anhalt, Pomerania, Hanover, Saxony, Kurhesse, Westphalia, and Bremen, among others.[48] In the Palatinate auxiliary affiliates contributed 8,000RM in goods and currency to the 1934 NSV's WHW campaign.[49] There were even places where the officers of the auxiliary served as officers of the local NSF unit, which meant that the two organizations could work hand in glove.[50] In short, 1933 was the closest thing to the millennium—with Hitler standing in as messiah—that Protestant women ever expected to experience.

In 1934 a few clouds appeared on the horizon. Auxiliary leaders became concerned about *Gleichschaltung*. Would the auxiliary be allowed to exist, or would it be subsumed into the NSF? The amiable Dr. Krummacher, whom Rudolf Hess had appointed head of the NSF and German Women's Enterprise in 1933, was well disposed toward the churches.[51] But in the spring of 1934 he was replaced by *Reichsfrauenführerin* Gertrud Scholtz-Klink, a relentless, ambitious person. In August, 1933, as the National Socialists prepared to organize all women's groups under the German Women's Enterprise, a ban on establishing new affiliates of any and all women's clubs, except of course the NSF, was decreed. When the auxiliary broke this ban, it was reprimanded, and local civilian authorities were notified.[52]

Sometimes it was stated explicitly that the auxiliary could

not start a new affiliate because this would only make it more difficult for the NSF to strike root and establish its own affiliates.[53] It is not known how widely the ban was upheld throughout the land, but the auxiliary leadership was certainly concerned. Even though women like Agnes von Grone fully supported the National Socialist movement, they believed equally in the right of Protestant women to do charitable work within the church, and in the principle that the auxiliary should be free to work for the church.[54] Early conflicts between the auxiliary and the NSV or NSF caused auxiliary leaders to worry about their organization's ability to compete with National Socialist–sponsored welfare and women's organizations. The latter had more funds at their disposal and demanded greater dues from their members.[55] Furthermore, if auxiliary affiliates came into conflict with Nazi women in disputes over competency in welfare, the leaders of the auxiliary did not know if they could count on the support of church officials in those areas in which the German Christian faction of the church had won control.[56] Then, toward the end of 1933 and early in 1934, concern over the possibility of *Gleichschaltung* increased when Reich Bishop Müller handed the organization of Protestant Youth over to the Hitler Youth.[57] Nothing prevented him from offering the auxiliary up, in like manner, to the NSF as a sacrificial lamb so as to further ingratiate himself with the National Socialists. Thus, the auxiliary had cause for anxiety over its future since the party had not issued any clear directives regarding its fate at a time when other associations of women—whether social, recreational or charitable—were being dissolved.[58]

Just after the Reich Bishop's cavalier dealings in the Protestant Youth affair, he became involved in proceedings against Klara Lönnies that deeply troubled the leaders of the auxiliary. Lönnies had long been associated with church-sponsored social work, having taken a certificate in this field in 1919 at the Protestant Institute for Women in Berlin. Lönnies reacted strongly against Marxist and feminist movements of the Weimar era and became intensely active in mothercare work in Silesia. Her promotional abilities impressed auxiliary and church leaders, as a result of which she was called to Berlin in 1929 to take over what would later evolve into the

Mothercare Service of the German Protestant Church.[59] In 1931 Lönnies began publishing *Mutter und Volk,* a pictorial magazine. She became a nationally known leader of Protestant women through this publication, through her film, *The Vast River,* and her radio addresses. In short, Klara Lönnies had developed a highly successful career by the time of the Nazi seizure of power.

In the eyes of NSV leaders, she was far too successful. Early in 1934 Reich Bishop Müller, in response to pressure from outside the church, began to work against Lönnies. Soon the National Socialists mounted a defamation and hate campaign against her.[60] Not only had Lönnies married a Jew, she had defiled the race by bearing his child! The personal attack against Lönnies was probably a smoke screen. The NSV, which coveted the far-flung mothercare work of the Protestant church, stood to gain from Lönnies's fall. The situation of the moment, which found the Motherhood service of the Protestant Church far more established than the NSV's *Mutter und Kind* program, could not be long tolerated. In all likelihood, Lönnies, who had aspirations to high office in the *Mutter und Kind* program, posed somewhat of a threat to NSV officials and perhaps to Scholtz-Klink herself.[61] In any event, the campaign against Lönnies resulted in her dismissal as head of the church's motherhood service. Auxiliary leaders were furious at the Reich Bishop for his connivance in this matter, and they were dismayed that they could not rely on the Reich Church to ease them through knotty problems with the party.

Meanwhile, prospects for the auxiliary's mothercare services seemed in jeopardy to the auxiliary's leadership. Unsure of their relationship to the party, the executive committee wrote to their provincial offices that it feared the auxiliary's well-established mothercare work would be "severely limited if not crippled."[62] The auxiliary received some reassurances the following month, but in March the women's worst fears were confirmed when a Saxon *Gau* leader sent word to local NSF affiliates that all mothercare work on the part of the auxiliary had been outlawed. Soon after this setback, *Reichsfrauenführerin* Scholtz-Klink issued her guidelines for German Women's Enterprise and attempted to bully the auxiliary into *Gleichschaltung* by first renewing the ban on new women's

clubs and then by obliquely threatening to push the auxiliary out of mothercare work.[63] As if these problems were not upsetting enough, the Protestant Church Struggle raged out of control in the latter months of 1934 causing uncertainty and divisiveness within the church and the auxiliary itself. Thus, a number of factors converged that caused apprehension among the leaders of the auxiliary.

But these conflicts tended to center around practical or organizational matters more than ideological questions, at least as far as the auxiliary and NSF were concerned. Therefore, auxiliary leaders worked optimistically and with some success to relieve tension between itself and the party organizations. Agnes von Grone, Reich leader of the Women's Work Front of the German Evangelical Church (*Reichsfrauführerin im Frauenwerk der Deutschen Evangelischen Kirche*), was ideally suited to smooth over disputes that might arise as the new National Socialist regime took hold, because she was both very active in the auxiliary and a member of the National Socialist party. Although she early realized that some problems in the working relationship of the NSF and auxiliary would be unavoidable, she believed in 1934 that the two organizations could learn to cooperate with one another.[64] Early that year von Grone succeeded in getting the central office of the NSF to issue a directive to its affiliates to the effect that they had no right to restrict the work of the auxiliary.[65] At about the same time, Scholtz-Klink announced that women who held membership in the auxiliary were not to be barred from membership in the NSF.[66] In February an agreement was announced between the NSF and Protestant women's organizations in Düsseldorf that served as a basis of coordination for these agencies' mothercare programs.[67] Next, von Grone succeeded in getting the NSV to overrule the orders of the inimical Saxon *Gau* leader.[68] Later the same year, Grone and Scholtz-Klink devised a plan of cooperation for National Socialist and Protestant organizations of women working in educational programs for mothers.[69] This agreement was between German Women's Enterprise (*Deutsches Frauenwerk*), the National Socialist–led federation of women's groups, and the Women's Work Front of the German Evangelical Church (*Frauenwerk der Deutschen Evangelischen Kirche*), the Prot-

estant federation of women's groups, which claimed to represent two and a half million women. Thus, the Protestant church and the auxiliary worked successfully to counteract conflict with the NSF and NSV that *Gleichschaltung* and other problems engendered in 1934.

One of the difficulties between the auxiliary and the NSF that Agnes von Grone was able to iron out in the summer of 1934 is of particular interest here because it concerns mothercare work. Gertrud Scholtz-Klink was eager to get her National Socialist women involved in mothercare efforts because this work was very popular among the German people, and, for that very reason, it would give the NSF access to German women at large for propagandistic purposes. Since the auxiliary already had a diversified mothercare program, which included more than forty recuperation homes and close to two thousand counseling programs for expectant mothers and young mothers, Scholtz-Klink was anxious to tap into this program. National Socialist women under Scholtz-Klink were obsessed with the idea of educating German women at large politically. This meant, among other things, an appreciation of racial purity, imparting the same to one's children while keeping them away from non-Aryan children and instilling in them an awareness of the national community.[70] To accomplish this, Scholtz-Klink could not resist trying to use the rest homes and counseling centers of the auxiliary as a theater in which her women in the NSF and German Women's Enterprise could hold forth. Agnes von Grone, for her part, was anxious to reach an agreement with the NSF so as to get the mothercare work of the auxiliary officially established in the social welfare program of the Third Reich. Accordingly, von Grone and Scholtz-Klink reached an agreement that opened the door for the NSF to use Protestant mothercare facilities to indoctrinate German women in Nazi racist ideology (Figure 2). The agreement spelled out the outline of this indoctrination: "The educated mother and the National Socialist philosophy. The responsibility of women in the new state. Women as the guardians of race. Cultivation of the race and racial teaching as a maternal responsibility."[71] The agreement also specified that only women who had accepted Nazi ideology could perform as teachers in the mothercare facilities of the auxiliary. The

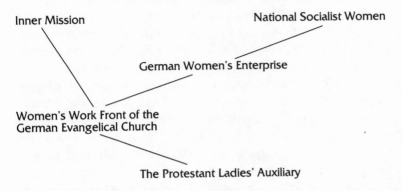

Figure 2.

The Organizational Ties of the Protestant Ladies' Auxiliary to the Church and to National Socialist Women

Inner Mission National Socialist Women

German Women's Enterprise

Women's Work Front of the
German Evangelical Church

The Protestant Ladies' Auxiliary

contrast in this particular issue between Protestant and Catholic women is direct and striking. In the summer of 1934, just before the von Grone–Scholtz-Klink accord, Catholic women rejected a cooperative mothercare venture with the NSF, and in early 1935, when the *Reichsfrauenführerin* reopened negotiations with the Catholics, they broke down on the specific point concerning the teaching of Nazi ideology in a Catholic facility. Scholtz-Klink insisted, as she had done with von Grone, that ideological input be the responsibility of a National Socialist, and the Catholics rejected the proposal.[72] Von Grone would not have been able to allow the auxiliary to become a partner in the NSV's racist undertaking had anti-Semitism not been widespread within her organization and the Protestant church itself.

Both the NSF and auxiliary benefited, or so it seemed at the time, from the agreement. Scholtz-Klink, struggling to get NSV mothercare work operational, got immediate access to a well-established program—the most extensive, in fact, in the country, and the auxiliary won, or thought it had won, the assurance of cooperation with the national welfare system, a long sought after goal for their services for mothers. It appeared as if the racism of national socialism and the racial prejudice of the Protestant faithful was to find concrete expression in joint mothercare work. Had this been so, and this was how it looked in 1934, the basis for an indefinite partnership

between Nazi women and Protestant women would have been in place (Figure 2).

Because of this cooperation, both the leaders and rank and file of the auxiliary reacted positively, and sometimes euphorically, to their experiences as communal volunteers during the first years of National Socialist rule. There were exceptions, of course, in both extremes. Some women at the communal level had already in 1934 experienced bitter conflict with NSF or NSV officials, and others would live through the entire decade without ever having to feel divided between loyalty to church and to the Third Reich. We know enough about the vagaries of fascist Germany not to be surprised by this.[73] When problems did arise, Protestant women had the satisfaction of knowing, at the very least, that, contrary to the Weimar period, the government now worked on behalf of mothers. Because of the hostility they had felt during the 1920s, Protestant women could look back proudly in 1933 and 1934 at their pioneering work for mothers. At a meeting in January, 1934, of all Protestant women's organizations in the old chambers of the House of Lords in Berlin, Klara Lönnies, at the time still the director of the Mothercare Services of the German Evangelical Church, pointed out how the work of the auxiliary had been vindicated: "Among the social solutions of recent years Protestant motherhood programs created a force opposing the anti-family policy of the previous system [Weimar], and furnished a model for the new [National Socialist] state."[74] In the same vein, Frau von Bismarck, who became president of the auxiliary when Pastor Hermenau and Helene von Oppen resigned their positions late in 1933, told the congress, among which were representatives of the NSF, that the new German state stood on the foundation of the family, which the auxiliary had preserved.[75] When the auxiliary of the province of Anhalt celebrated its tenth birthday, it expressed the same sentiment in its report to *Der Bote*. Born in a hostile environment, the auxiliary grew in spite of Weimar's adversities. Now the National Socialists officially recognized the work on behalf of mothers that they had begun.[76] Writing in a January, 1935, issue of the auxiliary weekly, Ruth Fuehrer gave the typical auxiliary interpretation of their history: they had gotten into recuperation homes and other mothercare

services because the Weimar state treated women only as voters, taxpayers, and workers, but not as mothers. From this beginning sprang the vast array of the Third Reich's motherhood programs.[77]

When auxiliary women prided themselves for beginning this movement, we may take them at their word. But we should not imagine that they spoke for all Protestant women, or even for all of the members of the auxiliary. As national socialism came into prominence, it had the effect of encouraging the more conservative people within organizations such as the auxiliary, bringing them to positions of leadership. Thus we find Klara Lönnies faulting those women who, during the Weimar Republic, had forgotten their true calling; they did not now deserve to be mothers in the new German state, which needed, she said, conscientious, Christian mothers.[78] Others belittled "liberal" women who, by accepting Weimar governments' statements that Germany would have to live within the constraints imposed upon it by Versailles, contributed to the declining birthrate.[79] In the wake of national socialism, these are the voices we hear, but other Protestant women knew that there were literally thousands of cases of women who supported families and were in the work force to stay.[80] While there was never any question of these women being held responsible for the country's supposed demoralization, they would find little or no support within the auxiliary as it fell increasingly under the spell of fascism.

For the great majority of churchgoing Protestant women, 1933 and 1934 were years of vindication and heady fulfillment. After feeling like second-class citizens during the twenties, Protestant women felt at home during the first years of the Third Reich. In their eyes, Hitler made this happen. He had restored the will to live, literally, in Germans, and he called upon women to fulfill their roles as mothers so that Germany might once again be growing and vibrant. An excerpt from *Mein Kampf* that was familiar to readers of *Der Bote* (because it was quoted so often), pointed out the importance of women: "The *völkisch* state puts race at the center of life. It promotes racial purity. It counts the child as a precious commodity of the state."[81] Protestant women felt that Hitler had called them to preserve "the German heritage, which means,

above all, German life," and they were grateful to him for giving them this important role as citizens.[82] "We mothers of Germany are proud and thankful that we are called once again to work for the future of the *Volk.*"[83]

The mentality we see forming here among practicing Protestant women tended to reduce women to biological entities for racist reasons. Race was the highest value of the state, and women were the guardians of its purity. Such ideas as these among a population that was already anti-Semitic were clearly dangerous. Völkisch mothercare blended with völkisch religion. But we must bear in mind, again, that not all auxiliary members, and not all Protestant women, subscribed to these ideas or allowed themselves to be carried away by them. Some had already begun to put limits on their racist notions, not so much out of a disgust with anti-Semitism as out of a commitment to religion and to religious orthodoxy. A regional auxiliary affiliate, in fact, had already in 1934 rejected some of the racist literature put out by the national office of the Protestant Women's Work Front.[84] Resolve such as this, however, characterized only a minority of Protestant women. To the majority, it probably did not really matter a great deal whether the state or the church carried out mothercare work, since the same spirit seemed to imbue both. Those whose voices filled the air with triumphalism spoke for this faction.

Even for those who had already had occasion to quarrel with NSF or NSV officials, faith in Hitler did not quiver. By the end of 1934 the auxiliary leadership knew that some stormy days lay ahead, but they remained unshaken in their hope and belief in Hitler because of the immensely favorable impression he had made on Christians in his first weeks in office. What was clear in the financially difficult years of 1933 and 1934 was that the party and the Volk needed the far-flung social services of Inner Mission and the auxiliary. Through this work, especially through NSV-auxiliary cooperation in the important WHW drives, Protestants felt that they were contributing to the renewal of the Volk and that their efforts and intentions were acknowledged at last by a grateful society and government. This success created an upbeat, vibrant spirit in Protestant women that can still be felt in the 1933 and 1934 pages of their newspaper. True, the leadership of the auxiliary made

sure that the paper omitted coverage of difficulties and disputes that they were already experiencing with National Socialists. Yet, even after taking this into consideration, one cannot mistake the mood of optimism. Protestant women had accepted the idea that they were an essential part of the national reawakening, which was a spiritual and psychological as well as physical renewal.

5
Women and the Catholic Compromise in Welfare

The linchpin of National Socialist foreign and domestic policy was racism. It drove the regime to deprive German Jews of their civil liberties and, ultimately, European Jews of their very lives. Not surprisingly, racism was also the cornerstone of the National Socialist welfare program. Because both the Catholic and Protestant churches were devoted to Christian charity, they would have to reconcile themselves to National Socialist welfare philosophy or suffer the consequences. Since women, rather than men, engaged in church-related charitable services, they found themselves in the middle of an ideological confrontation: traditional Christian charity for the disadvantaged versus the perfecting of the Aryan race.

Although we may formulate the racial question succinctly, we should not presume full clarity or awareness in the minds of the German populace. A main objective here, in fact, will be to determine to what extent Catholic women took cognizance of the race issue. No matter how we answer this

question, it is certain that conflicting ideologies in public wel-
fare were the historical context in which Christian women re-
lated to National Socialist racial doctrine. Everyone knew, of
course, about the consequences for the Jews. Discrimination
against them began immediately upon Hitler's assumption of
power and continued to unfold in full view of the German
people throughout the decade. Historians usually try to mea-
sure popular anti-Semitism by studying the Gentile reaction to
the Jewish predicament. This is an important issue, and I shall
come back to it in subsequent chapters. But National Socialist
racial doctrine had far-reaching implications for church-
related welfare, and Catholics, both shepherds and flock,
seemed more concerned with this than with the Jews' prob-
lems. We may say with complete certainty that their first reac-
tion to the racial ideology of national socialism related to
themselves and to their own religious beliefs.

Not long after the National Socialists took power,
women found themselves in the middle of a tug-of-war be-
tween their churches' welfare organizations and that of the
party. For the first two years the confrontation ran at a low
level, as we have just seen in the case of Protestants, mostly
because the situation of the NSV was not a favorable one. The
National Socialists had very little experience prior to 1933 in
welfare work, their efforts being largely confined to members
of the party. Upon coming to power in the midst of the great
depression, party officials in the welfare office were con-
fronted with a gigantic problem: how to develop a national
welfare program without benefit of operational principles
(other than racism) or a high-level priority for their work within
the party.[1] Under the circumstances, confusion and frustration
were inevitable.

These practical problems contributed to the difficulties
with which other private welfare agencies, such as Inner Mis-
sion and Caritas, had to contend, and they existed at every
level. Occasionally, the church found a high ranking party fig-
ure—Heinrich Himmler in Bavaria—blocking the path of its
charitable mission. Sometimes, conversely, a *Gau* leader
worked with church social workers against what he perceived
as NSV encroachment in his domain. Not infrequently, the op-
posite obtained: an inimical *Gau* leader obstructed coopera-

tion between church and NSV welfare workers out of con-
tempt for the church. Add to this the rivalry between officials
of welfare programs at every level—middle echelon function-
aries, for example, choosing to misinterpret church-party
agreements reached at a higher level on spheres of compe-
tency—and it becomes obvious that the potential for conflict
between party and church welfare agencies was endless.

But none of these problems was insoluble or critical. Only
the chasm of racism between NSV welfare and church welfare
could not be bridged. Women found themselves in the
middle of an ideological confrontation since both the NSV and
Caritas sought their financial support and volunteer services.
Catholic women's attitude toward this confrontation was in-
fluenced by many factors, two of which need to mentioned at
the outset. First, those Catholics who had themselves received
welfare from the NSV during the economically hard-pressed
early years of Hitler's rule, developed a "bread-and-butter"
loyalty to it that was difficult for the church to break down
through attacks on the NSV's "false" ideology. Secondly, al-
though the Catholic church urged its faithful to support Chris-
tian charity, it never publicly denounced the NSV racist ap-
proach to welfare. This failure had the effect of gagging church
leaders even as they urged the faithful to support Caritas
rather than National Socialist welfare when its racist tenets be-
came known.

It also tied the hands of Catholic volunteer workers in the
welfare field who were unlikely to voice their own objections
so long as church spokesmen remained silent. The Concordat
created this situation. If a Catholic organization was not spe-
cifically protected under article 31, it ceased to exist, a fate
that very nearly befell the league. Archbishop Conrad Gröber,
Rome's spokesman in Germany and chief Concordat negoti-
ator, had so little regard for an organization such as the
league, which stood up for women's rights, that he failed
to invite them to the meeting in Berlin at which the terms of
the continued existence of other Catholic organizations of
women were discussed.[2] It was terribly disconcerting for the
league's leaders to discover that, after having established its
independence over a period of three decades, its very exis-
tence could come to depend upon the *placet* of a single prel-

ate. The league ended up being included under article 31, but the agreement itself was drawn up and signed so hastily that its interpretation by the party and the church in the years thereafter was in constant dispute.[3] Because the article stipulated that the activities of the organizations under its umbrella had to be "purely religious," the league had to jettison most of its work. Even worse was the fact that it could no longer speak on its own behalf. Thus, while it could continue to do charitable work (welfare), it could not formulate policy or object to welfare policies of the National Socialist regime except through the church.

When the Concordat was signed in the summer of 1933, few Catholics would have guessed that an ideological conflict over racism awaited them in the near future. In that year more practical considerations and problems demanded everyone's attention. The NSV, not being in any position in the midst of the depression to forego the voluntary contribution of the churches to the commonweal, which saved the state around 250RM million annually, refrained from making an issue of racism.[4] Rather, Erich Hilgenfeldt, head of the party's welfare office, flattered the directors of Inner Mission and Caritas, Pastor Frick and Monsignor Kreutz, and acted conciliatory. Indeed, some early statements of the NSV said flatly that public welfare would be based on "Christian sentiments," and Christian charity was acknowledged as an important wellspring of voluntarism in the field of public welfare.[5]

In fact, however, the situation was ambiguous. Racism had already surfaced in public life and governmental policy. The German Catholic episcopacy warned the faithful in May of 1933 of the danger of overemphasis on race and blood in determining national allegiance. Soon this issue surfaced in other, church-related connections: Cardinal Faulhaber's Advent sermons, the treatment of Catholic Jews, and the placing of Alfred Rosenberg's *Myth of the Twentieth Century* on the Index of Condemned Books.[6]

In the field of social work itself, racism began to materialize as early as mid-1933 when the regime tried but failed to get the sodality to subscribe to their racist publication, *Mütter Kämpft Für Euer Kinder*. This publication urged German women to have large families on the grounds that it would

save the Aryan race from inferior people such as Jews and Ne-
groes.[7] Linking racism with Hitler's goal to recreate a *Gross-
deutschland*, the text urged that the "entire, gigantic struggle
for Austria would be senseless" if in one hundred years the
Slavic population floods over into German lands.[8] The NSV
also published a poster with the same title as the pamphlet,
which pictured an outraged and irate blond mother gathering
her brood of four very young, blond children around her. The
text explained that she was protecting her little Aryans from
the contamination of Jewish children, who were potential
playmates. Not surprisingly, the national Jewish welfare office
was closed down in 1933. Caritas, for its part, was certainly
aware that racism could affect welfare policy. In the summer
of 1933 a Caritas publication criticized National Socialist rac-
ism, saying that charity extends to all regardless of race.[9]

Unfortunately, the church's awareness of National Social-
ist racism did not prevent it from cooperating with the NSV in
public welfare. To this end, both the Protestant and Catholic
church, along with the Red Cross, agreed in March, 1934, to
form a united work force with the NSV. Although both confes-
sional agencies were to retain their autonomy and indepen-
dence, it was agreed that welfare was to be carried out ac-
cording to the disposition of the National Socialist party and
under the direction of the NSV.[10] Even though Caritas had al-
ready criticized racist aspects of National Socialist welfare, the
church professed to believe that the NSV would conduct so-
cial welfare in a Christian sense.[11]

This proved immediately not to be the case. In July the
National Socialist Law on the Prevention of Hereditarily Dis-
eased Offspring, which was to become effective at the begin-
ning of 1934, was decreed. The law defied Catholic teaching.
Hundreds of hospital personnel, not to speak of the thou-
sands of Catholics who would fall victims to sterilization, were
thereby put in a conflict of conscience. The German hierarchy
protested the law strenuously, winning some initial, quite min-
imal concessions.[12] For the rest, the National Socialists were
intransigent.

This early experience makes it appear unwise of the
church, and uncharacteristically rash of Monsignor Kreutz, to
have tied Caritas organizationally to the NSV.[13] Pastor Frick,

Kreutz's counterpart in Inner Mission, did not think that Kreutz was very perceptive in his assessment of the true intentions of party welfare officials.[14] Socialist party observers felt the same way. In their eyes the church's subsequent problems with the National Socialists resulted largely from their haste to sign the Concordat and become partners with national socialism in the struggle against bolshevism.[15] This interpretation is hardly surprising, but it rings true in the field of welfare. After having become a partner of the NSV, the church was hesitant thereafter to break this relationship. This made it difficult for church officials—and nearly impossible for the laity—to speak bluntly when the racial issue emerged more conspicuously in the middle part of the decade.

The Caritas-NSV agreement necessitated some organizational streamlining within the church. The league, the sodality, and the Elizabeth Society became agencies of Caritas, which coordinated their efforts in welfare, including mothercare work. When conflict arose between one of these women's organizations and the NSV or NSF, its resolution fell to Caritas. By combining the efforts of all three women's organizations, along with others such as the St. Vincent de Paul Society (of men) and various religious orders of both sexes, the Catholic church could hope to hold its own in the field of national social welfare work.

After Caritas and the NSV reached an accord, German Catholics were urged to support National Socialist welfare openhandedly. Archbishop Conrad Gröber, dubbed the "Brown Bishop" because of his support of the SA and SS (Schutz-Staffeln), insisted that Catholics could commit themselves fully to the WHW, the country's principal fund drive, because both church and state supported it. The Führer decreed it to save the country, and the church backed it because practicing charity was a condition of saving one's soul. Overlooking the racial question, the bishops and their faithful confidently looked forward to a time of blissful cooperation between church and state in welfare work. These expectations were often fulfilled in 1933 and 1934.[16]

Actually, the agreement allowing the confessional agencies to work under the NSV in social welfare set the stage for competition as well as for cooperation. At stake were the ser-

vices of millions of German women who as yet belonged to none of Germany's private welfare organizations. (Everyone took it for granted that men would not be very active in this work.) As we have seen, *Reichsfrauenführerin* Scholtz-Klink was already cajoling Protestant and Catholic women to join her German Women's Enterprise in 1933. Caritas officials became aware rather early that the extent of the church's welfare mission in German society at large would depend on the number of women it could count on as volunteers. Protestants appear to have been less worried about this, at least during the earlier years of the National Socialist regime, because of their assumption that their purposes and those of the regime largely overlapped. Thus, the initial competition for volunteers for social welfare work grew up between Caritas and the NSV, or, in terms of organizations of women, between the three principal Catholic women's associations and the NSF or German Women's Enterprise.

Caritas began its efforts to win women for its welfare work in the latter part of 1933. Since the regional office of Caritas in the diocese of Breslau had been successful in its membership drive, it was suggested that others follow their approach. Parish priests were to begin by making the point from the pulpit that the new National Socialist administration wanted all Germans to become active in social welfare work both by personal involvement and by contributions of cash. Then it was pointed out that with the signing of the Concordat, Caritas had been recognized as the official Catholic social welfare organization. Thus, at one and the same time, Catholics could perform a civil service and a charitable work by joining Caritas.[17] Later, more elaborate "Madison Avenue" schemes were concocted to snare new members.[18] The idea was to enlist as many women as possible, not just the more devout, and to sign them up before the NSV did.

Reichsfrauenführerin Scholtz-Klink had the same strategy of course. Ravenous at the prospect of gobbling up large organizations of women with their mothercare facilities, she invited the presidents of the league and the sodality to Berlin in the spring of 1934 to discuss with her the terms under which their organizations might work jointly with or under German Women's Enterprise in the natalist field. Scholtz-Klink let it be

known immediately that she felt that it was a matter of great importance that Catholic women join her organizations in joint mothercare work.[19]

Prominent women of the league and the sodality, along with their presidents, Dr. Gerta Krabbel and Monsignor Hermann Klens, discussed Scholtz-Klink's proposition intramurally, debating the pros and cons of throwing in their lot with national socialism. There would be definite advantages (funding for better facilities), but there would also be a loss of Catholic identity if Scholtz-Klink chose to meddle excessively in the operation of Catholic women's homes for mothers and other operations. Fearful of a capricious interpretation of the "goodwill" clause of Scholtz-Klink's "Guidelines for German Women's Enterprise in the Third Reich," Catholic women decided against working cooperatively with Scholtz-Klink.[20] About a week after Klens and Krabbel returned to the Rhineland from their meeting with the *Reichsfrauenführerin,* she received word of their negative decision.[21] Thus, for the second time in the course of one year, Scholtz-Klink had failed to effect a *Gleichschaltung* of Catholic women's organizations.

The adage "twice bitten, thrice shy" was not familiar to *Reichsfrauenführerin* Scholtz-Klink. Having failed to appropriate associations of Catholic women through negotiations, she next turned to subterfuge. Although she had received written notification that the sodality and the league would not be party to a joint effort in mothercare work, Scholtz-Klink brazenly stated just the opposite in the NSF's newspaper, *Frauenwarte.*[22] The article in question took note of the discussions on the guidelines that Scholtz-Klink had held with Klens and Krabbel, and, implying that the latter had accepted and confirmed them, it expressly listed the Catholic Mothercare Service as participants in National Socialist cooperative natalist ventures.

Scholtz-Klink's actions were dishonest but not rash. Having failed to bring the members of the league and sodality into her enterprise in orderly fashion, she hoped to start a stampede among the members that would force their leaders to consent to joint work. The circumstances of early 1934 probably suggested to the *Reichsfrauenführerin* that the situation was ripe for such a gamble. With the signing of the Con-

cordat, the church's ban, so to speak, on national socialism had been lifted, and a ground swell of Catholic support arose. The bishops were now urging Catholics to support the new regime actively. Thus, Scholtz-Klink was simply striking while the iron was hot.

The picture that we have, then, of the welfare situation during the early years of the National Socialist regime focuses attention on the practical, not on principles. The deviousness of the leader of National Socialist women is quite understandable. Virtually all German women were either Protestant or Catholic, and she needed them to build up her national organizations. She was taking it for granted that, once in the fold, they would not have any conflict of conscience problems, and the church, in urging Catholics to integrate themselves in the new Germany and allowing the faithful to join National Socialist organizations, was making the same assumption.

There was, nevertheless, some meanness and bitterness between party personnel and church welfare workers already in 1933 and 1934. The *Gau* leader in Cologne said that he would never allow a welfare recipient to be succored by an NSV agency if that person had joined Caritas, or if his children were not/members of the Hitler Youth, or if his wife was not a member of the NSF, and so on.[23] In Speyer party personnel seized the funds and records of a number of Catholic organizations, including those of the Elizabeth Society, the sodality, and the league.[24] In a small city in the middle Rhine, a local NSV officer threatened the pastor of a parish saying that if he carried out a scheduled membership drive for Caritas, the contributions made by the new members would be confiscated and the church fined.[25] In many other places Caritas was belittled in a number of ways: National Socialists said that it was only just tolerated by the regime, or that anyone who joined it could not be guaranteed welfare by the national community, or that only idiots and fools joined Caritas because it squandered their donations.[26]

The point to be made about these conflicts is that they arose rather spontaneously, and not as the result of NSV policy. A good example would be in Bavaria, where party personnel in the *Gau* offices and the police under Himmler repeatedly violated the terms of the Concordat even as it was being

signed. The Reich Ministry of the Interior and Reich Foreign Office could do little to stop this harassment and terrorization of the church.[27] The NSV, whose hands were full with organizational problems and with the task of providing welfare for thousands of destitute people in 1933 and 1934, did not authorize the disruption of other National Socialists in the welfare work of the churches. Thus, when the central office of Caritas wrote to a high-ranking NSV official in October of 1934 to complain about recruiting abuses, it received a courteous reply by return mail asking for patience and understanding, "since our workers are not always very cultured or educated people."[28]

A more normal example from the 1933–34 period—if we can speak of representative situations at all in National Socialist Germany—would be the experiences of the Catholic women of Siegen in Westphalia. Here the members of the Elizabeth Society worked closely with NSV workers. The city was divided in five sections, each of whose welfare efforts was overseen by a neighborhood director or *Gruppenwalter*. Caritas appointed five women from the society to act as liaison people and to work closely with the neighborhood directors. The latter communicated his or her plan for the collection and distribution of the country's major welfare drive, the WHW, to the liaison women, who then enlisted the help of society and Caritas members in carrying it out. If anything went awry or if the society was not meeting the goals set by the neighborhood director, the liaison person was to notify the Caritas office in Siegen so that remedial steps could be taken.[29] This presents us with a picture of close cooperation between the NSV and Caritas.

Partnership in welfare underwent a drastic change in 1935. As the German economy righted itself and the NSV, with its auxiliary forces of women in the NSF and German Women's Enterprise, became strong, competition moved from rivalry over members to rivalry over areas of church and National Socialist competency within the vast field of social welfare. The party's welfare system gradually rolled back church welfare activity. This resulted in a shift away from the question of whether Catholics would support Caritas rather than the NSV to a concern for the very life and future of church

welfare. There may have been indications of a bitter struggle early in the National Socialist years of power, but the proportions of it did not dawn on Catholic officials until the middle years of the 1930s.

We might take Siegen, again, to illustrate what was happening throughout the country, although it is doubtful whether any single pattern reflects experiences up and down the land. The NSV and Caritas had made a good start in Siegen toward cooperative work, but by early 1935 the spirit of "pulling together" had evaporated. During Christmas, 1934, the Elizabeth Society had distributed funds to needy families over and above the money and dry goods cooperatively collected by Caritas and NSV agencies in connection with the WHW. The NSV demanded to know the names of those who had received this additional charity. The society refused to divulge the names of the recipients because the funds were not part of the WHW drive and because of the principle of confidentiality.[30]

Shortly after this controversy arose, another issue exploded. The local NSV office demanded that all of the Elizabeth Society women who had participated in the WHW drive take an oath of loyalty that read: "I swear ever enduring faith to Adolf Hitler and, to those whom he has appointed as my leaders, absolute obedience."[31] The society's objection was not to the first part of the oath but to the latter portion that aimed, obviously, to force Elizabeth Society women to obey the local NSV in any future conflict such as the one that had only just arisen a few weeks previously.

At first the oath only affected Siegen women who had held membership from the beginning in both the NSV and Caritas. Some of these women had distinguished themselves in the WHW campaign and had, consequently, been appointed neighborhood coordinators of the drive. In spite of their good records, they were now asked to sign the oath "because of the principle of the National Socialist party according to which 'what *a* says, *b* must also say.'[32] Those who refused to sign the oath were forcibly removed from their posts. Some of the women who received letters from the NSV office directing them to sign the oath became so flustered that they signed it immediately. Others were put under considerable

pressure to do so. One of the society's members who had participated in the WHW drive was the wife of a formerly unemployed man who had recently been provisionally hired by the city. She was told that if she did not take the oath, her husband would be threatened with the loss of his job.[33]

The NSV continued to pressure Catholic women, but the society took a firm stand, which in effect said that any of its members who signed the oath of their own free will (meaning women whom the NSV had not contacted by letter with orders to sign), severed their ties with the society. The net result of the issue was that some women defected from the NSV and some from Caritas and the Elizabeth Society. This pressure, together with the actions of the regional director of the NSV, who refused to include Protestant and Catholic women welfare workers in his operational meetings if they were affiliated with a charitable organization of the church, permanently derailed the smooth cooperation that had initially existed in Siegen between church and party welfare agencies.[34]

In 1935 harassment of church welfare became commonplace in many other cities throughout Germany. In May the government of Bavaria forbade Caritas to go ahead with its customary house and street charity fund drive in Munich, Freising, Passau, and other cities, on the grounds that it would disturb public peace, order, and tranquility.[35] Officials also tolerated (and probably organized) a series of demonstrations by the students of the university of Munich against Caritas. Such a demonstration took place on Saturday, 18 May, *am Stachus,* the heart of downtown Munich. Throughout the day demonstrators followed a few steps behind Caritas welfare collectors around the streets of Munich, busy with Saturday shoppers, shouting through their megaphones, "Not a penny for Caritas," and "Everything for the NSV." In other Bavarian cities the Hitler Youth, SA, or SS taunted Caritas volunteers who were collecting funds for charity.[36] Occasionally, welfare workers were even physically abused.

Tension was also high in Catholic southwestern and western areas of Germany. In Trier the NSV accused Caritas of squandering alms and their fund drives were call a heist.[37] In 1935 various facilities owned by Caritas and used for public welfare were seized and taken over by the NSV while church

volunteers stood by helplessly.[38] In Freiburg, the national headquarters of Caritas, things became ugly in 1935 after two years of church-party cooperation in the WHW campaigns.[39] During the parade that opened the fund drive, the SA and SS marching contingent sang a song, evidently repeatedly, which contained the verse, "Hang the Jews and push the Catholics to the wall."[40] Clearly, the more desperate days of the depression were over, and Germans had other things on their minds.

In the provincial city of Aschaffenburg, Caritas personnel had collected 43 percent of the money contributed to the 1934 WHW fund drive. The next year, nevertheless, Catholic welfare women were excluded from participating in the drive. This perplexed Elizabeth Runkel who had been working in public welfare. Why had the 1934 practice stopped so abruptly? In 1935, if a person wished to receive support from the WHW campaign, he or she could only do so through the party agency. A form had to be obtained from an NSF woman, filled out by the person seeking relief, and resubmitted for processing by an NSV office. When Caritas workers inquired about the new operation, the local NSV director, who did not seem to harbor any personal inimical feelings toward church welfare personnel, told them that he had received instructions that year "*von oben*" to run the WHW politically (meaning without the input of confessional welfare agencies).[41]

The turn of the NSV's disposition in 1935 perplexed Elizabeth Runkel and many other Catholic women, who suddenly found themselves caught in the middle of a nasty tug-of-war. Why did they find themselves shut out of the WHW? Why did so many cities experience disruption in the WHW drive in 1935? Why were Catholics in some cities publicly put down after having served the program well for two years?

The reason was not circumstantial—Protestant women were turned aside at the same time and it concerned all welfare, not only the WHW. Rather, it was substantive: 1935 marked the year of a distinct policy change for the NSV when it moved from reactive to preventive welfare.[42] The previous years had been a period of coping with the unpleasant and urgent problems caused by the depression. But by the midpoint of the decade, at which time the National Socialist regime appeared to have righted the country's economy, Na-

tional Socialist welfare policy could afford the luxury of long-range planning and of basing policy on principles instead of expediency. Central to the NSV philosophy was the notion that poverty resulted from racial impurity. Ultimately, then, the purpose of welfare policy had to be to preserve the racial purity of the Volk. It followed logically from this that the degree of assistance in any specific case would "depend upon the individual's or family's value to society and not upon their level of need or suffering."[43] For the same reason the NSV placed more and more emphasis on *preventive* welfare, which meant in practice on the family-oriented *Mutter und Kind* program, through which racially fit Germans could be promoted. Thus, a clear change of course in National Socialist welfare policy took place in 1935. The central office of the NSV made a decision to be more aggressive in welfare work vis-à-vis the churches, and the 1935 WHW fund campaign, the major event of the year, was the testing ground of this decision.

The new approach of the NSV to welfare meant a less conciliatory attitude on its part toward its two partners, Inner Mission and Caritas. The director of the NSV, Hilgenfeldt, knew that his agency navigated at cross-purposes with them. The NSV was racist in philosophy but the churches were not, and he believed that he faced a "serious problem in the philosophy of charity of the Christian confessions." Realizing that "between the Christian philosophy, which the churches taught, and the National Socialist *Weltanschauung* there exists a chasm," Hilgenfeldt feared that traditional liberal and Christian sentiments, such as notions of equality and compassion, would continue to give direction to the work of NSV personnel and volunteers unless a concerted effort was made to stifle them.[44] He reminded his welfare people that, in the National Socialist state, fighting, not suffering, was virtuous and that the community came before the individual.[45]

The enunciation of these principles and their implementation beginning in 1935 occasioned a flood of complaints by Caritas against the NSV. The particulars varied from place to place, but conflict was general. In Württemberg there was interference in recruiting (for welfare personnel for Caritas); in Pomerania, interference with Caritas (and Inner Mission) welfare collections; in Prussia, accusations that Caritas used wel-

fare contributions for political purposes; in Upper Silesia and Lower Bavaria, restrictions on kindergartens and daycare centers.[46] In various places rest homes of the league and the sodality and Caritas's counseling centers for mothers were taken over outright by the NSV or simply shut down. Catholic doctors who worked in public hospitals had to have a "suitable" *Weltanschauung,* and women doing volunteer relief work felt the same pressure. Some of all new personnel in Catholic orphanages, correctional homes, and kindergartens had to belong to the NSV or some other National Socialist group.[47] Many institutions were simply taken over by the state.[48]

The complaints ran on and on. Work with the youth was monopolized by the NSV or Hitler Youth organization. Catholics were not allowed to express their reservations about the sterilization of the genetically ill. The NSV and NSF threatened Catholic relief work by demanding to know the names of its welfare recipients, by insisting upon regular reports on the activities of women working as welfare volunteers (especially in the Elizabeth Society), and by accusing Caritas of duplicating NSV services and facilities. Catholic welfare agencies were prohibited from collecting goods for the poor, except during the WHW campaigns, which allowed the NSV to control the activities of Catholic volunteers.[49] Caritas's and Inner Mission's share in the WHW collections were fixed at the 1932–33 rate (a bad year for the WHW), and in 1936 their shares were cut altogether.[50] In concluding their extensive list of grievances, the Catholic bishops complained that because of the "passionate, unjust, and undignified representation of Caritas" by the NSV, the agency's work was becoming "as good as impossible."[51]

While many of these instances of friction touched the lives of Catholic women, none did so more keenly and directly than NSV interference in mothercare work. This field of welfare was unique as well in that the NSV gave church volunteer workers a last chance to conform to their racist principles before turning them out altogether. After the Concordat was signed, Catholic women turned to mothercare work in greater numbers.[52] The sodality was inclined to this type of activity anyway, and article 31 of the Concordat left league women with little else to do.[53] Simultaneously, the NSV got its own

program for mothers, called *Mutter und Kind,* established and operational. The problem that *Reichsfrauenführerin* Scholtz-Klink faced in getting *Mutter und Kind* underway was that church mothercare facilities outnumbered hers by a large count, and they enjoyed close contact with their clientele. The easiest way for Scholtz-Klink to handle this situation was to infiltrate Christian mothercare work with NSV personnel, as she had attempted to do on a number of occasions before. Once inside the door of Protestant and Catholic mothercare facilities, her NSF and German Women's Enterprise volunteers could introduce National Socialist ideology into their programs.

What this meant specifically was the substitution of racist for religious ideology. In accordance with their philosophy of preventive welfare, the NSV began to concentrate its resources on *Mutter und Kind,* which embraced all programs that would promote "Aryan, genetically healthy, worthy children."[54] These wonderful specimens, it was thought, would cope well and never become wards of the state. In 1936–37 the NSV funded its mothercare operations to the tune of 60RM million, by far more than any other segment of welfare. The poor themselves received only 12RM million.[55] Unfortunately for the NSV, the racist philosophy behind their welfare strategy, and racist preoccupations in general, were not well understood or appreciated among German people at large. To remedy this the NSV hoped to use the churches' mothercare centers to propagate their ideology in place of religion.[56]

This was undoubtedly what *Reichsfrauenführerin* Scholtz-Klink had in mind when, in May 1935, she called the leaders of the league and sodality, Krabbel and Klens, to Berlin once again to attempt to integrate their mothercare work with that of the NSV. In the months preceding this conference, a number of incidents occurred that Scholtz-Klink hoped would have softened Catholic resolve since last she discussed joint operations with them. Caritas had been under the impression that funds raised for *Mutter und Kind* would be shared by the NSV with Caritas and Inner Mission for the benefit of their mothercare programs.[57] When this failed to materialize, it was obvious that Christian facilities for mothers would be underfunded and would therefore eventually become less attractive

than those of the NSV. In addition, several incidents took place that gave Catholic women a fairly clear indication of what the alternative would be if they declined a cooperative venture once again. In the diocese of Fulda, the league's counseling center for mothers was taken over by the NSV, and in Trier the NSV set up a mothercare facility to compete with that of Caritas.[58] In Württemberg the minister for domestic affairs instructed county and local officials to close down any mothercare facility whose educational philosophy was Christian.[59]

There were, nevertheless, also some positive factors. Scholtz-Klink promised that the Catholics would be able to run their facilities just as they had in the past. This was encouraging because, in some heavily Catholic areas of Germany there were NSV mothercare facilities that were run entirely by church volunteers who were in a position to impart Christian principles rather than National Socialist ideology. Circumstances like these prompted Krabbel to favor joining the church's mothercare work with that of German Women's Enterprise.[60]

The discussions with Scholtz-Klink went well at first. But when it came to the question of who would be responsible for ideological input, Klens and Krabbel foresaw problems. Scholtz-Klink said that the matter could only be handled by someone who was a member of a National Socialist organization and who had mastered National Socialist ideology.[61] Consequently, Klens and Krabbel decided against any immediate merger with German Women's Enterprise. They wanted to keep church mothercare programs completely religious and to keep the National Socialist *Weltanschauung* out.[62] Scholtz-Klink seemed to have promised autonomy but she vacillated on the question of ideology. Because of the bad experience Catholic women had had with Scholtz-Klink several years back in the state of Baden, Klens and Krabbel opposed attempting cooperation until the ground rules were clearly set.

Soon after the spring meeting with Scholtz-Klink, Catholic women found themselves banned from mothercare work. Responding to complaints from state governments—no doubt prompted by *Reichsfrauenführerin* Scholtz-Klink—to the effect that religiously affiliated groups were disturbing the

NSF's mothercare work, Reich Minister of the Interior Frick or-
dered such interference stopped. In July he decreed that all
women be educated according to National Socialist principles
with regard to the duties and responsibilities of motherhood.
Church mothercare work would not be allowed to compete
or interfere with the program of the *Reichsmutterdienst*.[63] A
period of skirmishing ensued. The NSV tried to force National
Socialist racist ideology on individual mothercare facilities,
claiming that these were too confessional or that religious
principles dominated the operation too extensively. The
church tried to defend its own rights to do mothercare work.
Krabbel wrote to Cardinal Bertram, objecting to Frick's state-
ment that the church could be involved in mothercare only to
the extent that it did not infringe on the state's purposes.[64]
The bishops were urged to clarify the infamous article 31 of
the Concordat in such a way as to protect Catholic women's
rights in mothercare work. When these efforts failed, the NSV
removed Catholic women from mothercare work altogether
by reorganizing private welfare in November of 1935.[65] The
competencies of the private welfare agencies, working under
the direction of the NSV (Inner Mission, Red Cross, and Cari-
tas), were redefined in such a manner as to end the work of
Catholic women in natalist welfare.[66] Protestant women, who
had been more receptive to Scholtz-Klink's mothercare pro-
posals, were also eliminated at this time, except for the Ger-
man Christians.[67]

The refusal of Catholic women to allow the NSV to intro-
duce racist propaganda in its facilities was important because
the impact of these ideas on the Catholic populace at large
would have been stronger had they seemed to have had the
church's blessing. Scholtz-Klink was forced to sell the National
Socialist *Weltanschauung* to the German people on its own
merits. With the confessional mothercare facilities out of the
way, the National Socialist brand of pronatalism enjoyed a
monopoly, but German women were disinterested in it.[68] The
racial motivation behind pronatalism interested them much
less than other aspects of mothercare education.[69] In Catholic
areas of Germany Scholtz-Klink used her mothercare facilities
to attack Catholic beliefs and values, such as virginity, that
were at variance with National Socialist racial doctrines.[70]

Thus, instead of being able to use religion as a smoke screen for National Socialist racist ideology by promoting it in Caritas-affiliated mothercare facilities, Scholtz-Klink was confronted with a neutral and sometimes hostile Catholic population.

Eliminating churchwomen from mothercare constituted only one part of an enormous revision of welfare that the NSV undertook in the middle of the decade. To avoid future conflicts with its welfare partners, and, more importantly, to unfetter the hands of the government so that it could pursue welfare as it saw fit, a division of labor between the NSV, on the one hand, and church welfare, on the other, was established. "Care for the mentally ill, cripples, the aged, and the chronically ill fell generally in the realm of Christian compassion of the churches' welfare organizations."[71] Furthermore, in the new division of competencies, the churches' concern for "hopeless cases had to be subordinate to racial considerations so that a material deprivation on the part of the genetically healthy [would] not result from supporting such cases excessively."[72] In a carefully thought-out statement, the government set forth its own welfare philosophy and explained how it differed from that of its Christian partners. "The NSV sees and practices the welfare of the individual from the standpoint of the good of the entire race; church charity characteristically extends help to the sufferer from the belief in the personal worth of that person in the eyes of God."[73] The NSV reasoned that since there was a basic difference between its welfare philosophy and that of the churches, the organizations were bound to fall into conflict. To avoid this rupture, the NSV decided to "care for all of the genetically healthy, whose potential for productivity was important for the entire Volk. Merciful solicitude for the genetically ill and asocial persons," on the other hand, would fall to the churches.[74]

The crystallization of National Socialist welfare philosophy and its implementation in 1935 had "extraordinary ramifications," to use the phrase of the concerned hierarchy of the Catholic church. The arrangement put forward by the NSV conflicted both with the Concordat, which assured the church freedom of action in carrying out its mission, and with the agreement that had originally been struck between Caritas and the NSV guaranteeing the church its independence in the

welfare sphere. The division of labor pushed the churches completely out of many of their traditional fields of charity.

In view of this shift, the reaction of the hierarchy of the Catholic church to the NSV's new policies was astonishing: they pretended that nothing was amiss in NSV-Caritas cooperative welfare. Privately, the strong accusations and objections of the hierarchy, which were made in its 1935 and 1936 position papers, were communicated to the government and to the National Socialist party. But publicly the bishops avoided conflict with the NSV. Although they were very pessimistic about the future of the Caritas-NSV partnership, their official statements did not so much as hint as these reservations.[75] "Thus, in the new Germany," wrote the director of Caritas early in 1937, "church and state have pioneered that path upon which free German welfare, powerful and successful, and at the same time responsible and sacrificing, can bring its succor to the people and can continue to do so in the future."[76]

It is difficult to understand why the church maintained this facade amidst what the bishops themselves called the regime's "systematic suppression of Caritas."[77] By reason of its organizational tie to the National Socialist welfare system, the church through Caritas was a partner, albeit a silent one, in racist programs such as *Mutter und Kind* and *Christliches Volk—gesundes Volk.*[78] Monsignor Kreutz said openly that Caritas had reservations about these programs, but he did not specify that its objections related to their racism.[79] Again, in 1938, the German bishops failed to speak out. After having drawn up a long, impressive, and explicit indictment of "false racial teaching," which would have underscored the importance of Christian welfare philosophy, the bishops failed to release the letter.[80] Thus, for whatever reason, the church allowed itself to be organizationally implicated with national socialism, and it temporized as the NSV pushed it out of whole fields of welfare and even despoiled it of many of its welfare institutions.

Although Caritas tried to paper over the crack that had appeared in its partnership with National Socialist welfare, the issue of racism in public welfare had been clearly drawn, and Catholic women were certainly conscious of it; the recruiting

practices of the church and the NSV for volunteer help accentuated the racial issue. The old idea that a volunteer served one and the same cause whether she became a member of Caritas or the NSV was now explicitly denied. The two were not equivalent because Caritas was religious and helped the weak whereas the NSV helped those who could help the German race.[81] The NSV approached German women with total candor: the motivation behind welfare for the churches was charity but, for the NSV, it was "the blood bond of race."[82] Since the overwhelming majority of welfare workers had traditionally been Protestant and Catholic women, the NSV wanted to drive home the message that, because of the racial issue, a person did not fulfill her obligation to the party by taking out membership in Caritas or Inner Mission. On the other hand, it was fully possible, the NSV said, for a woman to be active in both welfare organizations—in one as a believing Christian and in the other as a loyal German citizen.

Caritas's reply to the more intensive and explicit recruiting pitch of the NSV was to redouble its efforts to get Catholics to join Caritas and to emphasize its own philosophy of welfare. In 1935 the Elizabeth Society began holding regional seminars for potential Caritas volunteers that stressed three points: helping the poor and the sick amounts to more than welfare; real charity demands personal involvement; and Caritas is not just supportive (of the NSV) but also competitive.[83] These seminars appear to have been effective because membership in Caritas grew much faster between 1935 and 1939 than before. Thus, without taking explicit exception to the racism of the National Socialists and the NSV, Caritas emphasized its own welfare philosophy based on Christian charity.

The insistence of the Elizabeth Society that Caritas was competitive represented a new twist in its relationship to the NSV. In the past competition had been "friendly rivalry"; now it was open, public, and not so friendly. It frequently happened that the NSV, or (National Socialist) Brown Sisters, or NSV workers would set up a public welfare institution, such as a kindergarten, mothercare facility, daycare center, or orphanage, in a place where one of Caritas's already existed and where the population density did not warrant a second facility.[84] The seriousness of the competition was all the more ap-

parent when Catholic facilities were closed down or simply taken over by NSV personnel. After 1936 these seizures or closings of Caritas facilities became quite common.[85] Bishops sometimes hinted that Catholics should show their disapproval of the National Socialist regime by supporting Caritas rather than the NSV.[86] Parish clergy, responding to National Socialist accusations that Caritas squandered its funds, occasionally charged that the NSV exploited the poor and used welfare money for weaponry.[87] The point is that, when the church leaders became aware that the NSV wanted to push the church out of public life by monopolizing welfare, they gave a high priority to building up Caritas in the latter half of the thirties.[88]

All of these factors indicate that the issue of racism in public welfare was clear to the Catholic faithful. We are not dealing here with arcane theory. The National Socialists went to extreme lengths to "educate" the German public about racist principles. The schools, motion pictures, and theater, radio, and public rallies—where it was expressly stated that Christian charity must be terminated in the interest of the racial purity of the Volk—all served this end.[89] Naturally, German women who visited mothercare facilities of the NSV were instructed on National Socialist racist philosophy. Even *Neue Brockhaus,* the German ready-reference encyclopedia, pointed out the difference between National Socialist and Christian approaches to welfare.[90]

Given this situation, it is clear that Catholics could have registered their disapproval of the government's racism or hostility to the church by joining Caritas rather than the NSV. To what extent did they do this? The response to Caritas's appeals after 1935 increased a good deal. In 1934 Caritas had a membership of just 120,000; by 1939 the figure rose to over 535,000.[91] In 1935 less than one-half of 1 percent of the Catholic population were members of Caritas; by 1939 over 2 percent were.[92] The year before the church claimed that 70 percent of its parishes had Caritas cells (8,000).[93] Although this figure seems somewhat high, there is no doubt that Caritas grew quickly during the latter years of the decade.

Although its record may sound impressive, the fact is that Caritas did not begin to realize its potential. Many Catholics,

Figure 3.
Catholic Population Concentrations (as a percentage of the total population in 1925)

☐ 0–39

▦ 40–89

■ 90–100

especially women (since the program was aimed at them), ignored Caritas (see Figures 3–5). The dioceses of Regensburg, Passau, Munich-Freising, and Augsburg in Upper and Lower Bavaria, an overwhelmingly Catholic area, gave Caritas even less support than it gave National Socialist welfare.[94] The same must be said of the diocese of Speyer in the Palatinate, which falls into the lowest category in terms of support for Caritas and the second highest for the NSV. Catholics in the dioceses of Trier (middle Rhine-Mosel), and of Würzburg, directly east in Franconia, chose to serve both God and Caesar: they rank in the highest categories for membership in both the NSV and Caritas. The situation was just the opposite in the dioceses of Paderborn and Münster in northwestern Germany and in Cologne, straddling the Rhine, none of which were generous on behalf of either the NSV or Caritas. Had Catholic women everywhere in Germany chosen to make an issue over the racist principles of the party's welfare program, the entire country would resemble the dioceses of Freiburg in southwest Germany and Breslau in Upper Silesia, where Catholics were openhanded when it came to backing Caritas and tightfisted when it came to National Socialist welfare.

Figure 4.
Catholic Membership in Caritas (as a percentage of the total
Catholic population by diocese in 1937)

□ 2+

▨ 1.99–1

▨ .99–.50

▨ .49–0

Source:
ADC 103.1

It is clear that support for Caritas was weak. While 15 per-
cent of the German populace supported the NSV, only about
2 percent of the Catholic populace supported their church's
welfare agency. We should be aware, however, of certain ex-
tenuating circumstances. The NSV used massive pressure on
people to get them to donate to NSV projects—including
loss of employment or demotion—and their personnel ho-
neycombed German neighborhoods spying and reporting on
noncontributors.[95] The church was much more moderate in its
tactics. It may also be argued that Caritas's few members were
more useful than the NSV's many, because the latter were not
asked to be actively involved in volunteer work.[96] Evidently,
many Germans, who were neutral or even opposed to the Na-
tional Socialists, joined the NSV to maintain a facade of loyalty

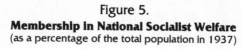

Figure 5.
Membership in National Socialist Welfare
(as a percentage of the total population in 1937)

☐ 7.09–10.76

▨ 10.77–14.42

▤ 14.43–18.09

■ 18.10+

Source:
NA T-81, roll 85

to the regime. Still, a moral principle was involved, and the bishops and Caritas personnel made a determined effort to swing popular support behind their welfare programs and charitable work.

The rather bleak picture of Caritas membership, which our quantitative data for the entire Reich projects, contrasts sharply with *Sopade* reports on the Catholic church. It appears the social democratic observers, wanting to find encouraging signs of popular dissent, exaggerated it in their reports. *Sopade* says, for example, that Caritas was heavily supported in the Rhineland.[97] Statistics demonstrate, however, that this was only true in the Upper Rhine country, and that, even there, the support can hardly be termed heavy. In the diocese of Trier, whose participation in Caritas was relatively high, one out of seven parishes did not have a Caritas affiliate in 1938.[98] Elsewhere *Sopade* reports optimistically that Catholics were sticking together in an impressive show of support for Caritas and the church. Less encouraging news, such as of a Catholic

community in Upper Bavaria in which NSV membership reached 65 percent of all families by 1938, is not reflected in *Sopade's* reports.[99]

Although *Sopade* reports provide a somewhat distorted picture, they do offer insights into why Caritas grew after 1935. In Saxony, where National Socialist newspapers maintained a smear campaign against religious orders for their alleged diverting of revenues to Rome, the Caritas collection went up. In one small town of 1,300, Caritas collected 500RM.[100] When Caritas welfare drives were banned in Bavaria, Catholics supported it abundantly in church collections.[101] In one area people dropped 100RM bills into the church's Caritas box. These instances make it clear that Catholics (and occasionally even Jews) contributed to Caritas as a protest against National Socialist actions against the church or of the NSV against Caritas. Such protests caused ripples of excitement and dissent, which was the kind of news *Sopade* looked for. What their observers failed to note was that after the momentary swell of discontent subsided, so did the contributions to Caritas. Thus, the church was unable to sustain any long-term protest.

Sopade was right to think that there was a potential for protest through support of Caritas. An incident involving Count von Galen, the brother of the famous bishop of Münster, illustrates this. Using as an excuse his membership in Caritas, to which he contributed generously, the count refused to join NSV. Galen's snub caused the government considerable embarrassment, and his case was handled by the director of the NSV himself.[102] The problem for the church lay in the fact that it could not bring itself to act decisively; it would not promote von Galen's kind of activism.

Why not? Had they done so, many Catholics certainly would have taken up the challenge, but others would not have, and the end result would have been a deeply divided Catholic community. Confronting the NSV would have caused divisions within the church at the level of the parish (as happened with Protestants) and probably within the family itself. If there is one point upon which all sources agree—National Socialist, *Sopade,* and the church itself—it is that women were more loyal to their religion than men. A second division would

have separated those who felt loyalty to both the NSV and Caritas from those who preferred to support only the latter. Toward the end of the 1930s many Germans were fed up and disgusted with the NSV's relentless badgering for money for one or the other of its many causes. But others strongly supported the NSV even though they may have been ideologically neutral toward national socialism.

An incident during a Sunday mass in a western German parish illustrates the point. The priest had denounced the NSV in very thinly veiled words, calling it heathen welfare in contrast to Caritas's Christian charity. This so upset the parishioners that some of them gave testimony against their own parish priest, and one woman got up and left, weeping, during the sermon.[103] These people were loyal to the NSV because they themselves had been nurtured by it during more difficult times. If the bishops had chosen to challenge the NSV's racism, which had only more recently become explicit, there is no doubt but that it would have caused deep divisions within the Catholic populace. National Socialist attacks on the church, like the accusation that religious orders were diverting money to Rome, rallied the faithful around their spiritual leaders. The bishops clung to this unity and therefore avoided confrontation with the regime. At no time during the Third Reich were Catholics forbidden to join the NSV or the NSF because of their racist principles.

This amounted to a failure in leadership. A perceptive American Catholic observer, George N. Shuster, took note of this. Why, after warning in 1933 that racism leads "to injustices which burden the Christian conscience," did the bishops fail to come to grips with this issue?[104] Perhaps the jubilant optimism of the hierarchy over the Concordat is understandable (though it was not shared by all of the bishops), but, when the NSV's racism became more blatant in 1935, the church should have disengaged Caritas from the NSV and told the faithful their reasons for doing so.[105] Later on, the bishops seemed to have realized their mistake, and they did not repeat it when the opportunity arose for collaboration between Caritas and the National Socialist German Work Enterprise.[106] By not disengaging from the NSV, the hierarchy of the church acted am-

biguously with regard to racism. One of the most outstanding spokesmen of the college of bishops, Cardinal Faulhaber of Munich, once said that there was no objection to National Socialist racist welfare.[107] Many did object, once racism became more explicit, but they never said as much in so many words. In fact, a Catholic could have surmised from Kreutz's 1937 statement on Caritas and the NSV that their cooperation in welfare work was going along swimmingly.

What effect did this failure have on German Catholics? For the most part, our discussion of Protestant and Catholic women has been based on evidence reverting to one or the other women's association, but the data which we have reviewed on membership in Caritas allow us to pose this question with reference to all Catholics. Fragmentary evidence suggests that most Catholics were not very interested in National Socialist racial ideology. Compared to Austrian and Sudeten Catholics, German women showed little desire to become active in the NSF, the National Socialist ideological organization for women.[108] Even in areas of strong NSV support by Catholics, there was little interest in National Socialist ideology.[109] By not speaking out on the racial issue in welfare, the bishops allowed the great majority of their faithful to remain neutral about it. This is what the low membership figures for Caritas portend. Support was so meager, in fact, that at least half of it can be accounted for entirely by sodality, league, and Elizabeth Society women. Thus, silence on the part of the German bishops preserved the indifference of the laity regarding National Socialist racism.[110]

Many Catholics were undoubtedly relieved that their church leaders chose this route. A forceful stand on racism in public welfare should have placed all Catholics in a position of conflict in which they would have been torn between loyalty to the church or loyalty to national socialism. Other Catholics, however, wanted their religious leaders to take the lead by formulating the important moral question of the day. "What are we supposed to do when the great dignitaries [bishops] cannot get up enough courage to protest against injustices?"[111] By refusing to bestir the consciences of the faithful on racial matters that concerned them directly—Catholic or-

phanages, hospitals, kindergartens, and mothercare facili-
ties—an opportunity was missed that would have set the
stage for posing the more critical racial question regarding
Germany's and Europe's Jews.

6
Women and the Protestant Church Struggle

I t would be impossible for us to grasp the situation of women in National Socialist Germany without a discussion of the Protestant Church Struggle. The purpose of this chapter is to provide such a discussion, but there are secondary reasons, as well, for examining the controversy. One of these is to gain a sharper perspective on Protestant women. Our study of Caritas membership in the last chapter provided a perspective on Catholic women, allowing us to distinguish what proportion of women were willing to risk conflict with national socialism by supporting their church's welfare program. The church struggle imposed an issue on Protestant women, analogous to the Catholic Caritas drive, forcing them to make a decision that carried political implications. A secondary objective here is, then, to be able to sort Protestant women out, making differentiations, as with Catholics, even among the churchgoers.

The history of the Protestant Church Struggle has been told and retold, but the role of women in that controversy has

largely been ignored. Yet, they were vitally involved, and the question as to which side they would favor, the German Christian or Confessing Church, was closely watched and contested. Some of the country's leading churchmen, such as Bishop D. Maharens and General Superintendent D. Zoellner, involved themselves deeply in the tug-of-war for the loyalty of Protestant women, as did the National Socialist–favored church leader, Reich Bishop Müller, whose failure to retain the backing of the Protestant Ladies' Auxiliary critically weakened his national stature. Church officials on both sides of the dispute eagerly courted women because they commanded closer contact and rapport with Germans at large than any other segment of the church. Protestant women, much more so than men, gave the church an impact in the public sector. Neither the German Christians nor the Confessing Church could hope to succeed without the support of the vital segment of churchgoing women, which the auxiliary represented.

The Protestant Church Struggle occurred essentially because the leaders of the church, unlike those in the Catholic sector, were unable to come to terms with the National Socialists over church-state matters. The resulting divisions among Protestants caused wide disarray and deep dismay, but this development was not without an advantage for Protestant women. The Protestant Ladies' Auxiliary had established its autonomy during the first decades of the century, and the Protestant Church Struggle had the effect of testing and strengthening this independence. Whereas Catholic women, especially those in the league, had been forced to sacrifice independence and hide behind their bishops who shielded them with the Concordat, Protestant women found themselves in the midst of a decade long melée in which they were buffeted about by contentious forces within the church and by the National Socialists from without. This experience proved to be a vital maturing factor for them, as a result of which they laid claim to positions of leadership in their church after the National Socialist era.

As Hitler came to power, no one foresaw these developments—least of all Protestant women. They were, as we have seen in previous chapters, National Socialist enthusiasts who felt themselves to be a part of the cutting edge of the

völkisch renewal the country was experiencing. Protestant women wished only to hasten the day when cooperation between their auxiliary and National Socialist agencies, especially the NSV and NSF, would become a reality. Consequently, they did not look upon the Protestant Church Struggle as an opportunity to establish their authority within the church, but as a tragic anomaly that frustrated the achievement of their goal and postponed their dream of a renewed church in a renewed Germany. In fact, it appeared that Protestant women had everything to lose and nothing to gain from the church struggle. As an organization, the Protestant Ladies' Auxiliary was dedicated to binding the community together through charitable works. Instead, the auxiliary would become another element of divisiveness in German towns and cities as one group of women were pitted against another in the church struggle while the NSF poured salt into the open wound.

Nor were there going to be any fringe benefits for Protestant women regardless of the victor. In a constitutional sense, the Protestant Church Struggle was a church-state contest that allowed one group of men to supplant another group of men in the middle and upper echelons of church leadership. What were women, who usually could not even fill the position of church elder, to gain? In a moral sense, what separated the nazified German Christians from other Protestants was the issue of racism, or, more specifically, what ramifications this issue would be allowed to have within the church. But Protestant women reflected the ambiguity of their church on the question of anti-Semitism, and, even if they had been of one mind regarding the place of Jews in the church and German society, they would not have been able to decide the matter for the official church. Had Protestant women been feminists, they might have coolly stood aloof from the church struggle or used it as a lever to pursue their own goals. But Protestant women, simply because they were religiously committed, could not stand aloof.

Under these circumstances, it is hardly surprising that the leaders of the Protestant Ladies' Auxiliary sought to steer a neutral course during the Protestant Church Struggle. They had no way of knowing that internal tensions in the church

would become so intense that neutrality would be out of the question. (Early in 1935 the gestapo reported that the church struggle had "aroused a spirit and fanaticism in Protestants to a degree that no one would have expected any more from religiously indifferent Protestantism.")[1] What made matters worse, and, in fact, assured the auxiliary a direct, bitter involvement in the controversy, was the choice of Pastor Hans Hermenau as executive director of the Protestant Ladies' Auxiliary in February of 1932. His election came about because of the enchantment of Protestant women with völkisch renewal. Although the executive committee of the auxiliary had some inkling of the coming ecclesiastical infighting, it expressly said that in choosing Hermenau it wanted to concentrate on the work of renewal and avoid politics.[2] Unfortunately, the organization could not have made a worse choice to carry out this policy.

The leaders of the auxiliary were blinded by their enchantment with völkisch renewal. In choosing Hermenau, they thought the auxiliary would be in a position to become one of the dominant organizations of women—perhaps *the* dominant organization of women—in the new Germany. This seems preposterous to us now, but in 1933 it was a commonplace idea among Protestants. A number of different women and organizations, including Margrete von Tiling of the Protestant Women's League, had their sights set on becoming the head of a National Socialist–oriented organization of women.[3] Two factors make this understandable. First, in 1933 Protestant women were convinced that the new regime was going to be profoundly Christian in its orientation, and second, in that year there was not yet a secular organization of National Socialist women (the NSF) that could begin to compare in size with that of Protestant women.[4] At any rate, this was the idea in the minds of the auxiliary's leaders when they chose Pastor Hermenau, and, in the back of his mind, when he set up a new umbrella organization, the Women's Work Front of the German Evangelical Church (*Das Frauenwerk der Deutschen Evangelischen Kirche*), with subdivisions for community work, social welfare, education and youth, mothercare services, and nursing sisters.[5] Agnes von Grone was named *Reichsfrauführerin* of the Work Front and Klara Lönnies headed the mother-

care section.[6] With the new organization in place, Pastor Hermenau issued a statement of principles and appealed for new members: the National Socialist revolution made it "obligatory" for every Protestant woman to join the auxiliary; the "new Germany needed a new woman"; and the auxiliary should become a massive organization corresponding to the national movement that the National Socialists had instilled in the country.[7]

While Protestant women streamlined their organization and Pastor Hermenau consolidated his position, the tumultuous events began to unfold that came to be known as the Protestant Church Struggle. It became known that the National Socialists gave preference to the highly anti-Semitic faction within the Protestant church, the German Christians, and the army chaplain, Ludwig Müller, emerged as Hitler's confidant in ecclesiastical matters.[8] When Pastor Bodelschwingh of Inner Mission was chosen Reich Bishop instead of Müller, all-out fighting within the church ensued. The brash young leader of the German Christians, Joachim Hossenfelder, used uniformed National Socialists to support their causes and to help get their candidates elected in the synodal elections of July, 1933. The issue was brought home to every Protestant when church authorities who opposed the German Christian movement ordered pentitential services to be held throughout the land on the first Sunday of July, and August Jaeger, the church commissioner of Prussia, countered with orders for a festive "flag service," complete with the Nazi swastika symbol to be held on the same day. These events distressed Protestant women throughout the country; having supported Hitler enthusiastically at the polls, many now found themselves inadvertently and awkwardly in apparent opposition to his regime (newspaper headlines politicized the affair: "Bodelschwingh Front Gegen Hitler").[9]

Thanks to Hermenau, auxiliary women became even more deeply entangled in the church struggle than other church members. As a committed German Christian, Hermenau had little chance of realizing his dream of directing a massive Protestant pro-Hitler *Frauenfront* if the Protestant church itself was at odds or cross-purposes with the National Socialists. With his future on the line, Hermenau chose to

break the confidence that the executive committee had invested in him by involving the auxiliary directly in the church struggle. At first he acted covertly—Agnes von Grone would say sneakily—by encouraging German Christian women to take over the leadership of auxiliary affiliates.[10] Then, on the occasion of the flag service controversy, Hermenau totally embarrassed the national leaders of the auxiliary. In an article about the problems surrounding the choice of a Reich Bishop, Hermenau wrote that the auxiliary recognized the God ordained authorities in church and state. While this issue was in the mail, August Jaeger gave orders for the flag service. Since Jaeger was the state appointee for church affairs, readers of *Der Bote* would conclude that the auxiliary leadership favored the flag service over the penitential service.[11]

As the German Christians made strides in taking over control of the church in the summer and fall of 1933, Pastor Hermenau openly committed the auxiliary to them. Breaking with the policy of the executive committee to stay out of politics, Hermenau wrote: "The storm which has come over the people and the nation must also come over the church because the church is so close to the nation and the people."[12] This—after the National Socialists had interfered in an unprecedented manner in the church's synodal elections of July 23! Hermenau aimed to distract Protestant women from the main issues that confronted the church, racism and church-state relations, by playing on old themes about which all Protestants could agree—bolshevism, secularism, and immorality, echoing in this Hitler himself.[13] Knowing that Protestant women heavily favored the country's new leader, Hermenau told readers of *Der Bote* what they wanted to hear: Hitler was providentially ordained to save the country. In the meantime, he glossed over the unparalleled interference of National Socialists in church affairs, saying that "with a political revolution there must come a church revolution."[14]

After the German Christian success in the church elections of July, 1933, Hermenau explicitly sided with them on the two critical issues of the Protestant Church Struggle, racism and church-state relations.[15] In August State Commissioner Jaeger pushed an ordinance (the Aryan Paragraph) through the synods of the German Christian—controlled *Land*

churches. This step, which barred converted Jews from holding church positions, fired the smouldering opposition to concerted action. The Pastors' Emergency League was formed, and in September it took explicit exception to the Aryan Paragraph.[16] With the issue of racism thus clearly drawn for all to see, Hermenau came down solidly on the side of the German Christians. In mid-October he committed the auxiliary to the racist position in no uncertain terms: racial inequality was God's will; parish personnel must be German (that is, Aryan).[17]

The other critical issue was church-state relations on which Hermenau sided unequivocally with the German Christians. After a prominent member of this faction, Ludwig Müller, had been elected Reich Bishop in September, Hermenau swung the auxiliary behind him: "In a new Germany there must be a new church. . . . The German Christian edifice arose from Luther's spirit and it is the embryo of the moral and national rebirth."[18] Nineteen thirty-three was a year of high expectations when ambitious people took bold steps. By identifying with the pro–National Socialist faction while it captured the leadership of the church, Hermenau no doubt felt that he had maneuvered into position to become the leader of the Protestant *Frauenfront* in the new Germany. In large bold print, he announced in *Der Bote* that "as the German Protestant auxiliary we are the religious Volk movement of German Protestant women. . . . The National Socialist state with its emphasis on positive Christianity is the fulfillment of ourselves, the answer to our question, the victory of our battle."[19]

In the space of just a few months Pastor Hermenau had managed to accomplish exactly what the executive committee of the auxiliary wanted to avoid—an entanglement in the web of the Protestant Church Struggle. His words and actions during the summer and fall displeased most of the leaders of the auxiliary, who fired him at the end of October.[20] Hermenau was let go, not because he was a German Christian, but because he had committed the auxiliary to the German Christian movement when the executive committee wanted to be neutral.[21] With the outcome of the Protestant Church Struggle still entirely up in the air, the auxiliary wanted to remain on friendly terms with all parties, including the German Christians.[22] His

coworker, Agnes von Grone, accused him within church circles of being less than honest and forthright regarding his activities at the time of the flag service and felt she could no longer work effectively with him in her capacity as head of the Women's Work Front of the German Evangelical Church.[23] In public, however, von Grone claimed that Hermenau's firing was due to an organizational dispute: his grand designs for the centralization of the auxiliary.[24] Since von Grone was herself part of the organizational restructuring, it makes sense to assume that her opposition arose only as a consequence of the Protestant Church Struggle. It is also entirely possible that the rift was a result of personal rivalry.[25] Von Grone, a member of the National Socialist party, may herself have wanted to be the one—not Hermenau—to lead Protestant women in the vital role they thought they were destined to play in the new era. Her visibility did in fact increase dramatically because of Hermenau's release, but he could not have been turned out without the concurrence of the majority of the executive committee. These leaders, mostly women, disagreed with their president, Helene von Oppen, in the Hermenau case, over which she resigned, saying that she no longer enjoyed their trust.[26]

Hermenau's dismissal came at a most critical moment of the Protestant Church Struggle. Within a fortnight, an event occurred in the *Sportpalast* in Berlin that shocked and polarized German Protestants: German Christians attacked not only Jews but also the Old Testament itself.[27] This event produced the famous Confessing Church coalition, which emerged to challenge the German Christians. The Hermenau affair now proved untimely because the women of the auxiliary found themselves in a position of having to choose a successor who would be acceptable to both groups. The auxiliary had already experienced problems with the NSF and the redoubtable Gertrud Scholtz-Klink that touched on their cherished mothercare work. To alienate the German Christian Reich Bishop would be to lose a potential intermediary in future disputes.[28] The executive committee also realized that, to avoid involvement in the Protestant Church Struggle, it needed to decentralize. By forcing "the individual provinces to answer for their own actions," the entire organization could not be

dragged into a political imbroglio if this or that province or affiliate took sides in the church struggle.[29]

Although this turned out to be wishful thinking, the auxiliary was fortunate to have gotten rid of Pastor Hermenau in the nick of time before the *Sportpalast* scandal. Nevertheless, its association with him was to prove immensely disadvantageous in the years to come.[30] But even if Hermenau had never entered the picture, the Protestant Church Struggle would have come home to the auxiliary. The polarization of German Protestants at the grass roots was so strong in the aftermath of the *Sportpalast* fiasco that bitter dissensions within auxiliary affiliates throughout the country became unavoidable. Reviewing these disputes will allow us to see how closely Protestant women became involved in the church struggle at the local level.

Nowhere was the outcry against the German Christians swifter or louder than in the Rhenish and Westphalian church provinces. Racism, as we have seen, was one of the central issues in the Protestant Church Struggle. It was also an issue about which most churchgoing Protestants were aware. The National Socialists were attempting to make race a central public issue. The matter was widely discussed in the media, and the auxiliary's own weekly devoted a good deal of copy to this question, reflecting just about every point of view. The Westphalian branch of the auxiliary stands out in this debate because of its sensitivity to the issue and its opposition to racist policies within the church and the auxiliary. Its stand on the matter first came to attention in connection with a special interest publication, *Mutter und Volk*, for which Klara Lönnies, as leader of the mothercare section of the Protestant Work Front, was responsible. *Mutter und Volk*, not to be confused with *Mutter und Kind*, an NSF publication that also aimed for readership among mothers and mothercare enthusiasts, actually sprang from the auxiliary's mothercare work. The auxiliary helped finance its publication, and members were instructed to hawk the newspaper after church on Sunday.[31] Perhaps because it dealt entirely with the racially sensitive subject of motherhood, *Mutter und Volk* adopted the National Socialist position on race more one-sidedly than did *Der Bote*. The Westphalian auxiliary found this objectionable, just as it did the

contents of Klara Lönnies' film, *The Vast River.* Its sensitivity to
the racial question led the group to excuse itself from extend-
ing financial support to *Mutter und Volk.*[32] Thus, Protestant
women of the Westphalian auxiliary took matters of con-
science into their own hands even before the development of
the Protestant Church Struggle.

Not surprisingly, the outcry in Westphalia against the
German Christians after the *Sportpalast* scandal was loud and
strong. At the end of May, 1934, the famous meeting at Bar-
men took place at which the Confessing Church issued its
statement of principle. Already at this point in the developing
Protestant Church Struggle there were, "*de facto* if not *de
jure,*" two Protestant churches, the Confessing Church and the
Reich Church under Bishop Müller.[33] When the latter ap-
pointed Bruno Adler as bishop of Münster and he in turn
forced sitting churchmen, including parish personnel, to retire
so as to replace them with German Christians, the church
struggle exploded with full force in Westphalia. It took the
form of legal battles pitting clergyman against clergyman, but,
as a civil servant advised the Prussian Ministry of Interior, it
was much more than a *Pastorenstreit.*[34] The laity were pas-
sionately caught up in the dispute, and the overwhelming ma-
jority (90 percent) of those who practiced their religion
backed the Confessing Church. Within less than a month of
the Barmen meeting, the women of the Westphalian auxiliary
proclaimed their allegiance to the Confessing Church. On 24
June the board of directors issued the statement:

> The Westphalian Auxiliary can no longer, in the face of the cur-
> rent situation of the church, keep silent. After an exhaustive
> discussion the extended board [not just the executive com-
> mittee] is issuing its decision: true to its character and history,
> the Westphalian Auxiliary takes its stand on Bible and Creed
> *Bekenntnis).* It declares its close, inner tie with the Confessing
> Church.[35]

This resolution passed by a 63 to 5 vote. The German Christian
dissenters denounced the statement, whereupon the presi-
dent of the Westphalian auxiliary asked them to withdraw
their rejection, which they refused to do.

Matters developed similarly in the neighboring province of the Rhineland. The church underwent organizational restructuring at the hands of the German Christians toward the end of 1933. This caused unrest that only intensified when Reich Bishop Müller appointed new German Christian personnel.[36] Opposition on the part of the auxiliary began early and led to the declaration of 23 July 1934: "The Auxiliary serves the community. The community can only be formed on the basis of Holy Scripture according to the credo (*Bekenntnis*) of the Reformation. This is the concern of the confessing community. Accordingly, we declare our close, inner ties with it."[37] Thus, the Rhineland auxiliary, like its sister organization in Westphalia, chose quickly and unambiguously to throw in its lot with the Confessing Church.

The reaction of German Christians to the events in the Rhineland and Westphalia was volatile. Although German Christians had by hook and by crook won control of the Protestant church, they could not hope to maintain their position without the moral support of the faithful. With its approximately one million members, the auxiliary represented by far the largest organization within the church, and its members could be numbered among the practicing rather than nominal Protestants. The support of this faction would have gone very far in giving the German Christian movement the moral currency it needed, not just to continue to run the church but to become the motivational factor in the country's life to which the movement had always aspired. For this reason an explicit statement of loyalty by the auxiliary to the Confessing Church represented a major setback for the German Christians.

Church authorities of both western provinces—those appointed the Reich Bishop—did what they could to sidestep the catastrophe. The head of the Rhineland church wrote a long letter to the president of the auxiliary, Frau von Waldthausen, accusing her of plunging the affiliates in her province into ferment and dissolution (*Verhetzung und Zersetzung*) and threatening her with dire consequences of her actions in the new National Socialist state.[38] He then wrote to every pastor in the Rhineland, assuring them that the action of the provincial board of directors had been taken without the knowledge and consent of the individual affiliates and requesting

them to denounce the decision of the board and to dissolve their churches' affiliation with the auxiliary if its members persisted in backing the decision of the provincial representatives.[39] Finally, the upset German Christian bishop wrote to Reich Bishop Müller informing him that, although the wording of the 23 July declaration was crafty, it nevertheless committed the auxiliary to the "Confessing Front."[40] Clearly, the German Christians saw the problem of the renegade auxiliary as a serious one.

Reaction on the part of German Christians in Westphalia was equally strong, and it demonstrates how the Protestant Church Struggle pitted women against women. The German Christians had a forceful leader in Eleanor Liebe-Harkort, who, as head of the provincial branch of the Women's Work Front of the German Evangelical Church, was a key liaison person between the auxiliary and the NSF. After the Westphalian auxiliary's July statement in favor of the Confessing Church, Liebe-Harkort began to enlist support for her election and that of the new German Christian bishop, Bruno Adler, to the provincial executive committee. In her quest for votes, she got German Christian–minded members of the auxiliary to visit other affiliates to lobby for herself and for the bishop.[41] She also held unofficial meetings of the auxiliary, such as the one in Hamm in October, to rally women to her side. The provincial executive committee responded in kind by sending its own representatives around the circuit to explain its position and to win support for the 29 June declaration.[42] This tug-of-war had the effect of dragging additional communities into the melée and of intensifying the degree of politicization surrounding the questions stirred up by the Protestant Church Struggle.

As the strategy of Liebe-Harkort became clear, namely that she and the bishop aimed to serve on the province's executive committee, the latter notified the episcopal office in Münster that only the board of directors could appoint new members and that it would not appoint any who were German Christians.[43] They based their opposition to German Christians on the grounds that the German Christian–controlled church was established on *Macht und Gewalt* rather than on the trust of the faithful. Undaunted, Liebe-Harkort attended the October meeting of the executive committee, along with some

clergymen who supported her. One of them put Adler and Liebe-Harkort's name in nomination for positions on the committee, but the motion was overwhelmingly defeated (71 to 5). Like Pastor Hermenau, Liebe-Harkort was defeated but still resolute; in the years to come she would continue to cause dissension among Protestant women and problems for the auxiliary.

Surprisingly, there was reaction to the 29 June Westphalian declaration within the auxiliary itself. It would be convenient if the Protestant Church Struggle consisted of a contest between two well defined groups, but many among the faithful sought an intermediate point. One such person was General Superintendent D. Zoellner, one of the oldest and most influential advisors of the Protestant Ladies' Auxiliary. Zoellner wanted Protestant women to be free of entanglement in the church struggle. Their role, he believed, was to be a unifying force in the midst of the storm, an undisturbed Christian influence within the community. Displeased with the declaration of 29 June and unable to forestall it, Zoellner got together with the executive committee (a smaller group than the board that issued the declaration) to provide an interpretation of the document, according to which the words *close, inner tie* did *not* mean that the auxiliary was linked organizationally to the Confessing Church.[44] This interpretation, issued simultaneously with the declaration itself, took some sting out of it.

Many Westphalian women found the action of the executive committee regrettable. Most women apparently preferred to take the 29 June declaration at its face value, namely, that the auxiliary was now tied to the Confessing Church. The interpretation of the executive committee retreated from this position. What right did the committee have to "interpret" or "correct" a decision made by the board of directors?[45] Local women saw Zoellner's hopes for a neutral auxiliary as unrealistic. They had done what they could to detour around the Protestant Church Struggle; they had not ostracized German Christian women from the auxiliary; and they had tried to keep politics out of community life. But the German Christians would not leave well enough alone. They would not content themselves with a neutral auxiliary. It was they who politicized the meetings through their demands to dominate them.[46] In

the minds of the women who had witnessed the local impact on the auxiliary of the Protestant Church Struggle, the German Christians had no right to "speak of peace after their actions over the past year and a half which have splintered the communities."[47] Consequently, there was no need for the executive committee to walk on eggshells to give the 29 June declaration the best face it could. The role that Zoellner wanted Protestant women to fill had already been destroyed.

The internal conflicts in the auxiliary affiliates in the western provinces during the summer of 1934 were a preview of the events that were to take place within the national office of the auxiliary during the fall and winter. Here, too, Zoellner wanted the auxiliary to maintain a low profile, but president Dagmar von Bismarck and Agnes von Grone were beginning to realize that there would be no safe, neutral ground in the Protestant Church Struggle.[48] Their discontent with the German Christian Reich Bishop-elect, Ludwig Müller, extended to two fronts—the church struggle and the NSF. Regarding the latter, Bismarck complained that Müller was not willing to use his office and position to help iron out problems that were arising between the auxiliary at both the local and national level with Gertrud Scholtz-Klink of the NSF.[49] Bismarck blamed Müller for the outcome of the Lönnies affair, which deprived the auxiliary of its publication *Mutter und Volk* and allowed it to fall into the hands of the NSF, calling this an intolerable encroachment on his part into the affairs of Protestant women.[50] The agreement between von Grone and Scholtz-Klink in August providing for cooperation between Protestant women and the NSF undoubtedly gave auxiliary leaders confidence in their ability to handle their own affairs.[51] Whatever future problems the auxiliary might have with the NSF, and there would be many during the last quarter of 1934, they might just as well be faced without the Reich Bishop as with him.[52]

The other area of disappointment concerned Müller's role in the ongoing Protestant Church Struggle. Together with seven other charitable agencies of the church, the auxiliary sent the Reich Bishop-elect a letter telling him that his position as spiritual head of the Protestant church was being undercut by the coercive conduct of the German Christians,

which he was tolerating.[53] These actions were bringing German Protestants, they said, into a conflict of conscience that would lead to a formally divided church if Müller did not take remedial action forthwith. Von Grone took the matter a step further by personally calling on the Reich Bishop-elect, just days before his installation on 23 September 1934 to tell him that Protestant women expected, but were not getting, *spiritual* leadership from him.[54]

The auxiliary did not have to wait long for Müller's response; shortly after his formal taking of office the Reich Bishop fired Agnes von Grone and appointed Pastor Hans Hermenau to her position as head of the Women's Work Front of the German Evangelical Church.[55] The president of the auxiliary responded by telling the new Reich Bishop that his dismissal of von Grone was unacceptable and would not be recognized.[56] Additionally, the auxiliary, along with the other groups associated with the Women's Work Front of the German Evangelical Church, decided to join with seven other Protestant charities to form an association whose parent and protector was Inner Mission.[57] In taking this step, von Grone said explicitly that she was not therewith bringing Protestant women into the Confessing Church, emphasizing that she was not herself a member.[58] But no matter how often or to whom the auxiliary repeated these disclaimers, the NSF and the German Christians would henceforth equate the auxiliary with the Confessing Church.[59]

Thus the fall of 1934 was a momentous time for the Protestant Ladies' Auxiliary. The women who were the national leaders of the auxiliary were not going to take General Superintendent Zoellner's advice and be wallflowers. They had the courage to seize the initiative both with the German Christians and the NSF. They knew, of course, that their decisions would be backed up by the two largest provincial auxiliary organizations, Westphalia and the Rhineland, both of which had already braved the storm of the Protestant Church Struggle. But these provinces had not had to contend with the NSF at the same time.[60] When the rupture with the Reich Bishop occurred, the auxiliary turned an important corner in its sojourn through the Third Reich, not least because it revived an old acquaintance-turned-adversary, Pastor Hans Hermenau.

Since his appointment as head of the Women's Work Front of the German Evangelical Church was not recognized by Protestant women, save those who were German Christians, Hermenau began immediately to organize a *Frauendienst,* or Protestant Ladies' Service, which he hoped would replace the auxiliary in every church throughout the land. In other words, he aimed to do nationally what Frau Liebe-Harkort had attempted to do in Westphalia—seize or transform the auxiliary on behalf of the German Christians. National auxiliary leaders stood firm and braced for a fight.

The significance of the ensuing contest between the auxiliary and Hermenau's service was that it deepened and widened the exposure of women to the Protestant Church Struggle. Many women around the country, especially those in small towns, did not have a very clear notion of the questions that lay at the root of the conflict between the German Christians and the Confessing Church, nor, quite understandably, did they have a clear perception of the incredibly muddled state in which the Protestant church found itself.[61] Regardless, the conflict would now be brought to their doorsteps. Hermenau put out a national directive to the effect that "in obedience to church and state officials (Romans, 13.1) and in the best tradition of the auxiliary performing its good works," all auxiliary affiliates should place themselves under his direction in the Protestant Ladies' Service, which, unlike the auxiliary, was recognized and sanctioned by the Reich Church.[62] Theoretically, then, each affiliate up and down the land would have to weigh the evidence for and against the German Christians and the Confessing Church and decide for the auxiliary or for the service.

The national leaders of the auxiliary did not shy away from the coming fight. In the words of Agnes von Grone, if the Reich Bishop "wants to allow our work to be torn apart and wiped out *we must simply say 'NO'!*"[63] The guidelines that the auxiliary set up to deal with the confrontation with the service provide some idea of how the conflict would unfold. Any woman who joined the service automatically forfeited membership in the auxiliary. On the other hand, German Christian women who were not contentious and divisive could remain in the auxiliary. If, at the local and regional level of leadership,

the German Christians were a minority, they were to be elimi-
nated; if they were in the majority, the others were to resign
and establish their own auxiliary affiliates.[64] To counter Her-
menau's directive, the national auxiliary office sent out notices
to all women's groups explaining the origin of Hermenau's
service along with the auxiliary's decision to part company
with the Reich Church.[65] An attack was also launched against
Hermenau, who was accused of heresy because of his apoth-
eosis of women.[66] In a sermon in August, 1933, Hermenau
had said that the blood German women shed in childbirth was
efficacious in the same way as Christ's blood shed in the cru-
cifixion.[67] Thus, the contest between the auxiliary and the ser-
vice was heated and polemical from the outset.

Attack and counterattack undoubtedly intensified Prot-
estant women's awareness of the church struggle, but not
every auxiliary met to debate the issues and cast its vote for or
against Hermenau and his service. Several different patterns
of conflict arose, each of which engaged women to a greater
or lesser extent in the controversy that plagued their church.

First of all, in those areas where the German Christians
had succeeded in taking control of church administration, a
confrontation between them and the regional auxiliary leaders
occurred whenever pressure was brought to bear on women
to join either the German Christian movement or commit to
the service. This pattern of development was common in
Pomerania, Mecklenburg, and Brunswick. Thus, we find the
auxiliary leaders in Pomerania informing the German Christian
administrators that the auxiliary "was constituted from the be-
ginning for free and independent work within the framework
of the church," that they had never been organizationally de-
pendent on the church's administrative structure, and that,
therefore, they could not be compelled to join the German
Christians.[68] The latter often viewed the auxiliary as integrally
involved with the Confessing Church movement or its fore-
runner, the Pastor's Emergency League. The Brunswick auxil-
iary found itself threatened with suppression. "The more
quickly the auxiliary disappears, the sooner we will have rest
and peace in the communities."[69] When church officials in
Mecklenburg tried to get the auxiliary to cut away from the
national auxiliary, the president, Hedwig Steinmann, resisted

the pressure and kept the province's affiliates true to their old allegiance.[70] Thus, in some areas the confrontation appears to have been limited to the leaders of the auxiliary and the German Christians.

In other areas, however, it was not possible to confine the dispute to this level. Instead, individual affiliates would decide between the auxiliary and the service. This pattern was frequently to be found in Thuringia, Württemberg, both Saxonies, and both Hesses.[71] Affiliates in these areas would have to gather whatever information they could on von Grone, Hermenau, and the Reich Church and attempt to make an informed decision.[72] Sometimes local auxiliary leaders would ask the regional office for direction, but at times even this was out of the question. In Saxony, where the bishop was quarreling with the NSF and German Christian clergymen were fighting with Confessing Church pastors, regional auxiliary leaders threw up their hands and gave up trying to advise local affiliates. Pastor Hermenau poured fuel on the fire by appointing a woman as head of the Saxon service whom he know would embroil Protestant women in "unbelievable trouble" and contentiousness.[73] In places of such intensity it was not unusual for members to attempt to opt out of the situation completely by breaking ties with the national auxiliary while refusing to join Hermenau's service.[74] Thus, direct involvement of Protestant women in the church struggle through participation at the local level in the decision-making process occurred in fairly large segments of the country.

A third pattern of involvement came about in places where the auxiliary was Confessing Church and its pastor happened to be or to become German Christian. This could lead to bizarre episodes. The German Christian Pastor Tobias seized all the money and materials belonging to the auxiliary of his church in order to start up a service affiliate. When the auxiliary initiated legal proceedings to get their treasury returned, Tobias donated all the money to Hitler "to whom as a Christian and National Socialist I owe the deepest gratitude" (because of the *Anschluss!*).[75] The problem of a German Christian pastor and a Confessing Church affiliate (it seemed to happen this way more than the opposite) was fairly common after 1935. Such conflicts were bitter and difficult to resolve

because of the traditional closeness of the auxiliary to its pastor. Not infrequently, a pastor who had done zealous work with the auxiliary long before the National Socialist era found himself at odds with his affiliate because of the Protestant Church Struggle and Hermenau's service. Problems of this nature arose most frequently in Pomerania, Brandenburg, and Saxony.[76]

The auxiliary-service conflict became the hottest and the degree of politicization among Protestant women the most intense in those places where the members of an individual affiliate split, with one faction favoring von Grone and the other Hermenau. This pattern of involvement was not infrequent by any means. Two examples, one from Brandenburg and one from Westphalia, demonstrate the litigious nature of this kind of dispute. In the latter province the auxiliary of Bochum-Engelsberg split in May of 1935 with 160 women favoring the service and 270 choosing the auxiliary. A decision of the elders deprived the auxiliary women, even though they were the larger faction, of the use of the church hall. This group of women then took their case to the district court, which had to decide whether they or the service women were the true successors to the old auxiliary. In September the court reversed the decision of the elders. For the next two years various church agencies attempted to mediate a truce between the two groups of women. When this failed, the service women took their case to the state court, but to no avail. In 1939 this court confirmed the judgment of the lower court.[77]

In Neurippin, Brandenburg, a similar chain of events unfolded in 1934 and 1935. The women of the auxiliary were divided between a German Christian and non–German Christian faction with the latter holding the majority. When the elders banned the auxiliary from the church hall and town hall, Elizabeth Schlaeger appealed to the regional church superintendent. The elders refused to relent; the women could use the church hall only if 51 percent of the leaders were German Christians. Meanwhile, a long list of complaints against Schlaeger was drawn up, which charged that she and other auxiliary women worked against German Christian pastors in the town. Schlaeger took the case to the Brandenburg church consis-

tory, saying that the elders had proceeded deceitfully against her because they had refused to produce any evidence to substantiate their charges. In the end, however, Schlaeger found she could not prevail over the stubborn council of elders who refused use of the hall unless she and other leaders of the auxiliary resigned and a new "folk-sensitive" board was elected in their stead.[78]

It is clear that the women of Bochum-Engelsberg and Neurippin became closely involved in the Protestant Church Struggle because of the auxiliary-service dispute. In some instances, where the conflict took on a local character, the disagreement could have been equally bitter. But in other situations, where the dispute was settled at a regional level, it appears that exposure of individual women to the Protestant Church Struggle was less intense. Bearing these differentiations in mind, we may conclude that hundreds of thousands of Protestant women found some degree of politicization in the church struggle because of their membership in the auxiliary. The wish of the national leaders of the auxiliary to remain free of church politics was completely dashed.

But the auxiliary won the contest with Pastor Hermenau whose Protestant Ladies' Service movement failed miserably. Although Hermenau renewed his efforts in 1936, claiming in a letter to Protestant bishops that women were flocking to his organization, its membership remained embarrassingly small and insignificant (Table 2).[79] Most Protestant women clearly preferred to remain loyal to Agnes von Grone and the auxiliary, which counted nine thousand affiliates and about a million members by 1938.[80] Hermenau's service did no better at the regional level where leaders remained faithful to the national auxiliary organization almost without exception.[81] Westphalia led the way by rejecting Reich Bishop Müller's firing of Agnes von Grone without even waiting to hear what the national auxiliary would say about it. Elsewhere all around Germany— in Baden, Bavaria, Würtemberg, Brunswick, Schlesswig-Holstein, Hamburg, and Hesse Waldeck—Protestant bishops notified state and National Socialist officials that they recognized and supported Agnes von Grone as the head of the Women's Work Front of the German Protestant Church.[82] Pastor Hermenau severely limited his chances of gaining support

Table 2.
Membership in the Protestant Ladies' Service in 1938

Province	Number of Affiliates	Number of Members
Westphalia	167	25,000
Saarland	13	1,000
Rhineland	180*	25,000
Brandenburg	80	n.a.
Silesia	79 (1936)	6,000
E. Prussia	19	2,815

*The statistics in this table were gathered by the Reich Church and may be inflated. The executive director of the auxiliary in the Rhineland counted only 32 service affiliates (as compared to 704 for the auxiliary); see Mybes, *Geschichte,* 109.

Source:
AEKU Gen. 12, no. 194, bd. 1 "Frauendienst."

when he joined the radical Thuringer wing of the German Christian movement, whose appeal among Germans at large was quite low. In terms of grass root and provincial support, then, the German Christians under Bishop Müller and Pastor Hermenau failed to attract widespread support.

Unfortunately, the success that the auxiliary could claim around the country in the confrontation with the German Christians was not mirrored at the national level where the most widely known leader of Protestant women, Agnes von Grone, found her position imperiled. This occurred when, in the midst of the neverending church struggle, Superintendent Zoellner emerged as chairman of the Reich Church Committee, which sought in 1936 to iron out the disputes that wracked Protestant church unity.[83] Zoellner sought a middle way: reconciliation of all moderates, whether Confessing Church or German Christian, and a positive relationship between the church and the Third Reich.[84] Commanding widespread respect throughout the country, Zoellner had been on the auxiliary's national board of directors since 1901. From the very outset of the Protestant Church Struggle, he had advised a neutral course for the auxiliary, and he was anxious to steer it back in this direction. What gave him the opportunity to do so was the catastrophe that befell Agnes von Grone in 1936.

In the fall of 1935 a National Socialist court in Hanover

found Agnes von Grone guilty of disloyalty to the party and deprived her of her membership.[85] Instead of coming to her defense in a matter that was transparently concocted between Pastor Hermenau and Scholtz-Klink of the NSF, Zoellner seized the opportunity to fault von Grone's leadership, claiming that she had mishandled relationships both between the auxiliary and the Reich Church and between the auxiliary and the German Women's Work Front.[86] Among the auxiliary's national leaders there was vacillation after the court's decision; some of von Grone's colleagues urged her to resign while others felt that this would amount to an admission of guilt on the part of the auxiliary itself. The indecision served Zoellner well. Declaring von Grone a persona non grata, he worked within both the church and the state to force her resignation.[87] Wanting to succeed her himself, Zoellner promised that, if the auxiliary accepted his leadership, the Reich Church Committee would, in turn, give the Women's Work Front of the German Evangelical Church its official stamp of recognition.[88] In order to make the auxiliary once again acceptable to the National Socialist party, Zoellner wrote to Scholtz-Klink, assuring her that the purposes of Protestant women were identical with those of the NSF and pleading with her to establish a good working relationship between the German Women's Enterprise and Protestant Women's work front.[89] When a higher court confirmed the decision against von Grone in the spring of 1936, she resigned, leaving the field open to Zoellner.

Before the year was over, however, auxiliary leaders realized they had miscalculated. A reaction against Zoellner and in favor of von Grone set in. Those circles within the auxiliary that were outspokenly Confessing Church believed that Zoellner had tainted himself with racism by a statement he made— "We said 'yes' to the National Socialist creation of a nation on the basis of race, blood, and soil"—when he assumed the chairmanship of the Reich Church Committee.[90] National auxiliary leaders became disgruntled when Zoellner failed to make public their agreement giving the auxiliary official church recognition.[91] Many of von Grone's former associates in the Protestant work front and auxiliary never really agreed with Zoellner's accusations against her. By the fall of 1936 the

voices that were supportive of her had recovered the initiative: "Frau von Grone could not have handled matters differently . . . from the point of view of the church, the Bible, and the Creed (*Bekenntnis*) than she did." With regard to the charge of disloyalty to the National Socialist party, auxiliary leaders defended von Grone, saying that she had "always been at pains to serve the German Volk honorably."[92] Zoellner now found himself accused of being unjust and unfair in the von Grone affair. He had been present at the meeting in 1933 when it was decided to tell Reich Bishop Müller that the auxiliary was displeased with him and intended to join the Bodelschwingh coalition. Why had he not spoken up? After having remained silent, how could he now fault von Grone for mishandling matters with the Reich Church? In a letter to Zoellner's Reich Church Committee, the leaders of the auxiliary concluded that the Protestant work front "under the leadership of Frau von Grone since 1933 tried to preserve the 'substance of the church' in so far as it exists in the lives of Protestant women and mothers."[93] One week later, in October of 1936, the Protestant Women's Work Front of the German Evangelical Church sent word to the Reich Church Committee that it did not consider its relationship to the committee to be organizationally binding and notified it officially that Protestant women would continue on under the Bodelschwingh coalition.

The involvement of Protestant women in the church struggle brought both short- and long-range consequences. The latter consists of greater visibility of women in community affairs from this time to the end of the National Socialist era and down to the present. The Protestant Church Struggle involved women directly in community decisions in a way that had not occurred earlier in the century. When women took sides in the auxiliary-service dispute, they often conflicted with the position of their pastor or even their bishop. Yet they persisted. In Westphalia they even took issue with the moderate position of General Superintendent Zoellner. At the national level the leaders of the auxiliary were caught up in what contemporaries viewed as a fundamental debate. Here, again they chose their own way. This does not imply that as women they rejected the counsel of church*men.* The point is that

opinion among the latter was divided. The women who led the auxiliary therefore made up their own minds and accepted the consequences of their actions.

The short-range consequences of women's involvement in the Protestant Church Struggle were several. The failure of Reich Bishop Müller to win the support of the largest and most active organization of the churchgoing faithful contributed significantly to his loss of credibility within Germany. On the other hand, the decision against the Reich Bishop was extraordinarily turbulent for the auxiliary. This may seem exaggerated since Hermenau's service could never claim more than a small fraction of active Protestant women. But to conclude from this that the impact of the German Christian movement on the auxiliary was minimal after 1935 would be totally incorrect. It was devastating because, first, it impaired the leadership ability of the national auxiliary office, and, second, it caused the NSV and NSF to turn against Protestant women with finality, depriving them of their cherished role of public service at the local communal level.

This double impact on the auxiliary will be the focus of subsequent chapters, but, before taking up these questions, we should pause to consider what the phrase "churchgoing Protestant women" means after the experience of the church struggle. This subgroup, hitherto unanimous in their support of national socialism, underwent a division that was threefold at the very least. On the right, of course, are the German Christians for whom no church-state conflicts existed because Hitler was awarded a *summus episcopus* role. Opposing them on the left is a considerably larger number of Confessing Church women who insisted on church autonomy both with regard to administration and doctrine (sensitive racial issues). The great majority of women fell somewhere in between these positions, hoping for a solution to the church-state controversy that both sides could accept. In the years to come— that is, from 1935 until the end of the Nazi era—the Protestant Ladies' Auxiliary came to be associated with women on the left, the Confessing Church. The reason for this lies in the intrigue surrounding the trial of Agnes von Grone.

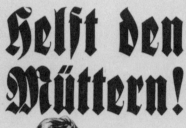

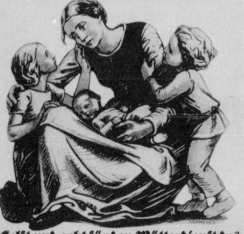

Helft den Müttern!

Helft und gebt für den Mütterdienst des
Reichsverbandes der Ev. Frauenhilfe!

Members of the Catholic German Women's League; *Bundestag* representative Helene Weber is seated in the center. Church activists tended to be relatively young in the 1920s and 1930s. (Courtesy of the Catholic German Women's League.)

A poster of the early 1930s illustrates the Protestant Ladies' Auxiliary's concern for mothers' health. (Courtesy of Fritz Mybes.)

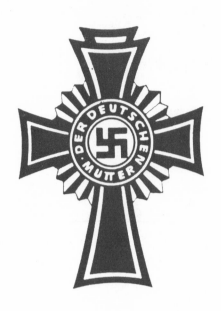

National Socialist medal for
women with large families.

One of many rest homes for
mothers operated by Protes-
tant or Catholic women.
(Courtesy of the Catholic Ger-
man Women's League.)

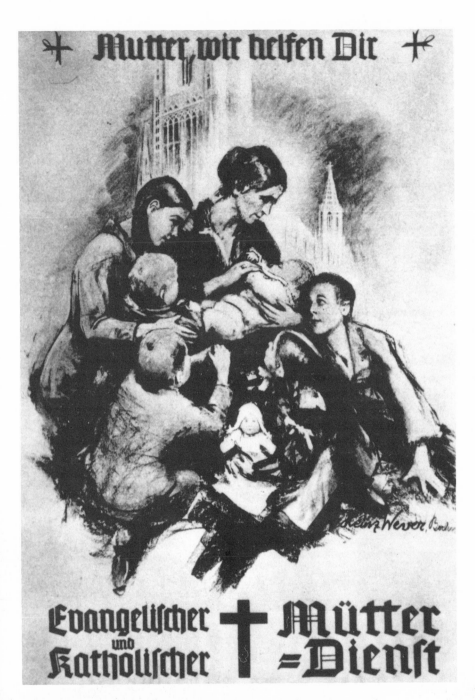

An interfaith poster of the early Nazi era promotes large families and concern for the health of mothers. In fact, Protestant-Catholic joint efforts never got off the ground. (Courtesy of Fritz Mybes.)

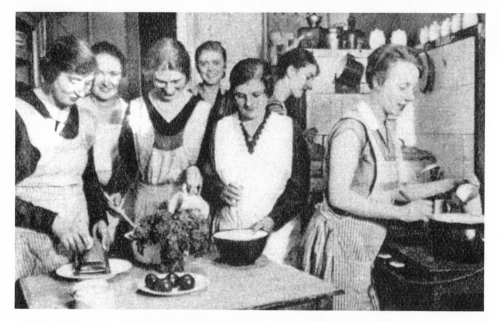

Women participating in a cooking class in 1933. The Protestant Ladies' Auxiliary sponsored a variety of home economic activities. (Courtesy of Fritz Mybes.)

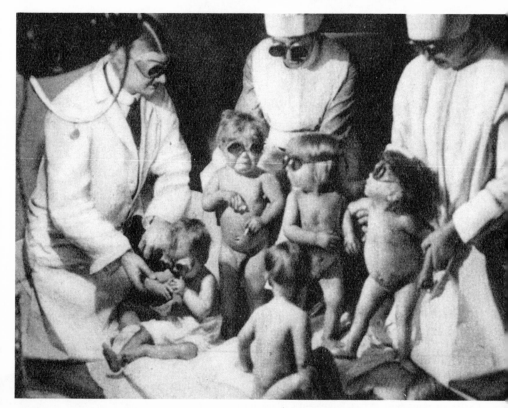

A good number of Protestant women shared the Nazi interest in a growing, racially pure Volk. Here babies are getting a sun-lamp skin treatment, probably in a facility operated by the Women's Work Front of the Protestant Church. (Courtesy of Fritz Mybes.)

Illustration from a Catholic women's magazine in 1938. To counter the Nazi emphasis on women as breeders, Catholic women promoted a virginal, Marian ideal. (Courtesy of the Catholic German Women's League.)

A Catholic wedding banquet, 1934. Catholic women were urged to preserve virginity before marriage. (Courtesy of the Catholic German Women's League.)

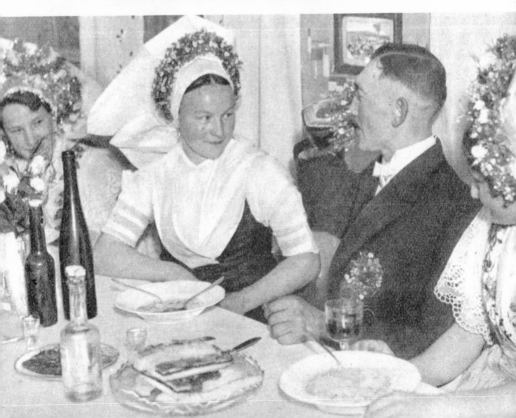

Young Catholic girl, 1938. During the latter years of the 1930s, Protestant and Catholic women resisted the Nazi attempt to eliminate Christian values among the youth. (Courtesy of the Catholic German Women's League.)

Helene Weber, a nationally prominent politician during the Weimar Republic, headed the Catholic Girls Youth Organization in the Nazi era. (Courtesy of the Catholic German Women's League.)

Look-alikes Agnes von Grone (*above*), leader of Protestant women, and Gertrud Scholtz-Klink (*left*), leader of National Socialist Women, became bitter rivals during the 1930s. (Courtesy of Fritz Mybes.)

Mutter und Volk, a pictorial magazine published by the Women's Work Front of the Protestant Church, was taken over in 1934 by Reichsfrauenführerin Scholtz-Klink. It had become controversial even earlier because some Protestant women objected to the magazine's racial emphasis. (Courtesy of Fritz Mybes.)

Margarete Sommer helped Berlin Jews and urged German bishops to speak out on their behalf during the Holocaust. (Courtesy of the Bistumsarchiv Berlin.)

Not wanting to endanger the family that was hiding her, the Berlin Jewess Liselotte Neumark gave herself up and died in a Nazi death camp. (Courtesy of the Bistumsarchiv Berlin.)

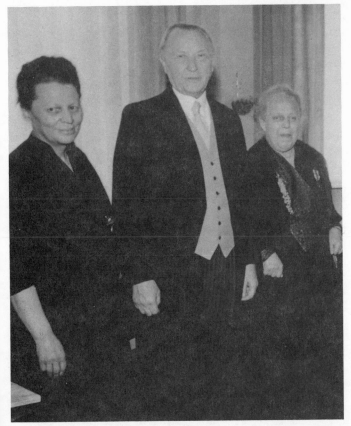

Helene Weber (*right*), elected to the *Bundestag* both before and after the Nazi era, was named to the cabinet of Chancellor Konrad Adenauer (*center*). Gertrud Ehrle (*left*) was a prominent member of the Catholic German Women's League during the 1930s and its president in the post-war era. (Courtesy of the Catholic German Women's League.)

7
Protestant Women under Attack: The Trial of Agnes von Grone

The enthusiasm with which Protestant women had greeted national socialism when the party came to power ill prepared them for the time when they would actually have to deal with Hitler's regime. In 1933 and 1934 auxiliary members felt that they were suddenly living in a new world that was at once friendly and strange. Protestant women wanted so very much to get on with völkisch renewal, but, plagued with the church struggle and rivalry with the NSF, they could not quite find their niche in fascist Germany.[1] Feeling at sea without a rudder, Protestant women nevertheless thought themselves secure, never imagining that a day would come when they would have to choose between their religion and national socialism. But this was precisely Agnes von Grone's predicament when she was called before a National Socialist court to answer charges of disloyalty to the party. After seeing the fate of their leader, many committed Protestant women realized that they too might have to make the same choice. We may view 1935 and 1936 as pivotal years when many

153

Protestant women were rudely awakened from reveries of well-being under the National Socialist banner.

Protestant, like Catholic women, ran afoul of national socialism over the question of racism. The fact that Protestant women were ambiguous regarding anti-Semitism explains to some extent why they could sojourn for so long with national socialism without seeing the conflicts between their hopes for the country and those of Hitler's party. The often devious dealings of Gertrud Scholtz-Klink do not conceal the fact that she would have been pleased to allow an ideologically docile auxiliary to remain at work under her German Women's Enterprise. At one point she and von Grone had even sealed an agreement according to which the auxiliary would give way to the National Socialist *Weltanschauung* regarding race. But the Protestant Church Struggle demonstrated a considerable diversity of opinion among Protestants regarding racial issues. Most Protestant women—certainly those who were members of the auxiliary—were uncomfortable with the extreme position of German Christians. From the point of view of the leader of the NSF, the ideological diversity among Protestant women was a disturbing element that threatened cooperative ventures between her women and Protestant women.

The role that the racial issue played is subtle and elusive. It would certainly be incorrect to imagine that it became a cause célèbre among Protestant women at large or even among Confessing Church followers. Furthermore, it is difficult, if not impossible, to sort out the degrees of anti-Semitism among Protestant women. Some may have been sensitive to the injustice of anti-Semitism, but most women thought about the issue of race in terms of religion. Should converted Jews preach? Should they hold administrative positions? Should they sit apart in church on Sunday? These questions, not ones directed at the moral wrong of anti-Semitism, were the ones being asked. We may want to object that these questions were not the important ones, but they were central enough to cause a breakdown in the close relationship between Protestant women and national socialism.

Two factors triggered the crisis: the Protestant Church Struggle and the pressure in fascist Germany to conform (*Gleichschaltung*). As far as National Socialists were con-

cerned, German Christians represented ideal conformity (or as ideal as could be expected within the pail of Christianity). Because of this, Protestant women found that when they became involved in church politics, they became involved in national politics as well, even though most did not want to. In other words, the German Christian movement was so closely aligned philosophically with national socialism that how a Protestant woman stood in relation to it became an index as to how loyal she was to nazism. As far as the party was concerned, Agnes von Grone was not loyal enough. The legal proceedings against her came about, without doubt, as the result of collusion between *Reichsfrauenführerin* Gertrud Scholtz-Klink and Pastor Hans Hermenau, head of the Reich Church's German Christian service movement.[2]

A self-study of Hermenau's service organization demonstrates how solidly it was linked to the NSF. In Westphalia, the Rhineland, and the Saarland 80 to 90 percent of the women of the service also belonged to the NSF or to the German Women's Enterprise.[3] All reported that relations between the two groups were excellent, or that the service avoided any conflict or competition with the NSF. Among service women there was an identification with and commitment to the ideals of the regime: "These are the women who want to work for the purposes of the Third Reich."[4] The report from Brandenburg puts it bluntly: "We are National Socialist and we are true to the National Socialist *Weltanschauung.*"[5] Auxiliary women, on the other hand, discovered that they had become politically questionable, or politically disloyal, or "outsiders" because they did not measure up to the full dedication of German Christian women in the service.

Putting Protestant women of the auxiliary in this position was a calculated effort. Pastor Hermenau's operational plan for breaking the auxiliary demonstrates the linkage between his service and the NSF. In places where no auxiliary affiliate was established and where the pastor was German Christian, women were simply to act as if the NSF leader was their director. If the pastor belonged to the Confessing Church, then regional German Christian pastors were to work against him, joining forces with NSF women to block the establishment of auxiliary affiliates. If an auxiliary affiliate had managed to guard

its neutrality, the Reich church would try to take it over in conjunction with the NSF. If the pastor was German Christian and his auxiliary neutral or leaning toward the Confessing Church, he was to ignore it and cooperate in all communal welfare programs with the NSF. And so on. Every scenario developed by Hermenau provided for close cooperation between the service and the NSF.[6] Thus, although auxiliary members constantly found themselves accused of being "political," it was actually the initiative of the German Christians and the NSF that placed them in this position.

Hermenau's plan of attack put auxiliary women at odds with National Socialist women in NSF affiliates. In March, 1935, the woman in charge of the regional NSF plotted with the German Christian bishop of Mecklenburg and some German Christian pastors to overthrow the auxiliary.[7] In a Silesian city the leader of the NSF tried to convert the auxiliary, to which she belonged, to Hermenau's service organization. When this failed, she passed word to regional newspapers that the auxiliary had been dissolved. After the pastors of the churches involved denied this from the pulpit, the obstreperous leader refused thenceforth to let any auxiliary member be a member of the NSF.[8] Elsa Dassler, the regional director of the NSF, took the same position in a letter to the president of an auxiliary affiliate: "You can't be in the NSF and in the auxiliary. Make up your mind!"[9] If a member of the NSF dared to join the auxiliary, she exposed herself to great pressure and abuse. One such person, a mother of six who was described as a simple workingman's wife, was told by the local NSF leader, "Don't imagine that [we'll] think of your children at Christmas time!"[10]

The experience of the women in the city of Gehrden in Saxony is interesting because it shows the impact of Hermenau's strategy. Some of the women of the Gehrden auxiliary had been members of the National Socialist party since well before the seizure of power, and they had always found an easy cooperation between the auxiliary and National Socialists in community projects. However, in 1936 an NSF affiliate was founded in Gehrden and old-time party members were told to get out of the auxiliary. If they continued to go to auxiliary meetings, they found that they were harassed. Petitions

against the auxiliary were passed around that women had to sign under threat of their husbands losing their jobs. As a result, a number of women who "were wives of workers and National Socialist from the beginning, said that they would have to drop out [of the auxiliary]." [11]

The pressures that arose from the numerous conflicts between auxiliary affiliates and the NSF or service, therefore, were not just organizational.[12] They affected individuals and their families. In Magdeburg, if auxiliary women did not conform, their husbands were threatened with loss of work or demotion, and their children were beaten up or made fun of.[13] The regional leader of the National Socialist party near Berlin told a large audience that "whoever has a National Socialist *Weltanschauung* joins the NSF. Those who have a Christian philosophy join the auxiliary. As a National Socialist I would divorce my wife if she joined the auxiliary and no court would stop me!" [14]

The attacks of the NSF and Pastor Hermenau's service on auxiliary women succeeded in politicizing their situation in their home communities. Without the initiative of Scholtz-Klink and Hermenau, the question of loyalty to one's country would never have occurred to most Protestant women, simply because they did not happen to be members of the German Christian faction. Auxiliary members, who had been among Hitler's most avid supporters at the polls and among whom were old-time National Socialist party members, now found themselves accused of being "bad citizens," or of being disloyal.[15] To the fanatic National Socialist and German Christian it was a black-and-white situation: either one obeys the Führer or one disobeys him. Hitler appointed the Reich Bishop; if the auxiliary is disloyal to him, they break faith with the Führer. In public gatherings and town meetings where there was a mixed NSF, service, and auxiliary audience, Protestant women heard over and over again that they were "against the Führer," that the auxiliary was "an enemy of the state," and that it breaks trust with God and country (*Treubruch*).[16] These accusations became commonplace for the entire duration of the Third Reich, but they began in 1935 as a result of the competition between the NSF and its ally, the service, and the Protestant Ladies' Auxiliary.

In time the NSF-service coalition became disastrous for the auxiliary because it meant that the organization would not be allowed to continue its tradition of communal social work. But the immediate outcome was to end the career of Agnes von Grone as head of the Women's Work Front of the German Evangelical Church. In 1935 Erich Hilgenfeldt, head of the giant NSV office, and his close associate, Gertrud Scholtz-Klink, accused von Grone of leading two and a half million Protestant women into rebellion against the National Socialist state. Not coincidentally, these were the same charges that Pastor Hermenau had brought against von Grone earlier at the time of the rift between the auxiliary and the Reich Church.[17] By letting it be known that the NSV and NSF wanted nothing to do with the auxiliary, the leaders of National Socialist women and of the service hoped to stampede Protestant women into their arms.[18]

Although somewhat contrived, the charges against von Grone were very serious. Before proceeding against her, Hilgenfeldt and Scholtz-Klink, themselves prominent personalities in the National Socialist state, cleared the matter with top party officials, Rudolf Hess and Martin Bormann.[19] Even though the litigation has the appearance of a vendetta against von Grone, it is more likely that the purpose was to force her as a party member to accept party discipline, a euphemism meaning submission to Scholtz-Klink and the *Gleichschaltung* of the auxiliary. The accusations were extensive, and they addressed the very issues that confronted German Protestants under National Socialist rule—church-state relations and racism.[20]

Regarding the first issue, Hilgenfeldt charged that von Grone had disobeyed Scholtz-Klink's order of July, 1934, not to establish new auxiliary affiliates.[21] This went to the heart of the church-state problem, since von Grone had consistently based her disregard of Scholtz-Klink's order on the 1933 agreement between her Protestant women's work front and German Women's Enterprise, which had provided for team-work between the two organizations but no organizational linking. Von Grone defended the right of the auxiliary to manage its own affairs free from state or party interference because of its status as a religious organization. Along with the

entire leadership of the auxiliary, she advised auxiliary affiliates in January, 1934, that members must insist on their right to "work for the church," and in March, 1935, she reiterated that Protestant women were pleased to work for the German Women's Enterprise so long as "their special religious affiliation was recognized."[22] Von Grone's insistence on the principle of the right of Protestant women to work for the church and her open defense of it annoyed and antagonized Hilgenfeldt and Scholtz-Klink.

Von Grone was charged, secondly, with departing from the auxiliary's neutral stance vis-à-vis the Protestant Church Struggle and with leading Protestant women into the Confessing Church front. Although von Grone, along with the president of the auxiliary, Dagmar von Bismarck, did break with the Reich Church, they did not lead Protestant women in this matter. Individual provinces were left to pursue their own courses, at least before the rival service organization was set up, and, as we have seen, some provinces actually began to act against the German Christians earlier and more emphatically than the auxiliary central office. Certainly, Hilgenfeldt knew by the summer of 1935 that the involvement of Protestant women in the church struggle was spontaneous and irreversible. To blame it on von Grone while picturing himself as a guardian of the peace who could still keep women free of church politics, was mere posturing on Hilgenfeldt's part. Since this charge revolved around relations of the auxiliary to the Reich Church, it bore directly on the church-state issue of the Protestant Church Struggle.

Third, the racial, ideological issue arose in Hilgenfeldt's complaint against von Grone, whose attitude and conduct he described as "*unnationalsozialistisch.*" The question was basic: did von Grone owe loyalty to her church or to national socialism? By 1935 many Protestants had begun to feel a threat to Christianity behind the neopaganism of Alfred Rosenberg, the ideologue of the party. Von Grone had expressed fear that her Protestant women's work front would be placed directly under Rosenberg's thumb in the office of cultural affairs, and she was, like her associates, apprehensive about neopaganism. In a 1935 circular letter, she wrote to Protestant women that "in this moment of decision between neo-paganism and

Christianity no one can deny us the right of distinctively Protestant activity."[23] We can judge from this statement to what extent the situation of Protestant women had changed since 1933 when everyone was certain that national socialism would create a healthy environment for institutional religion. Refusing to admit that any conflict of principle existed between Christianity and Rosenberg's racial teaching, Hilgenfeldt accused von Grone of attacking a leading National Socialist personality and of prejudicing Protestant women against him: von Grone was guilty of disloyalty to the party and she lacked party discipline!

Finally, Hilgenfeldt made an unscrupulous personal attact on von Grone. Her "excessive pride" made any kind of a "harmonious, trusting" working relationship impossible.[24] The blood of the Thirty Years' War should be on her head and the heads of her children for embroiling women in the Protestant Church Struggle! The personal slur against von Grone was excessive and in poor judgment. Von Grone's peers in the auxiliary went on record to the effect that she could not have acted differently.[25] Even the National Socialist court of appeals in its final judgment against von Grone showed greater decency than Hilgenfeldt when it admitted that von Grone had acted on principle and not in self-interest.

What Hilgenfeldt hoped to accomplish by denouncing Agnes von Grone to party leaders was to compel her to submit to Scholtz-Klink. The alternative—forcing Protestant women out of the German Women's Enterprise—would only serve to antagonize a large segment of the public that fully supported Hitler and national socialism in most respects. Far more satisfactory would be the *Gleichschaltung* of the Protestant women's work front under terms that would allow von Grone to stay on but in a subservient capacity to Scholtz-Klink. The role of racist principles in National Socialist welfare, which became more prominent in 1935, would be a problem with some auxiliary affiliates, but it could be handled by insisting that only National Socialist personnel deal with such questions in joint projects such as mothercare.[26] Scholtz-Klink wanted the support of Protestant women but on her own terms.

With this in mind Hilgenfeldt set up a meeting in the Brown House in Munich at which von Grone would be con-

fronted by himself, Scholtz-Klink, and another party officer. The purpose was to destroy von Grone's mettle, and the method was intimidation. Threats were followed by insults.[27] If von Grone did not give in, the auxiliary would be completely shut out of the German Women's Enterprise and would thereby lose all hope of participating in the dream of Germany's renewal. Hilgenfeldt and Scholtz-Klink intimated that they had had a very productive meeting the previous evening with Bishop Maharens (one of the country's most widely respected, non–German Christian churchmen), the upshot of which was that he was anxious for Protestants to participate in the work of renewal even if this meant that von Grone would have to be sacrificed. They would allow von Grone to stay on, however, if she would agree to a joint press release stating that "Frau von Grone regrets her past attitude and the resulting conflicts. She declares that in the future she will fully submit to the German Women's Enterprise in all matters even when these do not stand in harmony with 'church-political' directives."[28] The terms of the statement were obviously outrageous and humiliating. Von Grone refused to cave in.

But the ordeal in Munich deeply distressed von Grone. For years she had led Protestant women in welcoming and proclaiming national socialism as their friend and ally. In 1935 she was still boasting that it was among her organization that the mothers of the SS and SA were to be found. Now the burden of ending the dream of a working alliance between Protestant women and national socialism fell to her. Although she was obviously upset by this, von Grone acted consistently and logically. She had brought the Protestant women's work front into the German Women's Enterprise so as to guarantee Protestant women the same standing, meaning autonomy, within the Reich as Catholic women enjoyed under the Concordat.[29] To have submitted to Hilgenfeldt and Scholtz-Klink in the Brown House would only have defeated her original purpose.

Hilgenfeldt decided that if the branch would not bend it would have to be broken. Early in 1936 a district National Socialist court (South Hanover-Brunswick) charged von Grone with "making a harmonious, trusting cooperation between women's groups impossible," of "dragging church politics into women's work," and of "breaking down party discipline

by her obstreperousness toward the *Reichsfrauenführerin.*"[30] These were, of course, Hilgenfeldt's charges. Von Grone was accused of having encouraged auxiliary affiliates to "reject, and even, sometimes, to fight against national socialism."[31] In charging her with illicitly posturing as the head of an independent women's group and with needlessly embroiling Protestant women in the church struggle, the National Socialist court went so far as to characterize von Grone's activity as "general resistance."[32]

As evidence the court cited specific instances in Baden and East Prussia where auxiliary affiliates had hindered the formation of an NSF group or had obstructed its work. Von Grone was accused of forcing the women of Hagen-Haspe in Westphalia, who had not chosen the Confessing Church, to resign their positions as provincial and regional auxiliary officers. Von Grone's role in the Protestant Church Struggle was always depicted as central, while that of the real protagonist, Pastor Hermenau, was ignored. Never was it acknowledged that the issues of the Protestant Church Struggle aroused fundamental questions of conscience for Christians regardless of what personalities might be involved or that the outcome of the conflict could depend on local conditions and preferences.

The trial and its appeal, which dragged on from 1936 to 1939, became an indictment of the auxiliary as well as of von Grone. During the latter years of the decade the relationship between the auxiliary and the NSV and NSF deteriorated badly, and the proceedings against von Grone reflected this. Two years after the initial trial, when contention over welfare work between the churches and the NSV became acute, the high court of appeals in Munich faulted von Grone for encouraging Protestant women to continue to support church welfare, especially in those instances in which it contributed to the influence of the church over children (meaning kindergartens and day-care centers.)[33] This accusation had not been made in 1936 during her first trial.

To all of these changes von Grone protested her innocence. She had wished only to protect the right of Protestant women to work in welfare for the church. Breaking with the Reich Church did not mean that she led Protestant women into the Confessing Church; this assertion had been made re-

peatedly at the time of the withdrawal from the Reich Church and during the months thereafter. Above all, she had not betrayed Hitler: "Not only as a party member but also as a Protestant woman I stand in the most thoughtful, respectful, and most faithful obedience in our work behind our Führer." [34]

Von Grone's pleas of innocence and loyalty availed her nothing. She was found guilty. As a member of the party she had not tried hard enough to instill National Socialist purposes in the Women's Work Front of the German Evangelical Church, and she was personally responsible for the conflict between the auxiliary and the NSF and for the rumor that national socialism was inimical to religion. Von Grone "had hindered and driven countless well-meaning Protestant women from accepting the National Socialist *Weltanschauung*." [35] Von Grone's appeal of her case did not reverse the initial judgment against her, and she was stripped of her membership in the party. [36]

It is important to understand that the action taken against von Grone by the National Socialists at the instigation of Hermenau and Scholtz-Klink was directed against the auxiliary and Confessing Church as well. Since religion and völkisch racism were inextricably interwoven for German Christians, their service organization would not be affected by what happened to other Protestant women. As the case against von Grone developed, leaders of the German Christian service movement sided with Scholtz-Klink. [37] Early in 1936 a delegation of German Christian women, led by Eleanor Liebe-Harkort of Westphalia, went to Berlin to discuss with Scholtz-Klink the situation of the service in the midst of contention between the auxiliary and NSF. The *Reichsfrauenführerin* assured them that they would continue to be in good standing with the NSF and her German Women's Enterprise. [38] Scholtz-Klink had made up her mind that for "national socialism there can be no division of religious and völkisch interests." [39]

The high court's judgment against von Grone made the distinction between auxiliary and service women explicit. It characterized the Confessing Church course of the Protestant women's work front, of which the auxiliary was the largest and most active component, as political opposition. The leaders of the auxiliary, along with von Grone, interpreted the court's

judgment as a sentence of guilt against their organization and the Confessing Church. They were not of course mistaken.[40] Soon after the Brown House confrontation, the president of the auxiliary wrote to Scholtz-Klink to reject the insinuation that Bishop Maharens had faulted von Grone and to defend the steps that she had taken in the course of the Protestant Church Struggle as strictly religious and not political.[41] *Reichsfrauenführerin* Scholtz-Klink remained unsympathetic. In June, 1936, she dissolved the membership of the Women's Work Front of the German Evangelical Church in her own German Women's Enterprise.[42] This put into question all auxiliary community enterprises including mothercare work and left auxiliary affiliates throughout the country at the mercy of party and gestapo officials whenever they engaged in an activity that was not strictly religious. Except for the German Christian women of the service affiliates, it was a black day for Protestant women, one that ended once and for all a dream that they had cherished since the rise of national socialism.

The situation of Protestant women in 1936 proved irreversible. Being aware that most churchgoers preferred a moderate position between German Christians and the Confessing Church, Superintendent Zoellner attempted to become their spokesman after von Grone's fall. Wanting to reconcile Protestant women with the NSF and NSV, he wrote to Scholtz-Klink late in the year to plead their cause. Zoellner portrayed Protestant women and National Socialists as kindred spirits whom destiny was bound to unite. At the beginning of the Third Reich, Protestant women had been "prepared to undertake the enormous organized effort that would be necessary to build up a nationwide anti-Marxist and anti-liberal women's association."[43] But Zoellner could not speak for Protestant women, let alone reverse the situation in which they found themselves. After discovering that von Grone would not kowtow to her and that the auxiliary would not self-destruct in favor of the NSF, Scholtz-Klink did not view National Socialist women and Protestant women as birds of a feather as Zoellner portrayed them.[44] His initiative was rejected both by the auxiliary and by Scholtz-Klink.

The reasons for the action taken by Hilgenfeldt and Scholtz-Klink against the auxiliary and von Grone are not diffi-

cult to piece together. In the first years of the Third Reich, the auxiliary and the Protestant women's work front dwarfed the NSF and German Women's Enterprise in size. Although she would not admit it, Scholtz-Klink's ban on the establishment of new auxiliary affiliates in the summer of 1934 was aimed to halt its growth and leave the field open for her own organizations. She was playing a shell game. While attempting to thwart the auxiliary, Scholtz-Klink protested that she did not wish to restrict the work of churchwomen, and she even worked out an agreement with von Grone regarding joint auxiliary-NSF mothercare work.[45] In fact, not long after the ban was announced, representatives of both the NSV and NSF attended an auxiliary banquet in Anhalt at which thirteen new affiliates were welcomed into the auxiliary.[46]

The Protestant Church Struggle provided Scholtz-Klink with the opportunity to seize the organizations of Protestant women and integrate them into the German Women's Enterprise. She had already linked the Protestant women's work front to her National Socialist organization, but, while she might influence Protestant women through this tie, she could by no means control them. A situation in which a subordinate had more control over a greater number of women than she was clearly unacceptable to the ambitious Scholtz-Klink. The clear split among Protestant women occasioned by the Protestant Church Struggle opened the door for her and the disgruntled Pastor Hermenau to attack the auxiliary. Those women who chose Hermenau's service could be integrated completely with the NSF because of their ideological commitment to national socialism, including its racist tenets. At the same time the leadership of the auxiliary could be challenged in such a way as to force its submission to Scholtz-Klink's authority. The objective was not to dissolve the auxiliary but to rid it of its headstrong leader and to replace her with someone who would compliantly place the one-million-strong organization under Scholtz-Klink's leadership.

But the Protestant Church Struggle was only a facilitating factor in Scholtz-Klink's offensive. The essential cause of the confrontation lies in a general change of posture of the NSV in 1935. We have already seen that during the early years of the Third Reich, when National Socialist welfare was just getting

organized and on its feet, Erich Hilgenfeldt had been willing to temporize and concentrate on practical issues. By 1935 the NSV, and its daughter the NSF, felt strong enough to insist on a more ideological approach to public welfare. No doubt, the economic recovery allowed this switch in strategy. The action taken against von Grone should be viewed in the context of the general assertiveness of the NSV in 1935. We saw in chapter five how Catholic charities were affected by this new factor. Since Protestant welfare, like Catholic, was based on the traditional Christian virtue of charity, we would expect it to be confronted by the NSV as well. If the Protestant Church Struggle was not an essential factor, it nevertheless highlighted the philosophical difference that was emerging in 1935 between the welfare of the churches and National Socialist welfare. Only the German Christians, whose racist notions were closer to those of national socialism than any other faction within organized religion, would be acceptable as NSV and National Socialist partners in communal welfare.

Agnes von Grone was but one of many men and women whose lives were entangled in the Protestant Church Struggle. To judge her as an isolated, self-promoting opportunist is inaccurate and perhaps unfair.[47] Even the final decision of the party's court admitted that she acted on principle. It is true, of course, that she had been swept along in the swift current of Nazi enthusiasm during the first half of the decade, but so had virtually every other Protestant woman. Eventually, von Grone recognized the anti-Christian element in nazism and spoke out against neopaganism.[48] An evaluation of von Grone's actions should only be made in the context of the developing animosity between national socialism and the Confessing Church. After von Grone abandoned her leadership role among Protestant women, her successors eventually chose to disassociate with Zoellner's church committee (which sought accommodation with national socialism) and opted to remain in the Bodelschwingh coalition.[49] In coming to this decision, von Grone's peers went on record in defense both of her honor and judgment in dealing with national socialism.

8
Dissent among Catholic Women

Looking back on the decade of the thirties, it might seem to us that the situation of Protestant and Catholic women differed considerably until about 1935 and then became somewhat similar. This perception is not incorrect. What the two subgroups of women had anticipated of national socialism colored their views for some years, but in the latter half of the decade cold reality settled in uncomfortably, confronting both Protestant and Catholic with similar problems: racism in welfare, dechristianization in the schools, exclusion from mothercare work, and anti-Semitism. It was difficult for Protestant women to deal with these issues because, as we have seen in the previous two chapters, their church leaders were badly divided. Conversely, Catholic women coped with them much more easily because their church leaders spoke with one voice even when their opinions on any given question may have been widely divergent. But there was a disadvantage for Catholics as well: the sheep tended never to stray where their shepherds did not lead them. The bishops, cau-

167

tious and circumspect, chose paths that would not end in difficult moral tests for their faithful. They did not, for example, confront national socialism on the wrongfulness of its anti-Semitism, even though it was sometimes admitted in private.[1]

There were other areas, however, that the church simply could not leave uncontested—the dechristianization of schools and the youth, sexual immorality, and euthanasia. The bishops knew that the church had to take a stand on these questions. They also knew that they had three strong organizations of women—the league, the sodality, and the Elizabeth Society—whose members could be counted on to back them when confrontations with the National Socialists arose. It was above all these women who found themselves pulled into the maelstrom of church-state conflict where they played a role similar to that of Confessing Church women in the Protestant Church Struggle.

There were surely many other loyal Catholic women who were not members of one or the other Catholic women's organization but who opposed national socialism on those issues that the church singled out. The gestapo always identified women as the subgroup of Catholics most loyal to the church. But this kind of support usually leaves behind no record of its deeds, and there is good reason to question whether tacit disapproval of national socialism had much effect on the course of life in the country. The church made strong efforts to get such people to commit themselves to Caritas where their numbers, money, and activity could be put to constructive use. Perhaps many women failed to do this simply out of lethargy. Even so, it is difficult to see how the church profited much from this kind of noncommittal "goodwill," and, as a consequence, difficult for us to include these women in a discussion of dissent.

We must limit our circle, therefore, to those women who were members of Caritas or of one of the three Catholic organizations of women. Caritas and the sodality each counted about a million members, but we cannot realistically claim that that many of them were engaged in dissent. In the first place, many women held membership in Caritas as well as in one of the other organizations of Catholic women, and Caritas's membership included a small minority of men. The number

engaged in dissent would, then, be much closer to one than to two million.

If a million women had joined together to protest some action or policy of Hitler's regime, why has this been ignored by history? The answer, of course, is that protest among Catholic women was never unanimous or unequivocal. Our goal here, then, must be to determine the degree of dissent, or limits of dissent, among Catholic German women. The million or so who qualify as dissenters were not all equally courageous or outspoken. Some would go no further than their bishops or parish clergy urged them, while others were willing to act on the basis of their own decisions and conscience. Yet, we must not discount the importance of a million potential dissenters either in terms of their inhibiting influence on individual National Socialists and on the regime collectively or in terms of the example they provided for other Catholics who hoped against hope to avoid conflict between civil and religious commitments.

We have seen in an earlier chapter that conflict between the church and national socialism often centered around the latter's ideology. Thus, when Catholic women refused to be part of the NSV's mothercare work, they were eliminated from this field of welfare altogether. Not surprisingly, the racial conflict that lay at the bottom of this dispute did not simply evaporate thereafter, but its foci shifted to other areas, one of which was the youth. When the National Socialist regime made a major effort to win the loyalty of the German youth, the church, much alarmed, reacted strongly. At issue here was the church's belief in virginity and the sanctity of marriage as opposed to national socialism's goal of perfecting and propagating the Aryan race. In itself, the church had no quarrel with National Socialist pronatalist policies. It lauded the regime's loans for newlyweds with the generous reductions on the principal as new married couples produced babies.[2] But when pronatalist policies contradicted the sanctity of marriage, the church would not shy away from a confrontation with national socialism. Catholic women and mothers were in the middle of the racial conflict because, traditionally, Mary, the mother of Christ, embodied the church's ideals regarding virginity before marriage and fidelity between married couples. National

Socialist ideas often contradicted these teachings, and Catholic parents, quite naturally, wanted to protect their children from what they perceived as the low morals and loose ways of the Hitler Youth.[3]

Although women of the league and of the Elizabeth Society were involved in the dispute, the sodality led the church's fight. Specifically, the sodality promoted the idea that the Marian ideal of womanhood differed from the National Socialist perception of woman as protectress of the race.[4] *Die Mutter,* the sodality's monthly paper, was filled with copy on Mary, and her perpetual virginity was held up as an ideal for Catholic women to emulate. In the Augustinian spiritual tradition, even married women were to share in this ideal and, in some mystical if not real sense, remain virgins after marriage. The church clearly enunciated the Catholic ideal of womanhood vis-à-vis that of national socialism and consistently promoted it throughout the Third Reich:

> It is now especially necessary to emphasize all the more—in contrast to the current overemphasis on the reproductive function of women and the value system that results—the worthiness of the total womanly personality. We are concerned here most profoundly with that aspect of women's psychological nature to which St. Augustine referred when he said that women wish to remain virginal even when they become mothers.[5]

Thus, although Catholic mothers had not chosen a celibate life, they were to uphold the ideal of virginity for the benefit of their children, especially girls.

This Catholic tradition clashed head on with National Socialist racial doctrine. Party savants such as Ernst Bergmann and Rudolf Hess affirmed that childless women were without honor, while motherhood, whether marital or extramarital, was honorable.[6] Taking this teaching seriously, the bishops warned the faithful in 1935 against National Socialist proposals that sanctioned bastardy in the interest of the Aryan race.[7] Since the sodality was the only Catholic women's organization with a truly mass membership, the bishops depended on it, and on the Association of Catholic German Women Teachers,

to counter the ideology of the regime.[8] When the sodality's newspaper ran an article in 1936 suggesting to young Catholic women that virginity was a higher ideal than the National Socialist fertility campaign—"presenting Hitler with a baby"—the organization was severely reprimanded.[9] *Die Mutter* continued nevertheless to inundate its readers with copy on the Virgin Mary and the Holy Family.

The struggle for the allegiance of the German youth became more intense when the National Socialist regime attacked separate confessional schools, setting up "community" schools in their stead. The idea behind the National Socialist–sponsored community school was not the old liberal idea of championing a secular in place of religious education, but of supplanting Christian ideals with those of national socialism. In the words of Maria Schmitz, president of the Association of Catholic German Women Teachers, it was a struggle for Christianity itself: "The question is whether the children of Catholic parents will be allowed henceforth to be raised Catholic or not."[10] Although the removal of crucifixes from Catholic schools created an uproar and a rallying point for Catholics, a nazified education was a more serious threat.[11] In the community school Christ would be depicted as a fighter and hero who died a noble death not as redemption for sin but to free mankind from the Jews.[12] It came down to a simple process of dechristianization and nazification. In spite of strong feelings among Catholics against the community schools and efforts by local clergy to defeat them, the National Socialists succeeded by hook and by crook in establishing them, even in solidly Catholic areas like Bavaria.[13]

Once this was accomplished, the next step of the regime was to gain control of the kindergartens. Caritas estimated that around 1,200 of their kindergartens in widely scattered areas of the country were taken over by the NSV before the war.[14] By 1939 NSV agencies had compiled exact statistics on German kindergartens that showed how many were already in their possession and how many were "yet to be taken over."[15] In 1940 and 1941 the bishops remained very concerned over the status of their kindergartens. When Caritas director Kreutz proposed to the Fulda Bishops' Conference that they allow the NSV to take over all kindergartens, his sug-

gestion was rejected, evidently somewhat harshly.[16] Clearly, the bishops were concerned over what effect the elimination of the state-supported Catholic school system would have on the loyalty of the youth to the church.

With the rise of the nazified community school and the danger of losing the kindergartens, German bishops turned to Catholic mothers, asking them to step into the breach by teaching religious doctrines to their children. In the large Catholic city of Cologne, women actually forced Nazi officials to return already confiscated kindergartens to the church.[17] The sodality ran frequent articles in its paper urging its million members to be ardent: "The credal battle which surrounds us brings to mind for us Roman Catholic mothers our great calling and great responsibility."[18] New columns were introduced, such as "The Home Church," which explained doctrine to mothers in terms that they could pass on to their children.[19] The bishops' appeal was to all Catholic women, of course, but it is clear that the sodality gave them support by taking up the challenge.

During the war the church continued to remind lay women of their mission to catechize the youth, frequently pointing out the problem that the National Socialist community schools had created.[20] The bishops made a special effort to get members of the league involved with catechistics at the parish level (the sodality having by this time been suppressed).[21] "The problem of catechizing the young can only be solved in connection with the religious education of mothers," wrote the bishops in 1942.[22] The response of Catholic women was sufficiently strong to allow the church to develop its *Mutterkatechese* program. One approach was to train "apostolic minded women and mothers" in religious questions and then let them work in smaller communities where no program yet existed. Protestants developed this technique even more fully, and it is possible that the bishops were taking their cue from them.[23] In some dioceses the clergy held monthly classes for mothers during which they were instructed on how to present to children the religious ideas relating to just one month of the liturgical calendar. Yet another approach was to run two-week workshops to train women in the basic truths of religion.[24] Thus, German bishops continued during the war to

pin their hopes for the loyalty of the youth on Catholic women.

To what extent did the catechistical efforts of Catholic women make any difference in turning the youth away from national socialism? Although we are still only able to respond impressionistically to this question, historians no longer assume great Nazi propaganda success. There was a process of alienation, and we can be sure that women contributed to it. A survey of Hitler Youth, which was taken after the war, indicates that only about 30 percent of this group accepted National Socialist ideology. Even when Hitler was secure in power, the *Edelweisspiraten* phenomenon demonstrates how shallowly Nazi ideology had penetrated the public mind. Parents—meaning mostly mothers, since the war had removed men from the domestic scene—and the schools worked together against the Hitler Youth, which both saw as hostile to their influence and traditional roles. In the judgment of one historian, women did make the difference in turning the youth away from nazism during the war years, because they were at one and the same time more religious than men and less likely by far to be members of the National Socialist party.[25] The work of women in the church clearly bothered National Socialists, even those in high positions. Late in 1941 Reinhard Heydrich wrote to Foreign Minister Joachim von Ribbentrop, calling specific attention to the church's effort to use women to catechize the youth in a manner that was inimical to the National Socialist *Weltanschauung.*[26]

The fact that the Catholic episcopacy could appeal in such basic matters as ideology to large blocks of the populace irked the National Socialist regime. In 1934, for example, thirty thousand sodality women jammed into the Cologne cathedral to hear Karl Joseph Cardinal Schulte's sermon against neopaganism.[27] The sodality's publication printed warnings that young women should not be deluded by the National Socialist fertility campaign, and, when they were forbidden to pursue this line of attack, *Die Mutter* instructed mothers on how to impart Catholic doctrine to their children. In the eyes of the secret police, the sodality formed an important nucleus through which the clergy could work to instill Christian values and beliefs in the country's youth after the regime had at-

tacked or suppressed religious instruction in the schools.[28] Although we do not know the extent of success of this rearguard action against National Socialist dechristianization, we have it on their own authority that the sodality sometimes succeeded in luring members away from the Hitler Youth and League of German Girls, both of which were outrageously anti-Christian and anti-Catholic.[29] National Socialists saw the sodality as a major influence working against their propaganda, which urged girls "to place the race and purity of blood above all other ideals."[30] As a result of growing adversity, National Socialist authorities decided to close some Catholic Girls' Sodality affiliates, which were branches of the Catholic Women and Mothers' Sodality.[31]

During the latter years of the decade of the thirties, the gestapo became increasingly alarmed by the sodality and the success of its work. The organization was growing and it was reaching more and more people.[32] One of its publications, *Mutter und Frau,* increased its circulation from 642,000 in 1933 to 920,000 in 1939, giving it a readership comparable to *Frauenwarte,* the journal of National Socialist women.[33] The fact that the sodality grew rapidly during the very years when the National Socialist antagonism or persecution of the churches, and of the sodality itself, was most intense is significant.[34] Joining the sodality was a way to voice a measure of dissent against the regime, and those who took this step were certainly aware of this. The sodality's increasing popularity and growing activism led the regime to suppress it altogether in 1939, at which time the gestapo removed the organization's records from its central office in Düsseldorf.[35] Ironically, the regime took this action under authorization of the February, 1933, decree "against Communist acts jeopardizing the state."[36] This was patently absurd; the bishops complained bitterly, pointing out that the sodality dated all the way back to the 1860s.[37]

The continued loyalty of Catholic women, above all the members of the Elizabeth Society, the league, and former members of the sodality, to the church remained an important factor when new challenges in the field of welfare arose during the war years. When at first the war went well for Germany and the prospect of a nazified Europe seemed real, the regime let

its plan for the monopolization of welfare be known and intro-
duced a new and more extreme racist policy—euthanasia. Let
us consider the role of women in the church's reaction to
these problems.

It was already clear in 1939 that the regime intended to
extend its monopoly over private welfare even further than it
had. Most welfare facilities—such as rest homes for the el-
derly, kindergartens, outpatient clinics—were still either in the
hands of Caritas or Inner Mission, or staffed by them, but the
NSV had nibbled away at them since 1936, and their person-
nel kept careful records to ascertain how many facilities re-
mained for them to seize.[38] At the same time the regime took
measures that seemed to call into question the ability of the
church to provide personnel in the future for its far-flung wel-
fare operation. A number of organizations, such as the sodal-
ity, had been suppressed, and a 1940 decree forbidding able-
bodied Germans from joining cloisters promised to create
serious difficulties.[39] Caritas's personnel was already strained
by the war (25,000 nuns, mostly under forty-five years of age,
were working in military hospitals) and by a 60 percent drop
in vocations to sisterhoods that antedated the decree forbid-
ding vocational recruitment.[40] Who was going to take the
place of the nuns who were serving the military and of those
who were older and nearing retirement? The picture for the
NSV was more positive. Provided it could recruit Brown Sis-
ters, the NSV would eventually dominate the welfare field.[41] In
1940, when it looked as if the war would go so favorably for
Germany as to soon be over, the NSV began to talk of cutting
out "nonproductive" welfare groups during the ensuing
peacetime. This meant that the "entire social welfare area
must be placed ever increasingly in the hands of the party."[42]
The bishops of the Catholic church, finally aware of the bank-
ruptcy of their policy of cooperation with the NSV, took this
threat in all seriousness.[43] By 1942 they realized that the NSV
planned to close Caritas down altogether.[44]

The only way the church could defend against exclusion
from charitable work, which it saw as essential to its mission,
was to find new volunteers at the parish level. At the outset of
the war interest among the faithful in Caritas was still lethargic;
while some dioceses contributed more generously to it in

1939 than before, others slacked off.[45] Even though progress in this area during the previous decade had been very limited, renewed efforts were made during the early 1940s to recruit new members for Caritas. In the past enlisting new members had meant women, primarily, and the absence of men because of the war could only have accentuated this. In August, 1940, the bishops turned to the parish clergy with the "urgent plea that they take care to build up in the parishes the true spirit of Caritas and that they recruit serious new members."[46] The response of Catholics to the new appeal seems to have been good. Although in 1941 there were still only a little over a half million officially registered members (the same as in 1939), there was now an additional half million who were active locally in parishes around the country but who were not publicly inscribed.[47] Just who the "unofficial members" were is not clear. One suspects that this new category was made available for those people who would come under pressure or be penalized by the NSV, or the party itself, if they were known to be Caritas members. The bishops were encouraged by this development and by the financial support for Caritas in spite of the war economy.

Even if Caritas was able to double its "membership" during the early war years, two facts should not be overlooked. First, the increase was a relatively modest one that left millions of German women still not engaged, and second, even with the additional supporters, Caritas's membership never exceeded the combined membership of the league, the Elizabeth Society, and the (by then suppressed) sodality. This suggests, along with the fact of male disinterest in charity and their involvement with the war, that the women of these organizations provided Caritas with the bulk of its members from 1939 to 1945. We might further speculate that many of the new half million members were women who had been in the sodality until its suppression in 1939. Finally, it seems likely that the euthanasia issue drew the line between National Socialist and Christian welfare philosophies more sharply than ever before, causing additional numbers of Catholics to follow the dictates of conscience.

Euthanasia constituted a second area of sharp conflict

between the Catholic church and national socialism during the early years of the war. We cannot claim, of course, that only the voices of women were decisive in dissuading the regime from an open and public pursuit of its euthanasia program. German bishops spoke out forcefully and unequivocally against the program, and their denunciation of it was decisive. The minutes of the Fulda Bishops' Conference of 1940 show that the Catholic hierarchy condemned euthanasia for being against both the natural law and against Christ's teachings.[48] During the following months German bishops spoke out repeatedly, both individually and collectively, against euthanasia and the National Socialist propaganda film, *I Accuse*.[49] Given their performance record, we might question whether the bishops would have been so explicit and forceful in their denunciation of the program had they not had the support of the Catholic populace behind them. Of course, the National Socialists provided much of the fuel for the fire themselves by handling the paperwork of the program, which was offensive to most Germans anyway, in a shamefully crude manner.[50] Still, history has credited the Catholic church with being the only organization in Germany to take unanimous action against the euthanasia program and forcing Hitler, at the height of his power, to rescind the action, at least in public.[51]

Women helped thwart the euthanasia program in ways more direct than anonymous opposition and protest. When NSV personnel of the sterilization and euthanasia programs came to Catholic institutions to take away the mentally handicapped and the infirm elderly, it was not the staff in Caritas headquarters who had to act in an emergency situation but local women volunteers. Although Catholic sisterhoods usually ran the homes for the mentally or physically handicapped, lay volunteers helped staff them.[52] In two Berlin institutions in 1937, eighteen of a combined staff of thirty-five were not nuns. Some of the laywomen held high positions, sometimes even that of director.[53] The war may have had the effect of increasing the number of laywomen involved in institutional charities as the service of nuns in military hospitals took its toll. Whether nuns or laywomen, it fell to these people to protect their patients when the readily identifiable bus for transferring

victims to a euthanasia facility—German children called it the "murder box" when they saw it going down the street—appeared before their facilities.

Before actually killing people, the personnel from the Reich Enterprise for Health and Welfare Facilities (*Reichsarbeitgemeinschaft für Heil-und Pflegeanstalten,* or, in Nazi jargon, "T-4") transferred them from one part of the country to another so as, evidently, to get them as far distant from their relatives as possible.[54] Consequently, Caritas women who ran Catholic homes were frequently put in a position of having to protect their wards. In Berlin Margarete Sommer sought out social workers for Catholic homes who could be depended upon to protect the physically or mentally disadvantaged children whose lives were endangered.[55] Although exact data has not yet come to light, there are indications that Catholic women managed to protect many of their patients. T-4 killed about 70,000 people in six euthanasia facilities in 1941 and 1942.[56] Roughly 10,500 of these victims were mentally retarded Catholics.[57] Whether or not this number includes the physically handicapped is not certain, but if the statistic for Catholic victims is reliable, we can safely assume that church volunteers succeeded in harboring many potential victims. As some Elizabeth Society members from Berlin said at a meeting held shortly after the war, "How often did we have to hide the feebleminded protectively behind us to shield them from referral to one of those houses where imminent death was a certainty?"[58] Protecting the disadvantaged from T-4, either by falsifying records or by physically hiding people, meant that Catholic women were violating National Socialist law.

What we are dealing with here is dissent. The women who sought to preserve the Catholic ideal of womanhood, who worked to foil National Socialist dechristianization programs, and who protested or even sabotaged the euthanasia adventure of the regime, knew that their actions constituted dissent. There is no way they could not have known this given the gestapo's suppression of the sodality and its censorship of Catholic women's publications and harassment of individual women. High-ranking National Socialists recognized that the way to break down the church's influence over society was by "attacking Caritas, catechistical work, and the religious bond

[the church] enjoyed with women and mothers."[59] In 1941, when the Catholic bishops released a pastoral letter that the regime viewed as a "sharp, unmistakable" attack on the Third Reich, the gestapo linked women's activity to the statement. There is no doubt, then, that opposing National Socialist dechristianization and euthanasia policies constituted dissent.

The question is rather, how many women were willing to engage in dissent and how far were they willing to carry it? While there may have been millions of Catholic women who sided with the church when it came into conflict with national socialism, the number of those who were willing to become personally engaged in the conflict was strictly limited. Even though German bishops urged women to join Caritas, its membership barely exceeded one million, including some men. The membership of the sodality was also about one million, but we might reasonably assume that some sodality members had been Caritas members for some time, and that many of Caritas's new wartime members came to it from the suppressed sodality. We might estimate then that the number of Catholic women who were ready to register dissent beyond the walls of their homes was in the neighborhood of one million.

It would be wrong, however, to think of them as an army, one million strong and in lockstep. Most women did not wish to carry dissent too far. Of the three organizations of Catholic women, the sodality was least inclined to all-out conflict. Although it defended the Catholic ideal of womanhood and was ultimately suppressed, it had also temporized with national socialism. One of its publications, for example, told women that faith had nothing to do with nationality or race, but it praised the NSV's pronatalist programs, even those that were ideologically racist, and it allowed the NSV to advertise in *Die Mutter* for its recuperation homes for mothers.[60] Thus, there was an ambivalence in the sodality's attitude toward national socialism that was more evident than in other organizations of Catholic women. Joining the sodality was a way to register dissent without shouting it from the rooftops.

This modified dissent is the reason why the sodality, rather than the league or the Elizabeth Society, grew and prospered during the 1930s. Its growth during the early part

of the decade could be explained in terms of its having more appeal among Catholic women than the more feminist league, but this argument lacks validity thereafter when feminism ceased to be a factor of life under National Socialist rule. Most surprising is the lack of growth of the Elizabeth Society, which was restructured during the early thirties, linking it to Caritas in such a way as to encourage women to join. Any woman who joined Caritas (by paying the annual dues) automatically became a member of the Elizabeth Society if she so desired. Not many did.[61] As we have seen, the response of Catholic women to the bishops' repeated appeals on behalf of Caritas was meager, and among those who did respond, the overwhelming majority were not interested in personal involvement. If Catholic women had wanted to register dissent, membership in Caritas and the Elizabeth Society offered the opportunity, especially after the euthanasia issue took on such high visibility. It is revealing that the half million new members who came to Caritas just at this time did not choose to join the Elizabeth Society and even kept their association with Caritas a secret through "unofficial" membership.

We may conclude then that only a small nucleus of Catholic women stood ready for unequivocal dissent, open protest, or resistance. Such an attitude invited more or less unrelenting conflict with the National Socialist regime and exposed a woman and her family in surveillance by its agents in the NSV, NSF, or gestapo. There are many examples of women who risked this adversity. Babette Seitz, president of the league in the Palatinate, invited conflict when she attended the funeral of a Jewish man in 1936.[62] Dr. Gerta Krabbel openly protested the regime's seizure of the league's two educational institutes for women, and she tried to continue the league's advocacy of women's rights. In *Gau* Franconia Caritas women hotly disputed Julius Streicher's interference in the church's summer vacation programs for children.[63] When the NSV pushed Caritas out of the WHW in Aschaffenburg, Bertha Elizabeth Runkel urged the central office to do something about it: "In my opinion it is intolerable that we are obliged to allow this to happen [and] that such problems can be created for our welfare program."[64] But other Catholic women, even some members of the league and of the Eliza-

beth Society, were unwilling to carry dissent to any extreme. When the NSV and NSF became more hostile toward the league in 1936 (questioning its adherence to article 31 of the Concordat), some members wanted to take up the challenge "and be more active again." They discovered, however, that other members, disliking the aura of dissent that league work carried, refused to rally around them.[65] Similarly, the Elizabeth Society reported after the war that "not all [of its] affiliates were up to the test" of protecting Jews.[66] Thus, even within the two smallest organizations of Catholic women, many individuals wanted dissent to remain safe and discreet.

Above all, dissent remained disassociated from the "Jewish Question," which was treated as a civil but not moral issue. It is important to state this as an historical deduction but difficult to explain its historical underpinnings. Sarah Gordon has found that popular support for National Socialist anti-Semitic policies increased between 1935 and 1938.[67] On the other hand, Detlev Peukert believes that the return of normalcy took the wind from the ideological sails of nazism by 1936.[68] While these points of view may be resolved in the sense that economic normalcy for the "Aryan" was achieved, partly, at the expense of the Jew, they do not go far in helping us to understand why churchgoing Catholic women did not lend moral currency to the anti-Semitism. Putting the question in a religious context casts it in sharp relief. As H. D. Leuner has pointed out, few people, even among the clergy, understood that the evangelical command to love one's neighbor "included all human beings, irrespective of race and color."[69]

As Hitler led Germany into war, National Socialist racism drew near to its last phases: the deportation and eventual murder of Jews. It is important for us to note that a small nucleus of Catholic women were prepared to take a stand and to intervene on their behalf. These few women took the courageous step from dissent to resistance. For the overwhelming majority, however, dissent would not escalate this far. We must explain this, it seems, by the fact that churchgoing Catholics related Nazi racial policies to Catholic doctrine as it stood to affect them personally or their families. Religious awareness prompted Catholics to guard against Nazi racial tenets that might weaken their faith or observance of it. But this view re-

mained intramural; it did not embrace the Jewish Question. Perhaps the anti-Semitic policies of the Hitler regime made it a civil rather than moral question in the public mind.[70] For whatever reasons, most Catholics did not give moral currency to Nazi anti-Semitic policy.

9
Cross or Swastika: The Estrangement of Protestant Women

hen Hitler's movement was becoming popular in Germany in the early 1930s, banners showing the Christian cross and National Socialist swastika were a common sight in parades and in churches. A number of books and pamphlets appeared carrying the title "Cross and Swastika." But after a few years of experience with national socialism, many Protestant women began to think in terms of "Cross *or* Swastika." The trial of Agnes von Grone caused many church-going Protestants to wonder about the relationship between religion and national socialism. The events preceding the trial were common knowledge, since *Der Bote* was used by the Auxiliary to inform women of the organization's position vis-à-vis the Reich Church and Pastor Hermenau's Protestant Women's Service. Regional auxiliary women came to the support of von Grone when she fell under attack first by the Reich Church and then later by the National Socialists themselves. It was a national event that carried local meaning because of frequent neighborhood rivalry between the auxiliary and the ser-

vice or the NSF. The predicament into which Agnes von Grone had fallen was understood or felt by countless anonymous women.

The von Grone trial, however, was not so much a cause of the changed attitude among Protestant women as it was a startling signal that change was occurring. Other issues that were both ideological and practical in nature triggered attitudinal shifts, and they persisted as areas of conflict with the regime from the middle of the decade to the war's end. The timing of the change in mentality would have varied according to several factors: the strength of local NSF women; the degree of strain between local NSF and auxiliary affiliates; the early success or failure of the service movement of Pastor Hermenau; the amount of influence of local clergy, be they Confessing Church or German Christian, and, finally, the attitude of regional and local party officials toward the auxiliary. As a rule of thumb, we could say that by the end of 1936 practicing Protestant women knew that, while they still might have an attraction toward Hitler, their belief set them apart from some aspects of his movement.

The high expectations, once dashed, gave way to disappointment, and the new attitude is reflected in the pages of the auxiliary's newspaper, *Der Bote.* Gone was the bloom, the enthusiasm, the anticipation, the triumphalism of the early years of National Socialist rule, and, in their stead, disappointment, reserve, disagreement, and a distinct taste of bitterness crept in between the lines. The feeling of disillusionment, however, was not allowed to spill over onto Adolf Hitler himself, who continued to be idolized from afar. "If Hitler only knew what was going on here in his name, he wouldn't stand for it" was a common attitude. Nor did disappointment appear to greatly diminish the nationalism of Protestant women. Nevertheless, an uneasiness enveloped those Protestant women who were committed to their faith as they began to see in the second half of the decade that doing one's duty as a German and as a Christian did not perfectly coincide. Their reaction expressed itself concretely in a Scriptural renewal program, the energy behind which was provided entirely by women.

A principal reason behind the Scripture program was cer-

tainly ideological. The implications of the racial tenets of national socialism became increasingly clear. At times this awareness would take the form of opposition to the regime's anti-Semitic policies, but more often it was still confined to the ramifications of racism for religion. As the years of Hitler's rule unfolded in the latter thirties, it became clear to many auxiliary members that what had begun fondly in the land of Martin Luther as a völkisch religious renewal was ending up grotesquely as a religion of the Volk (German Faith Movement).

The racial conflict was brought home to Protestant women more commonly and immediately in the school question. During the Weimar Republic Protestant women had detested educational reforms that attempted to remove sexism from the curriculum, and they had applauded National Socialist rhetoric on educational reform.[1] The Nazis would put an end, once and for all, to the hated secular schools, which were to give way to the influence of "positive Christianity."[2] But what Protestants expected never materialized. Instead, the National Socialists pushed their own brand of racial secularism, which aimed to deprive children of exposure to Christian principles as early as kindergarten. Accordingly, many a Protestant mother found herself confronted with the racial question when her children reached school age.

The reaction to National Socialist racial ideology was provided by women of the Confessing Church, some of whom were engaged in dissent in the latter years of the decade and in resistance during the war. Ever since the Protestant Church Struggle, National Socialists had held Confessing Church people suspect on a broad range of ideological questions. We have already seen how this issue was raised in the trial of Agnes von Grone. *Reichsfrauenführerin* Scholtz-Klink refused to have anything to do with the Protestant Ladies' Auxiliary because she said it had chosen the Confessing Church side instead of the Reich Church in the Protestant Church Struggle. But this was an oversimplification on the part of Scholtz-Klink. There was a middle group of Protestants—those who favored Superintendent Zoellner's attempts to reconcile church and state. Another problem is that within the Confessing Church itself there was a range of attitudes, not perfect unanimity. Thus, as we go about trying to identify which women were

dissenters, it is important to keep several factors in mind: many churchgoing Protestant women were not Confessing Church members, many auxiliary affiliates were not Confessing Church subgroups, and the degree of dissent within the Confessing Church itself was wide.

Before there could be any dissent, an attitudinal change had to take place among Protestant women. There was, without doubt, a great change of heart in the middle part of the decade, and it appears to have affected all auxiliary members and probably hundreds of thousands of other Protestant women. This resulted both from day-to-day conflicts that originally may not have been perceived by all Protestant women as ideological in nature. But it was clear to everyone that local NSF-auxiliary relationships changed drastically when Protestant women found themselves shut out of all aspects of communal welfare—health, education, and public relief. For some reason, perhaps because of their self-identity as the majority group, this exclusion seems to have been more psychologically disturbing for Protestant than for Catholic women. Certainly, nothing disturbed them more than being eliminated from mothercare work.

After having planted the seed and nurtured the growth of Germany's pronatalist movement, being summarily removed from it was a devastating blow. The situation in the Nordmark province can be taken as fairly typical. The auxiliary of this province regularly sponsored evening meetings for young mothers-to-be during which a doctor or midwife, teacher, and minister would discuss practical and spiritual aspects of motherhood. By 1933 over two thousand young women took part in this program, but in 1934 the NSF simply took over its work, "so that we had to reorganize completely our own program for mothers."[3] The reorganization meant that the auxiliary would only be allowed to deal with the spiritual aspects of motherhood, a restriction that made their program less attractive. Reports from East Prussia, Saxony, Brandenburg, Westphalia, Mecklenburg, and Holstein establish that the experience of the Protestant women of Nordmark was a national pattern.[4] After having popularized mothercare in the late 1920s and early thirties and having anticipated expanding this work in cooperation with the NSV, Protestant

women were appalled to discover that "as an Auxiliary we were eliminated from the [mothercare work] of the NSF."[5]

Once eliminated, it was virtually impossible to compete with the NSV in the natalist field. In the economically depressed early years of National Socialist rule, the NSV had been happy to use the homes and centers of the auxiliary, but they withdrew their support and participation from these facilities when better times permitted it.[6] The NSV's budget in the state of Baden alone rose from 684,000RM in 1935 to 8 million RM in 1939.[7] The National Socialist regime refused to distribute the funds it raised through the giant *Mutter und Kind* program to Inner Mission and Caritas. With generous funds at its disposal, the NSV could dot the countryside with its own facilities, providing women with free medical care, healthful countryside excursions, and recuperative vacations. By the end of the decade, Scholtz-Klink bragged that her program (meaning the NSV's) had sponsored over two million mothers, while the auxiliary could only claim to have assisted about one hundred thousand. Thus, Protestant women were eclipsed in mothercare work, an enterprise that they had pioneered and cherished.

Even if there had been ample funds, the auxiliary would not have been able to carry on. This was because of National Socialist racial principles. The director of the NSV, Erich Hilgenfeldt, intended to use the mothercare program to propagate healthy families to insure the triumph of the "Aryan" race.[8] When a client came to a NSV facility, she was to be racially indoctrinated as well as provided with health care. Although most Protestant women would have allowed some racial indoctrination in their mothercare facilities, the primary emphasis was to be religious. Reflection on the Scriptures and communal prayer were part of the diurnal schedule.[9] The NSV disapproved of this emphasis, and it rightly suspected that some auxiliary affiliates would object altogether to racist teaching. The von Grone experience, and the fact that the national auxiliary withdrew support from the NSV's publication *Mutter und Volk* because it had the "wrong slant" and opposed the Gospel in some respects, demonstrated that Protestant women could not be entrusted with racial instruction.[10] As a result, the NSV would only allow those women whom it

had discarded as racially unfit or unfruitful to visit auxiliary fa-
cilities: the sterilized, the genetically ill, and those over fifty
years of age.[11] For this reason we find that the auxiliary still
operated homes for mothers in its Brandenburg province in
1939, but they were greatly underused, since only occasion-
ally did NSV or NSF personnel refer clients to them.[12] Thus,
Mutter und Kind monopolized the entire field of mothercare
work by the beginning of the war.

Elimination from mothercare cut Protestant women to
the quick. They probably would have felt the loss less keenly
had they been able to direct their energy into other aspects of
community work. But this, by and large, was not to be. During
the second half of the decade of the thirties, the NSV progres-
sively pushed the auxiliary out of WHW projects, education,
and communal health centers.

The pattern of exclusion from WHW resembled the
mothercare experience. The big annual campaign of the
WHW for dry goods and funds was exactly the kind of local,
self-help that the auxiliary had always promoted. Affiliates
were pleased to be able to work with the new National Social-
ist regime, especially since Socialists sometimes refused to
cooperate.[13] But after having worked hand in glove with the
NSV in this very important relief operation in 1933 and 1934,
they found that their services were no longer wanted, or that
they would be allowed to collect for the WHW but not distrib-
ute relief to the poor, or that they could only succor those
whom the NSV had dismissed on the grounds that they could
no longer contribute to the health of the Aryan race.[14] Al-
though exclusion from WHW work was not as universal as
from the mothercare field, it was national in scope. The East
Prussian province of the auxiliary reported matter-of-factly in
1937 that social relief had passed "into others' hands in our
communities."[15] A similar report came from Protestant
women in Brandenburg at about the same time.[16]

Had the NSV been in a position to do so, it would have
also taken over all communal health centers, which it re-
garded as vital for disseminating "racial instincts."[17] But the
NSV faced a serious problem here because of its inability to
attract young women to its nursing staff, the Brown Sisters.
For this reason the NSV had to be content with taking over a

few choice centers of the church, or with letting Red Cross personnel, whom it preferred over churchwomen, run its centers.[18] No comprehensive data on the decrease of church-operated communal health centers exist, but it is clear that the regime had not succeeded in removing Protestant women from this work by the time the war began. In East Prussia NSV centers outnumbered those of the church by 383 to 183, but in Württemberg they were about evenly divided. In Westphalia Protestant women worked as volunteers in four hundred of the church's communal centers, fifty-one of which were operated entirely by the auxiliary. Unable to eliminate church-operated communal health centers altogether, the regime found other ways to interfere with this work. German Christian administrators in Westphalian and Rhenish provinces withheld church funds from certain auxiliary health centers because of the their ties to the Confessing Church and because they did not "stand without reservations behind the National Socialist state."[19]

In the field of education things developed similarly; the NSV wanted the church to leave the care of children to them so that they could be properly indoctrinated, but the work was too vast. Still, the NSV took huge bites out of the church's educational operations. It was able to amass many day-care centers in a relatively short period of time by simply taking them away from the churches. In Saxony church kindergartens were banned altogether.[20] If, as frequently happened, a daycare center's sponsor was a combination of community and church interests, the NSV would seize the facility on the grounds that ownership could not be determined. Of course, auxiliary kindergartens were an easy prey, since local NSV or Protestant Ladies' Service members could claim that these facilities really belonged to the Reich Church.[21] What was particularly annoying about the way the NSV went about cutting into the church's work with children was its spottiness. Church-run kindergartens were being forced to give away to NSV kindergartens while nearby communities had no facility at all.

It is clear that the National Socialist regime had its sights on complete control of children's formation.[22] NSV director Hilgenfeldt negotiated regularly with state bureaucracies to effect transfers of kindergartens and daycare centers to his or-

ganization, and Martin Bormann urged *Gau* leaders to do the same.[23] This goal could also be accomplished by attrition: closing the Protestant institutes for training kindergarten personnel.[24] But national socialism ran out of time. Thus, at the beginning of the war the NSV controlled 567 daycare centers in southwestern Germany, not quite as many as Inner Mission and Caritas combined.[25] In the church province of Wiesbaden, Protestant kindergartens dropped from 70 to 46 between 1935 and 1940.[26] Nationwide, the Protestant church lost about four hundred facilities during these years, and the number of children in its care dropped by 40 percent.[27] Auxiliary women worked as volunteers in many of the church's facilities, but in 1935 it operated 7 orphanages, 121 kindergartens and daycare centers, and 14 children's vacation camps completely on its own. In all likelihood, many of the facilities taken over by the NSV would have been those of the auxiliary because of its relationship with the Confessing Church.

The total exclusion of Protestant women from mothercare work, their extensive exclusion from the WHW, and their partial elimination from education and communal health work left auxiliary members feeling estranged from the National Socialist regime and even, sometimes, from their own communities. As people saw what was happening to the auxiliary, their attitude toward it and toward active Protestant women began to change, although not always negatively. Women, perhaps former members of the liberal women's movement, who had been hostile toward the auxiliary during the Weimar Republic, warmed up to it when national socialism subverted it. Others, however, would ask, "What can you do for the people now that you can't offer them relief anymore?"[28] When auxiliary members set off for the meetings, they heard snide remarks: "You really ought to stay home. The auxiliary is about to go under!"[29] NSF personnel, in the driver's seat now, could be haughty, tolerant, or patronizing toward Protestant women.[30] If the latter, because of their long-standing commitment to communal service, wanted to work as volunteers for one or the other NSV program, it was on their terms.[31] Often, however, there was open hostility between Protestant women who had formerly acted as directors of local welfare projects (*Bezirksfrauen*) and their NSF successors.[32] In one

way or another, the position of the auxiliary in German communities had changed since the first half of the decade of the thirties.

As Protestant women found themselves on the outside looking in at communal welfare, the new perspective gave pause for thought. The differences between Protestantism and national socialism, either camouflaged by the latter or discounted by the former during the first part of the decade, began to be sorted out and thought through during the second half. As Protestant women became more mindful of these differences, racism emerged more clearly as the central issue. It manifested itself both in welfare and in religion.

1935 was a pivotal year in the awarenesses of Protestant women, just as it was for Catholics. That year the auxiliary published a pamphlet that explicitly attacked Alfred Rosenberg's racial teaching, and this issue arose for a second time in connection with the von Grone trial.[33] At a national auxiliary meeting held in August, 1935, Fräulein Lucas gave an address on the genetically handicapped that demonstrated that the organization had moved sharply away from its earlier position on this question: "The new state promotes the nordic heroic type and therefore guards against the handicapped as a mixed or inferior breed. We Christians know however that we will always have the sick and deprived among us for whom the church must be the last place of refuge, and that God chooses His witnesses also from among the most miserable."[34] The NSV said openly that National Socialist racial principles were the reason for the exclusion of Inner Mission and Caritas from the welfare field, and Protestant volunteers were quite aware of this.[35]

Protestants also became aware of the ramifications of National Socialist racial teaching for their evangelical principles around the middle of the decade. Some of the issues involved here, such as the efficacy of the Old Testament, were at the center of the Protestant Church Struggle and were therefore already well known. But issues relating to the apotheosis of the German race and dechristianization only became prominent after 1935. Thereafter, there was no more equivocation on the part of the auxiliary when it came to the Old Testament, which *Der Bote* affirmed again and again as the

word of God. After the German Christians renounced the Old Testament, the auxiliary began to fear that it would be under attack once again as it had been during the Enlightenment and during the last quarter of the nineteenth century. During Bible study meetings, which occupied Protestant women more and more after their exclusion from welfare, special attention was given to the exegesis of those passages of the Old Testament used by others to ridicule it.[36]

The auxiliary also spoke out against the apotheosis of the German race. The German Faith Movement, which organized in 1934 and became very visible and vocal thereafter, deified the Aryan race.[37] The movement was explicitly antichurch. Its members, like those of the Protestant Ladies' Service, were accepted by Scholtz-Klink as welfare volunteers. In this capacity they were quite visible because of the teutonic rune and swastika with rounded corners that they wore as a symbol of the German Faith Movement. Auxiliary women volunteers found this offensive to their church and faith and refused at times to work in NSV projects alongside of women wearing the German Faith symbol.[38] Thus, the conflict was a public one, and it was obvious that the issue behind it was one of race.

Because of the völkisch bent of many Germans, the German Faith Movement appeared to be dangerous to orthodox Protestants. The milieu out of which it grew contributed to the peril, because national socialism presented Germans with a pseudoreligion that was akin to the German Faith Movement. In 1937 a prominent spokesman of the regime said that "we believe that National Socialism alone is the redemptive faith for our people."[39] Auxiliary women reacted strongly against this deification of the nation and race and attempted to counteract "the increasing propaganda of the pagan movement."[40] Der Bote told its readers that true belief was not in a national "type, race, blood or soil, or in an 'eternal' German, but in the Holy Ghost."[41] The aura of neopaganism and dechristianization was kept alive during the second half of the decade of the thirties, encouraged by National Socialist attacks on the clergy, on religion, and on confessional schools. Thus, when "völkisch renewal" was stripped of its earlier ambiguity, Protestant women recognized that it was "commonplace for the Christian outlook and way of life to be con-

tested," and they became aware that their primary purpose in Germany's communities had to be to counteract the völkisch trend.[42]

In the ideological struggle nothing disappointed Protestants more than the school situation. After having been promised a school system imbued with a Christian spirit, the National Socialist community school turned out to be either anti-Christian or German Faith in orientation.[43] The regime viewed kindergartens as the educational key in the creation of the model Nazi follower.[44] National Socialist training centers for kindergarten personnel concentrated on racial demography, racial politics, racial history, and a Germanic racist "God belief" in place of Christianity.[45] A traveling Bible sister, reporting on her experience around the countryside, noted that "everywhere I found a circle of conscientious Protestant women doing battle with certain difficulties. . . . Most frequently I was confronted with the question of a true Christian upbringing. The schools have become an organ of the state and one cannot expect children to get a Christian education in them."[46] The reaction to this unexpected turn of affairs in education was widespread and deeply bitter among Protestant women, causing them to turn in greater numbers to the leadership of the Confessing Church.[47] Many churchgoing Protestants treated the school issue as an absolutely fundamental question upon whose outcome the country's Christian commitment depended.[48]

Protestant women responded to the challenge of dechristianization with two new activities, the Bible study program and a Young Mothers' Circle. The purpose of the latter was to help "young mothers who aren't aware that schools today no longer give Christian teaching."[49] Unable to influence women through its former mothercare activity, the auxiliary invited mothers who visited NSV mothercare facilities to its circle, where they were instructed on rearing their children from the standpoint of the Gospel in contrast or in addition to National Socialist principles.[50] At weekly, biweekly, or monthly meetings, emphasis was placed on instilling in youth a regard for the Scriptures, especially the Old Testament, and on teaching them the value of prayer.[51] The central office of the auxiliary developed an instructional plan, which was implemented

through the Young Mothers' Circle, to teach mothers how to tell their children Bible stories in an interesting and effective way.

More important by far in the confrontation with the National Socialist Zeitgeist was the auxiliary's Bible study program. The idea behind the movement was not to make contemplatives of Protestant women but to fortify them in the midst of the Protestant Church Struggle and enable them to counteract the effect that dechristianization and the German Faith Movement were having on the German people.[52] As an alternative to these ways, Protestant women wanted to develop interest in the Bible to offer it to the public as the "common property of the German People," or, in other words, as the source from which the country would draw its principles for day-to-day life.[53] Thus, the auxiliary set itself on an ideological collision course with the National Socialist *Weltanschauung*.

The Bible study program can be traced back to the 1920s, but after 1935 the work was greatly expanded and it took on an aura of urgency. To get Bible study quickly operational the auxiliary created a centralized crash program. The problem was that Bible study demanded an academic expertise that the ordinary Protestant believer did not possess. The clergy lacked both the time and the inclination to get involved in the program with women, not least because of the energy consumed in the Protestant Church Struggle.[54] So women decided to do it on their own. A person who was to act as the discussion leader in her community attended a two-day seminar on the Bible and then began to moderate discussions on the Scriptures in her home community. It soon became apparent that this was insufficient training, and so it was decided that week-long seminars around the country would have to be held. Lacking the personnel for such an extensive undertaking the auxiliary set up a Bible Institute in Potsdam under the direction of Deaconess Maria Weigle, the driving force behind the Bible renewal program. The women who completed the Potsdam course would form a nucleus of talent that, by working through the nationwide auxiliary network, could penetrate down to women even at the small community level. Through them, "the women of the communities would learn

how to use the Bible on their own, and would be capable of listening to the Gospel Word." [55]

The Potsdam Bible Institute opened its doors in November, 1936. For eight intensive months women followed a study course that concentrated on the Old and New Testaments and on pedagogical methods so that mothers could be taught how best to interest their children in the Bible. [56] By heavily subsidizing the institute, the auxiliary was able to draw students of varied age and educational backgrounds. [57] What these women shared were past experiences in church service either as deaconesses, youth counselors, or social workers. [58] A dozen women graduated from the Bible institute in 1937 and another twelve the following year. Working through the network of the auxiliary, these relatively few women infused the Bible program of the Protestant church with new life. The graduates, known as "Bible sisters," working full time and traveling all over the country, could hold as many as a thousand regional Bible seminars in the course of a year. [59] Regional auxiliary officers often took advantage of their underused mothercare facilities to house the Bible seminars, at which as many as forty women from the surrounding area participated. [60] In this way Bible study quickly spread up and down the land.

In 1935 and 1936, precisely when the auxiliary was shut out of mothercare work, Bible study workshops became the principal occupation of Protestant women. Cumulative data on the number of participants and workshops are not available, but it is clear that the program became very extensive. Over a period of two years, the Mecklenburg auxiliary ran eighty seminars, and in the Rhineland twenty counties sponsored a traveling Bible sister. [61] In Hamburg women met for two and one half hours weekly for ten months of concentrated Bible study. In Württemberg rest homes for mothers were converted into study centers. One such facility offered fifteen five-to-seven day seminars each year, which enrolled 150 women. Another former mothercare center gave even more intensive two-week courses. [62] Regular reports in *Der Bote* make it clear that Protestant women throughout Germany were sponsoring local Bible study. Thus, the extensive training of women on the national and regional level succeeded in giv-

ing them the familiarity with the Scriptures that they needed to lead discussions at the local level on a weekly or biweekly basis for the benefit of women at large in the community.

The auxiliary's new program set a tone of competition, conflict, and dissent in the latter part of the 1930s. Both the Young Mothers' Circle and Bible study were attempts to control the country's *Weltanschauung,* because of which auxiliary activists were constantly confronting questions posed by the National Socialist Zeitgeist: "Was Jesus a Jew or Aryan? . . . He must have been Aryan—He had such noble sentiments"; "Why is the Christian religion so divisive?"; "Was Jesus Jewish?"; "What does an oriental, Semitic religion have to offer the German people?"[63] Questions such as these, which were quite often formulated by the Hitler Youth or by women of the German Women's Enterprise or the NSF, engaged Protestant women in a public debate. As ideological polemic grew increasingly keen, Protestant women developed a confrontational attitude that contrasts sharply with their trusting, positive outlook of the early thirties. Auxiliary personnel and Bible sisters looked on themselves as "God's ambassadors" in a hostile environment, or as the church's "combat troops," or as fighters in "the front lines of the battle."[64] In a word, they became aggressive.

The Young Mothers' Circle and Bible study were apparently able to hold their own in the competition with National Socialist philosophy. By 1939 three thousand auxiliary affiliates had established contact with mothers through the circle and there was potential for more growth.[65] Reports from around the country reflected an upbeat mood. Even urban churches discovered that women responded favorably to the Young Mothers' Circle.[66] In some areas the church's counseling centers for young mothers were frequented more heavily than those of the NSV, and other church welfare services, especially kindergartens, were quite often preferred by the public over those of national socialism.[67] When the NSV retaliated by closing down church facilities in Baden and the Palatinate, it led to "open feuds," with the local populace taking sides.[68] Because the auxiliary's programs were a conscious effort to offer the public an alternative to National Socialist philosophy, Protestant women found that they had to "take a clear and

firm stand for their faith" when they became locked in controversy with the party's supporters.[69]

The shadow of the Protestant Church Struggle continued to hang over the ideological conflict between the auxiliary and national socialism. Women activists of the church were looked upon as Confessing Church agents, which, indeed, some of them were, and the auxiliary was considered by many to be linked to the Confessing Church in the same way as the NSF was to the NSV. This too was not infrequently the case. Consequently, even though the auxiliary protested its neutrality and even enlisted the services of Reich Bishop Müller in the Bible study program, it was constantly under suspicion. When the Bible sisters made their rounds, they were accused of propagandizing for the Confessing Church instead of proclaiming the Gospel. These women fell under the surveillance of the gestapo, which was very aware that, in their politics, philosophy, and racial attitudes, Confessing Church people did not stand fully behind national socialism.[70] Since local and regional auxiliary offices coordinated the work of the traveling Bible sisters, there was always an appearance—and sometimes certainly the reality—of conspiracy on the part of the auxiliary and the Confessing Church.[71]

National Socialists were especially irritated by the attitude of Confessing Church supporters toward Jews. Although the Confessing Church never publicly condemned or criticized the Nuremberg Laws, in the eyes of the gestapo it was "soft" on the issue of anti-Semitism and a bad influence on the public at large because of its sympathetic concern for Jewish Protestants.[72] *Der Bote* also failed to denounce the anti-Semitic policies of national socialism, but after 1935 it remained silent on this issue, no longer allowing its contributors to debate the matter openly in its pages. Gestapo agents filed reports linking Protestant women to Confessing Church pastors in work on behalf of Jews.[73] This perception stands in general agreement with that of *Sopade,* which reported in 1937 that Confessing Church supporters were considered "friends of the Jews" and that it came to the assistance of needy Jews.[74] The Confessing Church had originally rejected the "battle against Judaism" because it viewed the Jews as the Chosen People, but by the latter part of the decade opposition based

on religious principles was beginning to spill over to the secular world where it manifested itself in a concern for Jews' well-being.[75]

Many churchgoing Protestants, of course, were deeply anti-Semitic and did not object to National Socialist strictures against Jews. Thus, tension over racial issues was two-sided— within the church and between the Confessing Church and the party. The auxiliary had a special role to play in the ecclesiastical arena. In 1941, when all Jews were required to wear a yellow Star of David over their left breast in public, some Protestants refused to sit next to Jews during church services or to receive communion after them. Others went still further demanding separate services for Jewish Protestants.[76] When Gentile Protestants became upset over the prospect of having to attend worship with Jews, church authorities used the auxiliary to effect a measure of integration. Jews were to be ushered to certain pews for services, but their isolation was to be minimized by having women from the auxiliary sit in the same pews or nearby.[77] We can see from this that attitudes towards Jews were at times quite mixed in one and the same parsonage. The auxiliary could play an integrating role because its members tended to side with the Confessing Church, supporting religious over racial principles.

Although we can see that the activities of the auxiliary did not yet amount to resistance, the organization had a number of counts against it by 1936: its attitude toward Jews, its identification with the Confessing Church, its elimination from Scholtz-Klink's German Women's Enterprise, and its competitiveness with the NSV and its satellites. The degree of friction varied from one affiliate to the next, resulting in sporadic gestapo harassment.[78] Not infrequently, this took the form of shutting down local affiliates. Three were suppressed in Thuringia in 1938 and an additional three in a town near Cologne.[79] In all of these instances the gestapo took action against the auxiliary because of conflicts with the NSF. This was common. In 1939 the leader of the NSF in the Warthegau dissolved all auxiliary affiliates in her area.[80] Often simple identification, or alleged identification, with the Confessing Church led to harassment. Late in 1937 the gestapo seized a number

of pamphlets from the auxiliary because they were considered favorable to the Confessing Church.[81]

More often, harassment took the form of restricting the freedom of movement of the auxiliary. After its exclusion from Scholtz-Klink's German Women's Enterprise, the auxiliary's right to exist depended entirely on its definition as a religious organization. Consequently, members often found themselves confined to the church or church hall. Even meeting for coffee in public or attending a knitting bee subjected women to gestapo interruptions and immediate disbanding. Examples of this kind of ridiculous totalitarian interference abound during the latter part of the 1930s.[82] Thus, the auxiliary found itself under very regular surveillance by the gestapo.

Harassment on the part of the regime affected individual members as much as the organization itself. The president of the Brandenburg provincial auxiliary was called in for questioning by the gestapo in the summer of 1938.[83] In a small city near Berlin charges of disturbing the peace were brought against the president of the auxiliary along with five other women and the pastor, none of whom would agree to sign the complaint against them.[84] In Westphalia, a hot spot of German Christian–Confessing Church rivalry, Protestant women were told that, if they did not get out of the auxiliary, their husbands would be ousted from the party.[85] Frequently, local party officials or women of the NSF circulated sign-up sheets that proclaimed the signatories' resignation from the auxiliary. Not to sign one's name jeopardized the family—the husband whose job might be lost or downgraded and the children who would be subjected to ridicule from National Socialist youth organizations.[86] Reluctantly, the auxiliary member was forced in this way to give in. In other instances in Westphalia and East Prussia, women were told to get out of the auxiliary simply because it belonged to the Confessing Church.[87] Although these cases were minor affairs with no catastrophic outcome, they demonstrate that Protestant women were involved directly in church-state tension.

During the war years, a few Protestant women took the final step from dissent to resistance. This usually manifested

itself in concern for Jews. Protestants finally began to deal with
anti-Semitism as a humane issue rather than a religious one. In
other words, they began to offer welfare to the needy and to
hide Jews. Although we do not yet know much about its op-
eration, a support group functioned in the area around Berlin
whose purpose was to provide food for the city's Jews. Dea-
conesses went around to more rural congregations collecting
perishables from farmers. These provisions were then distrib-
uted either to poor Jews who had not yet been deported to a
concentration camp or ghetto, or to a family that was hiding a
Jew and needed food beyond what its ration card permitted.[88]
Unaware that certain death awaited Jews in eastern Europe,
some Protestant women helped them in their hour of need by
standing by and assisting them during their deportation or-
deal.[89] Later on, when the truth of the meaning of "transpor-
tation" became known, women helped hide Jews. We have no
idea of how many were involved in this effort, but women like
Inge Kanitz, working in the Bonhoeffer or Grüber circles, were
directly involved in hiding and providing for Jews who were
seeking to evade deportation.[90]

This humanitarian activity took place among Protestants
associated with the Confessing Church. Even in this circle it
was extremely difficult for Protestants to shed the anti-Semitic
bias that years of tradition had implanted in their church. Thus,
when the question arose as to whether Jews could or should
attend services with Gentiles, one Confessing Church congre-
gation decided they could attend and sit wherever they
pleased, but they should not enjoy the privilege of distributing
communion.[91] For many Protestants the excessive brutality of
the National Socialists toward Jews during the war years was
required before they were able to break free of their own anti-
Semitism. There were a few courageous exceptions. Elizabeth
von Thadden, who signed the Confessing Church's 1936
Whitsunday Petition protesting National Socialist interference
in church matters, went on to become involved in resistance
work. Von Thadden was brutally executed by the Nazis during
the war.[92]

It is clear that some Protestant women, most of whom
were members of the auxiliary, were involved in dissent and
that a few were involved in resistance. While it is obvious that

the number of the latter was severely restricted, the number of those engaged in some degree of dissent would have been considerable. Just exactly how many took part in dissent and the degree of dissent varied from one auxiliary affiliate to the next. Certainly, not all of the auxiliary's one million members can be counted among the dissenters, and auxiliary affiliates and NSF affiliates were not always at war with one another. If, at the local level neither the NSF nor auxiliary leader was ideologically rigid, it was quite possible for Protestant women to get along with NSF women for most of the decade of the thirties. Even after Scholtz-Klink drove the auxiliary out of mothercare work, there were places where Protestant women cooperated with the NSV in natalist projects.[93] Some Protestant women were pleased to see the NSV take over the mothercare field simply because it meant that programs could become far more sophisticated than the limited church funds would ever have allowed.[94] When the gestapo began taking action against the auxiliary, it tended to be local and sporadic rather than regional and systematic. Many affiliates came away with only minor skirmishes with authorities.

On the other hand, there is no doubt that the auxiliary's Bible study program emphasized a Christian rather than National Socialist ideology, nor that its participants were aware of this. The ability of the auxiliary to disengage itself from mothercare work and abruptly redirect its energies into Bible work testifies to the vitality of the organization. Serving a cause inspired Protestant women, leading them to give more time to the auxiliary as volunteers and making the Bible and young mothers' programs viable. In devoting themselves to these new efforts, Protestant women knew "that the work which the Auxiliary finds before it nowadays is more difficult and fundamental than before. Some matters which were of lesser importance [mothercare] have been taken from us, but what is really important [Bible study] has not."[95] Although auxiliary members were depressed about being turned out of mothercare work, they turned to the Bible program with determination, perhaps devoting greater effort to it than previously to mothercare. In 1934, when the Westphalian auxiliary sent out 785 questionnaires concerning the National Socialist *Mutter und Kind* fund drive, it received only 255 replies.[96]

Needing information about its members and their Bible work, the Nordmark auxiliary sent out 130 questionnaires in 1937 to its affiliates and got responses from 102 of them.[97] Thus, Protestants turned with dedication to the Bible program, which became a "service to the church so that the Gospel of Jesus Christ would be heard."[98]

Commitment to the Confessing Church or to the Bible program caused many Protestant women to take a public stand in their communities. Being an active auxiliary member brought individuals into conflict with party authorities, with Scholtz-Klink's NSF personnel, with the gestapo, and into open rivalry with the NSV. We could say that just being a member of the auxiliary branded a woman as slightly suspect on one end of the scale and as an outsider and dissenter on the other. Beyond any doubt, the National Socialist era thrust Protestant women into controversy and into the hubbub of community life. Nor should we overlook the impact that the auxiliary had on the German public at large. An organization of a million members whose principles differed patently from those of the National Socialist party, would be a matter of great concern to a totalitarian regime. Had the auxiliary's membership been in decline, National Socialist authorities could have felt reassured that its influence on the public presented no long-term problem. But, as we will see in the concluding chapter, German women were joining, not abandoning, the auxiliary.

During the late thirties and the war years, Protestant women awoke to the reality that serving both church and state might not be possible. Credal loyalty began to pry religion and nationalism apart like flesh from bone. Conscientious Protestants desperately wished to see the conflict resolved: "Because we affirm the great deeds of the Führer and the Third Reich on the one hand, and wish to remain Christians, on the other, we must seek a solution to this tension. . . . We must not allow ourselves to become stuck in a paralyzing divisiveness between Christianity and Germanness."[99] Wanting to postpone or avoid a final rupture altogether, most Protestant women sought to confine conflict to local targets. Their disappointment and anger was directed at known community figures, whether NSF or NSV personnel or party bosses, and

was not allowed to spill over onto national politics or leaders. National Socialist racism or that of the NSV was never denounced; Hitler's adventuresome foreign policy was staunchly supported (although there was markedly less enthusiasm among Protestant women for World War II than for the Great War); and Germany's military tradition was paid homage and the Führer himself enthusiastically acclaimed.[100] Yet, hearts beat uneasily inside those Protestant women who had come to realize that any final answer to the conflicts between Christianity and national socialism would not come from Hitler but from the Bible.

10

Catholic Resistance: Margarete Sommer and Germany's Jews

During the desperate years when Germany's Jews faced emigration, deportation, and mass murder in eastern Europe, Margarete Sommer was in charge of a church office in Berlin whose sole purpose was to help them. In this capacity Sommer became acquainted with all aspects of the ordeal that Berlin and German Jews faced. As a result of this work and of her ability to obtain information on anti-Semitic actions by the National Socialist regime before they took place, Sommer became the principal adviser to the German episcopacy on Jewish affairs. A study of this remarkable woman offers keen insights into what Catholics and the Catholic church did and did not do on behalf of Jews during the years of their escalating persecution.

Most of the actions of Sommer and her Berlin circle on behalf of Jews fell short of resistance. Sommer's work often dealt with religious questions such as the proper conduct of Catholics during church services at which Jewish converts were present, or the inviolability of a sacramental marriage in

which one of the partners was Jewish. Although they probably should not be counted as outright acts of resistance, other activities, such as obtaining visas and providing for elderly, impoverished Jews, were of questionable legality in National Socialist Germany. But the point is that Sommer's circle of Berlin Catholics were drawn closer and closer to resistance as the National Socialist persecution of the Jews grew ever more extreme until in the end they hid Jews who faced deportation.

In taking up Sommer's story we need not break off our study of Catholic women's associations or of their work with Caritas. Sommer herself was a member of the Catholic German Women's League; in certain respects, she epitomizes the type of woman who was attracted to this Catholic but liberal organization. Sommer spent her entire life in social work, having taken her doctorate in the field in 1927 from the University of Berlin where she wrote her dissertation on the rehabilitation of convicts. She then worked for the Prussian state welfare office as a university lecturer in several different schools before being released "under severe political pressure" by the National Socialist regime in 1934.[1] Unlike most league women, Sommer was able to carry on as a specialist for women's affairs during the National Socialist era, in which capacity she was first hired by the Berlin diocese. Many other women in Sommer's Berlin circle were active in the league or the Elizabeth Society; some held regional or national offices in these organizations. Sommer's work brought her into direct contact with the Caritas organization. In focusing in on Sommer and the Berlin circle, we can hope to gain insights into how Catholic women functioned under National Socialist rule. We lack evidence to assert, however, that Berlin was a microcosm of national efforts on the part of Catholic women.

Yet, Sommer's influence clearly extended beyond the city of Berlin. Her historical significance lies in the fact that she used her Berlin experiences to try to influence the conduct of the entire German church in matters pertaining to Jews. In many parts of the country Jews had become something of an abstraction for Germans either because they had lost their ethnic identity or because they constituted only a very negligible portion of the population.[2] But this was hardly the case in the city of Berlin where there were 190,000 Jewish citizens

in 1936 of whom about 40,000 were Christian.[3] Through her work with Catholic Jews, Sommer became sensitive to the burdens that national socialism had placed on the entire Jewish population. "The difficulty of this work," Sommer wrote after several years' experience, "lies in the fact that those affected [by National Socialist anti-Semitism] are psychologically deeply depressed because of the hopelessness of the efforts [to help them]."[4] In addition, Sommer noted, those Jews who had become Catholic felt that the church did not care enough about them in their plight. Having become aware of their problems, Sommer dedicated herself to helping Berlin Jews. It was clearly her personal involvement with them and her sensitivity to their predicament that led her to try to raise the awareness of the entire church to the desperateness of their situation.

The office that was created in 1935 to help Berlin Jews and which Margarete Sommer would eventually run, was called Special Relief of the Diocese of Berlin (*Hilfswerk beim Ordinariat Berlin*), a title that gave no hint of its purpose. Since nothing helped Jews more than a passport out of the country, special relief spent much of its resources in this effort. But it also dealt with the innumerable and ever mounting problems of the Berlin Jews who could not emigrate.

In their work on emigration, special relief acted as a branch office of a national Catholic emigration service called the St. Raphael Society, which had been in existence since Germany's unification. When the National Socialist regime began persecuting Jews, those who had converted to Catholicism turned to the Raphael society for assistance in emigration.[5] Much of Sommer's energies and the funds of the special relief office were spent in obtaining emigration papers from the German government and visas from host countries in Europe.[6] Unfortunately, this usually meant France or Holland.[7] Those who emigrated to these countries found themselves trapped in the Nazi web a second time due to German successes during the first years of World War II. It fell then to special relief to try to resettle these people once again (usually in Brazil).

After 1938 parents, whose children were classified by the regime as *Mischlingen* ("part Jewish"), often applied to special

relief to find homes for their children outside Germany.[8] In 1939 about one of every four of the approximately one thousand applications for emigration facilitated by the special relief office was a child. Between 1934 and 1939 about two thousand German Jews succeeded in getting emigration and visa papers through the St. Raphael Society. Roughly 20 percent of these Germans were Berliners.[9] These figures may strike us as relatively low (but certainly not insignificant); they must be understood, however, in the context of the difficulties involved in securing passports and visas. The Raphael society dealt with almost 100,000 applicants before placing only two thousand people. The ratio in the Berlin special relief office would, of course, have been very similar.

Finding funds for their work was a problem for the Raphael society and for the Berlin diocese's special relief office. In a span of five years the society spent about 360,000RM for emigration. Roughly half of special relief's funds went for the same purpose, even though the needs of the huge majority of Berlin Jews who were not able to emigrate grew steadily greater. The National Socialist regime did not allow public fund drives that would benefit Jews, nor did it allow funds collected by Caritas to be used on their behalf. This meant that records had to be juggled, and money "laundered" so that funds could be put at the disposal of special relief. Bishop Konrad Preysing of Berlin found it impossible to support the work of his diocesan office from funds at his disposal from within the city and those allotted to him from the Raphael society. Arguing that the large concentration of Jews in Berlin constituted a special case, he appealed to other bishops to contribute regularly to his special relief effort, especially to offset the required emigration fee.[10]

Budgetary problems of special relief were shared by the Reich Association of Jews in Germany (*Reichvereinigung der Juden in Deutschland*), the organization to which non-Christian Jews applied in order to emigrate. Consequently, the two offices cooperated with each other, sharing costs of families that were part "Aryan" and part Jewish. In Jewish-Gentile marriages the Reich association of Jews would pay emigration expenses for the Jewish party or parties. There seems to have been some disagreement between the two offices on this

point, but by and large they cooperated.[11] In 1940, for example, the Reich association of Jews referred eighty-four applicants to the special relief office, not because of the expense involved but because it was thought that they stood a better chance of obtaining emigration papers if they were processed by a church office.[12] The case of Alfred Fabian also illustrates Catholic-Jewish cooperation. Fabian was held in a detention camp in 1939 but could be released if funds to travel to Shanghai, China, for which he held a visa, could be found. His expenses ended up being shared by the Jewish community (840RM), the Raphael society (200RM), and special relief (sum not known).[13] Cases like Fabian's seem to have been common.

Although the special relief office was set up to help Catholic Jews, it was impractical to insist on confessional conformity. Records were kept on the date of conversion of Jews who applied to the Berlin office for emigration assistance. Evidently, this was to avoid "conversion" for the sole purpose of improving one's chance to emigrate. But as the situation of Jews became more and more desperate, this would have amounted to an absurdity. A study of Margarete Sommer's notebook shows that about 20 percent of those whose emigration she assisted were non-Christian Jews and that an additional 20 percent were Jewish converts to Protestantism.[14]

Although special relief served as a branch office of the St. Raphael Society, its objectives were much broader. The Berlin office attempted to provide moral support and welfare assistance of every sort for Jews. Originally, this meant Catholic Jews, since the Reich association provided this service for others. When Ursula Benningson converted to Catholicism in July, 1939, her parish priest wrote to special relief to say that she should be given assistance (meaning, evidently, that her conversion was sincere).[15] As the situation of Berlin Jews became more and more desperate, confessional preference lost importance. Almost half of the men who received assistance from special relief in 1939–40 were non-Christian Jews.[16] The kind of help provided by the special relief office ranged from supporting elderly people (about 37 percent of all adult clients), the sick, and the handicapped to helping those who

were too indigent to provide for their basic housing and nutritional needs.[17]

After the war began to take its toll in terms of battle fatalities, and Jews were deported from Berlin in increasing numbers to concentration camps, special relief was faced with a new problem: orphaned children. A *"Mischling"* child, whose father was killed on the front and whose mother was killed by the National Socialists, was helpless. Special relief sought to care for these children until it could place them in homes outside of the country.[18] This work took place relatively late in the war, and details on the number of such tragic cases are not available.

The various kinds of welfare work that special relief carried on were costly. In a five-month period between August of 1939 and February of 1940 the office spent about 5,000RM on welfare, which was 1,000RM more than it spent on emigration.[19] It is not clear how the office decided to distribute its limited funds. A decision to dedicate the entire budget to emigration work never seems to have occurred to Sommer.

During the war years Sommer's work on behalf of Jews spread from the city of Berlin to the entire country. From 1935 to 1939 her responsibilities in various branches of the church's social work had grown as her competence became known. In 1938 she was already involved and personally concerned with the plight of Germany's Jews. Her inspiration may have come from the cathedral canon, Bernhard Lichtenberg, whose daily prayers for Germany's persecuted races began after the Night of Broken Glass. Lichtenberg oversaw the office of special relief to which Sommer devoted most of her energies after 1939. At some point Sommer's capabilities came to the attention of Bishop Konrad Preysing who appointed her as the director of this office in 1941.[20] It was because of this appointment and because of Preysing's own interest in helping Jews that Sommer's deep concern for her country's Jewish populace began to be felt beyond the diocese and city of Berlin.

This first occurred in the fall of 1941, when Jews were obliged to wear the Star of David in public. This meant, of course, that Catholics and Protestants would worship at ser-

vices alongside converts wearing the star. The situation seems to have caused greater turmoil among Protestants than Catholics, but it was also a matter of concern to the latter, and especially to Margarete Sommer.[21] Evidently, some Catholics refused to kneel next to a Jew to take the eucharist at the communion rails that were to be found in churches prior to the Second Vatican Council. Also, some priests began avoiding Jews after the September, 1941, Star of David decree.[22] Because of her position within the diocese and, no doubt, because of Bishop Preysing's support, Sommer could address this issue "officially." Thus, we find Sommer writing to the dean of the German Catholic episcopacy, Cardinal Bertram, offering advice on how the church should deal with this matter. She warned that any prejudicial action, such as instituting separate services for Catholic Jews would be an additional psychological burden for them at a time when they were already being tormented. Sommer did not exaggerate. The diary of Erma Becker-Cohen, utilized by Claudia Koonz, demonstrates how painfully Christianized Jews felt the betrayal of "Aryan" Christians who rejected them after the star decree.[23] Rather, Sommer advised, bishops should awaken the consciences of priests and laypersons with regard to the Jewish predicament and urge them on to a truly catholic community that lives in the spirit of charity.[24]

The response of the church was disappointing and, in part, disturbing. Priests were instructed to avoid any announcements that would be embarrassing for Jewish Catholics, such as declaring a portion of the communion rail off-limits for them. Special Sunday services for Jews were to be avoided, but, when and if Jewish Catholics inquired about this, they were to be advised to go to the earliest possible mass. Parish priests were advised not to bring the matter up unless there was unrest among the faithful, in which case they were to be admonished in the spirit of Saint Paul to have charity toward all. Jews should only be advised to attend separate services in the event that Gentile Catholics, such as bureaucrats or members of the National Socialist party, made a scene by leaving the church during services to protest the presence of Jews.[25] Cardinal Bertram's letter to the country's Catholic bishops, in which these directives were spelled out, con-

cluded with a reminder from Saint Paul that in Christ there is neither Jew nor Greek. But there was clearly "Jew and National Socialist party member" and, if it should come down to it, the former would be sacrificed in the interests of the latter.[26]

During the war years Sommer played a key role in warding off another National Socialist attack on Jews—the dissolution of all Jewish-Gentile marriages. There was nothing the church could do, of course, if an "Aryan" Catholic wanted to be rid of his or her Jewish spouse. A person needed only to apply to a court, and a divorce was immediately granted. Thus, Werner Borcher divorced Stella, who was born and raised a Catholic, although both her parents were Jewish, in February, 1940. Werner provided very little money for the support of his children before dropping out of sight altogether in 1943. As a Jewess, Stella found it difficult to find work that would pay enough to support her family. Having to wear the Star of David distressed Stella Borcher because of her fear that it would lead directly to deportation.[27] After a time, she ceased wearing it but then had to fear the consequences from the gestapo if she was found out. Factors such as these made it extremely difficult for women in Stella Borcher's position to provide for their children. Many turned to the special relief office for child-support assistance. Thus, when Sommer learned of the plan to dissolve all Jewish-Gentile marriages, she was well aware of what the impact on individuals and families would be.

The proposed decree, barbarously inhumane in its terms, presented Sommer with a springboard to appeal for action on the part of the entire church. Through their apparently numerous contacts within the administration and party, Sommer and her associates learned of the terms of the imminent decree.[28] Gentile spouses were to divorce their Jewish partners in the immediate future or their marriages would be declared dissolved by the state. A child of such a marriage could declare loyalty to either parent—if for the Jew, the future meant deportation; if for the Gentile, life in Germany as a sterilized, publicly identified *Mischling*.

Working with Bishop Preysing, Sommer acted quickly to ward off the declaration on divorce. In November she wrote a strong letter to Cardinal Bertram in which she emphasized the violation of church law and the human tragedy that would en-

sue. It appears that the decree was enacted prematurely in certain areas in the city of Berlin, because Sommer was able to provide Bertram with concrete examples of the distress the decree would cause. In one case, an entire family committed suicide. Sommer pointed out that there were thousands of cases of sacramental marriages in Germany between Catholic Gentiles and Jews. Would the bishops allow the state to "put asunder what God had joined together?" Sommer went so far as to urge the bishops to ask Pope Pius XII to intervene by writing personally to Hitler.[29] Thus, the proposed decree gave Sommer an excellent emotional and doctrinal issue with which to urge the hierarchy to act.

The reaction of the Catholic church to this crisis was much more resolute than it was about the presence of Jews at liturgical services. A protest from Cardinal Bertram, together with planned, simultaneous local protests on the part of both Protestant and Catholic churches, forestalled the divorce decree.[30]

Thwarted in this direct attack on Jewish-Gentile marriages, the National Socialist regime began dealing with the "problem" through police action early in 1943. On the last Saturday of February the operation code named *Aktion Fabrik* took place in Berlin. Without warning, eight thousand Jews were taken to temporary, makeshift detention facilities, and then within twenty-four to forty-eight hours evacuated to concentration camps or ghettos in eastern Europe. Among those who were deported were many Christian Jews who had married Gentile Christians.[31] Margarete Sommer, after having witnessed the great Berlin *razzia,* set off immediately for Breslau, where she reported the details of the deportation to Cardinal Bertram. On the second and third of March, Bertram dispatched a strong protest to top National Socialist administrators, including Frick, Lammers, and Goebbels.[32]

The events of late February established a pattern of action and reaction on the part of the regime and the church. By April the bishops had worked out a coordinated, nationwide response should the divorce decree be proclaimed.[33] Probably because of this threat, the regime continued to violate the sacramentality of Jewish-Gentile marriages by simply deporting the "non-Aryan" party.[34] During the summer months,

Sommer was in frequent contact with a number of bishops, keeping them abreast of the "actions" taken against Jews.[35] Her familiarity with the problems confronting the Jewish populace led the bishops to appoint her to draw up a report for them that was to include her recommendation on how to protect the remaining "mixed" marriages.[36] Sommer's reports would be used by the bishops in their annual Fulda conference statement to protect the sanctity of such marriages and to urge the administration to disclose information on the whereabouts of deported Jews and to urge humane treatment for them.

Sommer filed her first report almost immediately. It provided little hope for a change in the regime's conduct. Jews were being arrested and deported on the most frivolous pretexts (going to an "Aryan" barbershop, for example). Temporary detention (before deportation) was under cruel conditions (large rooms divided by chicken wire into tiny cells of one cot's length and two cots' breadth). Just fourteen days after the deportation of these Jews, their families received word of their deaths. One case involved the deportation of a woman just six weeks after she had given birth to twins. Sommer's information was based on reports from Hesse, Austria, Westphalia, and Berlin. "In this way," Sommer concluded, "the administration was dealing with the "mixed" marriage problem in widespread areas of the country."[37]

The bishops' frequent protests, based on Sommer's stream of information, had some temporary effect. Jews in detention centers in Frankfurt and Bielefeld were allowed to return home in the summer of 1943. But in other areas, such as Upper Silesia where Jewish Christians were deported to Auschwitz, there was no respite.[38] In the long run, of course, the protests of the bishops did not deter the National Socialists from killing German Jews. Late in the war it appears that the operation was even expanded. In November, 1944, the director of Caritas in Silesia reported that as the Russian front advanced, *Mischlingen* who were married to "Aryans" were being transported.[39]

Sommer's work as a consultant to the Catholic bishops was just one aspect of her life during the war. The other was working directly for Jews in the city of Berlin. When National

Socialist policy changed from driving Jews out of Germany to deporting them to ghettos in eastern Europe, the work of the special relief office took on a new character. It sought to provide last-minute assistance for Jews who were about to be transported and sought to look after their needs after they had been resettled. To accomplish this, special relief formed parish support groups. The people involved in this work crossed over the line into civil disobedience when they hid Jews who were trying to avoid the fate of the concentration camp. At the same time, special relief continued to look after orphaned *Mischling* children and provided welfare for Catholic Jews as in the past. But let us turn to the more recent work made necessary by the regime's new transportation policy.

Although occasionally a terrifying *razzia* took place, such as *Fabrik Aktion* on 27 February 1943 in Berlin, deportations were frequently—perhaps, normally—individual rather than collective.[40] A family was simply notified that the time of its "transportation" had come. However long a person or family might have anticipated such notification, its arrival often caused unimaginable despair, hopelessness, and trauma. As a rule there were only a few hours between the time of notification and the moment of actual departure from home. Feeling mentally paralyzed, many people simply could not function during these terrible hours of uncertainty. Frequently, they were incapable of thinking about the immediate necessities that would be of some practical use during the forced journey that awaited them.

Special relief developed a system to help these victims through the moment of crisis. A group of parish volunteers, presumably people who knew the unfortunate deportees, stood ready so that one or two could go to the individual's or family's home at a moment's notice. Once there they attempted to prepare the person, "who in his bewilderment had lost all sensible orientation," for the imminent ordeal of "transportation."[41] The visitors helped with packing and took care of last-minute household details. Mostly, of course, they attempted to comfort the persons about to be caught up in national socialism's ghettoization operation. At some point a coded telephone message was made to the parish priest,

who came to spend the Sacraments of penance and the eucharist.

The scene conjured up by these last-minute visits may look more grotesque than humane. Just what does one say to a person facing permanent departure from home and life or death in a concentration camp? There were, however, several circumstances that threw a softer light on the mission and that may help us understand it better. First, it appears that one of the visitors was herself Jewish. All of the personnel of special relief, with the single exception of Margarete Sommer, were Catholic Jews.[42] This could have a double significance. Since the person whose "transportation" was imminent was often Christian, he or she would be given solace by a woman whose religious background was similar or identical. More importantly, the person offering solace faced exactly the same destiny, deportation, as the person whose imminent departure had occasioned her visit. Their common destiny undoubtedly made the compassion of the farewell mission genuine, allowing comforter and victim to bond in mutual support. Second, the victim was assured continuing assistance on the part of a support group from his or her parish. To this end circular letters made the rounds of Berlin parishes so that Gentiles who knew or recognized the names of "transported" Jews could provide continued support by contributing food or dry goods for their use. Packages were sent to Warsaw, Theresienstadt, and Lodz, where most Berliners were ghettoized.[43] More important, the support group gave assurance to victims that if they were able to survive whatever ordeal lay ahead and return one day to Germany, they could go "home." In other words, those who remained behind promised to keep track of the property of the deported. Restitution did, indeed, become the main work of the special relief office during the years immediately following the war.[44]

Since relief was organized by the Berlin diocese and carried out through its parishes, it might appear that Catholics were involved only with Catholics. Such was not the case. Sommer was explicit on this point, saying in her brief postwar memoir that aid was extended to all Jews.[45] It is clear from other records that the National Socialist persecution of the

Jews created a common bond among them that cut through lines of religious preference. Whether Christian or non-Christian, Jews pondered the meaning of the experience that gripped them. Thus, Gertrud Jaffe, a convert to Catholicism, worked in the missions of the special relief office to help as many people as she could, irrespective of their religious preference, and then decided, with great inner resolve, to give herself up for deportation and certain death in order to identify, as a Christian, with the suffering of her people.[46] It worked the other way as well. Jews who were not Christian, like Dr. Martha Mosse, worked to help and save other Jews regardless of their religion.[47]

Although special relief and parish support groups attempted to comfort Jews about to be "transported," there were few illusions as to what fate awaited them. By the beginning of 1942 Sommer had detailed information about life in the ghettos to which Berlin Jews were being herded: thirty to eighty people inhabiting one room; no heating; no plumbing, and four small slices of bread for a day's rations.[48] After the war, Sommer wrote that she knew "from secret sources of information" that most of the Jews who were deported died soon thereafter.[49] But it is difficult to say how early she knew this. She hints strongly at it in her report to the bishops on the great *razzia* in Berlin early in 1943 when eight thousand Jews were "very cruelly rounded up and literally driven" into trucks. Explaining that authorities would not allow the families of the detained Jews to bring them provisions for the imminent "transportation," Sommer concluded that "precisely this circumstance . . . changed our suspicion that they had no future into a certainty."[50]

At some point, certainly no later than the end of 1942, special relief began hiding Jews. There are a number of explicit references in Sommer's papers that establish this activity, yet it is difficult to piece together the story of how this was accomplished. Because of constant gestapo surveillance and the great risk involved, Sommer and the other personnel of special relief preferred not to deal by letter or even by telephone, but by personal contact. Obviously, no systematic records would have been kept. Furthermore, to protect themselves from divulging information under duress to the ge-

stapo, no one was told or wanted to know what she did not need to know. Not even Sommer knew how many Jews were being hidden by special relief personnel or by parish support groups working with them, because, as she says in her postwar memoir, it was a secret.[51] Still, Sommer knew some particulars. When one of her coworkers at the special relief office, Liselotte Neumark, faced deportation, she went into hiding with a Gentile family. After four weeks Neumark contacted Sommer through a third party to arrange a meeting. Not wishing to endanger the family with whom she was hiding any longer, Neumark asked Sommer to help her sneak herself into the next *Transport*.[52] Sommer was also aware that yet another special relief employee, Fräulein Joachim, helped ill Jews and hidden Jews "at great personal risk" throughout the period of National Socialist persecution.[53]

What we know about the clandestine operation of the special relief office is little. This is obviously regrettable; the important thing, however, is for us to be aware of the fact of their involvement in this activity. Both Jews and Gentiles crossed over the line of civil disobedience; they resisted national socialism. They hid Jews.

But Sommer was not able to coax her church's bishops over the line into open conflict with national socialism and resistance against Hitler's regime.[54] She was obviously in a position to do this, having become the episcopacy's consultant on Jewish affairs. Sommer had gained this position through the good offices of her ordinary, Konrad Preysing, whose confidant she had become by the 1940s. By no means was she a lone voice in urging the church to speak out. Other bishops besides Preysing, such as Berning and Wienken, as well as clandestine circles, offered Cardinal Bertram, the dean of German bishops, unsolicited advice on this score. Most of the pressure on Bertram, however, came from the Berlin circle. What Preysing and Sommer wanted was a protest statement. Our point of departure, they suggested, must concern Christian Jews and sacramental marriages involving Jews, but our statement "must go clearly beyond that to include the atrocities against Jews in general."[55]

Sommer made it her business to make sure that Cardinal Bertram knew about the atrocities that national socialism was

perpetrating against Jews, including German Jews, in eastern Europe. Since the German bishops spoke with one voice, Bertram had to be won over if a strong statement of protest was to be forthcoming. Not all of Sommer's reports to Bertram appear to be extant, but, judging from those that are, we can say that she was both timely and accurate.[56] About the Kovno massacre (27 October 1941), which included Jews from Berlin and elsewhere in the Reich, Sommer reported that "the Jews must undress (it could have been 18 degrees below freezing), then climb into 'graves' previously dug by Russian prisoners of war. They were then shot with a machine gun; then grenades were tossed in. Without checking to see if all were dead, the Kommando ordered the grave filled in."[57] Thus, just slightly more than three months elapsed since the Kovno massacre until Germany's Catholic bishops and their titular head, Cardinal Bertram, had an accurate account of the atrocity. In 1943 Sommer reported to Bertram personally on the Berlin *razzia, Aktion Fabrik,* and concluded that the deported Jews would not live long. In August she filed her lengthy report that dealt with the treatment of Jews from a number of regions in Germany and Austria; this was the report that said that the "Aryan" families of those who had been deported received death notices on them fourteen days thereafter. At the exact same time Bertram also received an extraordinary letter from a Polish Jew, which provided page after page of accounts of the murder of four million Jews by Germans and concluded with the indictment that "every German, yourself included, is guilty of these atrocities."[58] The months that followed brought more reports from Sommer.

Instead of winning Bertram over, Sommer's reports and urgings had the effect of straining the relationship between him and the Berlin circle of Catholics. After Sommer's August, 1943, report the Berlin group drew up a draft letter in the name of Germany's bishops, which they submitted to Cardinal Bertram: "We will stand guilty before God and man if we are silent" about the regime's persecution of Jews (referring both to Christian and non-Christian Jews).[59] The draft went on to demand specific rights for the deported Jews, such as healthy living conditions, correspondence rights, religious services, and personal contact with an inspection committee. Bertram

refused to endorse the draft on the grounds that there was insufficient proof of the conditions that it sought to redress.[60]

The situation between Cardinal Bertram and the Berlin circle deteriorated further in 1944. Since August of the previous year Sommer's reports to Bertram on Germany atrocities against Jews evidently increased in number and in detail. These reports appear to have been made personally by Sommer rather than by mail, no doubt because of the gestapo. Bertram responded to Sommer by questioning the reliability of her sources and by insisting on proof. It was, of course, impossible for Sommer to provide proof without disclosing the identity of those in the regime and administration who leaked information to her. She therefore continued to bring as detailed information as she could to Bertram, invoking the authority of her bishop and confidant, Konrad Preysing, to authenticate her mission. This exasperated Bertram, who grew weary of Sommer's persistence. Bertram finally notified Berlin that in the future Sommer's reports would have to be undersigned by Bishop Preysing verifying their details and correctness. "Please make this clear to *Frau* Dr. Sommer," Bertram wrote, "since my warnings don't help. Otherwise I will not schedule any more appointments with her." [61]

The problem was not just that Bertram refused to accept on face value the detailed accounts of atrocities with which he was presented. Rather, there was a complete lack of communication at the highest levels of the hierarchy. In November, 1943, Bertram wrote the Vatican secretary of state, Cardinal Maglione, asking what could be done to provide the last Sacraments for those being condemned to death in Poland and summarily executed. (Evidently, then, Bertram *did* believe that Jews were being killed.) By this time all higher officials in the Vatican knew about the mass murders in eastern Europe; even lower Vatican bureaucrats knew.[62] But instead of writing back that it would be impossible to get permission to provide the last Sacraments for the victims because Germans were murdering them by the tens and hundreds of thousands, Maglione assured Bertram that the Vatican was doing everything it could through local church officials (in eastern Europe) to get permission to spend the Sacraments.[63]

The effort of Sommer and the Berlin circle to spread re-

sistance through the entire German church failed. Rather than protest, the bishops pleaded faintly. In November, 1942, Cardinal Bertram urged that "other races" be treated humanely, as did the 1943 Fulda bishops' letter. Lacking in these pronouncements is the sense of outrage that typified their attitude toward euthanasia. There is no statement from the bishops that addressed the excruciating situation of Jews in the ghettos or of those machine-gunned in open pits so poignantly described by Sommer.

Margarete Sommer was not the only Catholic woman who resisted national socialism on behalf of the Jews. Gertrud Luckner, who was employed in the Caritas headquarters in Freiburg, worked, like Sommer, both personally and within the institutional church on behalf of Jews.[64] Luckner spent the last three years of the war in the Ravensbrück concentration camp for hiding Jews and for arranging for their escape from Germany.[65] Else Heidkamp also spent some time in prison for her work on behalf of Jews.[66] Evidently, there were also Catholic support groups in Munich, similar to those in Berlin, which attempted to help Jews who were being "transported."[67] Just how many other women engaged independently and anonymously in resistance by helping Jews is impossible to estimate. It is certain that there were smaller circles of Berlin women who sheltered Jews but were not in contact with the special relief operation.

The wartime experiences of Susanne Witte demonstrate that individuals were acting independently to protect Jews.[68] Just before the National Socialist era, Witte graduated from the Catholic German Women's League school for social work in Berlin. At some point during the 1930s she became friends with a Fräulein Kirschbaum, a Jewish social worker who had converted to Catholicism. When the "transportation" of Berlin Jews began, Kirschbaum asked Witte to hide her mother, who was not Catholic and who was opposed to her daughter's conversion. During the years of the elder Kirschbaum's concealment in Witte's apartment, a number of other people became involved at various levels of risk to themselves. Witte's friends took turns providing food since it was difficult for two to live off of just one ration card. Occasionally, when Witte had to be away on a trip, Frau Kirschbaum would stay with one of

Witte's friends. The involvement of the latter became greater when a Berlin priest, who was hiding Jews and who knew that Witte was also involved in this, asked her to take in another refugee. Witte felt it would be too dangerous for her, but she was able to place the Jew with one of her friends. Besides Witte's circle of acquaintances, many other people knew that Frau Kirschbaum was being hidden from the gestapo. Witte's flat was located on the fourth floor of her building, and when there were air raids—sometimes as often as two a day— everyone poured out of their apartments onto the stairs to go to the basement. Frau Kirschbaum's hiding place was an open secret; no one disclosed her whereabouts even when the gestapo searched Witte's apartment.[69]

Just how many anonymous circles of resistance, like that working around Witte, existed in Berlin and throughout the country no one can say. The impression is emerging that Catholics were more likely to come to the rescue of Jews than Protestants, but it is certain that a number of the latter were also engaged in hiding refugees in Berlin.[70] *Sopade* reported in 1938 that Inner Mission personnel observed the National Socialist proscription against succoring Jews, whereas Caritas volunteers did not.[71] In a great city like Berlin, where Jews and Gentiles had lived together for some time and had intermarried, resistance to the regime's anti-Semitism does not seem to have been confined to people or groups of any particular religious or political preference.[72] It is certain that Catholic nuns hid Jews, but, again, we do not know how extensive their work was. A consideration of the Elizabeth Society will provide us with at least some idea of how many Catholic women actively resisted national socialism by concealing Jews or helping in this effort.

Many women, who like Witte were members of the Elizabeth Society, sheltered Jews and sent provisions to those who had been deported to ghettos in the East. As with the special relief office in Berlin, this seems to have begun as an effort to help Catholic Jews and then was extended to all Jews. "In their flight," the Elizabeth Society reported, "some of them found refuge in our homes and a period of rest and hiding."[73] Although the society was not a large organization, its members were concentrated in urban areas. In southwest Ger-

many, for example, the cities of Karlsruhe and Mannheim accounted for 25 percent of all members in the diocese of Baden, and in the diocese of Würzburg in Bavaria the city of Würzburg itself accounted for nearly 50 percent of the members.[74] In Berlin, where there were more Jews than anywhere else in Germany, there were six hundred members of the Elizabeth Society. Nationally, not all of these members engaged in resistance or in hiding Jews. Some "affiliates were not up to the test," as it was put at a meeting of the society soon after the war.[75] But the society seemed to have been very active in Berlin where its national director, Dr. Marianne Pünder, was under frequent gestapo surveillance.[76]

What we may conclude is that there was a small nucleus of Catholic women who understood the implications of National Socialist racial teaching in the 1930s and who were willing to become directly involved in resistance once the war began and the regime's anti-Semitism went berserk. The number of these women is unknown, but it is confined to members of certain groups: the Elizabeth Society, the Catholic German Women's League, or Caritas. All of the women whom we have identified as active resisters were members of one or more of these organizations. Within these circles of women, some—it is impossible to guess how many—shared another characteristic; they were Jewish. Additionally, a larger number of non-Jewish Catholic women surrounded this nucleus, who were willing to assist in the work on behalf of Jews but who could not or would not become committed to the extent of providing a shelter. These would be the people who worked in the Berlin parish support circle of special relief or the circle of friends around Susanne Witte and members of the Elizabeth Society who sent provisions to the ghettoes in eastern Europe. All of these women were ready for the challenge when national socialism posed the ultimate moral question of death for the disadvantaged and for Jews during the 1940s.

To allow oneself to formulate judgments on National Socialist racial teachings and to elevate them to the moral sphere was of course enormously stressful for any German living in the Third Reich. Most Catholics were surely relieved that their bishops did not demand extraordinary courage of them by forcing the racial issue—in other words, by making it a point

of public conflict with the government. This meant that women who were prepared to resist had to act on their own or within a localized church affiliation. How many more members of Caritas or the league or the Elizabeth Society would have been willing to be directly involved in resistance had the bishops chosen to break openly with national socialism over the treatment of Jews as they had over the treatment of the disadvantaged in the euthanasia dispute? How many women of the massive sodality organization would have at least been willing to participate in parish support groups on behalf of Jews had not their church leaders acted pusillanimously?

The failure in leadership among Catholic bishops—not to speak of hypocrisy on the part of some of them—comes through clearly in their statements immediately after the end of the war.[77] Many of the bishops, anxious to defend the innocence of the Catholic populace as the occupational forces tried to sift out the "good" Germans from the "bad" ones, asserted that the ordinary man-on-the-street had no idea of the terrible crimes that their government had perpetrated on Jews in the East.[78] But if it is true that Catholics were unaware of the Holocaust, the fault lies with their church leaders, who did know about it or could have known about it but failed to tell them. The excuse usually given for their action, or lack of it, is the experience of the Dutch church. In the summer of 1942 the archbishop of Utrecht protested the deportation of non-Christian Jews, whereupon the German occupational forces immediately deported Catholic Jews in reprisal.[79] But this excuse no longer held any validity in Germany in 1944 when the National Socialists, as we have seen, began deporting Christian Jews along with all other Jews.

Had the bishops of Germany confronted national socialism publicly with its crimes, Margarete Sommer would have played the critical role in the decision to act. Working late into the night in her special relief office in Berlin, Sommer kept herself informed about the fate of the Jews in eastern Europe. At considerable risk to herself from the gestapo, which kept a close watch on her, Sommer worked to save Berlin's Jews and acted as a courier to bring news of German atrocities to the attention of the country's bishops. In engaging in resistance and in urging her church to do so, Sommer acted coura-

geously. We may ask, however, why she and the Berlin circle—above all, Bishop Preysing—did not act on their own to confront the regime with its crimes after it became clear that Cardinal Bertram would not allow himself to be influenced by their information. Although Preysing did object more strongly than other Catholic prelates, he chose his words carefully.[80] A public protest of German atrocities against Jews made from all the city's Catholic and Protestant pulpits was certainly possible.[81] The opportunity was missed.

These limitations, however, should not keep us from recognizing the accomplishments of Sommer and the Berlin special relief office. Under Sommer's direction this office saved many orphaned Jewish children (perhaps dozens), obtained passports for hundreds of other Jews, and saved many additional Jews (perhaps several hundred) by hiding them until the collapse of national socialism. The lives of these survivors testify to the success of Margarete Sommer and the Berlin circle of Catholics.

11
Challenges Met and Opportunities Missed: A Final Word

Without question, national socialism had a tremendous impact on Protestant and Catholic women. Our subjects constituted such an enormous subgroup, however, that we can hardly speak in general terms in attempting to formulate concluding remarks about this impact. Furthermore, the difference between the institutional churches and their responses to national socialism, along with the self-perceptions of Protestant as opposed to Catholic women, caused them to experience the Third Reich somewhat differently. These factors must be taken into consideration in our attempt to find a balanced conclusion. To formulate the question along these lines, however, seems one-sided. Even in a police state, authorities must take some cognizance of public opinion. We have long known that National Socialists were concerned about the power of the churches to shape or at least nuance public opinion. The actions that the regime took against Protestant and Catholic women tell us that it was also concerned about what women thought and did, especially in conjunction

225

with their churches. We ought then to look at both sides of the coin: how did national socialism affect Protestant and Catholic women, and what inhibiting influence were these women able to bring to bear on the regime?

In trying to assess the impact of national socialism on women, it seems easier to begin with the Protestant sector. Because of the Protestant Church Struggle, women of this confession were left to find their own way in the Third Reich to a greater extent than Catholics. As a result, there was more differentiation amongst Protestant women, which makes our task somewhat less formidable. Instead of having to stretch credibility by speaking in terms of all Protestant women, we can break them down into smaller groups and assert that the impact of national socialism varied according to each.

What makes differentiation among Protestant women possible is the fact of their nearly unanimous support of Hitler at the outset of the 1930s. This support was at one and the same time so overwhelming and spontaneous that I have argued that internal incentives propelled Protestant women toward their acceptance of national socialism. Since the largest association of churchgoing Protestants was predominantly middle class, one could easily formulate an alternate thesis, namely, that material considerations led these women to support Hitler. On the surface this argument may seem more plausible, but it is difficult to sustain for the period after 1935. The internal incentive that drew Protestant women toward national socialism was their ability to associate it with a religious renewal. When, later on, it became clear that this was a mistaken association, many Protestant women withdrew from full support of the regime. They did this even at the expense of forfeiting their cherished mothercare programs. Thus the internal incentive, religion, was the constant factor regulating the response among Protestant women to national socialism.

The reason why Protestant women gave Hitler broad support need not detain us further. The fact is that in 1933 there was consensus, but by 1945 or even 1939 there was not. In other words, national socialism shattered the consensus. The resulting divisions can be used as guides to the impact of national socialism on Protestant women.

Four groups resulted, three of which emerged rather dis-

tinctly. At one extreme were the German Christians, Protestants who accentuated anti-Semitism and *Caesaropapism.* The suspicion is that many Germans who supported the German Christian Faith Movement in the 1933 church elections verged on being nominal Protestants, but as many as seventy-five thousand to one hundred thousand from this faction were active in the Protestant Women's Service organization. We may assume that at least this many women, and perhaps three to four times as many, remained active during the Third Reich both as churchgoers and as enthusiastic supporters of the National Socialist regime.

At the other extreme were women of the Confessing Church movement. This group stood for church independence and against National Socialist racism, especially as it affected religious principles. Beyond any question, there was more sympathy for the Confessing Church than for the German Christians within the Protestant Ladies' Auxiliary. If the latter's membership was around the one million mark during the 1930s—a figure that we shall evaluate critically below—perhaps as many as five hundred thousand were actual members of the Confessing Church. As with the German Christians, we may assume that there were a great many more Protestant women who supported the Confessing Church and were active church members but were not members of the auxiliary. We might estimate, then, that roughly twice as many women were active in the Confessing Church movement than in the German Christian Faith movement. By the end of the war Confessing Church women had turned away from the National Socialist regime or had lost all enthusiasm for it.

Now for the women who took their place in the middle somewhere between the German Christians and the Confessing Church. Most churchgoing women wanted to preserve a link in fact or in spirit between the church and the National Socialist state. Even when the neopaganism of national socialism strained this relationship, most Protestant women sought accommodation and hoped for reconciliation. Without being any less sincere in their religious commitment, the majority of Protestant women did not take much cognizance of the conflicts, such as racism, that strained church-state relations or credal principles. One suspects that for the most part this was

because people did not understand the issues involved or, understanding them somewhat, assigned them little significance in day-to-day life. Still, in spite of their goodwill, most of these churchgoers no longer felt the enthusiasm for national socialism in 1939 that they espoused in 1933. Not only had they been dismissed from mothercare work, but, for the most part, from other kinds of communal service. The manner in which national socialism had resolved the school question was displeasing to this group, perhaps as much as to Confessing Church members. In place of enthusiasm, a pall of uneasiness spread over these Protestant women as they became increasingly aware during the latter years of the thirties that relations between their church and the regime were volatile.

The identity and profile of the fourth group of Protestant women is more difficult to bring into focus. In question here are more nominal believers or occasional churchgoers. Apparently, many backsliding Protestants were brought back to church, for a time anyway, by the revivalist talk early in the thirties, which spoke of a religious and national reawakening. These were the people to whom National Socialists appealed in an effort to get out the vote for German Christians in the synodal elections of 1933. Since these were women who were Protestant by custom rather than conviction, it seems safe to assume that, when conflicts arose between the church and the state, most of them ceased to be active members of the church and accepted anti-Christian policies and actions of the regime with no pangs of conscience.

It is not possible to make the same exact differentiations among Catholic women. While it is true that there were very active women who opposed racism and anti-Semitism, a group corresponding to German Christian women at the other end of the spectrum did not exist within the fold of Catholicism. We suspect, naturally, that a minority of Catholics dropped active membership in the church, if only out of expediency or convenience. But the great majority—and this obtained especially for women—remained active, even if they refused to elevate conflicts between National Socialist ideology and Catholic teaching to the level of conscience. I have argued that, over and beyond these two groups of backsliders and conformists, a distinction can be made between those

Catholic women who were willing to participate in dissent and those willing to become active in resistance. The number of the former may have been around one million, but the latter were less than half that number, perhaps really, only a fraction of it. In 1933 Catholics had low expectations of national socialism; by 1939 little had happened to suggest to them that they had miscalculated.

What is striking about the impact of national socialism on Protestant and Catholic women during the thirties is the fact of change. While the Protestant sector allows us to illustrate an evolutionary process more clearly, there is no doubt that Catholic women too reacted variously to life under National Socialist rule. The question that we might ask at this juncture concerns the drift of the evolution among churchgoing women. In other words, what trend among them was more predominant? What was likely to be their final profile vis-à-vis national socialism—dissent, resistance, or neither? We may address these questions by studying the memberships of the various organizations of churchgoing women with which we have become familiar.

It is clear that various National Socialist officials or members tried to discourage women from joining organizations such as the auxiliary, the league, the sodality, and the Elizabeth Society. Starting around 1935, church women found they exposed themselves to charges of disloyalty to Hitler if they were members of a church-sponsored women's group. By the time the war began, some of the affiliates, both Protestant and Catholic, had been shut down by the gestapo. The overwhelming majority of affiliates escaped with some less drastic form of harassment, but there could be no doubt in anyone's mind about the opposition of the regime to these organizations of women. There were, of course, a number of factors besides outright harassment that affected them. The auxiliary lost members to the Protestant Ladies' Service, and all groups felt the impact of rivalry with the NSF, especially in terms of difficulty in recruiting younger women and the deprivation of mothercare work. The total effect of these combined circumstances did not, however, impact with the same intensity or severity on each organization of women.

Let us first review the experience of the auxiliary.

Table 3.

Auxiliary Membership in Four Church Provinces

Year	East Prussia	Silesia	Nordmark	Tungendorf*
1930	26,847	70,500	19,028	288
1931	26,676	72,000	19,028	n.a.
1932	30,000	73,000	20,000	240
1933	28,298	74,000	n.a.	n.a.
1934	27,753	74,000	16,073	n.a.
1935	27,954	66,000	n.a.	222

*The first figure for Tungendorf is for 1929; Tungendorf represents one congregation rather than an entire province.

Source:

EKU Gen. 12, no. 123, vol. II, Reichsmutterdienst; for Tungendorf: *Der Bote* 33, no. 4 (26 January 1936): 44.

Throughout the decade of the 1930s, the auxiliary claimed a membership of nine hundred thousand to one million. We cannot accept these figures without skepticism, because, in contrast to data for previous decades, they are general and not as carefully derived. One might hypothesize that, with the initial bloom of enthusiasm during the first years of National Socialist rule, membership would have surged upward and then declined when problems between von Grone and Scholtz-Klink and the auxiliary and NSF began to emerge around the middle part of the decade. In fact, the trend was just the reverse. For the areas for which membership data are available (see Table 3), a general decline in membership can be established for the first half of the decade. Furthermore, this decline seems to have come during the first two or three years of National Socialist rule.

Although data for the second half of the decade is scarce, what we have suggests a rebound in membership. Nordmark, for example, counted nearly 18,500 members in 1937, up almost 1,500 since 1934 in spite of the losses it sustained in the intervening years because of the schismatic Protestant Ladies' Service.[1] This surprising renewal of interest in the auxiliary in the second half of the decade also took place in the province of Hanover. In 1935 in this central German province there were 315 affiliates, but in 1938 there were 395, even though

19 renegade affiliates had switched allegiance to the Protestant Ladies' Service.[2] In one urban congregation in Hanover, membership grew from 225 to 263 in 1936–37. Data from one other province indicates the same trend. Mecklenburg lost eight affiliates to the Protestant Ladies' Service of the German Christian movement, but eleven new groups joined the auxiliary.[3] These data, although sparse, suggest that the general figure of 900,000 to a million members that the auxiliary always used during the 1930s may be correct. In terms of the confrontation with national socialism, this amounts, superficially, to a standoff: no appreciable gain or loss during the Nazi era.

What the data indicate in particular is that the auxiliary faltered in prosperity and flourished in adversity. It is easier to state this fact than it is to explain it. During the early years of the National Socialist rule, when it seemed likely that the Protestant mothercare system might become the standard bearer for the entire country, membership inexplicably fell off. This is difficult to account for, since in the previous several years' membership grew, riding the crest of the auxiliary's very popular natalist work. We cannot blame the loss entirely on Hermenau's schismatic service group, because the decline in membership comes somewhat too soon. It is possible that potential new members from the younger generations were joining National Socialist circles of women instead of church-related ones. Agnes von Grone mentioned this, in fact, in 1932.[4] But this, too, seems inadequate as an explanation in itself, because we know that the rapid growth between 1927 and 1933 did not issue entirely from younger German women.

Even more puzzling is the growth of the auxiliary in the later thirties, precisely when it came under siege from the regime. From whence came the new members after 1935? The auxiliary had hoped to attract new members from its Young Mothers' Circle, but this seems unlikely as well since its mothercare work in 1933 and 1934 had failed to attract any new members. A more probable source lay in those women who had either disdained the auxiliary or shown little interest in it during the Weimar Republic. Ten years made a great deal of difference. An organization like the auxiliary, which could eas-

Table 4.
The Decline of League Affiliates and Members in the State of Baden, 1934–44

Year	Members	Affiliated Clubs
1934	6,086	56
1935	6,283	n.a.
1937	6,038	53
1944	5,300	44

Source:
BAF 55/69, reports of 16–17 February 1935; April 1937, and 1944.

ily have been dismissed in the twenties for its conservatism, would have been seen in a far different light in the thirties because of its ideological differences with national socialism or its insistence on independence. Women who had formerly preferred one of the more radical or liberal subgroups within the Federation of German Women's Associations in the twenties could join the auxiliary in the thirties as a protest against the NSF, or against the nazification of German society (atomization), or against the German Christians and the cult of the "Aryan" race.[5] Joining the auxiliary would also be a way to protest in some small manner against the country's ludicrous lifestyle, which allowed the gestapo to swarm down on a group of women enjoying a coffee break, simply because they were outside the confines of the local church grounds.

It is interesting to compare the membership record of Catholic women with that of the auxiliary. The Catholic Women and Mother's Sodality, the largest association of women within the Roman confession, grew at a remarkable rate during the National Socialist era. By 1939 it counted 1.3 million members, up 450,000 since 1933. As we have seen, its in-house publication, *Mutter und Frau,* also found a much greater readership at this time, rivaling that of *Frauenwarte,* the NSF publication. Its successful record could not be matched, however, by the other two principal organizations of Catholic women. Far from prospering, the Catholic German Women's League suffered a serious decline in terms of both affiliates and members during the 1930s (Table 4). Although

Table 5.

Number of Members and Affiliates of the Elizabeth Society by Diocese, 1932–38

Year		Freiburg	Fulda	Meissen	Muenster	Paderborn	Rottenburg
1932	Members	n.a.	n.a.	n.a.	n.a.	n.a.	n.a.
	Affiliates	39	30	39	172	210	n.a.
1936	Members	519	n.a.	n.a.	2599	3892	795
	Affiliates	68	n.a.	n.a.	171	247	53
1937	Members	597	n.a.	n.a.	2354	3844	662
	Affiliates	68	n.a.	n.a.	180	248	56
1938	Members	651	273	n.a.	2924	3847	761
	Affiliates	69	35	43	180	248	56

Source:

ADC 349, minutes of *Vertretertag,* October, 1932; 349 M.1, 1938
Statistics; in the same file, see data on the years 1936 through 1938.

the picture was not quite as bleak for the Elizabeth Society, it also remained an extremely exclusive subgroup of Catholic women throughout the National Socialist era. It must be remembered that the Catholic church made strong efforts to build up the Elizabeth Society, which was tied organizationally to the national Catholic charity organization, Caritas. On the eve of the National Socialist era, the Elizabeth Society seemed to have ample potential for growth as it was organized on the diocesan level in only half of the country's bishoprics.[6] When the contest in welfare between the churches and the NSV got underway in all seriousness, Caritas made strong efforts to encourage membership in the society. This was an advantage that the league did not enjoy, yet it did not prove of much benefit to the Elizabeth Society. It is evident from table 5 that many dioceses failed to keep count or to report on their success, or lack thereof, in building up the society. An exception was the diocese of Rottenburg where all fifty-six affiliates submitted membership data in 1938. It is clear that Rottenburg, which shows a slight decline in membership in 1937 and, in general, a plateau in the second half of the decade, bears out the trend in other dioceses and in the Reich. Even in areas such as Freiburg, where growth was relatively large, membership remained limited. In 1926 the society counted only 168 members in the entire diocese. Even though this fig-

ure rose to 651 in 1938, it hardly needs to be mentioned that there were literally thousands of potential members whom the society was unable to attract.

Because the membership data on the four church-related organizations of women that we have reviewed is reliable, we may form some conclusions from them about Protestant and Catholic women's relationship to national socialism. Most obvious is the fact that the two largest organizations—one Catholic and the other Protestant—faired better than the smaller ones. It seems certain that a principal reason for the advantage lay in the fact that the auxiliary and sodality were less extreme in their opposition to national socialism than the league and the society.[7] Yet we should not minimize the importance of the auxiliary and sodality in terms of their dissent. Both were subjected to harassment, and the latter was completely suppressed. Although we lack information about the years of the sodality's growth during the National Socialist era, it is clear that the auxiliary grew between 1935 and 1940, the years when it was in sharpest conflict with the NSV, the NSF, German Women's Enterprise, and various local or regional party officials. These were the years following the auxiliary's elimination from mothercare work—the years of the Bible program. Thus, under duress, the auxiliary rejuvenated itself. Only after it had become ideologically distinct from national socialism did the organization experience growth. The fact that two church-related organizations of women, which had massive memberships that were still growing, existed under National Socialist rule gives us an insight into the limits of the party's influence over the German people.

Protestant and Catholic women were essential in the churches' efforts to withstand dechristianization and those aspects of National Socialist ideology that patently contradicted Christian teaching. The importance of this effort and the part that women played in it need not be questioned, but, at the same time, nazism was making an impact on Christianity. Although it appears that the churches successfully defended their ideology against that of national socialism, it also seems likely that the latter penetrated society deeply enough to discourage those who reached young adulthood in the 1930s from a full commitment to service in the church. The Catholic

church was concerned about the declining number of women who were prepared to become nuns. To join one of the church-related women's associations demanded less of a commitment, of course, but even here many of the younger generations held back. In 1938 women in their twenties constituted only 3 percent of the Elizabeth Society's members in Paderborn, 6 percent in Munich, and 12 percent in Freiburg.[8] We may conclude from this that National Socialists succeeded in neutralizing young Protestant and Catholic women, at least to the extent of restraining them from joining an organization whose purposes sharply conflicted with those of the party. In other words, the churches lost the support of many of those who, under more normal circumstances, would have been zealous.

The fact that the two largest organizations of church-going women, the auxiliary and the sodality, grew during the Third Reich might tempt us to suppose that the affect that national socialism had on women was not particularly adverse. Such was hardly the case. Nothing illustrates this more clearly than the disastrous erosion within the Catholic German Women's League. Although it suffered greater loss of members than any other Protestant or Catholic group, the impact on the league went well beyond statistics into the very nature of the organization. The league had always been more forthright than any other church-related women's group in its advocacy of women's liberation in the economy, in politics, and even in the church. Table 6 illustrates the wrenching effect that the Third Reich had on the league's work. In 1936 the league could no longer express itself in those areas of secular life that had traditionally interested it.

Nor was the league allowed to practice advocacy of women's rights. When the Essen affiliate redrafted its constitution describing its objectives as "the ongoing education of Catholic women, especially of the poorer classes, in occupational, home economic, legal, moral, and social areas," the National Socialist party took it to court to force it to confine its interest to exclusively religious or charitable activities.[9] The party even deprived the league of its own independence, forcing it to shelter itself under the roof of the church, a step that it had carefully avoided during the first three decades of

Table 6.

Topical Breakdown of Articles Appearing in the League's *Die Christ-liche Frau* in 1926 and 1936

Topic	1926	1936
Art*	0	9
Education (especially of women and girls)	6	0
Politics	4	0
Religion	5	24
Social Legislation	3	0
Welfare (church and state)	8	2
Women's Affairs (extrafamilial)†	19	0
Women's Affairs (familial)‡	5	26
Women's Employment	5	0

*Usually a Marian theme
†Usually about current events of importance to women
‡Usually about husband-wife or mother-child relationships

its existence.[10] Because no Catholic organization could exist in Germany outside of the framework of the Concordat, the league affiliates found that they had to place themselves under the authority of their local bishops or face foreclosure.[11] Thus, the principles that the league had stood for—an organization by women and for women—were not to be tolerated in National Socialist Germany.

The experience of the league was jolting simply because of its interest in women's liberation, but it tells us by implication something about the impact of national socialism on all Protestant and Catholic women. During the Third Reich they were not allowed to evolve as they normally would have in their understanding of women in society. The Catholic Women and Mother's Sodality illustrates this point. On the eve of the National Socialist era the sodality was evolving into a society, which connotes a switch in emphasis away from the exclusively spiritual toward an action-oriented association. Indeed, during the Third Reich it made this transition, but only in one sphere. Thus, in the eyes of the gestapo, the sodality had "ceased to be a pious, praying association" and had become involved in Catholic Action, upholding Christian ideals on the family, motherhood, and chastity.[12] Under the close scrutiny that national socialism imposed on German society it was impossible for sodality members to develop interest in or ac-

tively promote women's rights. After the National Socialist era the sodality took up this kind of work and changed its name to the Catholic Women's Society of Germany (*Katholische Frauengemeinschaft Deutschlands*).

The experience of the sodality suggests that, were it not for National Socialist intervention, both Protestant and Catholic women would have gradually developed a wider interest in women's affairs outside the home during the 1930s. Even though the Federation of German Women's Associations had drifted further and further to the right during the interwar period, there still existed pockets of liberal and feminist support within it.[13] Within church organizations the tradition was carried on by the Evangelical Women's League and the Catholic German Women's League, especially the latter. Without National Socialist intervention, the pace of change would have been the quickest within the leagues. Even the sodality, which had been cool toward women's issues during the twenties, and the auxiliary, which was hostile toward liberalism and feminism, would have undoubtedly thawed somewhat during the second half of the thirties as the impact of the depression waned. The effect of national socialism on Protestant and Catholic women generally was to forestall the evolution toward wider social and economic roles for women that had begun earlier in the century and would continue after the Nazi debacle.

Surprisingly, there is one exception to the stultifying impact of national socialism on Protestant women: church leadership (ministry and eldership). This last preserve of "maledom" collapsed during the Third Reich due to two pressures, the Protestant Church Struggle and the shortage of clergymen brought about by the war. During the interwar period Protestant women never enjoyed full ministerial ordination and only rarely were allowed to serve as elders in their churches. A typical attitude was expressed in 1929 by a Prussian province that reported that it had "emphatically rejected the election of women as elders because women belong at home and in charitable work, not in church leadership."[14] The experience of the Protestant Church Struggle ended this attitude toward women once and for all because it involved women directly in community decisions in a way that had not

occurred earlier in the century. When women took sides in the auxiliary-service dispute, they often conflicted with the position of their church elders, or pastor, or bishop, or local National Socialist officials. These were public disputes, which frequently led to litigation. In some provinces women even took issue with the middle-of-the-road policies of General Superintendent Zoellner. At the national level leaders of the auxiliary were caught up in what contemporaries viewed as a fundamental and important debate over Bishop Müller and the Reich Church. At every level Protestant women became accustomed to making up their own minds and accepting the consequences of their actions.

Once they overcame their preoccupation with mother-care and blind enthusiasm for national socialism, auxiliary women mounted an extensive and successful Bible study program, which became the church's first line of defense both against Nazi neopagan elements and against the more common attacks on the Confessing Church. The deep malaise among Protestant men meant that the church had to rely on women for popular support in the face-off with national socialism. "Because of the generally modest participation of male community members," a Westphalian churchman wrote in 1940, "the work of women is especially important."[15] Since the auxiliary was either sympathetic to the Confessing Church or squarely behind it, church leaders relied upon it as a national organization. Thus, the auxiliary found itself rather officially in the middle of fractious community relationships triggered by the Protestant Church Struggle.

This experience made women sensitive to the importance of eldership. Immediately after World War II, when church administrators tried to deny women the right of eldership, the auxiliary objected strongly. Reminding the church of its loyalty to the Confessing Church during the Protestant Church Struggle and of its defense of the faith during the Nazi era, women denounced the administration's decision, calling it petty.[16] In the end women prevailed, as one church synod after another, beginning with Westphalia in 1946, changed its constitution to allow women elders.[17] Having won in principle, the auxiliary began promoting women candidates for eldership positions.[18]

Women's breakthrough into the ministry occurred even sooner during the National Socialist era itself. The context of this development was the religious malaise among men, but the immediate catalyst, as with eldership, was the Protestant Church Struggle. Church authorities never overcame the divisiveness that national socialism introduced into their ranks. Contention drained their energy and that of individual pastors who were in greater demand than ever because of splinter groups of Confessing Church laypersons. During the latter years of the thirties, the shortage of ordained ministers became more critical when the National Socialists harassed Confessing Church pastors, sometimes cutting off their salaries or jailing them and always attempting to interfere with their preaching the Word and spending the Sacraments. Then the war came and thinned the ranks of ministers even further because of the demand for military chaplains. As a result of these combined factors, the Protestant church found itself acutely short of personnel.[19]

Women took up the slack. During the Weimar years women had taken theological degrees in increasing numbers, and when the Bible study program got underway, women ran it. These trained theologians, along with women who had graduated from the auxiliary's own Bible institute, became involved in the ministry when pastoral shortages became critical. In other words, they began to cross over the line separating catechistic work from preaching the Word. In those areas where women had already served as assistant pastors, the line marking off their area of competency from that of the pastor became blurred. The *Vikarin* evolved into a *Pastorin.* This seems to have occurred first in large urban churches.[20]

This transition from the pew to the pulpit took place under the auspices of the Confessing Church. Helga Weckerling, who may have been the first woman ordained under emergency circumstances in 1937, worked for the Confessing Church, as did Sieghild Jungklaus, another early *Pastorin.*[21] There appear to be no exceptions to this pattern. The first cases of ordination were isolated instances, but before long the exception became the rule within the Confessing Church. It is important to note that this change took place with the collaboration of church leaders, that is, churchmen. Church au-

thorities were well aware of the Bible program of the Protestant Ladies' Auxiliary, whose greater development they encouraged.[22] Women played a key role because, as Maria Weigle wrote, their Bible renewal work often provided Protestants, who had lost contact with their pastor, the sole link to the church—that is, to the Confessing Church.[23] As the Protestant Church Struggle dragged on and the Confessing Church confronted National Socialist neopaganism, churchmen attached more and more importance to the Bible program and began to see the involvement of women in the church as indispensable. Official acknowledgment and greater responsibility could not take place without a "real incorporation [of women] in the structure of the church and community."[24] Thus Protestant women prepared their own way for acceptance as ministers. This became explicit when a Confessing Church synod formally adopted two propositions, one on "The Ministry of Deaconesses" and the other on "The Preaching of the Gospel by Women."[25] By 1942 the Confessing Church had officially authorized women to act as ministers.[26]

The circumstances imposed on the Protestant church by national socialism sped the evolution of women from *Vikarin* to *Pastorin*. Although in the twenties Paula Müller, longtime leader of the Evangelical Women's League, had urged that women be ordained, her ideas were well ahead of those of most Protestants, including women.[27] Without the impulses of the Protestant Church Struggle, National Socialist neopaganism, and the war, German women probably would have had to wait for the feminist movement of the 1960s to secure ordination and eldership. Instead, their intense involvement in the life of the church and community between 1935 and 1945 had the effect of raising self-esteem and a consciousness of their importance. As a result, they demanded and won eldership after the war. As church elders, women could nominate and urge the appointment of women theologians as ministers. In this manner, what began under emergency circumstances continued on as church policy and practice without interruption after World War II ended the National Socialist era.

All of this was completely unforeseen. Who could have

imagined in 1933 that one of the most conservative groups in Germany, the auxiliary, would become the vehicle for an important development in women's affairs? Meanwhile, Catholics emerged from the Third Reich empty-handed. The Catholic German Women's League, by far the most advanced church-related group when it came to women's affairs, all but suffocated under the terms of existence in National Socialist Germany as spelled out by the Concordat.

Before concluding our study, let us look again at the view from the other side. What did National Socialists think of Christian women? Those who had invested deeply in National Socialist ideology had reason to view churchgoing women with concern because of their ties with church authorities and commitment to the Word of God. Much more than men, these women held firm to an ideology that opposed national socialism at some critical points. Both sides knew that the answer to the question as to which ideology would emerge victorious lay with the youth. After 1935 a major struggle developed that took the form of a fight for control of the kindergartens and daycare facilities. The churches and their women held on tenaciously. Membership statistics suggest that while the party had succeeded in keeping young women from joining those associations of women that were more extreme in their opposition to national socialism than others (the Elizabeth Society, the Catholic German Women's League, and, presumably some Confessing Church cells), it was not able to block their path when it came to other organizations. The battle over the kindergartens and for the allegiance of teenage girls and women in their twenties suggests that the confrontation between Christian and National Socialist *Weltanschauungen* was something of a standoff. When the war broke out, neither side could be certain that it would prevail.

After six years of rule, such uncertainty had to be disturbing from the National Socialist point of view. The ties of women to the churches created a volatile situation. Although churchgoing women had varying levels of credal commitment, they were all linked together by the bond of religion, which was the last remaining vehicle of mass protest or opposition to national socialism. The bond of religion proved ef-

fective in "Thalburg," where church attendance increased when local National Socialists attacked Lutheranism.[28] Religious belief created a volatile situation because if a subgroup of churchwomen, who were stronger or more vocal in their opposition to the prevailing secular ideology than others, was given strong support by the authorities of their church, there was a potential for a shift in public opinion. Some backsliders would decide to return to active church membership; some churchgoing women who had hitherto not dared to register dissent by joining the auxiliary or sodality would gather up the courage to do so; and a select few would make the step from dissent to resistance. Membership statistics for the two largest organizations of Protestant and Catholic women suggest that the potential for a shift in public opinion on a national basis was real.

It is in this light, and especially in connection with National Socialist racism, that the failure of church leadership was crucial. The German public refused to assign racial teaching the high priority the Nazis wished, but, on the other hand, women continued to support the NSV even after it acknowledged its racist principles. The Catholic church urged women to support Caritas, but it could not make this a major issue since Caritas was itself linked to the NSV. Except for isolated incidences (sterilization and euthanasia), the churches never publicly objected to the racist principles of National Socialist welfare, let alone its anti-Semitism. Instead of supporting Agnes von Grone in a case that touched fundamental moral and church-state issues, General Superintendent Zoellner abandoned her and worked to isolate her from Protestant women. After von Grone was found guilty, Zoellner wrote *Reichsfrauenführerin* Scholtz-Klink in 1936, pleading the cause of Protestant women and begging her to include the auxiliary in the work of German Women's Enterprise.[29] There is little doubt but that he would have tolerated National Socialist racist teaching in the auxiliary's mothercare centers had Scholtz-Klink decided to take him up on the deal he proposed. When the war came, and with it the mass murder of European Jews, the churches' objections were too late and too faint. Only one Protestant synod spoke out unequivocally about the "Final Solution."[30]

Cardinal Bertram's pusillanimity was even more critical, because Margarete Sommer supplied him with information about the Holocaust. Instead of pursuing these leads relentlessly, Bertram apologized weakly to National Socialist officials whenever church statements were used by Germany's enemies for propaganda.[31] In this connection, the failure of the Vatican to inform Bertram about the Holocaust was awesomely critical.

It is in this one essential area of racism that we find a basic similarity in the experiences of Catholic and Protestant women. It was difficult for them to deal with National Socialist racism as a moral issue. Even while the regime's anti-Semitic campaigns mounted in intensity from 1933 to 1939, Protestant and Catholic women remained concerned only about doctrine, not people. To put the best face on it, we could suggest that, by dealing with racism in only a religious context, individuals protected themselves from capricious arrest or surveillance on the part of the gestapo. In truth, however, this argument seems specious, especially for the early years of Hitler's rule.

Whatever shortcomings their attitudes carried, they were not unimportant or completely ineffectual. The conflict surrounding mothercare demonstrates their influence. Although Catholic women were more resolute and principled in their rejection of racism in mothercare work, Protestants were eliminated from it as well (and I would contend essentially for the same reason). As a result, National Socialist racist teaching was less well received in Germany than would have been the case had it enjoyed the moral authority of the churches. Thus, Protestant and Catholic women, along with their several associations, frustrated national socialism in a key ideological matter.

But they did not frustrate the National Socialist design to deport, ghettoize, and murder Jews en masse. Indeed, it appears that acts as drastic and unspeakable as these were required to spur a certain number of Protestant and Catholic women to acts of civil disobedience. Inge Kanitz, a member of the Bonhoeffer circle, was initially outraged when she was put in a position of endangering her family by hiding a young Jewish woman. Only when the latter recounted to her how Nazis

had brutally murdered her baby and deported her sister to Auschwitz did Kanitz overcome her misgivings.[32] Of course, what a limited number of women could do at the eleventh hour was very little.

Notes

Introduction

1. Those who are now questioning the German "*Sonderweg* thesis" argue a valid point when they contend that placing national socialism in the center stage of the country's history flattens out the complexity of German society. This has been the fate of Protestant and Catholic women whom historians have tended to ignore in favor of much smaller subgroups of women. I found the following historiographical essays useful for my own orientation: Gordon Craig, *The Germans* (New York, 1982); Theodore Hamerow, "Guilt, Redemption, and Writing Germany History," *American Historical Review* 88, no. 1 (February 1983); 53–72; and Konrad H. Jarausch, "Il-liberalism and Beyond: German History in Search of a Paradigm," *Journal of Modern History* 55, no. 2 (June 1983); 268–84.

2. Claudia Koonz, *Mothers in the Fatherland* (New York, 1987).

3. Sarah Gordon, *Hitler, Germans and the "Jewish Question"* (Princeton, 1984); Ian Kershaw, *Public Opinion and Political Dissent in the Third Reich: Bavaria, 1933–1945* (New York, 1983); Detlev Peukert, *Volksgenossen und Gemeinschaftsfeinde: Anpassung, Ausmerze, und Aufbegehren* (Cologne, 1982).

4. Except for brief mention by H. D. Leuner in *When Compassion Was a Crime* (London, 1966), Sommer has been ignored by historians.

5. See Gordon, 246ff.

6. Klaus Scholder, *Die Kirchen und das Dritte Reich, 1918–1945* (Berlin, 1977); Ernst Christian Helmreich, *The German Churches Under Hitler: Background, Struggle, and Epilogue* (Detroit, 1979). Local Studies of the Protestant Church Struggle have begun, fortunately, to address this gap in the historical record; see, for example, Bernd Hey, *Die Kirchenprovinz Westfalen, 1933–1945* (Bielefeld, 1974). For an excellent collection of documents see Fritz Mybes's *Geschichte der evangelischen Frauenhilfe in Quellen* (Barmen, 1975).

Chapter 1

1. The auxiliary had the disconcerting habit of changing its name with regularity: *Die Frauenhülfe des Evangelisch-Kirchlichen Hülfsvereins, Die Evangelische Frauenhilfe*, and *Der Reichsverband der Evangelischen Frauenhilfe* were all used at one or the other time. Today it is again, simply, *Die Evangelische Frauenhilfe*.

2. P. Cremer, ed., *Die Frau im evangelischen Gemeindeleben* (Potsdam, 1912), 11; *Statistik der Frauenorganisationen in Deutschen Reiche* (Berlin, 1909), 18–66; *Jahresberichte des Evangelisch-Kirchlichen Hülfsvereins, 1902–1929; Handbuch der Inneren Mission* (Berlin, 1929), 128–32; and ADW B III I 5 II. Whether or not the auxiliary continued to grow during the Third Reich is a question I deal with in chapter eleven.

3. *Statistik der Frauenorganisationen in Deutschen Reiche* (Berlin, 1909), 18–66.

4. On these statistics, see *Aus der Caritas im Bistum Paderborn* (1924), 5–12 (on the Elizabeth Society); Hildegard Becker, "Der Katholische Deutsche Frauenbund in der Katholischsozialen Bewegung bis 1933," (Diss., Freiburg i.B., 1966), 29 (on the Catholic German Women's League); and *Frau und Mutter* 25, no. 1 (January 1934): 16 (on the Catholic Women and Mother's Sodality).

5. *Uebersicht über die Organization der Zweigvereine* (1896); and *Verzeichness der Zweigvereine der Frauenhilfe des Evang. Kirch. Hülfsverein* (1908).

6. Anon. [Ingeborg Rocholl-Gärtner], *Anwalt der Frauen, Hermann Klens* (Düsseldorf, 1978), 88.

7. Becker, 41, 115.

8. *Piepers Kirchliche Statistik* 1 (1895): 91.

9. Hoover Institute, NSDAP Hauptarchiv, reel 24, folder 489; *Statistik über erfolgte Kirchenaustritte.*

10. Archival and published sources make this abundantly clear; for Catholics, see OAT B III 11,12 which deals with Bruderschaften, the *Vinzenz Blätter*, and the *Bulletin de la Société de St. Vincent de Paul* (see 1930–39 of the old series); and for the Protestants, see the material in ADW Evang. Kirchl. Hilfsverein, 1931–1945. Note that the material in this file, which was written after the Nazi era by Pastor Hoppe, is self-serving and does not square with the other documents in the file.

11. Paula Müller, "Die Kirche und die Frau," *Hefte zur Frauenfrage* 20 (1922): 22; and, Gerta Krabbel, "Concerning the Question of a Female Priesthood," *Die Christliche Frau* (1922): 43.

12. Eva Senghaas-Knobloch, *Die Theologin in Beruf* (Munich, 1969), 17–18, and Agnes von Zahn-Harnack, *Die Frauenbewegung* (Berlin, 1928), 358.

13. AEKU 12, no. 40 B, vol. 4, Auxiliary to High Church Council, Potsdam, 13 October 1923.

14. *Der Bote* 28, no. 27 (5 June 1931); 322.

15. On Protestant women, see EKW Frauenhilfe records [henceforth, "Frauenhilfe"] and ADW B III 15 1, Minutes of the conference held in Berlin, 27 March 1903; on Catholic women, see Peter Altenstetter, "Die soziale Tätigkeit der katholischen Kirchengemeinde Karlsruhe im 19ten und 20ten Jahrhundert," (Diplomarbeit, U. of Freiburg i.B., 1966), 28, and Michael Gasteiger, "Der St. Elizabethenverein in München," (unpublished manuscript in ADC), 14 and 29–30.

16. Ursula von Gersdorff, *Frauen im Kriegsdienst, 1914–1945* (Stuttgart, 1969), 23.

17. Hedwig Dransfeld, "Die Ausbreitung des Katholischen Frauenbundes Deutschlands," *Christliche Frau* 15, nos. 6–7 (June—July 1917): 160.

18. Gersdorff, ch. 1.

19. Gertrud Osterloh quoted in Fritz Mybes, *Geschichte der Frauenhilfe in Quellen* (Barmen, 1975), 294; Frankfurter Rundschau, 17 October 1985. For a detailed development of this theme, see Laura Gellott and Michael Phayer, "Dissenting Voices: Catholic Women in Opposition to Fascism," *Journal of Contemporary History* 22 (January 1987): 91–114.

20. *Mitteilungen der Evang. Frauenhilfe in Rheinland,* no. 11 (December 1918); document printed in Mybes, 44.

21. Doris Kampmann, "'Zölibat ohne uns!'–Die soziale Situation und politische Einstellung der Lehrerinnen in der Weimarer Republik," *Mutterkreuz und Arbeitsbuch* (Frankfurt am Main, 1981), 82–90.

22. ADW Evang. Frauenhilfe 1919–1931, vol. I B III b2; see the annual programs.

23. Renate Bridenthal, "Something Old, Something New: Women Between the Two Wars," *Becoming Visible,* ed. R. Bridenthal and Claudia Koonz (Boston, 1977), 426.

24. S. Dammer and C. Sachse, "Nationalsozialistische Frauenpolitik und Weibliche Arbeitskraft," *Frauengeschichte,* Beiträge 5(1981), 109.

25. HAK CR 22,20 Generalpräses Klens to 1928 Fulda Bishop's Conference, Düsseldorf, 9 July 1928.

26. Tim Mason, "Women in Germany, 1925 to 1940: Family, Welfare and Work," *History Workshop* 1(Spring 1976): 426.

27. Claudia Hahn, "Der Oeffentlichen Dienst und die Frauen Beamtinnen in der Weimarer Republik," *Mutterkreuz und Arbeitsbuch*, 58.

28. *Der Bote* 28, no. 27(5 June 1931): 324.

29. Becker, ch. 4; *Frauenbund* 1, no. 1(20 October 1907).

30. Gellott and Phayer, 91–114.

31. *Die Mutter* 8(1910): 31.

32. Frank Gordon, "The Evangelical Churches and the Weimar Republic, 1918–1933" (Ph.D. diss., University of Colorado-Boulder, 1977), 165ff.

33. OAT B III 14,5 B, minutes of the 7 March 1927 meeting.

34. See the fine discussion of these encyclicals in Laura S. Gellott, "The Catholic Church and the Authoritarian Regime, 1933–1938: A Relationship Reexamined" (Ph.D. diss., University of Wisconsin-Madison, 1982), 268–73.

35. In Silesia there were 25,000 members and 350 affiliates in 1926; two years later there were 62,000 members and 460 affiliates; see Mybes, 57. The sodality grew from about 300,000 in 1925 to about 900,000 in 1933; see *Frau und Mutter* 15, no. 1(January 1934): 16.

36. Hartmut Lehmann, "Pietism and Nationalism: The Relationship between Protestant Revivalism and National Renewal in Nineteenth-Century Germany," *Church History* 51, no. 1(March 1982): 47.

37. On the origins of the Protestant Ladies' Auxiliary, see Michael Phayer, "Protestant and Catholic Women Confront Social Change in Germany." In *Another Germany: A Reconsideration of the Imperial Period*, Ed. Jack Dukes and Joachim Remak (New York, 1987), 95–113.

38. The correct title of the Messenger until 1917 was *Der Bote für die Christliche Frauenwelt*; thereafter, *Der Bote für die deutsche Frauenwelt*. The directors of the auxiliary explicitly aimed *Der Bote* at women of "des kleinen Standes."

39. Archival material on this effort can be found in EKB Holz/Regel 4/4; important printed literature includes *Aus Der Kriegsarbeit der Berliner Frauenhilfe* (Berlin, 1915); Pastor Cremer, *Mit dem Liebesgabenzug der Frauenhilfe für Hindenburgarmee* (Potsdam, n.d.); *Der Bote* 11 (1917). See also, [anon.], *Die Evangelische Kirche in Nassau-Oranien, 1530–1930* (Siegen, 1933), II, 455–57.

40. EKB Holz/Regel 4/4, Frauenhilfe to Consistorium of Brandenburg Province, Berlin, 29 September 1914.

41. *Jahresbericht*, 1917–1918, 6.

42. Gordon Craig's recent survey of modern Germany brings out the position of Catholics as "outsiders": *Germany, 1866–1945* (New York, 1980). Works in English that deal specifically with the Catholic tradition in Germany are Ronald Ross's *Beleaguered Tower* (Notre Dame University Press, 1976), and David G. Blackbourn's *Class, Religion, and Local Politics: The Center Party in Württemberg Before 1914* (New Haven, 1980).

43. Becker, 28, 46; *Frauenland* 8, no. 5(January 1915).

44. *Frauenland* 8, no. 5(January 1915).

45. OAF 55/66. Reports (by women) on the war-related work of women's organizations of the city of Karlsruhe. See also Becker, 46.

46. Evans, *The Feminist Movement*, 223–27; Gersdorff, ch. 1.

47. I am basing this conjecture on a 1918 address by Hedwig Dransfeld, one of the league's foremost leaders, in which she ventured the opinion that the women's movement had lost enough emotional overcharges that the league could sponsor it; see Becker, 46–53.

48. Ibid., 120.

49. Greven-Aschoff, 160.

50. ADW Ev. Frauenhilfe, vol. 1. B III b2. See the annual programs in this file; see also, Mybes, 43.

51. J. R. Wright, *Above Parties: the Political Attitudes of the German Protestant Church Leadership, 1918–1933* (London, 1974), 17; Patricia Leonard Fessenden, "The Role of Women Deputies in the German National Constituent Assembly and the Reichstag: 1919–1933," (Ph.D. diss., Ohio State University, 1976), 146–48; Thomas Childers, *The Nazi Voter* (Chapel Hill [N.C.], 1983), 40–41.

52. *Frauenland* 17, no. 3(December 1924); on pacifism, see ibid. 25, no. 3(March 1932), 77–79.

53. OAF 55/69 Tätigkeitsbericht, 1924–25; Becker, ch. 4; Fessenden, 111–12.

54. HAK CR 22,20 Bezirkspräses Protokoll, December, 1926, and Generalsammlung, 1930.

55. The Bund Königin Luise put out a pamphlet in 1934 that described itself and its history: Franziska von Gaertner, *Der Bund Königin Luise* (Halle, 1934).

Chapter 2

1. Geiger's *Panik im Mittelstand* appeared in 1930, and he followed it up two years later with *Die Soziale Schichtung des Deutschen Volkes* (Stuttgart, 1932).

2. Richard Hamilton, *Who Voted For Hitler?* (Princeton, 1982).

3. The idea that a few capitalists in each country, perhaps interrelated with one another, controlled the lives and destinies of the masses, a theme which Fritz Lang's silent motion picture *Metropolis* masterfully propounded, found acceptance among Protestant women; see *Der Bote* 28, no. 7(2 February 1931), 75.

4. Thomas Childers, *The Nazi Voter* (Chapel Hill [N.C.], 1983), 40–41, 116.

5. Patricia Leonard Fessenden, "The Role of Women Deputies in the German National Constituent Assembly and the Reichstag, 1919–1933" (Ph.D. diss., Ohio State University, 1976), 111–12, 143.

6. I am aware that historians think Hitler's economic recovery lacked substantial underpinnings and that it would have collapsed had not World War II intervened. I refer here only to the apparent recovery of the economy.

7. Peter Merkl writes, for example, that the "acceptance of National Socialism appears to have been a function of the decay of the Protestant faith in Germany. Nazism was a substitute religion for Protestants who had lost their faith." *Political Violence Under the Swastica* (Princeton, 1975), 94.

8. This group was known as the *Evangelische Frauendienst*; they are discussed in some detail below in chapters dealing with Protestant women.

9. For more details on the Catholic-Protestant vote split, see chapter three. Hajo Holborn's standard history of Germany takes the view that Protestants voted for Hitler; see *A History of Modern Germany* (New York, 1969), vol. 3, 742. Two excellent recent studies, Richard Hamilton's *Who Voted For Hitler?* and Thomas Childers's *The Nazi Voter* are in agreement on this point.

10. J. R. Wright, *Above Parties: The Political Attitudes of the German Protestant Church Leadership, 1918–1933* (London, 1974), 106.

11. Hamilton, 183.

12. Thomas Childers, *The Nazi Voter,* and Richard Hamilton, *Who Voted For Hitler?,* are in complete agreement on this point.

13. I have no statistics on the ages of auxiliary members, but excellent data exist on Catholic women activists, which show that in western Germany between 50 and 60 percent were younger than fifty years of age in 1938. Only in Bavaria were they slightly older. See ADC 349K, 11, 30, 62, and 71.

14. In *Who Voted For Hitler?,* Richard Hamilton has shown that upper-class and lower-class support of national socialism was important. Although I have argued that the middle class dominated the auxiliary, the continued existence of lower- and upper-class membership is beyond doubt. While providing much needed balance to

the discussion of the national socialist constituency, Hamilton is quite ready to admit the importance of middle-class votes.

15. I suspect that because western Germany was strongly socialist, it is atypical of the country as a whole as far as lower-class representation in the Protestant auxiliary is concerned. On social composition in this industrialized area, see Adolf Noll, *Sozio-ökonomischer Strukturwandel des Handwerks in der zweiten Phase der Industrialisierung* (Göttingen, 1975), 24.

16. Analysis of the social composition of the auxiliary is based on the province of Westphalia and the Rhineland for the period before 1911 and on Westphalia alone therafter. For the Rhineland, see Pastor Arnold, *Die von der Frauenhülfe organisierten Krankenpflege auf dem Lande durch freiwillige Hilferinnen* (Potsdam, n.d.[1911]), 13. For Westphalia, see the *Hilferinnen* records in EKW. I am indebted to Dr. Hans Steinberg, director of the Westphalian church archives, who let me work through the *Hilferinnen* records, although they were not yet catalogued.

The *Hilferinnen* records deal with the Volunteer Nursing Program of the Protestant Ladies' Auxiliary. These records provide valuable information such as the age of the volunteers and their social class (occupation of father). In many respects, the volunteer nurses were like Catholic sisters. The records reflect those segments of German society, therefore, who provided the Protestant church with its most zealous members. I do not believe that these records contain an inherent bias against lower-class Protestant activism because the physical necessities of the volunteer nurses were provided by the institutions (hospitals, orphanages, and so on) for which they worked. A woman, therefore, did not have to have an independent source of funds.

17. The increase for each group from the Wilhelmian to the Weimar eras were as follows: handicrafts—1.2 percent; shopkeepers—8 percent; professions—2.4 percent; civil servants—7.4 percent.

18. Among the professional group, women from ministers' families constituted the largest single segment. Lawyers are not represented at all.

19. A number of members of the Protestant Nurses' Organization specified *Gutsbesitzer* and *Hofbauer* in citing their family background.

20. ADW, CA 401, minutes of 11 February 1931. Among the women carrying titled family names were a baroness and a countess.

21. See, above all, the recent studies by Hamilton, *Who Voted For Hitler?*, and Childers, *The Nazi Voter*, and their bibliographical citations. A partial list of additional important recent studies include H. S. Winkler, "German Society, Hitler and the Illusion of Restoration 1930–1933," *Journal of Contemporary History* 11, no. 4 (October 1976); Wilfried Böhnke, *Die NSDAP in Ruhrgebiet, 1920–1933* (Bonn, 1974); Peter Merkl, *Political Violence Under the Swastica* (Princeton, 1975); Thomas Childers, "The Social Basis of the NS Vote," *Journal of Contemporary History* 11, 4 (October 1976); Jeremy Noakes, *The Nazi Party in Lower Saxony* (Oxford, 1971); Rainer Hambrecht, *Der Aufstieg des NSDAP in Mittel und Oberfranken* (Nürnberg, 1976); and James Paul Madden, "The Social Composition of the Nazi Party," (Ph.D. diss., University of Oklahoma, 1976).

22. Richard Hamilton argues persuasively that class fragmentation has been overemphasized by historians and that there was actually more pulling Germans together than apart. Among these forces, nationalism. and religion are important. See *Who Voted For Hitler?*, passim.

23. The anti-Bolshevism of the paper is frequent and explicit; see vol. 28, no. 27(5 June 1931); 322, 324. More surprising is its anticapitalism, which is less frequent and typically postdepression; see vol. 28, no. 7(15 February 1931); 75—76. Identification of industrialism and materialism with Jews is explicit but remains muted until after the National Socialists take over the country (see chapter five). The paper vaguely supports the notion of an economy based on agricultural and artisanal production (see the above citation from volume 28 and footnote 18). *Der Bote* reflects a revulsion among Protestant women for the Weimar system of government and a deep yearning for the Bismarckian *Kaiserreich* (see, for example, vol. 28, no. 1[4 Jan-

uary 1931]; 5 and, in the same year, no. 4[25 January]:41.) See these two articles for nationalistic, francophobic feelings and vol. 28, no. 1(4 January 1931): 5; negative attitudes toward Versailles appeared regularly, often as *obiter dicta,* but see vol. 31, no. 26(1 July 1934): 307–8.

24. In 1931 a staff writer of *Der Bote* identified the artisans as the element in the Volk that embodied "morality, education, and piety"; see vol. 28, no. 12(22 March 1931): 140. Protestant women were far from being a "remnant" within German society, but, because they felt like "outsiders" during the Weimar Republic, they tended to look upon themselves as a minority.

25. In 1930 the auxiliary ran extensive city missions (soup kitchens and health stations) on behalf of the urban poor, and it operated 14 hospitals, 13 youth hospices, 14 orphanages, 12 homes for the aged, and 140 kindergartens. In addition, many Protestant women continued to put in many hours in personal service to the sick and poor throughout the land; see *Jahresbericht aus der Arbeit des Gesamtverbandes der Evangelischen Frauenhilfe (1928–1929).* On the impoverishment of the middle class, see the annual report of the Berlin auxiliary for 1929 in *Der Bote* 28, no. 10(8 March 1931): 115.

26. Gabrielle Bremme, *Die Politische Rolle der Frau in Deutschland* (Göttingen, 1956), 76ff.

27. Karl Holl, "Konfessionalität, Konfessionalismus und demokratische Republic–zu einigen Aspekten der Reichspräsidentenwahl von 1925," *Vierteljahrschrift für Zeitgeschichte* 17, no. 3(July 1969): 263.

28. *Der Bote* 29, no. 49(4 December 1932): 587.

29. The percentage of women to men theology students increased from one to five between 1919 and 1931. The biggest increase came after 1927 when women won the right to hold a salaried position as an assistant pastor, *Vikarin,* in a number of synods; see Eva Senghaas-Knoblock, *Die Theologin in Beruf* (Munich, 1969), 17–18.

30. The völkisch theme, which was nuanced and complicated, is described in detail in volume I of Kurt Maier's *Der Evangelische Kirchenkampf* (Göttingen, 1976), passim; for a briefer explanation, see Kurt Scholder, *Die Kirchen und das Dritte Reich* (Berlin, 1977), 125ff. A recent English-language study of this subject is Daniel R. Borg's *The Old-Prussian Church and the Weimar Republic: A Study in Political Adjustment, 1917–1927* (Hanover and London, 1984).

31. This völkisch view is increasingly in evidence in the reports of the annual meetings of the Protestant Ladies' Auxiliary for 1930 and 1931; see ADW Ev. Frauenhilfe 1917–1931, I BIII b2 and 400 CA BIII 15.

32. See Rainer Hambrecht, 284–292, on Franconia, and Jeremy Noakes, 209, on Saxony. On racism, see Ernst C. Helmreich, *The German Churches Under Hitler* (Detroit, 1979), 68.

33. J. R. Wright, *Above Parties: the Political Attitudes of the German Protestant Church Leadership, 1918–1933* (London, 1974), 17; see also Scholder, 144.

34. Richard Gutteridge, *Open Thy Mouth for the Dumb: the German Evangelical Church and the Jews, 1879–1950* (New York, 1976), 49; on exploitation of the anti-Semitism in the church, see also Winkler, 177, 219–220; Böhnke, 209; Chambers 76–78, 258; and Childers, 258–59;

35. Aside from an occasional anti-Semitic remark, there was no discussion of the "Jewish question" until after 1933; but *Der Bote* did not protest against anti-Semitism when the chance to do so arose, such as following the 1931 National Socialist attack on Jewish shops along the Kurfürstendamm in Berlin.

36. See below, chapter five.

37. ADW 401 CA B III b2. See the minutes of the 4 February 1932 meeting.

38. *Der Bote* 29, no. 17(14 April 1932): 201; 30(24 July 1932): 357; 45(30 October 1932): 525; 35(24 August 1932): 417. This copy in *Der Bote* was especially noticeable because political coverage during 1931 had declined sharply.

39. *Der Bote* 29, no. 49(4 December 1932): 587. See also the pamphlet published by the auxiliary, *Evangelische Frauenhilfe* by Ernst Koch, 6.

40. Chambers, 260.

41. *Der Bote* 28, no. 47(22 November 1931): 564; 31, no. 26(1 July 1934): 308; 28, no. 2(4 January 1931): 5.

42. See Martin Broszat, "Soziale Motivation und Führer-Bindung des National-sozialismus," *Vierteljahrschrift für Zeitgeschichte* 18, no. 4(October 1970): 399; and chapter four.

43. Hambrecht, 290.

44. Frank Gordon, "The Evangelical Churches and the Weimar Republic, 1918–1933," (Ph.D. diss., University of Colorado-Boulder, 1977), 292–301.

45. The Protestant Men's Apostolate did not gravitate toward national social-ism like the Ladies' auxiliary, and, when some church leaders made a shameless and misguided effort to increase the involvement of Protestant men in the apostolate by using it to promote national socialism, the response of churchgoing men was sluggish at best. See ADW Inn. Mission Verbundene: EKH II B III 1 and ADW Evang. Kirchlicher Hilfsverein, 1931–37. For the specific connection with national socialism, see ibid., Sitzung des Hauptschlusses des Evang.-Kirchl. Hilfsverein, 11 December 1933. One of the church leaders behind this effort, Dr. Hoppe, wrote a report in 1948 in which he turned history inside out by maintaining that the effort to reinvigorate the Men's Apostolate was doing well until the success of national socialism smothered it. His self-serving report is in ADW CA/HA Kunze 2 Evang.-Kirchl. Hilfsverein, 1935–49.

46. Gellott and Phayer, 91–114.

47. *Der Bote* 28, no. 7(15 February 1931): 79.

48. AEKU 12, no. 40 bd. V. Klara Schlossman-Lönnies to Kapler, Potsdam, 4 January 1932.

49. In 1930 the province of Nordmark counted about twenty different activi-ties exclusive of mothercare, but the latter occupied half of the member's time; see *Der Bote* 28(12 July 1931): 355.

50. *Der Bote* 28, no. 12(22 March 1931): 139.

51. Ibid. 29, no. 20(26 June 1932): 309.

52. Ibid. 29, no. 20(15 May 1932): 239.

53. An arrangement was worked out whereby part of the per diem expenses would be paid for by the auxiliary's central office and the other half by the local affiliate.

54. *Der Bote* 28, no. 18(3 May 1931): 215; in vol. 29, see no. 1(3 January 1932): 79 and no. 19(8 May 1932): 224.

55. Mybes, 49.

56. Fessenden, 146–48.

57. Although the auxiliary's paper, *Der Bote*, emphasized that women of every class visited the homes, my impression is that the guests tended to reflect the class structure of the auxiliary itself, which means, of course, that most guests would have been of the middle class. Regarding the inability of some middle-class women to pay for their visit, see *Der Bote* 29, no. 49(4 December 1932): 583.

58. *Der Bote* 32 no. 8(24 February 1935); 87.

59. Extensive work on this question may be found in the following: Leila J. Rupp, "Mothers of the *Volk*: the Image of Women in Nazi Ideology," *Signs* 3, no. 2(Winter 1977): 362–79; Tim Mason, "Women in Germany, 1925–1940: Family, Welfare and Work," *History Workshop* 1 (Spring 1976): 74–113, and 2 (Autumn 1976): 5–32; Karen Hausen, ed., *Frauen Suchen Ihre Geschichte: Studien zum 19. und 20. Jahrhundert* (Munich, 1983); Frauengruppe Faschismus Forschung, ed., *Mutter-kreuz und Arbeitsbuch* (Frankfurt, 1981); Gruppe Berliner Dozentinnen, ed., *Frauen und Wissenschaft* (Berlin, 1977).

60. Childers, 239.

61. Doris Kampmann, "'Zölibat-Ohne Uns!' Die soziale Situation und politische Einstellung der Lehrerinnen in der Weimarer Republik," *Mutterkreuz und Arbeitsbuch*, 99.

62. Ibid.; for the petition, see ADW Sitzung des Hauptvorstandes der Ev. Frauenhilfe, 18 February 1927.

63. ADW Evang. Frauenhilfe 1919–1931. Vol. I B III b2. See the annual pro-grams.

64. On the school question, see Frank Gordon, "The Evangelical Churches and the Weimar Republic, 1918–1933," (Ph.D. diss., University of Colorado-Boulder, 1977), 165ff.

65. Childers, 114.

66. *Der Bote* 28 no. 51(20 December 1931): 611. The film was called *Der Grosse Stromm—ein Film von Mutter und Volk.* The new magazine seems to have been delivered to subscribers of *Der Bote.* Eventually the National Socialists terminated publication of this magazine by the auxiliary and distributed it themselves under the same title.

67. AEKU Gen. 12, no. 23, bd. II. Zoellner to Scholtz-Klink, Berlin-Charlottenburg, 7 December 1936.

68. AEKU Brandenburg 12, no. 40, bd. V. Schlossman-Lönnies to Kapler, Potsdam, 4 January 1932.

69. Martin Broszat, "Zur Struktur der NS Massenbewegung," *Vierteljahrschrift für Zeitgeschichte* 31, no. 1(January 1983): 52–76.

70. Ibid., 62.

Chapter 3

1. Becker, 59–60.

2. Broszat, 62.

3. William S. Allen, *The Nazi Seizure of Power* (New York, 1973).

4. There were, of course, exceptions—the famous Brown Bishop of Freiburg being one. Overall, however, it would be correct to assert disapproval on the part of the Catholic church.

5. It took up issues such as divorce, alcoholism, and abortion; see their newspaper, *Die Mutter* 20, no. 11(November 1929): 86–87; and 21, no. 2(February 1930): 14.

6. Historischesarchiv Köln [henceforth HAK] CR 22, 20; see the various papers in this file, especially the letter of Klens to the Bishops' Conference.

7. An in-house publication, *Frau und Mutter,* charted the organization's growth in vol. 25, no. 1(January 1934): 16.

8. *Die Mutter,* the newspaper of the sodality, seems also to have been destroyed by the gestapo. I was able to obtain only pre-National Socialist copies of the paper on microfilm.

9. HAK Fr. und Mutter CR 22,20, yearly report for 1933.

10. *Frau und Mutter* 22, no. 2(February 1931): 14.

11. Anon. [Gertrud Ehrle], "Aus der Arbeit des Katholischen Deutschen Frauenbundes," printed as manuscript, n.d. [1948], 17.

12. Ibid.; *Frau und Mutter* 25, no. 1(January 1934): 14–15.

13. I refer here, above all, to the *Frauenland* and *Die Christliche Frau,* both published by the league, and to *Frau und Mutter,* the house paper of the sodality.

14. On 10 October 1932, *Frauenland* ran an illustrated article covering children's books from around the world; for more on this question, see Becker, 128.

15. Scholder, 160–70.

16. This theme is discussed in the previous chapter, and it will be taken up again in the following chapter.

17. Katholischer Deutscher Frauenbund [henceforth KDF] House archives *Nachrichtenblatt* 17, no. 4(April 1933).

18. It is difficult to assess just how strongly German women found themselves attracted to the Marian cult. In my opinion, they were less influenced by it than women in France. Other scholars disagree, maintaining a strong Marian revival in Germany in the nineteenth century; see Jonathan Sperber, *Popular Catholicism in Nine-*

teenth-Century Germany (Princeton, 1984). Certainly, by the twentieth century, Marianism was one of the major popular devotions in Germany.

19. *Frauenland* 25(July 1932): 180–84.

20. Rupp, "Mother of the *Volk*," 362–79.

21. HAK Frauenb Gen. 23, no. 36, Aufgaben des Kn. Dn. Frauenb'es in der Zeit, August 1933. OAF 55/69 Abschrift 8–9–1933. Oppositon among Catholic women will be discussed in greater detail in subsequent chapters.

22. HAK Frauenb Gen. 23, no. 36, Aufgaben des Kn. Dn. Frauenbundes in der Zeit, August 1933; Ordinariatsarchiv Freiburg (henceforth OAF) 55/69 Abschrift 8–9–1933.

23. See the pamphlet by Amalie Lauer (hereafter cited as Lauer) in the Gen. 23 file of HAK.

24. Laura S. Gellott, "The Catholic Church and the Authoritarian Regime in Austria, 1933–1938: A Relationship Re-examined," (Ph.D. diss., University of Wisconsin, 1982), 263.

25. Tim Mason, "Women in Germany, 1925 to 1940: Family, Welfare and Work," *History Workshop* 1 (Spring 1976): pt. 1, 91–102.

26. Ibid., 268ff.; see also Fessenden, 176–77.

27. Mason, 88.

28. *Die Christiliche Frau* 30, no. 7(July 1932): 202–4. Both this publication and that of the Catholic Women and Mother's Sodality, *Frau und Mutter,* were critical of national socialism. In addition, the women of the league actively campaigned against Hitler after 1931. Claudia Koonz argues, to the contrary, that Catholic women were "nonpartisan" regarding national socialism; see *Mothers in the Fatherland* (New York, 1987), 269.

29. Ibid., 185–88.

30. See chapter two.

31. See Helene Weber's "Gedanken Zum Wahlkampf," *Die Christliche Frau* 30, no. 7(July 1932): 202–3.

32. For a more detailed discussion of German and Austrian women between the wars, see Gellott and Phayer, 190–214.

33. HAK Frauenb Gen. 23, no. 36. See Argus press coverage no. 151, 2 June 1932.

34. *Die Christliche Frau* 30, no. 7(July 1932): 202–3.

35. HAK Frauenb Gen. 23, no. 36. Among others, the cities of Trier, Koblenz, and Cologne are mentioned.

36. HAK Frauenb Gen. 23, no. 36, Lauer.

37. *Der Bote* 21, no. 26(1 July 1934): 307–08; these themes crop up repeatedly in the paper, frequently as obiter dicta rather than as a separate article.

38. See, for example, *Frauenland* 17, no. 3(December 1924).

39. Peter Merkl, 579–80, makes this point about women. On militarism, see Winkler, *Mittelstand,* 160–64.

40. *Frauenland* 25 no. 3(March 1932): 77–79; see, also, Becker, 128.

41. See, for example, vol. 25 of *Frauenland.*

42. *Frau und Mutter* 22, no. 4(April 1933): 20.

43. Bremme, 73.

44. Hajo Holborn, *A History of Modern Germany* (New York, 1969), vol. 3, 742.

45. Childers, *The Nazi Voter,* 112–16, 140–41, 188–89; Hamilton, 38–41, and chapter 13; see also, Winkler, "German Society," and Rainer Hambrecht, *Der Aufstieg der NSDAP in Mittel und Oberfranken (1925–1933)* (Nürnberg, 1976), 284–92. Ernst Helmreich states a contrary opinion: "Catholics and Protestants joined the [National Socialist] movement with equal abandon" (page 125), but he seems to contradict this statement when he says that there was no landslide of Catholic votes for national socialism (page 237).

46. Scholder, 161–62.

47. Martin Broszat et al., eds., *Bayern in der NS-Zeit* (Munich, 1977), 48–51.
48. *Frau und Mutter* 24, no. 2(February 1933); 10.
49. AEKU Gen. 12, no. 123 BD. II Zoellner to Scholtz-Klink, Berlin-Charlottenberg, 7 December 1936.
50. Scholder, 165–70.
51. Hambrecht, 284–92, but compare Helmreich, 123–28.
52. Helmreich, 98–99; Gordon A. Craig, *Germany, 1866–1945* (New York, 1980), passim. Catholics also had some reservations about the republic; see Günther Plum, *Gesellschaftstruktur und politisches Bewusstsein in einer Katholischen Region, 1928–1933* (Stuttgart, 1977), 152–65.
53. *Frauenland* (1930): 226.
54. *Die Christliche Frau* 30, no. 7(July 1932): 202–4. This issue contains the article "Gedanken zum Wahlkampf" by Helene Weber and "Um Deutschlands Schicksal" by Gerta Krabbel.
55. OAF 55/69. Activity report of Baden for 1 January 1930 to 6 January 1932.
56. Becker, 72–77.
57. See Gellott and Phayer, 190–214.
58. In *Mothers in the Fatherland,* Claudia Koonz does not indicate that Catholic women of the league were engaged in politics in opposition to national socialism during the critical elections between 1930 and 1933.
59. *Frau und Mutter* 22, no. 7(July 1931): 42, 54; no. 9(September 1931): 69; no. 12(December 1931): 95.
60. A shrewd American observer, who enjoyed close contacts with members of the Center party and was one of the first United States citizens to write on the new Reich, George N. Shuster, noted that at the end of 1932—just a few months before the Concordat was signed—that Centrist leader Monsignor Kaas felt certain that the bishops would not be able to reverse their negative assessment of national socialism; see Shuster's *Strong Man Rules* (New York, 1934), 154. See also, A. Ihorst, "Zur Situation der Katholischen Kirche und ihrer Charitativen Tätigkeit in den ersten Jahren des Dritten Reiches" (Diplomarbeit, University of Freiburg, 1971), 1–5.
61. *Frau und Mutter* 24, no. 6(June 1933); 41.
62. *Frau und Mutter* 24, no. 7(July 1933): 54.
63. *Die Christliche Frau* 21, no. 9(September 1933): 226.
64. HAK Frauenb. Gen. 23 no. 36, Aufg. Des KDFs in der Zeit, August 1933.
65. Gellott and Phayer, 190–214.
66. Gottfried Krummacher, Scholtz-Klink's predecessor as head of the NSF, assured Catholic women that double membership was allowed; see KDF Nachrichtenblatt 18, no. 11(November 1933). On Krummacher, see Jill Stephenson, *The Nazi Organization of Women,* 102ff. The competition between party and church groups will be discussed extensively in subsequent chapters.
67. Johnpeter Horst Grill, *The Nazi Movement in Baden* (Chapel Hill [N.C.], 1983), 372.
68. Jill Stephenson, *The Nazi Organization of Women* (London, 1981), 118.
69. Ibid., ch. 3.
70. OAF 55/71. Report on the Meeting of 24 April 1933.
71. OAF 55/71. Letter of Klara Phillip, Karlsruhe, 27 April 1933, and Report of the meeting of 24 April 1933.
72. KDF Frauenorgans. Staatsvolkstumspflege u. Pol. Denis to Scholtz-Klink, 12 March 1934.
73. Ibid. Letter of Klara Phillip to league central office, Karlsruhe, 12 March 1934.
74. Ibid. Rundschreiben no. 2 *Kurze Richtlinien zur Deutschen Frauenarbeit,* Berlin, 21 March 1934.
75. Ibid., emphasis added; see also Stephenson, *The Nazi Organization of Women,* 135.
76. See chapter four.
77. Scholder, 646.

78. Niewyk, 60–61.
79. *Veröffentlichungen der Kommission für Zeitgeschichte* (henceforth, VKZ), Reihe A, Vol. 5, 353–54; on the bishops, see ibid., 321–39, especially, 330.

Chapter 4

1. *Der Bote* 30, no. 16(16 April 1933): 185.
2. ADW CA B III b2. Minutes of the board of directors, 26 October 1934.
3. Jochen-Christoph Kaiser, *Frauen in der Kirche* (Düsseldorf, 1985), 236.
4. Ernst C. Helmreich, *The German Churches Under Hitler* (Detroit, 1977), 128–29.
5. Klaus Scholder, *Die Kirchen und das Dritte Reich. Vorgeschichte und Zeit der Illusionen, 1918–1934* (Frankfurt, 1977), 282.
6. *Der Bote* 30, no. 10(5 March 1933): 115 and no. 33(13 August 1933): 392.
7. Ibid., no. 12(12 March 1933): 130; see also, Stephenson, 116.
8. *Der Bote* 30, no. 17(30 April 1933): 213.
9. Ibid., no. 31(30 July 1933): 368.
10. Ibid., no. 32(6 August 1933): 379.
11. Ibid.; see the August issues of 1933 for Hermenau's avowals of national socialism.
12. *Der Bote* 31, no. 7(18 February 1934): 75.
13. Ibid., no. 14(14 April 1934): 163.
14. Ibid., no. 26(1 July 1934): 304.
15. Ibid., no. 27(8 July 1934): 323.
16. Ibid., no. 8(25 February 1934): 91.
17. Ibid., no. 41(14 October 1934): 491.
18. Scholder, 288.
19. Most of these women collaborated on a book with Pastor Hans Hermenau in 1931: Hans Hermenau, ed., *Bereit zum Gottesdienst* (Potsdam, 1932).
20. Both Agnes von Grone and Klara Lönnies should be counted in this group of German Christian sympathizers / members. See Jochen-Christopher Kaiser, "Das Frauenwerk der Deutschen Evangelischen Kirche. Zum Problem das Verbandsprotestantismus in Dritten Reich," *Weltpolitik Europagedanke Regionalismus* (*Festschrift* for Heinz Gollwitzer), ed. Heinz Dollinger et al. (Aschaffendorff, 1981), 486.
21. ADW Executive Committee meeting of 11 February 1931; CA 401 I.
22. Hermenau was very much of a known entity within auxiliary circles. He believed in a woman's apostolate in the church and had worked with the auxiliary for years.
23. Hermenau made use of this theme in connection with the widely circulated film *Der Grosse Strom*; see *Der Bote* 30, no. 6(5 February 1933): 67. Also see his "Kirchliche Rundschau" column in vol. 29, no. 38(18 September 1932): 453. For a discussion of "order of creation" theology (or *Schöpfungsordnung*), see Kurt Meier, *Der Evangelische Kirchenkampf* (Göttingen, 1976), I, 66ff.
24. *Der Bote* 30, no. 15(9 April 1933): 173; and no. 18(30 April 1933): 525. On the inaugural ceremonies, see Helmreich, 128–29.
25. I refer here to the schism in the auxiliary caused by Hermenau, which is discussed at length in chapters six and seven.
26. Kurt Nowak, *'Euthanasie' und Sterilisierung im "Dritten Reich"* (Göttingen, 1980), 91ff.
27. *Der Bote* 30, no. 42(15 October 1933): 498.
28. Ibid., no. 6(February 1933): 67.
29. Ibid. 31, no.1(7 January 1934): 4 and no. 12(25 March 1934); 137.
30. Ibid. 31, no. 3(21 January 1934): 31.
31. Nowak, 74.

32. *Der Bote* 31, no. 7(18 February 1934): 76 (emphasis added).

33. Ibid. 31, no. 35(2 September 1934): 417.

34. Berlin Document Center (henceforth BDC), Lönnies file; see her resumé.

35. Nowak, 97.

36. *Der Bote* 31, no. 35(2 September 1934): 415.

37. Ibid., 417.

38. Ibid. 30, no. 10(5 March 1933): 115.

39. Ibid. 28, no. 18(3 May 1931): 215. Until her divorce in 1933, Lönnies used her husband's name with a hyphen, "Schlossmann-Lönnies."

40. Ibid. 28, no. 12(22 March 1931): 139.

41. EKU Brandenburg 12, no. 40, bd. V. Schlossmann-Lönnies to Kapler, Potsdam, 4 January 1932.

42. Ibid., Schlossmann-Lönnies to Kapler.

43. EKW "Zusammenarbeit" Schlossman-Lönnies to Berlinicke, Berlin, 8 March 1933.

44. Ibid.

45. Ibid. See *Anhang*.

46. Ibid.

47. *Der Bote* 31, no. 23(10 June 1934): 275.

48. See for example, *Der Bote* 31, no. 41(14 October 1934): 491.

49. ADW CA B III b2 Uebersicht über die diakonische Arbeit der Evangelishe Frauenhilfe (henceforth "Uebersicht"), 22 October 1935.

50. *Mutter und Volk* 3, no. 5(n. d., n. p.); EKW Zusammenarbeit mit NSV und NSF, 1933–38. Report of Westphalia.

51. On Krummacher, see J. Stephenson, 102ff; and, Kaiser, 488.

52. AEKU J IX 150h Kannengiesser to Seetz, Perleberg, 2 February 1934.

53. Ibid.

54. ADW CA B III b2. See "Streng Vertraulich" letter of the auxiliary central office to all provincial offices, Potsdam, 31 January 1934.

55. ADW CA B III b2. Minutes of Executive Committee, Potsdam, 18 January 1934.

56. Kaiser, 490; see chapter seven on the German Christians and the auxiliary.

57. Scholder, 730–40.

58. Scholder, 412; Meier, I, 93ff.

59. BDC Klara Lönnies file. See her resumé.

60. Kaiser, 491. Kaiser is too generous in his characterization of Lönnies. Her politico-religious ideas were bizarre even in the German Christian milieu. A Nazi party official was not very far off the mark when he described her writings as "awful kitsch"; see BDC Klara Lönnies file, letter of Hiernen [?] to Brandt, Berlin, 13 August 1942.

61. Lönnies had been in contact with party officials in Munich, attempting to impress them with her work and organizations; see AEKU, "Zusammenarbeit," Lönnies to Berlinicke, Berlin, 8 March 1933.

62. ADW CA B III b2. Letter of central office to provinces, Potsdam, 31 January 1934.

63. Kaiser, 491.

64. ADW CA B III b2, meeting of 18 January 1934.

65. Ibid., minutes of 2 March 1934.

66. AEKU J IX. See correspondence of 2 February 1934 and 8 March 1934.

67. *Mutter und Volk* 3, no. 5.

68. ADW CA B III b2. Central office to provinces, Potsdam, 9 March 1934.

69. *Der Bote* 31, no. 32(12 August 1934): 383.

70. Jill Stephenson, *The Nazi Organization of Women*, ch. 4.

71. *Der Bote* 31, no. 32(12 August 1934): 383.

72. See chapter five.

73. E. N. Peterson, *The Limits of Hitler's Power* (Princeton, 1969).

74. *Der Bote* 31, no. 5(4 February 1934): 52–53.

75. Ibid., 53.

76. Ibid. 31, no. 52(30 December 1934): 630.
77. Ibid. 31, no. 1(6 January 1935): 3.
78. Ibid. 31, no. 3(21 January 1934): 31.
79. Ibid. 30, no. 13(26 March 1933): 147; 31, no. 7(18 February 1934): 75; 31, no. 5(14 February 1934): 52; and 30, no. 19(13 May 1934): 228.
80. Ibid. 28, no. 27(5 June 1931): 324.
81. Ibid. 28, no. 19(13 May 1934): 630.
82. Ibid. 31, no. 3(21 January 1934): 31.
83. Ibid. 31, no. 36(9 September 1934): 430–31.
84. Reference is made here to the film, *The Vast River.*

Chapter 5

1. Thomas E. J. De Witt, "The Nazi Party and Social Welfare, 1919–1939" (Ph.D. diss., University of Virginia, 1971), 81ff.
2. Gröber treated the women of the league brusquely, but other women's groups were not excluded from Concordat business. The sodality, the Association of Catholic Women's Clerks, and the Association of Catholic German Women Teachers, among others, were all invited; see VKZ Reihe A., vol. 2, 174. For a contrary assertion, see Koonz, *Mothers,* 274. On Gröber's attitude toward the league, see OAF 55/69, report on December 1933, meeting of league leaders and Archbishop Gröber.
3. On article 31, see VKZ Reihe A, vol. 2, 221, 237–42, and vol. 30, 92; see also Scholder, 503–21, 629ff.
4. De Witt, 37.
5. Ibid., 174.
6. Helmreich, 264.
7. HAK Frau u. Mutter CR 22,20. Vicar General to Kaplan Sinzig, Cologne, 25 September 1933.
8. ADC CA XXX 62a. This file contains a copy of the pamphlet.
9. Ihorst, 61–62.
10. HAK Caritas CAB. Reg. 22, 31a, III.
11. Ihorst, 33.
12. Nowak, 111–13. See also Koonz, *Mothers,* 284–86, for excellent data on the sterilization controversy.
13. Scholder, 521. Kreutz had earlier cautioned against an hastily drawn up Condordat between the Vatican and the Third Reich.
14. See Frick's statement of 1947 in ADW CA B37.
15. *Deutschland Berichte der Sopade* (henceforth DBS), (1937), 250.
16. VKZ Reihe A, vol. 5, 396–99, 601–3, and passim.
17. Archiv Deutscher Caritas (henceforth ADC), 103.
18. These included the lighting of a flaming cross, personalized letters from pastors, and inscribing members' names in a "Golden Book"; see ADC 103, no. 2.
19. HAK Frau und Mutter CR 22,20.
20. With regard to the "goodwill" clause of the guidelines, see above chapter three.
21. HAK Frau und Mutter 22,20. Klens to Joseph Cardinal Schulte, Düsseldorf, 29 May 1934. In all likelihood, the decision had been made even before the meeting in Berlin. Klens and Krabbel used as an excuse for their rejection of Scholtz-Klink's proposition the ongoing negotiations over the implementation of the Concordat, which they said made it impossible for them to agree to joint mothercare work.
22. Ibid.
23. ADC 20, no. 62c, Meurers to central office, Köttingen, 2 July 1934.
24. Hoover Institute NSDAP Hauptarchiv, reel 24, folder 489, frame 877. Ludwig, Bishop of Speyer, to Reichstatthalter, Speyer, 1 July 1934.

25. HAK Cab. Reb. 22,31a, III. Pastor of Levenkusen-Rheindorf to the vicar general, 5 July 1934.

26. Ibid., see the correspondence of March and April, 1934, in the Cab. Reg. 22,31a file; see also Ihorst, 81.

27. Helmreich, 262ff.

28. ADC 121 Fasz. 2, Erke to Caritas, Berlin, 23 October 1934.

29. ADC 103, no. 2, Sister Maria Ernst to Caritas office (in Freiburg), Siegen, 12 October 1934.

30. ADC 103, no. 2, Ernst to Baumeister, Siegen, 8 Feburary 1935.

31. Ibid., 26 February 1935.

32. Ibid., 11 March 1935.

33. Ibid., 26 February 1935.

34. Ibid., 3 March 1935.

35. OAT B III 15,1, bd. 4. See the long complaint of Cardinal Faulhaber.

36. Ian Kershaw, Popular Opinion and Political Dissent in the Third Reich: Bavaria, 1933–1945 (Oxford, 1983), 205.

37. OAT B III 15,1, bd. 4. See the report of Caritas for 1935.

38. Unless a local Gau official was friendly toward the church, not much could be done in these situations. In this case, Caritas officials managed to get the Gauleiter to go to bat for them; see ibid., letter of Gauleiter to the Gauamtsleitung of the NSV, Trier, 22 February 1935.

39. Reference is always to Freiburg i.B. unless otherwise specified.

40. ADC 121 Fasz. 2 The verse actually refers to political Catholics: "Hängt die Juden, stellt die Schwarzen an die Wand."

41. ADC 103, no. 2, Berta Elizabeth Runkel to Caritas director Jöger, Aschaffenburg, 18 September 1935.

42. de Witt, 171.

43. Ibid., 117.

44. Ihorst, 59.

45. de Witt, 119.

46. OAT B III 15,1, Position Paper of the German Episcopacy with Anlage 1, 2, 4, and 8; Hoover Institute, NSDAP Hauptarchiv, reel 7, folder 152, frame 494.

47. OAT B III 15,1; see Position Paper.

48. Emma Horion, "Wer eine Mutter hilft, hilft einer ganzen Familie," Jahrhundertwende Jahrhundertmitte, ed. Anon. [KDF] (Köln, 1953), gives the following statistics on state-appropriated or foreclosed church institutions: 20 hospitals or homes with 2,000 beds, 1,200 kindergartens, 300 outpatient facilities, 233 railroad station welfare posts, 136 employment agencies for young women, 2 educational institutes for women (run by the league), 9 institutions in the diocese of Limburg with 1,000 beds, and 5 rest homes for mothers. These figures do not include additional appropriations during World War II; see page 51. See also, VKZ Reihe A., vol. 30, 316, 679–81.

49. OAT B III 15, 1, Hilgenfeldt to Kreutz, Berlin, 26 June 1936.

50. Thomas E. J. de Witt, "The Economics and Politics of Welfare in the Third Reich," Central European History 11, no. 3(September 1978); 268.

51. OAT B III 15, 1. See the bishops' position paper and Anlage.

52. HAK Kath Frauenb. Gen. 23, no. 36, Aufgaben des Kn. Dn. Frauenbundes in der Zeit, 1933; OAF 55/69. See the letter of the Freiburg league affiliate, 17 November 1934.

53. On the sodality, see Frau und Mutter 25, no. 1(January 1934); 14–15.

54. DBS (1938), 78–79.

55. Ibid., 312.

56. Stephenson, The Nazi Organization of Women, notes that of the various courses the NSF offered its members, the ones on race attracted relatively few women; see ch. 4.

57. Ihorst, 66–67.

58. ADC 20, 62c, Thielemann to Caritas, Kassel, 7 July 1934; OAT b III 15,1, bd. 4. See the remarks of Wagner, the Caritas director in Trier.

59. ADC Gauleiter A. Kling to Württemberg Caritas office, 9 July 1935; DBS (1935), 1302.

60. Archives of the Veröffentlichungen der Kommission für Zeitgeschichte (henceforth AVKZ). See the letter of Dr. Gerta Krabbel in I A25 V96; letter was poorly microfilmed, and top portion is missing.

61. [Rocholl-Gärtner], 152; Krabbel, "Wege der Persönlichkeitsbildung durch die Katholische Frauenbewegung," Licht über dem Abgrund, ed., Gertrud Ehrle (Freiburg, 1951), 12–13.

62. AVKZ I A 25 v 96. See document dealing with the ban against religious mothercare.

63. AVKZ I A 25 v 96. See Erlass of 3 July 1935 and also Runderlass, no. 188 in Düsseldorf Tagblatt.

64. Ibid., Krabbel to Bertram, Aachen, 20 July 1935.

65. OAT B III 15,1,bd. 4, position paper, Anlage 7.

66. VKZ Reihe A, vol. 25, 77–78.

67. The Protestant experience is discussed in chapters six and seven.

68. DBS (1936), 629–30.

69. Stephenson, ch. 4.

70. Susanna Danner, "Kinder, Küche, Kriegsarbeit–Die Schuling der Frauen durch die NS-Frauenschaft," in Mutter-Kreuz und Arbeitsbuch, 243.

71. Ihorst, 59.

72. Ibid.

73. ADC CA XX 62 NSV, National Socialist Welfare as the Basis of All Welfare.

74. Ibid.

75. VKZ Reihe A, vol. 20, 309.

76. Ihorst, 93.

77. VKZ Reihe A, vol. 20, 280–82.

78. Ihorst, 166, footnote 333. Dr. Maria Bornitz, the woman in charge of these cooperative ventures, maintained in an interview with A. Ihorst that Caritas was not organizationally tied to the NSV in the WHW and Mutter und Kind programs. Ihorst, however, found archival proof that they were.

79. VKZ Reihe A, vol. 25, 65–66.

80. Ibid., vol. 30, 564–76.

81. ADC CA XX 62a, Königs Wusterhausener Zeitung, 28 July 1937, 173.

82. Ibid. See letter of January 1937, to Oberamtsanwalt Meyer from NSV.

83. ADC 349 Vertretertag in Freiburg, September 1935.

84. See, for example, the incident at Büchelberg in the Palatinate, VKZ Reihe A, vol. 30, NS report of 7 September 1937, 202, and a similar incident in Lower Bavaria, DBS (1934), 1304.

85. VKZ Reihe A, vol. 30, 291, 316, and especially, 679–81.

86. Ibid., vol. 24, 202; see the National Socialist report from Speyer of 7 January 1936 in ibid., 105.

87. Franz Josef Heyen, NS Im Alltag (Boppard, 1967), 192–95; DBS (1937), 508.

88. Bertram to Pacelli, Breslau, 26 December 1936, in VKZ, Reihe A, vol. 30, 63.

89. Nowak, 69–70; on propaganda, see Berthold Hinz, Art in the Third Reich (New York, 1979); and David Hull, Film in the Third Reich (Los Angeles, 1969).

90. de Witt, "The Nazi Party," 131.

91. ADC 103 2, minutes of bishops' conference, 24–26 June 1942. There is some confusion here because the minutes of a 1937 conference claim one and a half million; see VKZ Reihe A, vol. 30, 637. This figure may be correct for 1942 (see chapter eleven), but other data indicate it is probably inaccurate as a prewar statistic.

92. ADC 103.1. See Caritas statistics.

93. VKZ Reihe A, vol. 30, 314.
94. Kershaw gives the opposite impression; see *Popular Opinion,* 221.
95. de Witt, "The Nazi Party," 200ff.
96. VKZ Reihe A, vol. 30, 314.
97. DBS (1936), 920.
98. OAT B III 15, 1, bd. 7, Caritas report, 15 August 1938.
99. Martin Broszat et al., *Bayern in der NS Zeit* (Munich, 1977), I, 366.
100. DBS (1935), 678, 681.
101. Ibid., 864–65; see also, Kershaw, 205.
102. de Witt, "The Nazi Party," 166.
103. Heyen, 192–95.
104. Quoted in George N. Shuster, *Like a Mighty Army* (New York, 1935), 187.
105. See Kershaw, 192, on Cardinal Faulhaber and the Concordat.
106. VKZ Reihe A, vol. 25, 124, 130ff, 175, 428.
107. Kershaw, 248.
108. Stephenson, *The Nazi Organization of Women,* 118.
109. Broszat, I, 366.
110. Compare Kershaw, 219, 253.
111. DBS (1934), 1, 302; see also (1936), 918, and (1937), 254. See Koonz, *Mothers,* 289–90, for additional examples of women urging stronger leadership.

Chapter 6

1. Boberach, 69.
2. ADW 401 CA b III b2, minutes of meeting of 4 February 1932.
3. On Tiling and the Protestant Women's League, see Jochen-Christoph Kaiser, *Frauen in der Kirche* (Düsseldorf, 1985), 166–72.
4. See Kaiser, "Das Frauenwerk," 486, and Scholder, 280–88. Tiling's chances of heading a national front of Protestant women were not good, since her organization, the Protestant Women's League, counted only 72,000 members in 1933 as opposed to about a million women in the auxiliary; see Pastor Brandmeyer, *Die Frauenarbeit der Kirche* (Dresden and Leipzig, 1940), 36.
5. The work front of Protestant women claimed to speak for two and one half million women who were members of one or more of the following subgroups: the Protestant Ladies' Auxiliary, the Protestant Women's League, the Protestant Mothercare Service, the Protestant Teachers' Association, and the deaconesses.
6. *Der Bote* 30, no. 21(12 May 1933): 249.
7. *Der Bote* 30, no. 22(28 May 1933): 259; no. 24(11 June 1933): 283; no. 29(16 July 1933): 343; and no. 30(23 July 1933): 368. Hermenau's efforts to increase membership seem not to have been rewarded; see membership statistics in chapter eleven.

In February, 1933, the Protestant Ladies' Auxiliary changed its title from simply *Evangelische Frauenhilfe* to *Evangelische Reichsfrauenhilfe.* This required that it seek recognition from all *Land* churches that were members of the German Evangelical Church Confederation. Recognition was announced in *Der Bote* 30, no. 21(21 May 1933): 249. The following month Hermenau further secured his position when the state representative to Inner Mission appointed him to be the commissioner for Protestant women's organizations; see Mybes, 63, and *Der Bote* 30, no. 28(9 July 1933): 329.
8. On the church struggle, see Scholder, 340ff., Helmreich, 137ff., and Meier, I, 269ff.
9. Scholder, 433.
10. See Kaiser, *Frauen in der Kirche,* 218–19. German Christian women were demanding 75 percent representation on synodal auxiliary boards.
11. *Der Bote* 30, no. 22(2 July 1933): 317. The auxiliary's leaders took the

unusual step of telephoning all its provincial offices to ask them to make sure that the auxiliary's affiliates absented themselves from the "flag service"; see *Der Bote* 30, no. 28(9 July 1933); 329.

12. Ibid. 30, no. 31(30 July 1933): 368.

13. Helmreich, 142; on Hermenau, see *Der Bote* 30, no. 32(16 August 1933): 379; no. 33(13 August 1933): 392; and no. 39(29 September 1933): 463.

14. Ibid. 30, no. 37(10 September 1933): 438.

15. Within the Old Prussian Union, only the province of Westphalia failed to give the German Christians a majority. On the elections, see Meier, I, 277, and passim, and Scholder, 564–68.

16. Helmreich, 144–48.

17. *Der Bote* 30, no. 42(13 September 1933): 498–99.

18. Ibid. 30, no. 37(10 September 1933): 438.

19. Ibid. 30, no. 37(10 September 1933): 438.

20. ADW CA III b2. See the minutes of the 30 October 1933 meeting.

21. The German Christians meant many things to many different people. During the summer and fall of 1933, it was not yet clear that a radical group within this faction would gain control. Uncertainty about the German Christians and a general openness to their movement is reflected in the correspondence of clergy who were members of the auxiliary's executive committee; see the correspondence between Zoellner and Johanneswerth, Zoellner and Kunze, and Kunze and Hoppe in ADW CA B III b2.

22. Kaiser, "Das Frauenwerk," 489. In the chapter "Protestant Women For the Fatherland," Claudia Koonz views the struggle for the leadership of Protestant women as a contest between women in which the younger generation, in the person of von Grone, won out; see *Mothers,* chapter 7. It was, in fact, a struggle between Hermenau and von Grone, the outcome of which was decided by the executive committee of the Ladies' auxiliary, which seriously considered firing von Grone at the same time it sacked Hermenau.

23. See document no. 83 in Kaiser, *Frauen in der Kirche,* 216.

24. Von Grone always said that it was an organizational dispute, not the German Christian problem, which led to Hermenau's firing, but I believe she followed this line so as not to open herself up to accusations of being an early, determined opponent of the German Christians, which, in truth, she was not; see her long paper entitled "*Frauenwerk der Deutschen Evangelischen Kirche*" in EKW Bestand 13, 1, no. 20.

25. Jochen-Christoph Kaiser hints at this in "Das Frauenwerk," 487, 502, footnotes 27 and 29; and again in *Frauen in der Kirche,* 207, where he calls her an ideal Aryan type.

26. ADW CA B III b2, minutes of the 30 October 1933 meeting. The executive committee also considered asking for the resignations of von Grone and Klara Lönnies but decided against this. In November von Grone wrote to Reich Bishop Müller, asking him to fire Hermenau officially; see Kaiser, *Frauen in der Kirche,* 217.

27. There are numerous accounts of this; see Helmreich, 149–50, and Scholder, 668–710.

28. The executive committee chose Pastor Walter Jeep to succeed Hermenau. Jeep was a member of the Young Reformation faction within the Protestant Church Struggle, which had played an active role in defeating Müller in the first Reich Bishop election; see Scholder, 412. He would therefore have been viewed as closer to the Confessing Church than the German Christians.

29. ADW CA BIII b2, minutes of the Mitgliederversammlung, 12 December 1933.

30. See, especially, chapter seven.

31. ADW CA B III b2, minutes of Finance Committee, 21 September 1932.

32. EKW O 3 53/I 22, minutes of the auxiliary meeting of 12 May 1932; ADW CA B III b2, Johanneswerth to L. H. G., Soest, 24 May 1932; and Hoppe to Kunze, Potsdam, 12 August 1933.

33. Helmreich, 163.
34. Bernd Hey, *Die Kirchenprovinz Westfalen 1933–1945* (Bielefeld, 1974), 69.
35. EKW Erklärungen zum 29 Juni u. 3 August 1934 (henceforth "Erklärungen"). See minutes of the board of directors of 29 June.
36. Mybes, 66.
37. EKW Auseinandersetzung mit dem D.C. 1930–1936 (hereafter "Auseinandersetzung"). Report of the Westphalian central office to its affiliates, 6 August 1934.
38. The letter is reproduced in its entirety in Mybes, 67.
39. Letter quoted in full in Mybes, 68.
40. Ibid., 69; the letter is substantially reproduced. The Rhenish prelate also requested that the national executive director of the auxiliary be instructed to fire the provincial executive director in the Rhineland, Pastor Kunze, who was described as a "most radical opponent of the current [German Christian] regime." This demonstrates how rapidly matters came to a head in the Protestant Church Struggle. Only a year earlier, Kunze had described himself as indifferent regarding the candidacies of Müller and Bodelschwing for Reich Bishop.
41. ADW CA B III b2, minutes of the board of directors' meeting of 26 October 1934.
42. EKW "Erklärungen." See the correspondence betwen Natorp and Johanneswerth, 10–13 July, and other documents in this file.
43. ADW CA B III b2, minutes of the executive committee, 24 October 1934.
44. Zoellner was present at the meeting that adopted the 29 June declaration; see EKW "Erklärungen," minutes of 29 June 1934. On Zoellner's influence see ADW CA B III b2, minutes of the board of directors, 26 October 1934. On the statement of the executive committee, see EKW "Auseinandersetzung" Rundschreiben of 6 August 1934.
45. On this debate, see the "Auseinandersetzung" and "Erklärungen" files in EKW.
46. On these local attitudes see EKW "Erklärungen:" Kreisverband Bochum to Johanneswerth, Bochum, 8 August 1934; Altbochum auxiliary's letter (signed by 700) to Siebold, 2 August 1934; and Kreisverband Minden-Ravensberg report of July 1934.
47. ADW CA B III b2, minutes of the board of directors, 26 October 1934.
48. Zoellner's influence can be seen in the early response of the national office to the 29 June declaration, which it criticized as being too aggressive and divisive; see EKW "Erklärungen" Lohmann to Westphalian auxiliary, Potsdam, 18 July 1934.
49. Some of the early conflicts between the auxiliary and the NSF are discussed above in chapter four. For Bismarck's grievances with Müller, see ADW CA B III b2, Eyl and von Bismarck to Müller, Hannover, 19 October 1934.
50. Ibid. A civil and criminal suit was brought against Lönnies as a result of which she was found guilty of fraud on two counts. Thus, she lost control of *Mutter und Volk*, which was taken over by the German Women's Enterprise; see BDC Lönnies file, Lönnies to Sievers, Berlin, 11 February 1942.
51. On the accord, see above, chapter four.
52. These problems were discussed in chapter four.
53. Letter quoted in full in Mybes, 77.
54. ADW CA B III b2, Grone *Rundschreiben*, Westerbrak, 18 September 1934.
55. The pertinent documents are reproduced in Mybes, 77–84.
56. ADW CA B III b2, Eyl and von Bismarck to Müller, Hannover, 19 October 1934.
57. The official title of this group was *Die Arbeitsgemeinschaft der missionarischen und diakonischen Werke und Verbände der Deutschen Evangelischen Kirche*. It should be noted that in joining with this group the auxiliary did not renounce its ties to the Reich Church.
58. AEKU Gen. 12, no. 123, bd. II. Abschrift of the Women's Work Front of the

German Evangelical Church to the Reichskirchenausschuss, Potsdam, 6 October 1936. On von Grone's nonmembership in the Confessing Church, see EKW Bestand 13, no. 20.

59. This was understandable. The leader of the coalition, which the Protestant women's work front had joined, was Pastor Friedrich von Bodelschwingh, Müller's one-time rival in the quest for the Reich bishopric. He and others continued to call for Müller's resignation.

60. After refusing Liebe-Harkort and Bishop Adler as candidates for the West-phalian executive committee, a resolution was passed "not to alter the hitherto posi-tive relationship of the Westphalian Auxiliary with the NSF." See ADW CA B III b2, minutes of the board of directors, 26 October 1934.

61. ADW CA B III b2, minutes of the board of directors of the auxiliary, 9 April 1935.

62. Hermenau's directive is reproduced in Mybes, 103–04.

63. ADW CA B III b2, Von Grone Rundschreiben 4/35, Westerbrak, 26 March 1935.

64. Ibid., Auxiliary Rundschreiben of 2 May 1935; EKW "Auseinandersetzung": discussion of the executive committee, 5 November 1935.

65. There were many of these statements; the most important is the Rund-schreiben of 2 May 1935, in ADW CA B III b2.

66. Pastor Wilhelm Kunze published a pamphlet containing these charges and explaining why Hermenau had earlier been fired from the auxiliary; the pamphlet is in file III/4 of ibid., and is reproduced by Mybes, 106–9.

67. EKW Bestand 13, 1, no. 20. See Grone's 1935 statement. The charges against Hermenau are discussed in Fritz Mybes, Agnes von Grone und das Frauen-werk der Deutschen Evangelischen Kirche (Düsseldorf, 1981), 44–49.

68. ADW CA B III b2, Pomeranian auxiliary to central auxiliary office, Stettin, 30 April 1935.

69. Kaiser, Frauen in der Kirche, 217.

70. Niklot Beste, Der Kirchenkampf in Mecklenburg von 1933 bis 1945 (Göt-tingen, 1975), 24.

71. ADW CA B III b2, Reich auxiliary to provincial offices, 12 April 1935.

72. Ibid., Landesverband für christlichen Frauendienst, Saxony, to auxiliary affil-iates, 3 May 1935.

73. AEKU Gen. 13 no. 123, bd. 2, memo of October 1935.

74. ADW CA B III b2, minutes of the board of directors of the Reich auxiliary, 1 February 1935.

75. AEKU M III 45b, 1932–39.

76. ADW CA B b2, minutes of the Reich auxiliary board of directors, 1 February 1935 and 9 April 1935; report from Bethel, 6 February 1935.

77. Bernd Hey, Die Kirchenprovinz Westfalen 1933–1945 (Bielefeld, 1974), 229.

78. AEKU J IX 150 h. This file contains a number of documents and letters on this case.

79. Some groups that had become German Christian in 1935 drifted back to the auxiliary a year or more later; see AEKB III 45b, Brandenburg auxiliary to Consis-torialrat, 29 September 1936.

80. These figures are critically evaluated below in chapter eleven.

81. See the following in ADW CA B III b2: for Nordmark, Messtorff to Reich auxiliary, 10 May 1935; for Saxony, Bertha von Burgsdorf to Reich auxiliary, 3 May 1935; for Pomerania, auxiliary to Reich auxiliary, Stettin, 30 April 1935; for Thuringia, Mecklenburg, and Hannover, see minutes of the Reich board, 9 April 1935; for East Prussia, auxiliary to Reich auxiliary, Königsberg, 14 May 1934; for the Rhineland, minutes of the executive committee, 1 February 1935; and for Silesia, Mybes, Geschichte, 103–5.

82. ADW CA B III, Abschrift to Länder Auxiliary, Potsdam, 21 March 1935.

83. See Meier, II, ch. 5, and Helmreich, ch. 10.

84. *Der Bote* 34, no. 31(1 August 1937): 335; Kaiser, 496.

85. See the following chapter for details.

86. AEKU Abschrift of Evang. Luth. Kreisdekan to Consistory, Munich, 11 September 1936.

87. Many of the pertinent documents are reproduced in Mybes, *Agnes von Grone*, 55–63.

88. Kaiser, "Das Frauenwerk," 496–97.

89. AEKU Gen. 12, no. 123, bd. 2, Zoellner to Scholtz-Klink, Berlin-Charlottenburg, 7 December 1936.

90. Helmreich, 191.

91. Kaiser, "Das Frauenwerk," 497.

92. AEKU Gen. 12, no. 123, bd. 2, Abschrift of Evang. Luth. Kreisdekan to Consistory, Munich, 11 September 1936. In *Mothers in the Fatherland*, Claudia Koonz is severely critical of von Grone on the grounds that she never denounced Nazi ideology either in part or in whole; see pages 253–54. Although I do not doubt von Grone's racism, she acted on principle in defending the right of Protestant women to work for their church. The documents that I have quoted in the text indicate clearly that her peers recognized that she acted on principle in her conflict with national socialism.

93. Ibid., Abschrift of Frauenwerk der DEK to Reich Church Committee, Potsdam, 6 October 1936.

Chapter 7

1. These feelings were expressed by members of the executive committee of the auxiliary on 2 March 1934; see ADW CA B III b2.

2. Kaiser, *Frauen in der Kirche*, 233.

3. AEKU Gen. 12, no. 194, bd. 1, Fiebig to Consistory, Hagen, 14 May 1938; Lempert to ?, Solingen, 28 January 1938; Saarland Frauendienst to Consistory, Düsseldorf, 7 February 1938.

4. Ibid., Saarland Frauendiest to Consistory, Düsseldorf, 7 February 1939.

5. Ibid., Pastor Tobias to Brandenburg Consistory, Kleinobbern, 2 March 1938.

6. ADW CA B III b2, Hermenau Abschrift, 6 March 1935.

7. *Der Bote* 33, no. 40(1 October 1936): 487.

8. AEKU Gen. 12, no. 193, bd. 1, Hagitte to APU, Ruhlsdorf, 20 December 1936.

9. Ibid., Dassler to Kuntze, Oranienburg, 11 August 1936.

10. Ibid., Hagitte to Consistory, Ruhlsdorf, 7 December 1936.

11. Ibid., Frau Peter to Consistory, Gehrden, 26 July 1936.

12. The number of conflicts became so frequent that in August, 1935, the Reich auxiliary office asked all provincial offices to notify their affiliates that they should keep written accounts of the problems they experienced; see EKW Frauenwerk der D. E. V. Kirche, *Rundschreiben*, Soest, 23 August 1935.

13. AEKU Gen. 12, no. 123, Anna Braem to *Gauleiter*, Magdeburg, 19 January 1935.

14. Ibid., Miller to Brandenburg auxiliary office, Bernau b. Berlin, 2 February 1936.

15. Ibid., Anna Braem to *Gauleiter*, Magdeburg, 19 January 1935.

16. See the examples given by Kaiser in *Frauen in der Kirche*, 224–26.

17. ADW CA B III b2, von Grone's *Rundschreiben*, 4/35, Königsberg, 16 May 1935; see also EKW Bestand 13.1, no. 20 Grone's statement, 1935.

18. Kaiser, "Das Frauenwerk," 494.

19. Kaiser, *Frauen in der Kirche*, 246; Mybes, *Agnes von Grone*, 35.

20. Kaiser, "Das Frauenwerk," 494.

21. BDC Von Grone file. See the letter from Hilgenfeldt to Bach, Berlin, 24 June 1935.

22. ADW CA B III b2, letter of the president and executive director, marked "Streng Vertraulich," to provincial leaders, Potsdam, 31 January 1934; and ibid., *Rundschreiben* of von Grone, Westerbrak, 26 March 1935.

23. Ibid., *Rundschreiben*, Westerbrak, 26 March 1935.

24. BDC Von Grone file. Hilgenfeldt to Buch, Berlin, 24 June 1935.

25. See the previous chapter.

26. Kaiser, *Frauen in der Kirche*, 218. As far as von Grone herself is concerned, I doubt if the racial policies of the party, as far as they were perceived in 1935, posed any difficulty.

27. BDC Von Grone file, minutes of the 25 June 1935 meeting. Von Grone was told that she "completely lacks the ability to think, and therefore to act logically."

28. Ibid.

29. BDC Von Grone file. See von Grone's letter to Bach, Westerbrak, 1 June 1935. It is clear from the original agreement with Scholtz-Klink that this was von Grone's intention; see Mybes, *Agnes von Grone*, 34–35.

30. Kaiser, "Das Frauenwerk," 494.

31. BDC Von Grone file. Transcript of the 1936 proceedings, 3.

32. Ibid., 5.

33. Ibid., transcript of the 1938–39 proceedings, 5.

34. EKW "Auseinandersetzung," von Grone to Protestant Frauenwerk, Königsberg, 16 May 1935.

35. Kaiser, "Das Frauenwerk," 494.

36. EKW "Frau von Grone" Kammer des Oberstens Parteigerichts, Geschäftsnummer II/28/36/HR.

37. Kaiser, *Frauen in der Kirche*, 236.

38. EKW "Auseinandersetzung" Service Abschrift, 14 February 1936.

39. Kaiser, "Das Frauenwerk," 494–95.

40. Ibid., 507, footnote 111. Agnes von Grone, with the backing of other auxiliary leaders, refused to resign as head of Protestant women's work front when the initial judgment of the National Socialist court was handed down because this would be seen as an admission of guilt on the part of the organization; see Mybes, *Agnes von Grone*, 55–62.

41. Kaiser, *Frauen in der Kirche*, 255–56.

42. Document reproduced in Kaiser, *Frauen in der Kirche*, 223.

43. AEKU Gen.l 12, no. 123, bd. II, Zoellner to Scholtz-Klink, 7 December 1936.

44. Kaiser, "Das Frauenwerk," 506–7, footnote 110.

45. Regarding the agreement, see above, chapter four. For her claim that she did not wish to staunch the auxiliary, see Kaiser, "Das Frauenwerk," 491.

46. *Der Bote* 31, no. 31(19 August 1934); 391.

47. Koonz, *Mothers in the Fatherland*, 254.

48. My account of the experiences of von Grone and Protestant women with National Socialism differ both with regard to fact and intepretation from that of Koonz, ibid., chapter seven.

49. See above, chapter six, pg. 151.

Chapter 8

1. Thus, Archbishop Gröber, having lost his admiration of nazism, obliquely damned the National Socialist regime for its outrages against Jews during *Kristallnacht*; see OAF 55/69, Gröber to league members at Gengenback cloister, 28 November 1938.

2. *Die Mutter* 28, no. 4(May 1938): 59.

3. Michael H. Kater, "Die deutsche Elternschaft im National-sozialistischen Er-

ziehungssystem," *Vierteljahrschrift für Sozial-und Wirtschaftsgeschichte* 67, no. 4(1980): 507.

4. VKZ Reihe A, vol. 20, Klens to German bishops, Düsseldorf, 1 August 1935, 225–28.

5. OAT B III 14 5 B. This is a report, circa 1934, on the 1933 conference of Catholic bishops.

6. VKZ Reihe A, vol. 5, 720–21, and vol. 34, 399.

7. Ibid., vol. 20, 334.

8. Ibid., vol. 5, 279. On the organization of teachers, see Elisabeth Mleinek, "Der Verein Katholischer Deutscher Lehrerinnen im Kampfe Gegen den Nationalsozialismus," printed as manuscript by the Kommission für Zeitgeschichte bei der Katholischen Akademie in Bayern, 17–18.

9. [Rocholl-Gärtner], 150.

10. Mleinek, 25.

11. Kershaw 209ff. and 240ff.

12. Kater, 507.

13. Kershaw, 209ff.

14. ADC 357, fasc. 9a.

15. Hoover Institute NSDAP Hauptarchiv roll 86, folders 63, 72.

16. For concern over the kindergartens, see VKZ Reihe A., vol. 30, 340–44, 572; on Kreutz, see ibid., 455.

17. Peter Matheson, *The Third Reich and the Christian Churches* (Edinburgh, 1981), 93–96, document 62.

18. *Die Mutter* 27, no. 1(January 1936).

19. Ibid., no. 9; see also 27, no. 3(March 1936): 37; no. 6(June 1936): 98; and no. 8(August 1936): 120.

20. VKZ Reihe A, vol. 30, 658.

21. Ibid., vol. 34, 417, 457.

22. Ibid., 756; see 457 as well.

23. On the Protestant effort, see the following chapter.

24. VKZ Reihe A, vol. 34, 882–88.

25. Kater, 492–508.

26. VKZ Reihe A, vol. 34, 1046; Heydrich to Ribbentrop, Berlin, 7 October 1941.

27. Ulrich von Hehl, *Katholische Kirche und National Sozialismus in Erzbistum Köln, 1933–1945* (Mainz, 1977), 79.

28. Boberach, 505–08.

29. VKZ Reihe A, vol. 24; see National Socialist reports of June, 1935, 77, and July 1935, 86; on their anti-Catholicism, see vol. 30, 106–20.

30. Ibid., vol. 24; see the report of 10 May 1938, 246.

31. Broszat, I, 364–65. Documents pertaining to this action are reproduced in [Rocholl-Gärtner], 154–57.

32. On the growth of the sodality, see chapter eleven.

33. Ibid., 159; Scholtz-Klink, 83.

34. Hoover Institute, NSDAP Hauptarchiv, reel 24, folder 489, frame 877. Gen. Vik. Riemer to Eggenfelder, Passau, 9 January 1935.

35. [Rocholl-Gärtner], 154–57.

36. VKZ Reihe A, vol., 30, 753.

37. Ibid., Bertram to Reichssicherheitshauptamt, Breslau, 4 December 1939.

38. Hoover Institute, NSDAP Hauptarchiv, roll 84, folder 63–72.

39. VKZ Reihe A, vol. 30, 711; Bertram to Kreutz, 6 September 1939.

40. VKZ Reihe A, vol. 34, 292; Kreutz to Seldte, 11 December 1940; on vocations, see ibid., 173.

41. de Witt, "The Nazi Party," 122.

42. OAT B III 15.1, bd. 7. See notes on meeting of 25–27 October 1940.

43. VKZ Reihe A, vol. 34, 279.

44. Ibid., 895.

45. Ibid., 172.

46. Ibid., 110; see the minutes of the bishops' plenary conference.

47. Ibid., 434–55.

48. Ibid., 110–11.

49. Nowak, 158–77; see also Guenther Lewy, *The Catholic Church and Nazi Germany* (New York, 1965), 263ff.

50. G. Sereny, *Into That Darkness. From Mercy Killing to Mass Murder* (London, 1974). Kershaw is especially good on public reaction in Bavaria; see 334–40 of *Popular Opinion*.

51. Nowak, 176.

52. I use the word lay here loosely since the Catholic church did not admit women to any of the degrees of ordination.

53. BAB Sommer Nachlass, "Angestellte des Kath. Fürsorgevereins," June, 1937.

54. VKZ Reihe A, vol. 34, 86–87; Kreutz to Frick, Freiburg, 5 August 1940.

55. Bistumsarchiv Berlin (henceforth BAB), Sommer Nachlass. See *Lebenslauf* and correspondence with Zentrale des Katholischen Fürsorgevereins für Mädchen, Frauen und Kinder.

56. Statistics come from a National Socialist brochure of 27 June 1945, published at Hartheim, one of the killing facilities; see Nowak, 192.

57. See the article on euthanasia by K. Borg in the 1957 *Katholisches Jahrbuch*, 134–40.

58. ADC 349.040M.1, minutes of Limburg Meeting, 5–6 September 1946.

59. Heydrich to Ribbentrop, Berlin, 18 August 1941, in VKZ Reihe A, Vol. 34, 1040.

60. See the following issues of *Die Mutter*–28, no. 9(September 1937): 107; 29, no. 4(May 1938): 39; and (for the advertisement) 29, no. 6(June 1938): 59.

61. See the statistics of the Elizabeth Society's growth in the final chapter.

62. VKZ Reihe A, vol. 24, 124; report of 8 July 1936.

63. Ibid.

64. ADC 103, no. 2, Runkel to Jorger, Aschaffenburg, 18 September 1934.

65. VKZ Reihe A, vol. 24, 193; see the report of 9 December 1936.

66. ADC 349.040 M.1, minutes of the Limburg meeting, 5–6 September 1946.

67. Gordon, *Hitler*, ch. 6.

68. Detlev Peukert, *Volksgenossen und Gemeinschaftsfremde* (Köln, 1982), 294.

69. H. D. Leuner, *When Compassion Was a Crime* (London, 1966), 101.

70. On the popularity of pre-*Kristallnacht* anti-Semitic policies, see Gordon, ch. 6, "Public Reactions to Nazi Anti-Semitism."

Chapter 9

1. *Der Bote* 30, no. 10(5 March 1933): 115; and no. 33(13 August 1933): 392.

2. See Stephenson, 116, and chapters two and four.

3. *Der Bote* 34, no. 24(13 June 1937): 263; and 28, no. 51(20 December 1937): 607.

4. Ibid. 33, no. 47(22 November 1936): 559; 34, no. 15(11 April 1937): 161; 35, no. 21(22 May 1938): 255; and no. 49(4 December 1938): 543.

5. Ibid. 34, no. 10(3 July 1937); 107; no. 28(11 July 1937); 307; and no. 41(10 October 1937); 451.

6. ADW CA Statistik 223/15, 1940–41. This file deals with the entire Reich.

7. Johnpeter Horst Grill, *The Nazi Movement in Baden, 1920–1945* (Chapel Hill [N.C.], 1983): 385.

8. Grill, 384.

9. ADW CA Statistik 223/15, 1940–41. See papers on Dessau.

10. ADW CA B III b2, minutes of the meetings of 6 December 1934 and 1 February 1935; *Mutter und Volk* was formerly an auxiliary-sponsored publication, which Klara Lönnies edited. The NSV took it away from her in the fall of 1934. It could be argued that the auxiliary withdrew its support for this reason rather than for reasons of principle, but it is clear that some auxiliary provinces, like Westphalia, objected to the publication's contents.

11. Mybes, *Geschichte,* 116.

12. ADW CA Statistik 223/15 1940–41; Brandenburg papers. During the war years, some of the auxiliary's homes, such as the one in Bad Harzburg, were seized by the government and converted into hospitals.

13. *Der Bote* 33, no. 4(26 January 1934).

14. AEKU Gen. 12, no. 193, vol. 1; see the letter of 16 December 1936 regarding *Deutsches Frauenwerk* and the *Evangelische Frauenhilfe;* see also reports of exclusion or limiting of the auxiliary's work in *Der Bote* 33, no. 23(7 June 1936): 271; 34, no. 16(18 April 1937): 171; and 35, no. 23(5 June 1938): 255.

15. Ibid 35, no. 49(4 December 1938): 543.

16. ADW CA Statistik 223/15 1940–41; see Brandenburg papers.

17. Grill, 394.

18. ADW Statistik 223/15 1940–41; report from Württemberg.

19. Letter of the finance department to the church and the auxiliary; reproduced in Mybes, *Geschichte,* 96. See also, *Der Bote* 33, no. 47(22 November 1936): 559.

20. ADW CA Statistik 223/15 1940–41; see report from Saxony.

21. Ibid.; see especially the reports from Darmstadt and Hannover.

22. The intentions of the NSV are clear from the correspondence in Hoover Institute, NSDP Hauptarchiv T86, rolls 63 and 72, which deal with Baden, and from reports in ADW CA Statistik 223/15, which deal with most of the Reich.

23. Grill, 390.

24. Thus, the *Frauenschule für Volkspflege* in East Prussia was closed; see Martin Gerhardt, *Ein Jahrhundert Innere Mission* (Gutersloh, 1958), pt. 2, 374.

25. Hoover Institute, NSDAP Hauptarchiv T86, rolls 63 and 72.

26. ADW CA Statistik 223/15 1940–41; Wiesbaden.

27. Manfred Heinemann, "Evangelische Kindergarten im Nationalsozialismus. Vom den Illusionen Zum Abwehrkampf," *Erziehung und Schulung im Dritten Reich,* ed., M. Heinemann (Stuttgart, 1980), 56.

28. *Der Bote* 33, no. 1(5 January 1936): 7.

29. Ibid. 35, no. 33(14 August 1939): 367.

30. Ibid. 33, no. 18(3 June 1936): 211; no. 36(27 August 1936): 463; and 34, no. 3(19 January 1937): 31.

31. Ibid 33, no. 31(2 August 1936): 367.

32. Ibid. 34, no. 24(13 January 1937): 263.

33. Gerhard Kehnscherper, *Mythos des Blutes?—Jesus Christ* (Potsdam, 1935).

34. *Der Bote* 32, no. 31(4 August 1935): 371.

35. Ibid. 33, no. 31(2 August 1936): 367.

36. Ibid. 33, no. 16(19 April 1936): 187; and no. 24(14 June 1936): 283.

37. John S. Conway, *The Nazi Persecution of the Churches* (New York, 1968), 106–8.

38. AEKU Gen. 12, no. 193, vol. 1; see letter of 16 December 1936, regarding *Deutsches Frauenwerk und Evangelische Frauenhilfe.*

39. Quoted in Conway, 149.

40. *Der Bote* 33, no. 25(30 August 1936): 410.

41. Ibid. 33, no. 47(22 November 1936): 559.

42. Ibid. 35, no. 9(4 December 1938): 543.

43. Kershaw, 181–84.

44. Grill, 387.

45. Ibid. 392.

46. *Der Bote* 33, no. 25(30 August 1936): 416.

47. Broszat, *Bayern,* NS report of 30 November 1936, 97; 3 September 1937, 105; and 12 December 1936, 408.

48. Heinemann, 68, 79.

49. *Der Bote* 35, no. 31(31 July 1938): 334.

50. Ibid. 33, no. 18(3 May 1936): 211; no. 31(2 August 1936): 367; and no. 34(23 August 1936): 403.

51. Ibid., no. 24(14 June 1936): 283; and no. 25(30 August 1936): 415.

52. Ibid. 33, no. 25(30 August 1936): 410.

53. Ibid. 35, no. 13(27 March 1938): 150.

54. AEKU Gen. 12, no. 193, bd. 1; interoffice memo, 24 October 1936.

55. Ibid.; see the report of January 1937.

56. *Der Bote* 35, no. 13(27 March 1938): 140.

57. *Ibid.* 33, no. 28(12 July 1936); 332. To participate, a woman had to pay only 60RM a month; this covered room, board, and tuition. Whether or not regional or provincial church organizations paid this for the volunteer is not known, but it seems not unlikely.

58. AEKU Gen. 12, no. 193, bd. 1; interoffice memo of 24 October 1936.

59. Ibid.; this estimate is based on the experience of women who had already done Bible work in Pomerania and who subsequently enrolled in the Potsdam program.

60. *Der Bote* 33, no. 10(8 March 1936): 115.

61. Ibid. 34, no. 2(10 January 1937): 19; and 35, no. 33(14 August 1938): 367.

62. ADW CA Statistik 223/15; see especially East Prussia and Württemberg.

63. *Der Bote* 34, no. 2(19 January 1937); 19.

64. Ibid. 33, no. 25(30 August 1936): 413; and 34, no. 24(13 June 1937): 263; Eberhard Klügel, *Die Lutherische Landeskirche Hannovers und ihr Bischof, 1933–1945* (Berlin and Hamburg, 1964), 440.

65. AEKU Gen. 12, no. 194, bd. 1; see "Frauendienst."

66. *Der Bote* 34, no. 17(25 April 1937): 195; 33, no. 18(3 May 1936): 211; and 34, no. 34(22 August 1937): 375.

67. Grill, 395.

68. ADW CA 223/15 1940–41; see reports from Baden and the Palatinate.

69. *Der Bote* 34, no. 24(14 June 1937): 263; and 35, no. 35(28 August 1938): 387.

70. AEKU Gen. 12, no. 40, bd. 6; see the correspondence dealing with the activities of Bible sister Dorothea Gürtler.

71. Heinz Boberach, ed., *Berichte des SD und der Gestapo über Kirchen und Kirchenvolk in Deutschland, 1934–1944* (Mainz, 1971), 72.

72. On the Nuremberg Laws, see Gutterage, ch. 5, and on the gestapo, see Boberach, 343. For a brief overview of the attitude of the Protestant church regarding anti-Semitism, see Gordon, 254–60.

73. VKZ Reihe A, vol. 5; National Socialist report of 6 March 1937, 157.

74. BDS (1937), 494, and (1939), 926.

75. Broszat, *Bayern;* National Socialist report from Ebermannstadt, 2 October 1937, 108.

76. Boberach, 599.

77. Ibid., 600.

78. The auxiliary continued to assert that it was not linked organizationally to the Confessing Church, but the gestapo rejected this claim; see Boberach, 111.

79. AEKU Gen. 12, no. 193; Brandmeyer to High Church Counsel, Berlin, 28 August 1938; and Brandmeyer to Geheim Staatspolizei, 11 May 1938.

80. Paul Gürtler, *National Sozailismus und Evangelische Kirchen im Warthe-gau* (Göttingen, 1958), 121.

81. AEKU Gen. 12, no. 193, Brandmeyer to Bender, Potsdam, 21 January 1938, and Brandmeyer to High Church Counsel, Potsdam, 20 November 1937.

82. AEKU Gen. 12, no. 193, bd. 1; there are entire lists of this kind of police action in this file.

83. Ibid., Brandmeyer to Chancery, Potsdam, 28 August 1938.

84. Ibid.; see the report on Blumberg.

85. Ibid.; Krieg and Steckelmann to High Church Counsel, Münster, 31 January 1938.

86. EKW "Zusammenarbeit" Abschrift, 31 May 1935.

87. EKW Brandmeyer to Bender, Potsdam, 21 January 1938, and Brandmeyer to National Socialist party leader Stande, Potsdam, 19 February 1938.

88. Gerda Szepansky, *Frauen Leisten Widerstand: 1933–1945* (Hamburg, 1983), 276–82.

89. Wolfgang See, *Frauen im Kirchenkampf* (Berlin, 1984), 62ff.

90. Ibid., 41ff., and Szepansky, 283–88. Heinrich Grüber headed a Protestant relief mission for Jews in Berlin whose operation was evidently similar to that of the Catholic Special Relief office described in the following chapter.

91. See, 102ff.

92. Carolsue Holland and G. R. Garrett, "The Skirt of Nessus: Women and the German Opposition to Hitler," *International Journal of Women's Studies* 6, no. 4, 369–70.

93. *Der Bote* 33, no. 31(2 August 1936): 367.

94. Ibid. 33, no. 23(7 June 1936): 271; no. 9(1 March 1936): 138; 34, no. 23(6 June 1937): 251; and 33, no. 34(23 August 1936): 403.

95. Ibid. 35, no. 1(2 January 1937): 7.

96. EKW "Zusammenarbeit" Lönnies to Berlinicke, Berlin, 8 March 1933; see Angang.

97. *Der Bote* 34, no. 23(5 June 1937): 251.

98. Ibid. 34, no. 28(11 July 1937): 307.

99. Ibid. 35, no. 6(6 February 1938): 59.

100. Ibid. 35, no. 5(10 April 1938): 158; 18, no. 1(4 May 1938): 195; 36, no. 41(9 October 1939): 452; on the military, see 36, nos. 6, 11, 12; no. 16(16 April 1936): 171; and no. 39(24 September 1939): 391.

Chapter 10

1. BAB Sommer Nachlass. See her "Uebersicht über Meine Tätigkeit."

2. Kershaw makes this point in reference to rural Bavaria, 358ff.

3. Lutz-Eugen Reutter, "Die Hilfstätigkeit Katholischer Organisationen und kirchlicher Stellen für die im nationalsozialistischen Deutschland Verfolgten" (Ph.D. diss., Hamburg, 1969), 105.

4. BAB Sommer Nachlass. See Sommer's 1938 paper marked "Streng Vertraulich," entitled "Die Tätigkeit des Hilfsausschusses für den katholischen Nichtarier im Jahre 1938."

5. On the St. Raphael Society and the relationship between it and the Special Relief office, see "Kirchliche Arbeit für die Auswanderung der Juden und Mischlinge katholischer Konfession" (hereafter "Kirchliche Arbeit") in BAB Sommer Nachlass; and, Burkhard van Schewick, "Katholische Kirche und Nationalsozialistische Rassenpolitik," in *Die Katholiken und das Dritte Reich,* ed. K. Repgen and K. Gotto (Mainz, 1980).

6. BAB Sommer Nachlass, "Kurzer Bericht ü. Entstehung und Entwicklung des Hilfswerks beim Bischöflichen Ordinariat Berlin" (henceforth, "Kurzer Bericht"); this statement was drawn up by Sommer in 1946.

7. BAB Sommer Nachlass, "Kirchliche Arbeit."

8. BAB Sommer Nachlass, Statistische Uebersicht, 1939–1940.

9. Fairly reliable figures exist for the number of German Jews who succeeded in emigrating through the sixteen branch offices of the St. Raphael Society, but the figures for the city of Berlin are less certain; for the former, see BAB Sommer Nachlass, "Kirchliche Arbeit," and for the latter, see ibid., Statistische Uebersicht.

10. BAB Sommer Nachlass, letter of Preysing to the bishop of Osnabrück, Berlin, May, 1939.

11. Bishop Preysing seemed to think that the Reich Association of Jews should be willing to pay for the emigration expenses of the entire family in cases of Jewish-Gentile intermarriage; see BAB Sommer Nachlass, "Kirchliche Arbeit."

12. BAB Sommer Nachlass. See the letter of the director of the Reich associatoin, Ernst Israel Bukofzer, to special relief, Berlin, 30 July 1940.

13. BAB Sommer Nachlass.

14. Ibid. See her notebook.

15. Ibid.

16. Ibib., "Statistische Uebersicht."

17. Ibid.

18. Ibid., "Kurzer Bericht."

19. Ibid., "Uebersicht über meine Tätigkeit." In this postwar "vita," Sommer says that she took over the special relief office in 1939; it may be that, in effect, she directed it since then, but she was not actually appointed director until 1941.

21. On Protestants and this issue, see the previous chapter.

22. VKZ Reihe A, vol. 34, 550–51; this report is at odds with the report of Bishop Berning to Cardinal Bertram, Osnabrück, 27 October 1941, in ibid., 583–84.

23. Koonz, Mothers in the Fatherland, 15–16.

24. VKZ Reihe A, vol. 34, 552–53.

25. Ibid., 555–57; Bertram to German bishops, Breslau, 17 September 1941.

26. The absence of subsequent material on this question in volume 34 of VKZ may be an indication that the presence of Jewish Catholics at church services did not become a problem; Bishop Berning of Osnabrück said as much in fact: see Lewy, 286. In Mothers in the Fatherland, Koonz gives the opposite impression; see pages 16–17.

27. BAB Sommer Nachlass. See Stella Borcher's Lebenslauf.

28. Sommer and the Berlin circle of Catholic resisters were in constant touch with Heinrich Grüber, who stated during the Eichmann trial that he had many contacts within the party and administration; see H. D. Leuner, When Compassion Was A Crime (London, 1966), 114–19. Sommer also would have known about Kurt Gerstein's account of the process of genocide going on in Poland; see Saul Friedländer, Counterfeit Nazi (London, 1969), 158.

29. VKZ Reihe A, vol. 34, 938–45; Sommer to Bertram, Berlin, before 10 November 1942.

30. Erich Klausener, "Margarete Sommer," Miterbauer des Bistums Berlin, ed. Wolfgang Knauft (Berlin, 1979), 175; VKZ Reihe A, vol. 38, 21.

31. Ibid., 19–21.

32. Ibid., 21–24; Bertram to Lammers, Muhs, and Goebbels, Breslau, 3 March 1943; and Bertram to Frick, Muhs, Thierack, Lammers, and the RSHA, Breslau, 2 March 1943.

33. Ibid. See the correspondence to and from Bishop Preysing and the Entwurf, 62–65.

34. Ibid. See the report for the Bishops' Fulda Conference, 14 August 1943.

35. Ibid., passim.

36. Ibid., Preysing to Sommer, Berlin, 21 August 1943, 207.

37. Ibid., Sommer's Report, Berlin, 24 August 1943, 218–20.

38. Ibid, 267–77; Berning to Bertram, Osnabrück, 3 November 1943.

39. VKZ Archive I A 25 j12, director of Caritas-Breslau to Oberpräsidium-Breslau, Breslau, 16 November 1944.

40. For an account of Berlin and its Jewish citizens during the Holocaust, see Leonard Gross, The Last Jews in Berlin (New York, 1982).

41. BAB Sommer Nachlass, "Kurzer Bericht."

42. Reutter, 105.

43. BAB Sommer Nachlass, "Kurzer Bericht."

44. Ibid.

45. Ibid.

46. BAB Sommer Nachlass, "Zum Gedächtniss an Frau Jaffe." This was written by her parish priest.

47. BAB Sommer Nachlass. See Sommer's "To Whom It May Concern" letter on Martha Mosse, Berlin, 6 June 1947.

48. VKZ Reihe A, vol. 34, 675–78; Bericht Sommers, Berlin, 14 February 1942.

49. BAB Sommer Nachlass, "Kurzer Bericht." One of Sommer's sources of information seems to have been Bernhard Lösener of Nürnberg law fame.

50. VKZ Reihe A, vol. 38, 19–21; Bericht Sommer, Berlin, 2 March 1943.

51. BAB Sommer Nachlass, "Kurzer Bericht."

52. BAB Sommer Nachlass, Sommer to Anneliese Triller, Berlin, 11 September 1946. Neumark did not survive the war.

53. BAB Sommer Nachlass. See Sommer's letter on Joachim, Berlin, 9 July 1946.

54. My interpretation of the documents is that Sommer tried to get the bishops to protest National Socialist atrocities against Jews, but not everyone would agree; Schewick, 120, says Sommer did not urge the bishops to speak out, basing his assertion on a statement Sommer evidently made in 1960. Sommer's loyalty to her church seems to have made it impossible for her to find fault with it publicly. Possibly because of this unresolvable conflict, Sommer found fault with herself during the last years of her life, retracing each step she had made during her work in the special relief office and blaming herself for the deaths of Jews on account of insignificant details that she might have handled differently.

55. VKZ Reihe A, vol. 38, 99–100.

56. Sommer's reports are reproduced in volumes 24 and 38 of VKZ Reihe A. The original documents, if they exist, are in Breslau, now part of Poland. The Breslau archival holdings are microfilmed and are now housed in the VKZ archives in Bonn. I am indebted to the director of the archives, Ulrich von Hehl, for letting me use the microfilm.

57. VKZ Reihe A, vol. 24, 675–78; Sommer's Report of 14 February 1942.

58. Ibid., vol. 34, 210–15.

59. VKZ Reihe A, vol. 38, 220–21; the draft originated in Berlin, 22–23 August 1943.

60. Ibid., 267–77; Berning to Bertram, Osnabrück, 3 November 1943.

61. Ibid., 350, footnote 2; quote is taken from a letter from Bertram to Prange, the Vicar General of the diocese of Berlin, written on 17 April 1944.

62. Pierre Blet et al., *Actes et Documents du Saint Siège relatifs à la seconde guerre mondiale* (Vatican City, 1975), IX, see the memoranda of the spring and summer of 1943.

63. Ibid., 269–72; Maglione's reply is in the footnote.

64. Ibid., 317; Gröber to Pius XII, Freiburg, 2 February 1944; Gröber mentions that Luckner was working for Jews under his mandate. The extent of her work is not yet clear.

65. Ibid., vol., 34, 635, footnote 3.

66. Sarah Ann Gordon, "German Opposition to Nazi Anti-Semitic Measures Between 1933 and 1945 with Particular Reference to the Rhein-Ruhr area" (Ph.D. diss., SUNY-Buffalo, 1979), 374.

67. Lenten Letter of Cardinal Faulhaber, 8 February 1946. Quoted in *Dokumente Deutscher Bischöfe*, ed. Wolfgang Löhr (Würzburg, 1985), I, 87.

68. Katholische Nachrichten Agentur, 104, 3 June 1982; Witte was awarded a *Bundesverdienstkreuz* for her work.

69. For this information, I am indebted to Frau Susanne Witte who graciously agreed to an interview in Berlin in June, 1985. Frau Kirschbaum survived the war, but her daughter was deported and killed in a concentration camp in eastern Europe.

70. See chapter nine; Sarah Gordon found that Catholics were more sensitive to National Socialist anti-Semitism than Protestants; see her study, *Hitler, Germans, and the "Jewish Question"* (Princeton, 1984), ch. 8 and passim.

71. DBS (1938), 194.

72. The account of Ilse Rewald of her experiences as a refugee in Berlin bears this out; see Ilse Rewald, "Berliner, die uns halfen, die Hitler-diktatur zu überleben," *Beiträge zum Thema Widerstand,* no. 6, 1975.

73. ADC 349.040 M.1, minutes of Limburg meeting, 5–6 September 1946.

74. ADC 349 K. 30 and 93, fasc. 1.

75. ADC 349.040 M.1, minutes of the Limburg meeting, 5–6 September 1946.

76. *Petrusblatt* 33, 15 August 1980.

77. For a study of the bishops, see Frank M. Buscher and Michael Phayer, "German Catholic Bishops and the Holocaust, 1940–1953," *German Studies Review* 11, no. 3(October 1988), 163–85, and Ethel Mary Tinnemann, "The German Catholic Bishops and the Jewish Question: Explanation and Judgment," *Holocaust Studies Annual,* ed. Jack Fischel and Sanford Pinsker (Greenwood [Florida], 1986), II, 55–86.

78. Many of these statements are reproduced in vol. 38 of VKZ; it is interesting to compare that of bishop Preysing, who wanted the church to oppose the government's anti-Semitism publicly, to the statements of others who did not—archbishop Gröber's for example. See Buscher and Phayer, "German Catholic Bishops," for details.

79. Schewick, 114–15.

80. See Leuner, 105.

81. Klausener, 175, writes that such a protest, but nationwide, was planned if the regime published the divorce decree dissolving marriages between "Aryans" and Jews.

Chapter 11

1. *Der Bote* 34, no. 20(16 May 1937): 251.

2. Statistics are from AEKU Gen. 12, no. 194, bd. 1, "Frauendienst," and from Klugel, 441.

3. *Der Bote* 33, no. 40(4 October 1936): 487.

4. Ibid. 29, no. 8(21 February 1932): 96.

5. Allen, ch. 14. Allen suggests a general disillusionment of Germans in "Thalburg" by 1936 and a resulting trend toward increased church attendance. This would correspond with my finding of increased auxiliary membership at the same point of the National Socialist era.

6. ADC 349, minutes of the *Vertetrertage,* October 1932.

7. See chapter 8.

8. ADC 349K.30; 349K.71; 349K.11; and 349K.62.

9. HAK Frauenb. Gen. 23, 36.

10. Phayer, "Protestant and Catholic Women Confront Social Change," 95–113.

11. Gellot and Phayer, 190–214.

12. Boberach, 116.

13. For a review of all the various organizations of women on the eve of the National Socialist era, see Koonz, "The Competition for Women's *Lebensraum,*" 199–236.

14. Mybes, *Geschichte,* 172.

15. EKW C15–01, directive of 19 November 1940.

16. AEKB F11 Frauenhilfe, 1946–1956.

17. Ibid., 2 November 1949. For Westphalia, see *Kirchliches Amtsblatt der Evangelishcen Kirche von Westfalen* (September 1947), 10.

18. Today it is common for women to be church elders. In western Germany,

women constitute 30 percent or more of all elders, and the proportion of women serving in this position in larger cities is even greater. See EKW Report on Election of Elders, 1976 (Westphalia); Mybes, *Geschichte,* 173 (Rhineland); and the *Evangelische Staatslexikon* under "Frau" for cities.

19. Wolfgang See, *Frauen im Kirchenkampf* (Berlin, 1984), passim.

20. Ilse Bertinetti, *Frauen im geistlichen Amt* (Berlin, 1965), 71; G. Heintze, "Das Amt der Pastorin," *Evangelische Theologie* 22, nos. 12/13(1962): 512.

21. See, 24 and 62ff.

22. AEKU Gen. 12, no. 193, "Vermerk" of 9 February 1937.

23. *Der Bote* 33, no. 25(30 August 1936): 410.

24. Adolf Brandmeyer, *Die Frauenarbeit der Kirche* (Dresden, 1940), 31.

25. Bertinelli, 71; see also, Joachim Heubach, *Die Ordination zum Amt der Kirche* (Berlin, 1956), 58–64; and Senghaas-Knobloch, 44–45.

26. Wilhelm Niesel, ed., *Um Verkundigung und Ordnung der Kirche. Die Bekenntnissyoden der Evangelischen Kirche der Altpreussischen Union, 1934–43* (Bielefeld, 1949), 95–97.

27. Paula Müller, "Die Kirche und die Frau," *Hefte zur Frauenfrage* 20(1920); 22.

28. Allen, 222–23.

29. AEKU Gen. 12, no. 123, bd. 2, Zoellner to Scholtz-Klink, Berlin-Charlottenberg, 7 December 1936.

30. The text is in Matheson, 98–99.

31. VKZ Reihe A, vol. 38, Bertram to Lammers, Breslau, 25 August 1943.

32. Szepansky, 276–88.

Bibliography

I. Archives

Archiv Deutscher Caritas

 CA XX — NSV-Caritas papers

 121 — Conflicts with the NSV

 022 — Caritas Organizations

 349 — Elizabeth Society, 1920–70

 103 — Caritas Membership, 1934–41

 357 — Caritas Losses to NSV

Archiv des Diakonischen Werkes

 CA B III 15 — Protestant Ladies' Auxiliary Männerdienst

 CA B III b2 — Protestant Ladies' Auxiliary

 CA 837 III — Pastor Frick's Statement

 CA G — NSV 1932–41

 CA 223/15 — Charities, 1940–41

 CA 761/22 — Health / Day Care, 1940

 CA 1195/2 — Gestapo / NSV Actions

 CA 1195 XII — Charities, 1934

Archiv der Evangelischen Kirche der Union

 Gen. 12, no. 193 — NSV / NSF Friction with Protestant Ladies Auxiliary, 1936–40

 Gen. 12, no. 194 — Protestant Ladies' Service

 Gen. 12, no. 123 — Reich Mother Service

 Gen. 12, no. 40 — Protestant Ladies' Auxiliary

Archiv des Evangelischen Konsistoriums Berlin-Brandenburg

 F 11 — Protestant Ladies' Auxiliary

 J IX — Protestant Ladies' Auxiliary

 Holz-Regel — Protestant Ladies' Auxiliary

 M III 45 b — Protestant Ladies' Auxiliary

Archiv der Veröffentlichungen des Kommissions für Zeitgeschichte

 Bertram Papers

 I A — Catholic Associations

Bistumsarchiv Berlin

 Sommer Nachlass — Sommer's Papers

Bistumsarchiv Freiburg
 55/69 Catholic Women and Mothers' Sodality
 55/71 Catholic Associations

Berlin Document Center
 Agnes von Grone file
 Klara Lönnies file

Evangelische Kirche von Westfalen
 Nursing Personnel (uncatalogued)
 0,3 53 Protestant Ladies' Auxiliary
 C 15-01 Protestant Ladies' Auxiliary
 Zoellner file 1923–36
 Agnes von Grone file
 Frauenwerk der deutschen Evangelischen Kirche, 1935–36
 Zusammenarbeit mit NSV/NSF 1933–1938
 Erklärungen zum 29 Juni u. 3 August 1934
 Bestand 13,1 Westphalian Auxiliary

Historisches Archiv des Erzbistums Köln
 Gen. 23, no. 36 Catholic Women and Mothers' Sodality
 CR 22,20 Annual Reports; Klens's papers
 Cab. Reg. 22,31 Caritas

Hoover Insitutute
 NSDAP Hauptarchiv, reel 24 Conflicts in Bavaria

Katholischer Deutscher Frauenbund
 (Note regarding the archives: papers dating from 1933 to 1936 are mostly missing as are the *Sitzungsprotokolle* from 1933 to 1948. Dr. Gertrud Ehrle, a member of the league during the Nazi era and president thereafter, informed me that no papers were kept during this time to avoid problems with the regime.)

 Frauenorganiz. Staatsb., Volkstumpflege u. pol. This file contains important correspondence, including some with Scholtz-Klink.

Ordinariatsarchiv Trier
 B III 11,12 Lay Organizations
 B III 15,1 Caritas Papers
 B III 14,5 Catholic Women and Mothers' Sodality and the Catholic German Women's League
 105 2976 St. Vincent de Paul Society

U.S. National Archives
 T-81, rolls 63, 85, 86 NSV Activity in Baden

II. Newspapers

 Der Bote für die Christliche Frauenwelt (title varies), 1904–39
 Die Christliche Frau, 1902 to present

Frau und Mutter, 1929 to 1939
Frauenland, 1903 to 1968
Die Mutter, 1910 to 1913
Mutter und Volk, 1931 to 1939

III. Other Printed Sources

Akten deutscher Bischöfe über die Lage der Kirche, 1933–1945. 5 vols.
Pastor Arnold. *Die von der Frauenhülfe organisierte Krankenpflege auf dem Lande durch freiwillige Hilferinnen.* Potsdam, n.d. [1911]. 16 pp.
Aus der Caritas im Bistum Paderborn. 1924–31.
Boberach, Heinz, ed. *Berichte des SD und der Gestapo über Kirchen und Kirchenvolk in Deutschland 1934–1941.* Mainz, 1971. 1021 pp.
Brandenburgische Frauenhülfe. Bericht über die konstituierende Versammlung am 4 Marz 1902. Potsdam, 1902. 32 pp.
Buchberger, Michael. *Vereinsbüchlein für die Mitglieder des christlichen Müttervereins.* Regensburg, n.d. 32 pp.
Bulletin de la Société de St. Vincent de Paul. Old series, 92 vols. New Series, 5 vols. Paris, 1848 to 1951.
Deutschland-Berichte der Sopade 1934–1940 (7 vols.) Frankfurt am Main, 1980.
Elizabeth-Briefe. Freibug i. Br. 33 vols.
Evangelische Frauenhilfe: Blätter für Frauenarbeit in der evangelischen Gemeinde. 1928–40.
Evangelischer Männerdienst. 1930–39.
Gaertner, Franziska von. *Der Bund Königen Luisa.* Halle, 1934.
Gemminger, Ludwig. *Kleiner Marien-Kalender für christliche Frauen und Jungfrauen.* Regensburg, 1888. 192 pp.
Giese, Friedrich, and Johannes Hosemann, eds. *Das Wahlrecht der Deutschen Evangelischen Landeskirchen.* Berlin, 1929. 2 vols.
Hermenau, Hans. *Bereit zum Gottes-Dienst.* Potsdam, 1932. 43 pp.
———. *Die evangelische Frau in Kirche und Nation.* Potsdam, 1933. 133 pp.
———. *Evangelische Frau als Volksbewegung.* Potsdam, n.d. 13 pp.
Handbuch der Inneren Mission. Berlin, 1929. 397 pp.
Hoppe, Pastor Dr. *Männerdienst und Frauenhilfe.* Potsdam, n.d., n.p.
Jahresbericht aus der Arbeit des Gesamtverbandes der Evangelischen Frauenhilfe. 1899 to 1929.
Kirchliches Amtsblatt. 10 September 1947. No. 10.
Krose, H. A., S. J. *Kirchliches Jahrbuch f.d. Katholische Deutschland.* Freiburg, i. Br., 1910. 1 vol.
———. *Kirchliches Handbuch.* 28 vols.
Kirchliches Jahrbuch. 1903–74.
Marx, Dr. *General-Statistik der Katholischen Vereine Deutschlands.* Trier, 1871. 96 pp.
Mitteilungen der Evangelischen Frauenarbeit in Deutschland. 1949–54.
Mybes, Fritz. *Geschichte der evangelischen Frauenhilfe in Quellen.* Barmen, 1975. 228 pp.
Niesel, Wilhelm, ed. *Um Verkundigung und Ordnung der Kirche. Die Bekenntnissynoden der Evangelischen Kirche der Altpreussischen Union.* 1934–43. Bielefeld, 1949. 121 pp.
Noetel, H. *Die Kirchenordnung für die Evangelischen Gemeinden der Provinz Westfalen und der Rheinprovinz von 6. Nov. 1923 mit Erläuterungen nebst Ergänzungsbestimmungen in Anhang.* Dortmund, 1928.
Rees, Hanna. *Frauenarbeit in der NS Volkswohlfahrt.* Berlin, 1938. 63 pp.
Statistik der Frauenorganisationen in Deutschen Reiche: Bearbeitet in Kaiserlichen Statistischen Amte Abteilung für Arbeiterstatistik. Berlin, 1909. 77 pp.
Theologisches Jahrbuch. 1893–1903.

Tiling, Margarete von, and Paula Mueller. *Die Kirche und die Frau.* Berlin, 1919. 40 pp.
*Übersicht über die Organisation der Zweigvereine (Evangelisch-kirchlicher Hülfsver-
ein).* 1893, 1896, 1907.
*Die Verhandlungsniederschriften der Westfälischen Provinzialsynode vom Oktober
1946.* Bielefeld, 1971. 69 pp.
Veröffentlichungen der Kommission für Zeitgeschichte, Reihe A. Vols. 2, 5, 11, 20, 24,
25, 30, 34, and 38.
*Wie Können die Elizabeth und Vinzenvereine für ihre Gegenwärts-und Zukünftsauf-
gaben Befähigt Werden? Denkschrift an den Hochwürdigsten Deutschen Ep-
iscopat.* N.p., n.d. [1927].
Zehn Jahre Caritasarbeit in Wuppertal. Wuppertal-Eberfeld, 1937. 47 pp.

IV. Selected Books and Periodicals

Allen, William Sheridan. *The Nazi Seizure of Power: The Experience of a Single German
Town.* New York, 1984.
Bertinetti, Ilse. *Frauen im geistlichen Amt.* Berlin, 1965.
Beste, Niklot. *Die Kirchenkampf in Mecklenburg von 1933 bis 1945.* Göttingen,
1975.
Bock, Gisela. *Zwangsterilisation in Nationalsozialismus. Untersuchungen zur Rassen-
politik und Frauenpolitik.* Berlin, 1985.
Bracher, Karl Dietrich. *The German Dictatorship.* Trans. Jean Steinberg. New York,
1970.
Bridenthal, Renate, and C. Koonz. "Beyond Kinder, Küche, Kirche: Weimar Women in
Politics and Work." In *Liberating Women's History: Theoretical and Critical Es-
says,* 301–29. Ed. Bernice A. Carroll. Urbana, 1976.
Bridenthal, Renate. "Beyond Kinder, Küche, Kirche: Weimar Women at Work," *Central
European History* 6, no. 2(June 1973): 148–66.
Broszat, Martin. *The Hitler State. The Foundation and Development of the Internal
Structure of the Third Reich.* Trans. John W. Hidden. New York, 1981.
Bühler, Anne Lore. *Der Kirchenkampf im evangelischen München.* Nürnberg, 1974.
Buscher, Frank M., and Michael Phayer. "German Catholic Bishops and the Holocaust,
1940–1953," *German Studies Review* 11, no. 3 (October 1988): 163–85.
Childers, Thomas. *The Nazi Voter.* Chapel Hill, 1983.
———. "The Social Basis of the NS Vote," *Journal of Contemporary History* 11, no.
4(October 1976): 17–42.
Conway, John S. *The Nazi Persecution of the Churches.* New York, 1968.
De Witt, T. E. J. "The Economics and Politics of Welfare in the Third Reich," *Central
European Studies* 11, no. 3(September 1978): 256–79.
———. "The Nazi Party and Social Welfare, 1919–1939." Ph.D. diss., University of
Virginia, 1971.
Dietrich, Donald J. *Catholic Citizens in the Third Reich: Psychosocial Principles and
Moral Reasoning.* New Brunswick, NJ, 1988.
Eilerts, Rolf. *Die nationalpolitische Schulpolitik.* Cologne, 1963.
Elling, Hannah. *Frauen im deutschen Widerstand. 1933–1945.* Frankfurt, 1981.
Engfer, Hermann, ed. *Das Bistum Hildesheim, 1933–1945.* Hildesheim, 1971.
Evans, Richard J. "Feminism and Female Emancipation in Germany, 1870–1945:
Sources, Methods and Problems of Research," *Central European History* 9, no.
4(December 1976): 323–51.
———. *The Feminist Movement in Germany, 1894–1933.* London, 1976.
———. *The Feminists.* London, 1977.
———. "Liberalism and Society: The Feminist Movement and Social Change." *In So-
ciety and Politics in Wilhelmian Germany.* Ed. R. J. Evans. London, 1978.

——. "Modernization Theory and Women's History," *Archiv für Sozialgeschichte* 20(1980): 492–519.

Fischer, Joachim. *Die sächsische Landeskirche im Kirchenkampf, 1933–1937.* Göttingen, 1972.

Frauengruppe Faschismusforschung, ed. *Mutterkreuz und Arbeitsbuch: Zur Geschichte der Frauen in der Weimarer Republik und im Nationalsozialismus.* Frankfurt, 1981.

Friedländer, Saul. *Counterfeit Nazi.* London, 1969.

Gellott, Laura S. "The Catholic Church and the Authoritarian Regime in Austria, 1933–1938: A Relationship Reexamined." Ph.D. diss., University of Wisconsin. 1982.

Gellott, Laura S., and Michael Phayer. "Dissenting Voices: Catholic Women in Opposition to Fascism," *Journal of Contemporary History* 22(January 1987): 91–114.

Gerhardt, Martin. *Ein Jahrhundert Innere Mission.* 2 vols. Gutersloh, 1948.

Gordon, Frank. "The Evangelical Churches and the Weimar Republic, 1918–1933." Ph.D. diss., University of Colorado-Boulder, 1977.

Gordon, Sarah. *Hitler, Germans, and the "Jewish Question."* Princeton, 1984.

Greven-Aschoff, Barbara. *Die bürgerliche Frauenbewegung in Deutschland, 1894–1933.* Göttingen, 1981.

Grill, Johnpeter Horst. *The Nazi Movement in Baden, 1920–1945.* Chapel Hill, NC, 1983.

Gross, Leonard. *The Last Jews in Berlin.* Chapel Hill, NC, 1983.

Gruppe Berliner Dozentinnen, ed. *Frauen und Wissenschaft.* Berlin, 1977.

Gürtler, Paul. *Nationalsozialismus und evangelische Kirchen im Warthegau.* Göttingen, 1958.

Gutteridge, Richard. *Open Thy Mouth for the Dumb; The German Evangelical Church and the Jews, 1897–1950.* New York, 1976.

Hamilton, Richard. *Who Voted for Hitler?* Princeton, 1982.

Hehl, Ulrich von. *Katholische Kirche und Nationalsozialismus im Erzbistum Köln, 1933–1945.* Mainz, 1977.

Heinemann, Manfred. "Evangelische Kindergärten im Nationalsozialismus. Vom den Illusionen zum Abwehrkampf." In *Erziehung und Schulung im Dritten Reich,* 49–89. Ed. M. Heinemann. Stuttgart, 1980.

Helmreich, Ernst C. *The German Churches Under Hitler.* Detroit, 1977.

Hey, Bernd. *Die Kirchenprovinz Westfalen, 1933–1945.* Bielfeld, 1974.

Heyen, Franz Josef. *Nationalsozialismus im Alltag.* Boppard am Rhein, 1967.

Hoffmann, Peter. *The History of the German Resistance, 1933–1945.* Trans. Richard Barry. Cambridge, 1977.

Holland, Carolsue, and G. R. Garret, "The Skirt of Nessus: Women and the German Opposition to Hitler," *International Journal of Women's Studies* 6, no. 4(1982): 363–81.

Kaiser, Jochen-Christoph, ed. *Frauen in der Kirche.* Düsseldorf, 1985.

——. "Kirchliche Frauenarbeit in Westfalen. Ein Beitrag zur Geschichte des Provinzialverbandes des west. Frauenhilfe, 1906–1945." In *Jahrbuch f. Westfälische Kirchengeschichte* 74(1980): 159–90.

Kaplan, Marion A. *The Jewish Feminist Movement.* London, 1979.

Kater, Michael H. "Die Elternschaft im Nationalsozialistischen Erziehungssystem," *Vierteljahrschrift für Sozial-und Wirtschaftsgeschichte* 67, no. 4(1980), 484–512.

Kaufmann, Doris. *Katholisches Milieu in Münster, 1928–1933.* Düsseldorf, 1984.

Kershaw, Ian. *Popular Opinion and Political Dissent in the Third Reich: Bavaria, 1933–1945.* New York, 1983.

Klügel, Eberhard. *Die Lutherische Landeskirche Hannovers und ihr Bischof, 1933–1945.* Berlin and Hamburg, 1964.

Koonz, Claudia. *Mothers in the Fatherland: Women, the Family, and Nazi Politics.* New York: 1986.

——. "Mothers in the Fatherland: Women in Nazi Germany." In *Becoming Visible:*

Women in European History, 445–73. Ed. R. Bridenthal and C. Koonz. Boston, 1977.

———."Nazi Women Before 1933: Rebels Against Emancipation," *Social Science Quarterly* 56, no. 4(March 1976), 553–63.

Koschorke, Manfred, ed. *Geschichte der Bekennenden Kirche in Ostpreuss, 1933–1945*. Göttingen, 1976.

Laqueur, Walter. *The Terrible Secret*. New York, 1982.

Leuner, H. D. *When Compassion Was a Crime*. London, 1966.

Lewy, Günther. *The Catholic Church and Nazi Germany*. London, 1966.

Linck, Hugo. *Der Kirchenkampf in Ostpreussen, 1933–1945. Geschichte und Dokumentation*. Munich, 1968.

Littell, Franklin H., and Hubert G. Locke. *The German Church Struggle and the Holocaust*. Detroit, 1974.

Matheson, Peter. *The Third Reich and the Christian Churches*. Edinburgh, 1981.

Meier, Kurt. *Der evangelische Kirchenkampf*. 3 vols. Göttingen, 1976.

Moltmann-Wendel, Elizabeth, ed. *Menschenrechte für die Frau*. Munich, 1974.

Mosse, George. *The Nationalization of the Masses*. New York, 1975.

Mybes, Fritz. *Agnes von Grone und das Frauenwerk der Deutschen Evangelischen Kirche*. Düsseldorf, 1981.

Nowak, Kurt. *'Euthanasie' und Sterilisierung im "Dritten Reich."* Göttingen, 1980.

Paucker, Arnold, ed., *Die Juden im Nationalsozialistischen Deutschland. The Jews in Nazi Germany, 1933–1945*. Tübingen, 1986.

Paulsen, A., ed. *Die Vikarin*. Berlin, 1956.

Peukert, Detlev. *Volksgenossen und Gemeinschaftsfremde*. Cologne, 1982.

Phayer, Michael. "Protestant and Catholic Women Confront Social Change." *Another Germany. A reconsideration of the Imperial Period*. Ed. Jack Dukes and Joachim Remak. Boulder, CO, and London, 1988, 95–113.

Plum, Günter. *Gesellschaftstruktur und politisches Bewusstsein in einer katholischen Region, 1928–1933*. Stuttgart, 1972.

Quataert, Jean H. *Reluctant Feminists*. Princeton, 1979.

Reichle, Erika. *Die Theologin in Württemberg. Geschichte-Bild-Wirklichkeit eines neuen Frauenberufes*. Frankfurt, 1975.

Rupp, Leila J. "Mother of the Volk: The Image of Women in Nazi Ideology," *Signs* 3, no. 2(Winter 1977): 362–79.

Schmidtchen, Gerhard. *Protestanten und Katholiken*. Munich and Bern, 1973.

Schoenbaum, David. *Hitler's Social Revolution: Class and Status in Nazi Germany*. New York, 1981.

Scholder, Klaus. *Die Kirchen und das Dritte Reich. Vorgeschichte und Zeit der Illusionen, 1918–1934*. Frankfurt, 1977.

Schüddekopf, Charles, ed. *Der Alltägliche Faschismus. Frauen im Dritten Reich*. Berlin, 1982.

Senghaas-Knobloch, Eva. *Die Theologin im Beruf*. Munich, 1969.

Shuster, George N. *Like A Mighty Army*. New York, 1935.

———. *The Ground I Walked On*. Notre Dame, 1969.

———. *Strong Man Rules*. New York, 1934.

Speier, Hans. *Die Angestellten vor dem Nationalsozialismus*.Göttingen, 1977.

Stephenson, Jill. *The Nazi Organization of Women*. London, 1981.

———. *Women in Nazi Society*. New York, 1975.

———. "Women's Labor Service In Nazi Germany," *Central European History* 15, no. 3(September 1982), 241–65.

Thévoz, Robert. *Pommern, 1934–1935, im Spiegel von Gestapo-Lageberichten und Sachakten*. Cologne and Berlin, 1974.

Tidl, Georg. *Die Frau im Nationalsozialismus*. Vienna, 1984.

Tinnemann, Ethel Mary. "The German Catholic Bishops and the Jewish Question: Explanation and Judgment," *Holocaust Studies Annual*. Ed. Jack Fisthel and Sanford Pinsker. Vol. 2, 55–86.

Vorländer, Herwart. *Kirchenkampf in Elberfeld, 1933–1945*. Göttingen, 1968.

Winkler, H. A. *Mittelstand, Demokratie und Nationalsozialismus*. Cologne, 1972.
Wright, J. R. *Above Parties: The Political Attitudes of the German Protestant Church Leadership, 1918–1933*. London, 1974.
Zabel, J. A. *Nazism and the Pastors*. Missoula, MT, 1976.
Zahn, Gordon. *German Catholics and Hitler's Wars: A Study in Social Control*. New York, 1962.
Zahn-Hernack, Agnes von. *Die Frauenbewegung*. Berlin, 1928.

Index

Michael Phayer is the director of the Institute for Family Studies and a professor at Marquette University. He holds the doctorate in history from the University of Munich. His publications include *Sexual Liberation and Religion in Nineteenth Century Europe*, *Religion und das gewöhnliche Volk in Bayern in der Zeit von 1750 bis 1850*, and numerous articles.

The manuscript was edited by Elizabeth Gratch. The book was designed by Don Ross. The typeface for the text is Friz Quadrata. The display face is Kabel Bold.

The book is printed on 55-lb Glatfelter paper and is bound in Joanna Kennett black cloth.

Manufactured in the United States of America.